FRANK LLOYD WRIGHT
AMERICAN MASTER

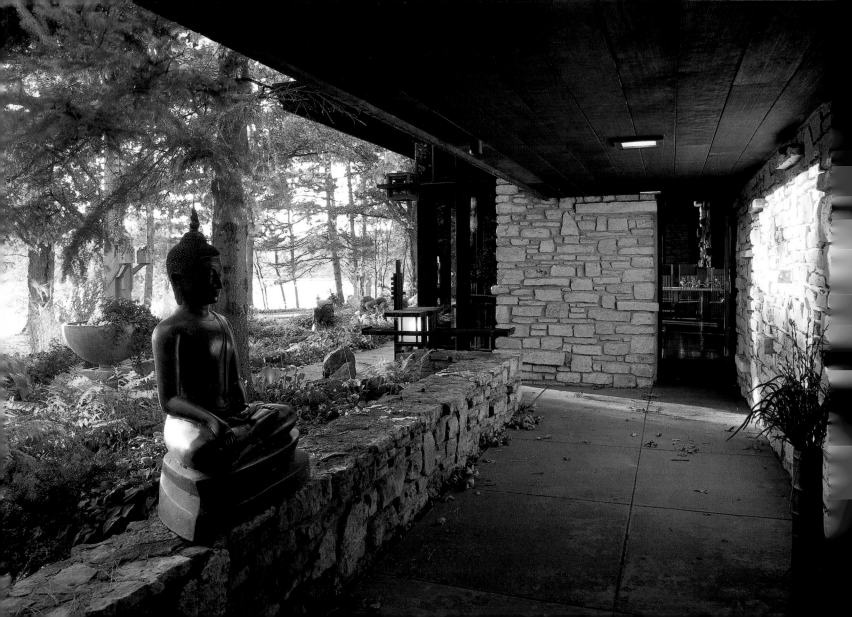

FRANK LLOYD WRIGHT
AMERICAN MASTER

PHOTOGRAPHS BY ALAN WEINTRAUB TEXT BY KATHRYN SMITH

RIZZOLI
NEW YORK

CONTENTS

To Federico de Vera — AW

To Randy as always — KS

First published in the United States of America in 2009 by
RIZZOLI INTERNATIONAL PUBLICATIONS, INC.
300 Park Avenue South
New York, NY 10010
www.rizzoliusa.com

ISBN-13: 978-0-8478-3236-1
Library of Congress Control Number: 2008937196

Photography (except when otherwise noted throughout book) © 2009
 Alan Weintraub/Arcaid@arcaid.co.uk
Text © 2009 Kathryn Smith
© 2009 Rizzoli International Publications

Pages 180–185: The Kaufmann House (Fallingwater®) is a property owned and
operated by the Western Pennsylvania Conservancy, whose permission was obtained
in connection with the photographs of this house appearing in the book. Fallingwater®
is a trademark and a registered service mark of the Western Pennsylvania Conservancy.

Pages 376–379: The image of the Solomon R. Guggenheim Museum
is a trademark of The Solomon R. Guggenheim Foundation. Used by permission.

Photography, drawings, and other artwork not credited here are credited,
when appropriate, in the section in which such images appear.

Names of houses refer to the terminology established by the Frank Lloyd Wright Archives.

Dates used throughout refer to the year the work was conceived.

Endpapers: Textile block detail from the Arizona Biltmore, Phoenix, Arizona, 1927;
Albert McArthur, architect; Frank Lloyd Wright, consulting architect

Page 2: Lovness House, Stillwater, Minnesota, 1955
Page 5: Window detail, Robie House, Chicago, Illinois, 1908
Page 400: Storer House, Los Angeles, California, 1923

All rights reserved. No part of this publication may be reproduced, stored in a retrieval
system, or transmitted in any form or by any means, electronic, mechanical, photocopying,
recording, or otherwise, without prior consent of the publisher.

Distributed to the U.S. trade by Random House, New York

Designed by Zand Gee

Printed and bound in China

2009 2010 2011 2012 2013/ 10 9 8 7 6 5 4 3 2 1

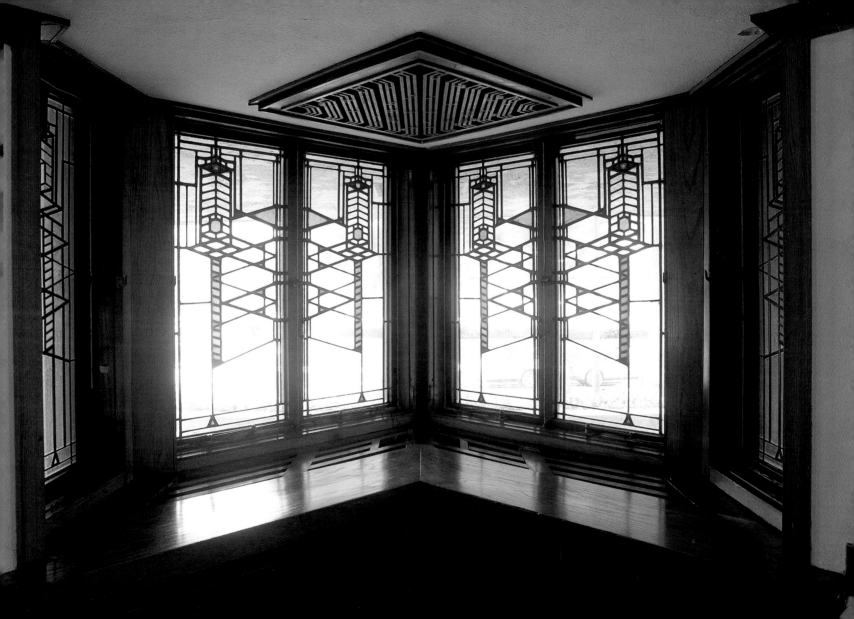

INTRODUCTION

One figure dominated the American architectural scene for the entire first half of the twentieth century, Frank Lloyd Wright. He was an architect, town planner, furniture designer, and author of countless articles and numerous books. His buildings can be seen in every region of the country from Illinois to Florida, from California to Virginia, and his influence has extended around the world. Major masterworks such as the Frederick C. Robie House in Chicago, Fallingwater in Pennsylvania, or the Guggenheim Museum in New York City can stand with the most important buildings in history. Like Picasso, Einstein, or Freud, he was a rare individual who permanently altered the fundamental way we perceive our world.

Beginning in 1893, Wright challenged the antiquated orthodoxy of the Beaux-Arts. By going back to classical principles while rejecting classical forms and ornament, he confirmed that history at its most fundamental level was at the core of his restoration of architecture to its original role in society. He replaced academic

language with a modernist canon of open plans and abstracted horizontal and vertical planes.

He took his mentor Louis H. Sullivan's aphorism, "form follows function," one step further with "form and function are one." In light of this declaration, many erroneously put Wright in the functionalist camp of the Modern movement. However, his position was just the opposite of that of the school that believed architecture was a mechanical process intended to produce buildings at the lowest cost fulfilling society's greatest needs. Rather, he firmly believed architecture was an art, in fact, the mother art. Thus Wright was not a modernist in the common definition of the term; he absorbed contradictions, synthesized them and created an entirely new architecture from classical principles and non-Western traditions, picturesque regional forms, and industrial technology.

Wright stood aside from the major architectural figures of the twentieth century such as Mies van der Rohe or Walter Gropius in that rather than embrace a singular and homogeneous idea he created a heterogeneous and multivalent vocabulary. He eludes easy categorizations of stylistic judgments and his use of vague terms such "Organic Architecture," which he perpetuated and numerous critics have followed, only obscures understanding of his meaning to a contemporary audience. Yet without such catch

phrases, the contradiction of his multiple styles creates an awkward belief that his work lacks continuity and logical coherence.

Wright's career spans over seventy years starting with the Industrial Revolution and ending with the missile age. His architectural output was prolific; he built more than 500 buildings and designed an equal number that never left the drawing board. The Prairie Style houses garner the most attention, not least for their highly decorative characteristics—intricate art glass, fine craftsmanship, built-in furniture, subtle color palettes, and supple use of geometric ornament—but more importantly for their seminal position in influencing the Modern movement and changing the direction of architecture in Europe.

In Chicago during the 1890s, Wright seemed intent at first to reinvent the single family American house, which he succeeded in doing by 1901. Once he had made his major breakthroughs —the open plan, the composition of the walls and windows as abstract solids and voids, and the layering of space from the interior through transitional zones of porches and terraces to the gardens beyond—he spent the next fifteen years elaborating on the typology with variations in floor plan, materials, and square footage.

With the domestic realm conquered by 1902, he turned to another challenge—the public building. He began by analyzing institutions—

schools, churches, and offices—and reducing complex problems to major and minor functions, horizontal and vertical circulation. From this process emerged a universal format: the binuclear plan, which he returned to again and again until the end of his career. This phase was accompanied by his exploration of industrial materials, primarily reinforced concrete, which would remain his material of choice for both monumental and smaller scale structures.

This development comes to an end shortly before the First World War, when we find him on a journey of self-discovery first to Japan, and then to the Far West—California and Arizona. During these years of reassessment up to 1932, he explored the expressive possibilities of regionalism and primitivism. These tendencies were consolidated in the ornamental efflorescence of the Imperial Hotel in Japan and the tactile surfaces of the Los Angeles concrete blocks. The smooth planes of the Prairie houses were left behind in the pursuit of a heroic sense of mass and an archaic mood. With this stylistic shift, Wright had moved into a creative period of extraordinary depth and richness where he explored the common ground between Eastern and Western traditions.

By the beginning of the Great Depression, Wright's years of regeneration culminate with his return to the Midwest, when we see his experiments coming to fruition in the formulation of a radical town planning idea for America based on decentralization; in theories set forth in the book *The Disappearing City* (1932); and in a reconstituted modernist vocabulary of forms. The year 1935 is pivotal: he formulated a new building system for the middle-class with the Usonian house, and his utopian proposal for Broadacre City was first exhibited as a model at Rockefeller Center in New York City. Wright sought to prove that the historical need for high density that he believed was the root of all economic and social injustice had been made obsolete by modern transportation and telecommunications: the automobile, telephone, radio, and television.

The whole range of Wright's production after the Second World War until his death in 1959 at the age of ninety-one reestablished his dominating position in twentieth-century architecture. The grand estates for corporate titans and suburban houses for teachers and journalists demonstrated his facility with the domestic program. We see his architectural vocabulary expanded as he addressed the problems of worship (for instance, Beth Sholom Synagogue and the Unitarian Meeting House), the performing arts (Kalita Humphreys Theater and Grady Gammage Auditorium), and programs for large institutions (Florida Southern College and Marin County Civic Center). When he died, he had succeeded in fulfilling his own prophecy; he was eulogized as one of the greatest architects that ever lived.

Wright spent his entire seventy-year career in a quest for the ideal. In so doing he developed a social philosophy that was, at times, at odds with the conventional positions of his day. It was a blend of futurism and nostalgia, along with a faith in technological progress and an obsession with the moral superiority of nature. It was based on a romantic understanding of complex economic and social forces as the underpinnings of a new society. In his vision, the architect played an exalted role. In the end, ironically, these very paradoxes and contradictions that make him so difficult to compartmentalize are what give him such lasting appeal.❖

ONE:

DECONSTRUCTING HISTORY
1886–1901

In retrospect, Frank Lloyd Wright's choice of Chicago as the place to begin his career may seem inevitable given the depth of structural and artistic experimentation that was taking place in the city's commercial architecture in the late nineteenth century. But it is doubtful that the twenty-year-old knew much about steel frame construction or the birth of the skyscraper when he first arrived. Yet within a year, he would be working in the most progressive design firm, Adler and Sullivan, drawing details for one of their most daring structures, the Auditorium Building (1887–1889).

The moment of his arrival was pivotal. During the 1880s, industrialism was rapidly transforming the city into a high-density business district while converting nearby villages into suburbs through the building of commuter railroad lines. Chicago offered an auspicious starting point as it exposed Wright to the foremost architects and engineers of the first high-rise office towers including Louis H. Sullivan, Dankmar Adler, and William Le Baron Jenney and to different strands of nineteenth-century thought (Transcendentalism and *Japonisme*, in particular). It was here that Wright gained first-hand knowledge of advanced building techniques such as reinforced concrete construction and wood balloon framing that he would utilize for decades to come.

Wright's career took off almost immediately. Eleven years Wright's senior, Sullivan in time elevated him to the position of his assistant. The firm introduced him to advanced engineering practices while Sullivan steered him in the direction of books and theoretical tracts that contributed to his formative education. While Sullivan rejected the facile revivalism of outmoded forms, he emphasized that underlying principles could be used as organizational tools adapted to modern means. From his "lieber meister" as he called him in later years, Wright learned to think in terms of analysis of form and function, creating standard building types for a new age.

Yet all these progressive ideas were secondary to the domination of Beaux-Arts training in academic historicist styles that ruled the day throughout America. Architects were taught according to the models of Ancient Greece, Imperial Rome, the Italian Renaissance and Baroque, while studying appropriate details of the French Gothic, English Tudor, and Dutch Colonial. While the Beaux-Arts emphasized formulas for sculptural ornamentation and motifs, it also prescribed planning systems following the methods of formal axes, symmetry, and the hierarchy of spaces. Wright learned from Sullivan to reject classical forms, but he adopted classical principles and applied them as his own system

of analysis to deconstruct history and return architectural expression to its origins.

Between 1889 and 1893, while still working at Adler and Sullivan, Wright took on residential commissions outside his regular employment contract. The first was a house for himself and his young wife, which allowed him the opportunity to try out his new methods. The Wright House, known as the Home and Studio, in Oak Park, just outside Chicago, is a formal, yet modest, symmetrical composition with a triangular gable set over a broad base of bay windows, ornamented with a half-Palladian window. Once inside, there is a relatively loose pinwheel plan with an arched fireplace set deep within the volume of a traditional inglenook. Wright seemed intent to infuse his first house with a strong geometric character and the symbolism of a protective shelter.

Since the house commissions of these years were bootlegged, in order to evade detection, Wright avoided any overt Sullivanesque forms, instead trying his hand at various styles of the day such as Shingle Style, Queen Anne, and Colonial Revival. The final outcome of these efforts for the Gale, Emmonds, Blossom, and Parker families among others was the termination of his job with Adler and Sullivan when he was discovered.

In 1893, Wright opened his own office. At last, he had his first major commission and he was determined to make the most of it. The William H. Winslow House was both a suburban villa and a prototype for the Prairie house reflecting all of Wright's accumulated knowledge, from the breaking down of the front facade into tripartite horizontal divisions of base, high wall, and window band, to the axial placement of the central fireplace. The debts to Sullivan and classical planning are apparent, but the deep overhanging roof points in the direction of a new style suited to the regional topography of the Midwest.

Wright had a mind that was able to analyze models and synthesize them into a new architectural vocabulary, and between 1894 and 1900 certain planning methods were becoming distinctly his own. Both his talents and his circumstances suited him for domestic design and he found commissions that allowed him to apply his architectural devices in experimental ways. His houses of this period rise above a Sullivanesque decorative style and the specifics of each client's needs to an ideal housing type.

Elements such as the horizontal organization of the facade, the low sheltering roof, the broad mass of the chimney, and the free-flowing sense of interior space that opened out to views through window bands were used in new combinations but without becoming a trite formula. To go from the stiff formalism of the Isidore Heller House (1897) to the geometric clarity of the B. Harley Bradley and Warren Hickox Houses (both 1900) is to see the flowering of a personal style and a set of principles that would guide Wright—and later a younger generation of European architects—in the next two decades.

Wright culminated this period by redrawing the Bradley and Hickox houses in plan, perspective, and section for publication as "A Small House with 'Lots of Room in It'" and "A Home in a Prairie Town" in the homemaker magazine *Ladies' Home Journal* (1901). And in so doing, he presented two distinct types, the cruciform and in-line plans, which would in the next ten years form the basis of his residential practice.

Although a type, each Prairie house would ultimately become a solution to the particular problems of the client's needs, the site, and the budget. By examination of each design one can gain greater awareness of the interweaving of the generals and the particulars, the attainment of the ideal over the challenges of the moment. ❖

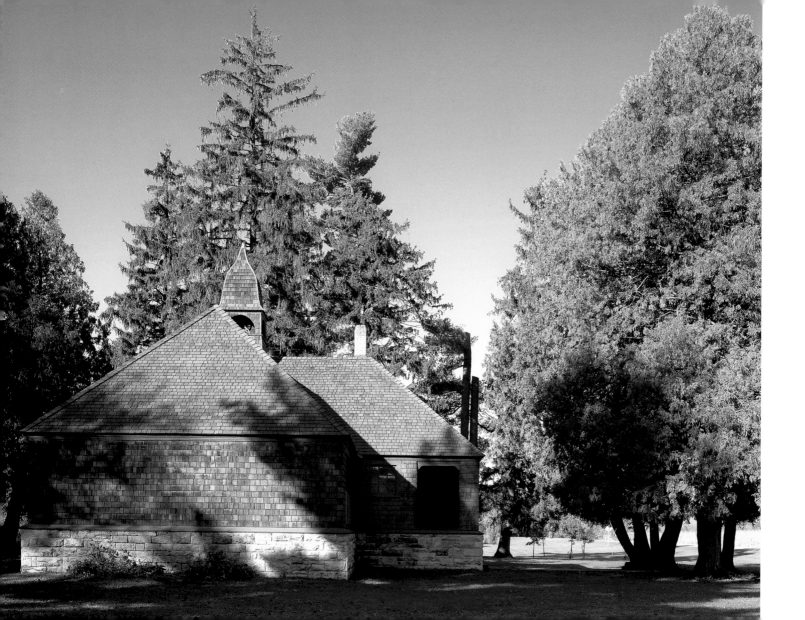

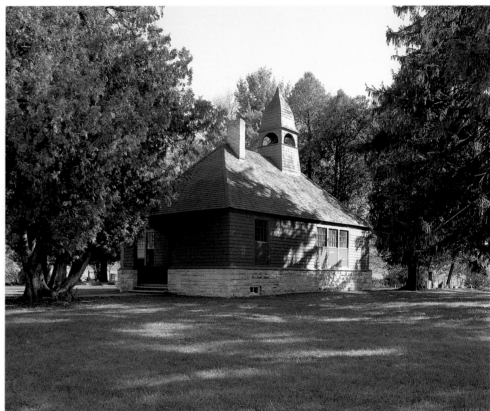

Opposite and above: Unity Chapel, Spring Green, Wisconsin, 1886

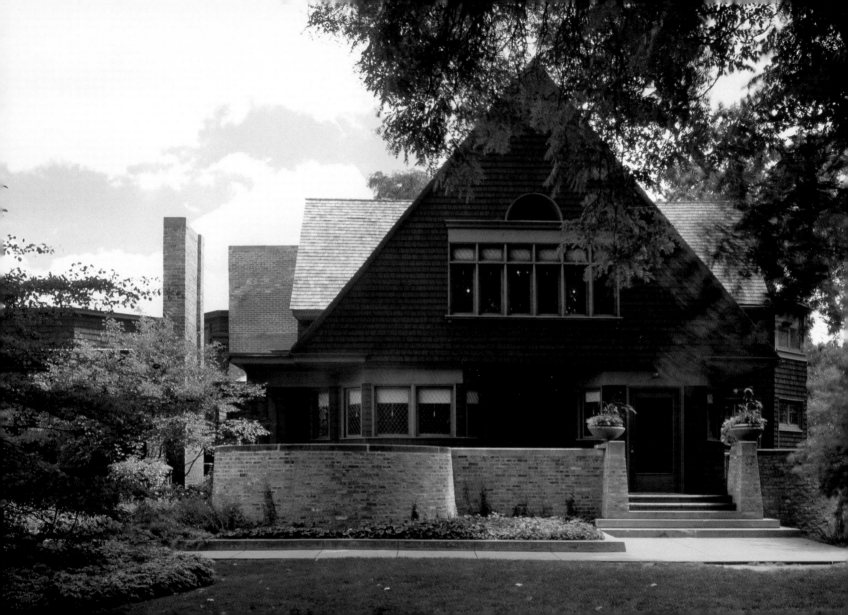

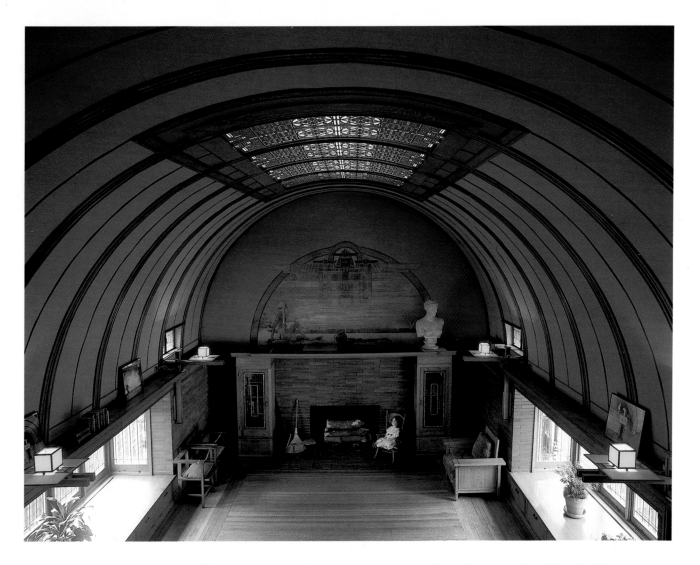

Opposite, above, and following pages: Frank Lloyd Wright Home and Studio, Oak Park, Illinois, 1889; playroom addition, 1895; studio, 1897

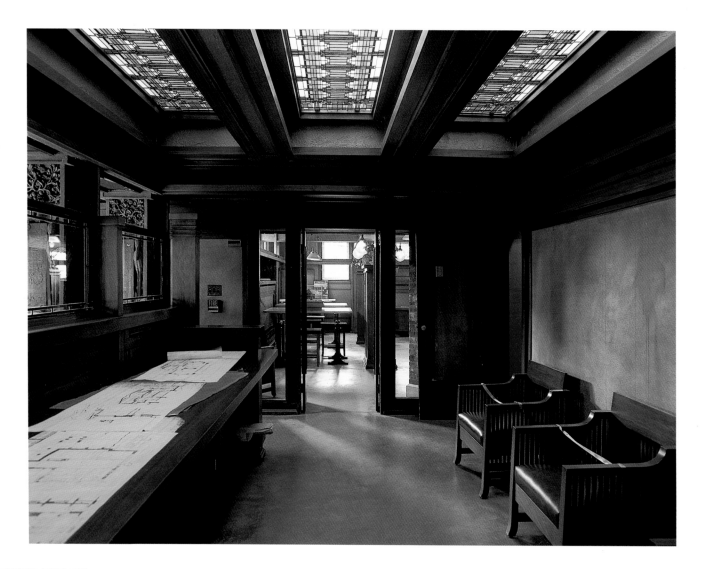

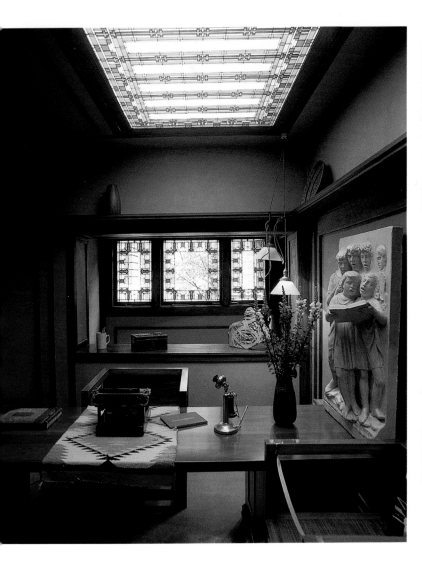

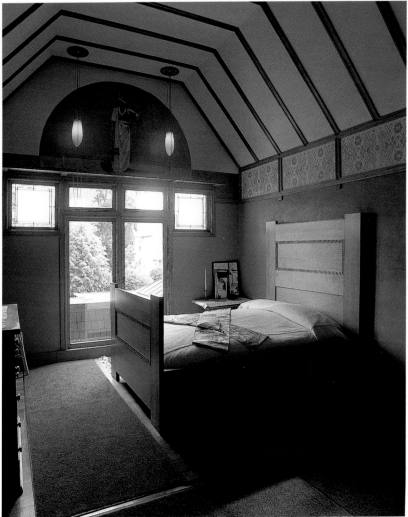

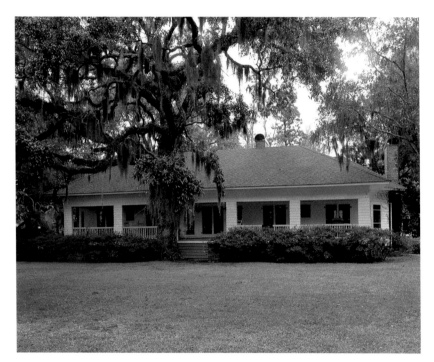 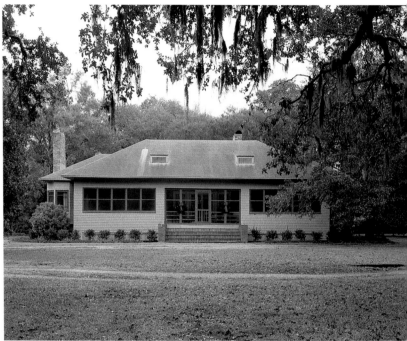

Above left: Sullivan House, Ocean Springs, Mississippi, 1890; Above right and opposite: Charnley House, Ocean Springs, Mississippi, 1891

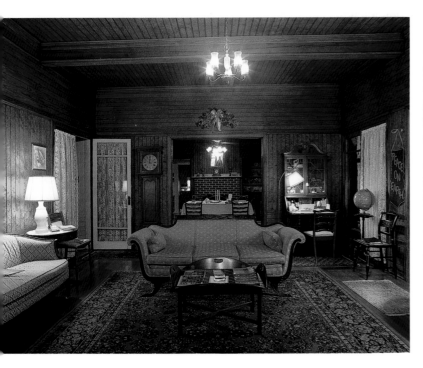

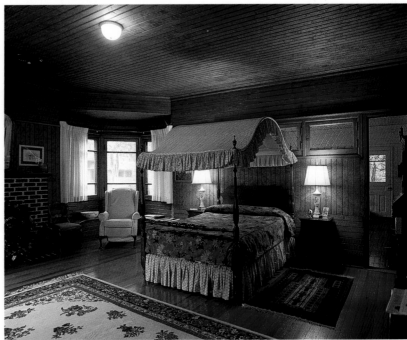

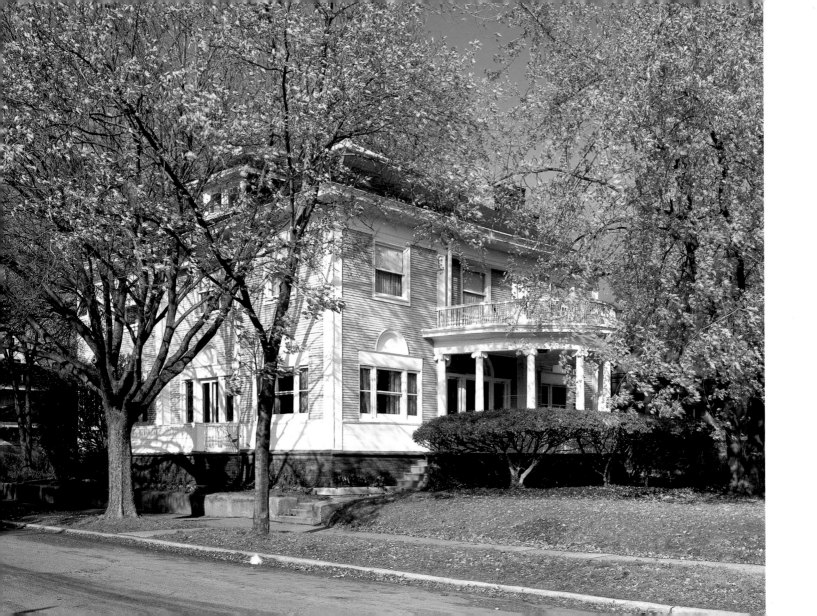

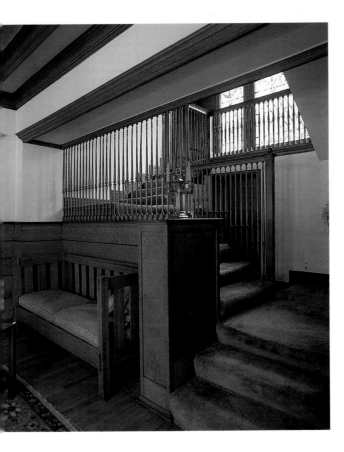

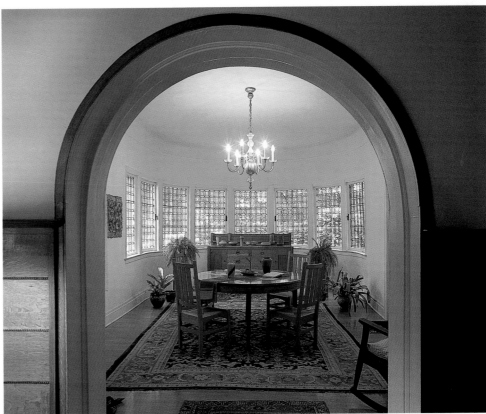

Opposite and above: Blossom House, Chicago, Illinois, 1892

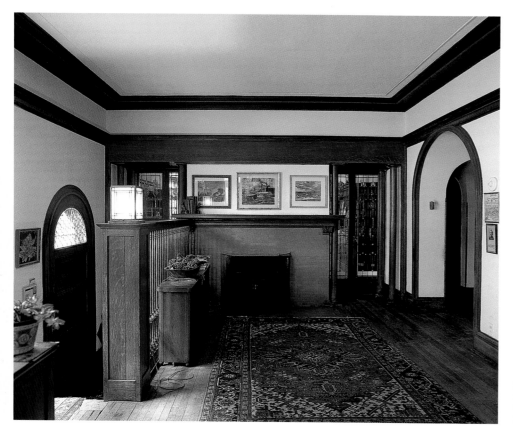

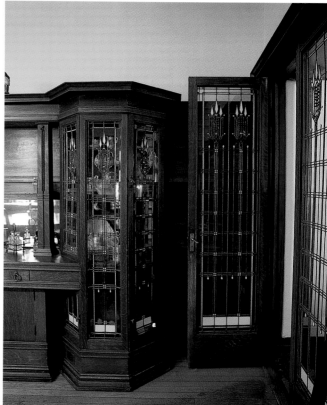

Above and opposite: McArthur House, Chicago, Illinois, 1892

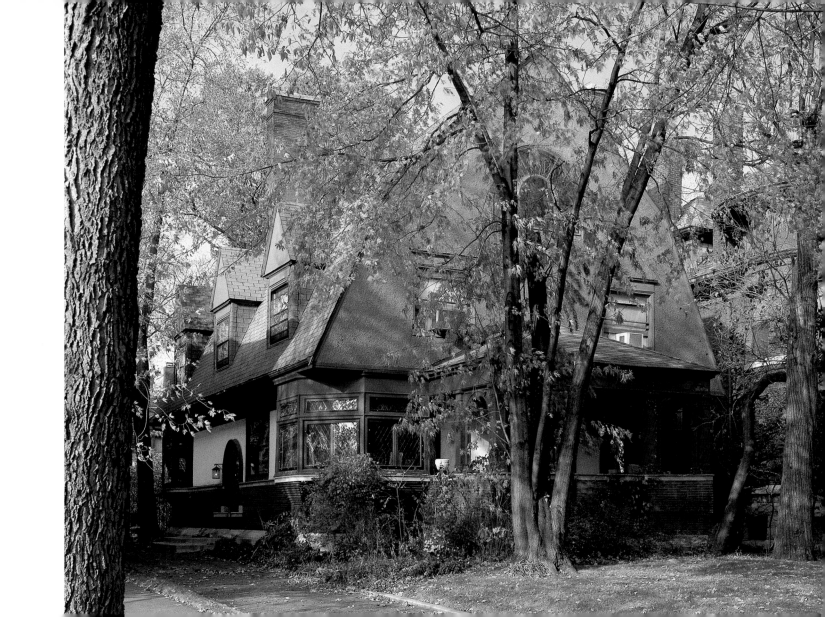

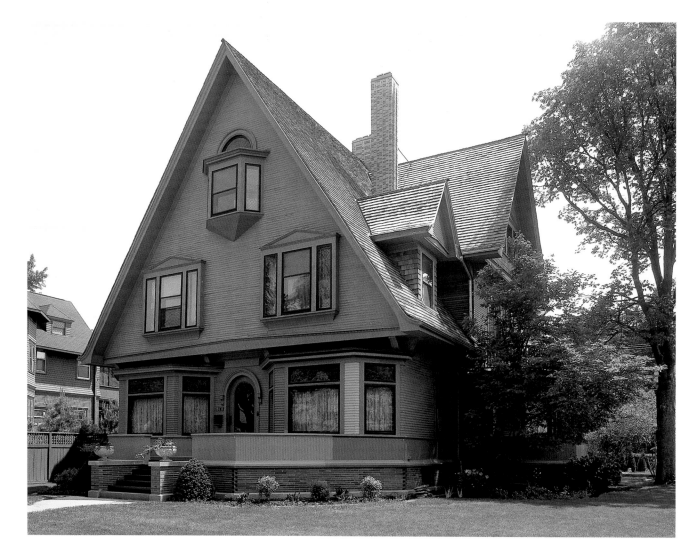

Clark House, LaGrange, Illinois, 1892

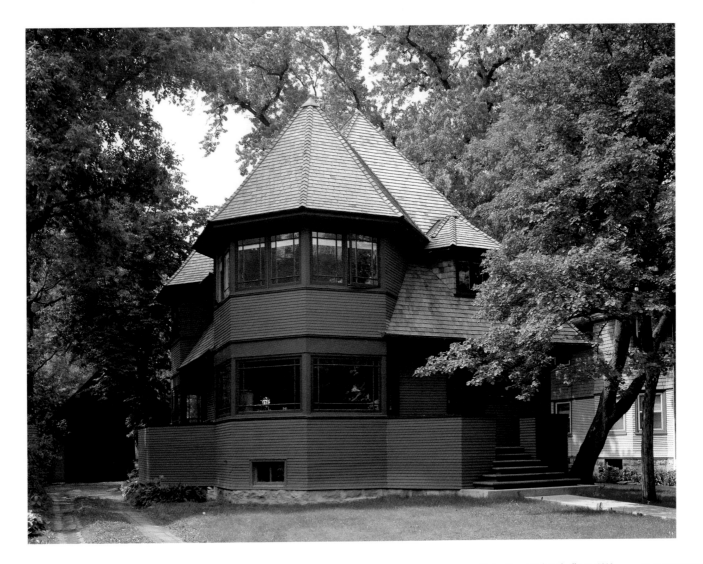

Parker House, Oak Park, Illinois, 1892

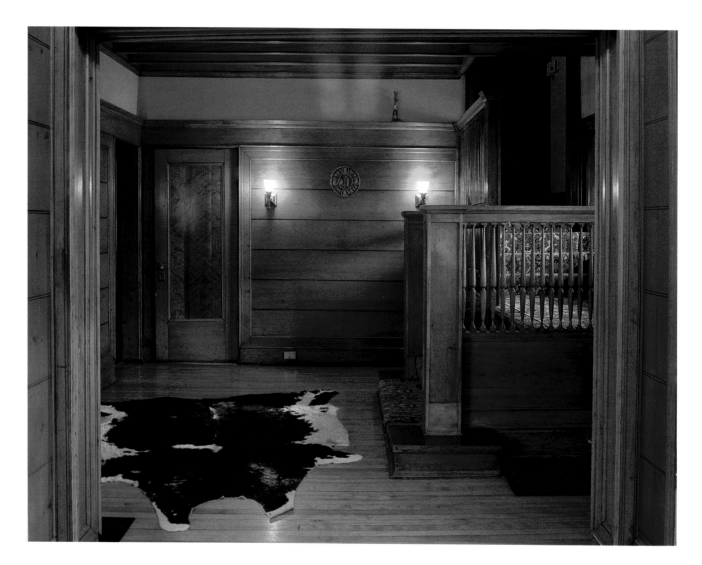

Above and opposite: Walter M. Gale House, Oak Park, Illinois, 1893

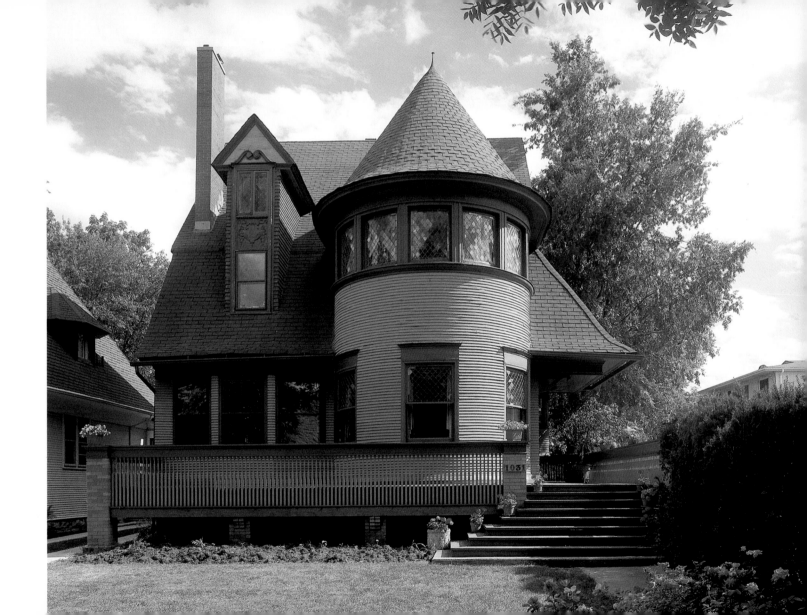

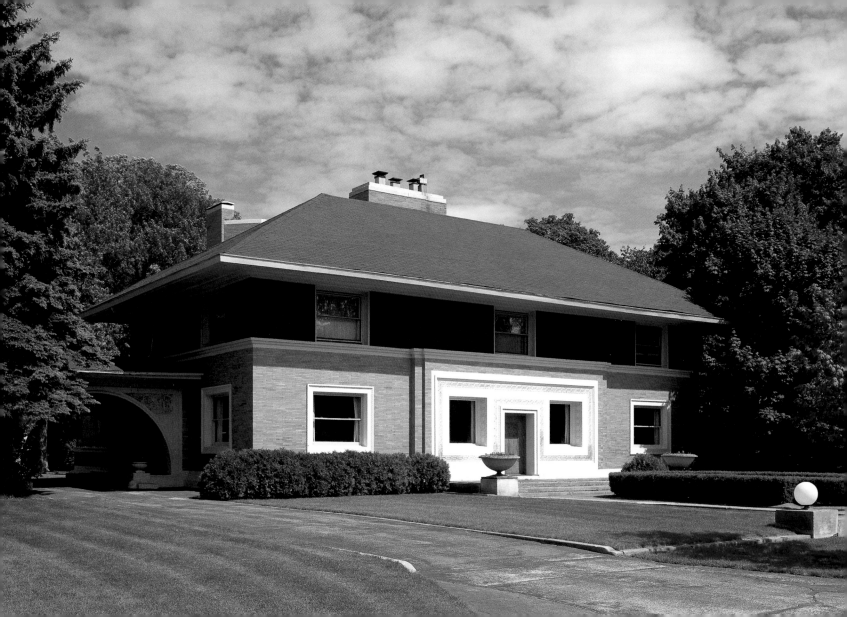

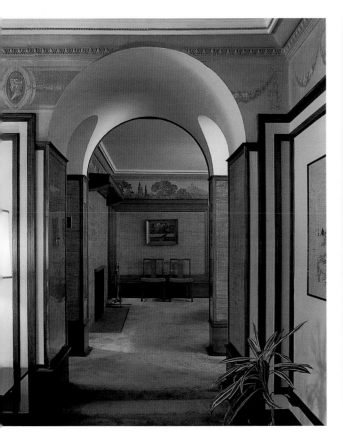

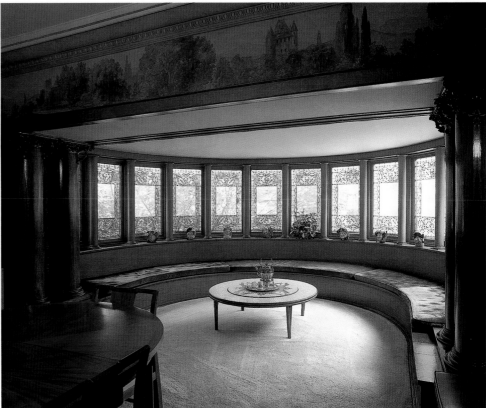

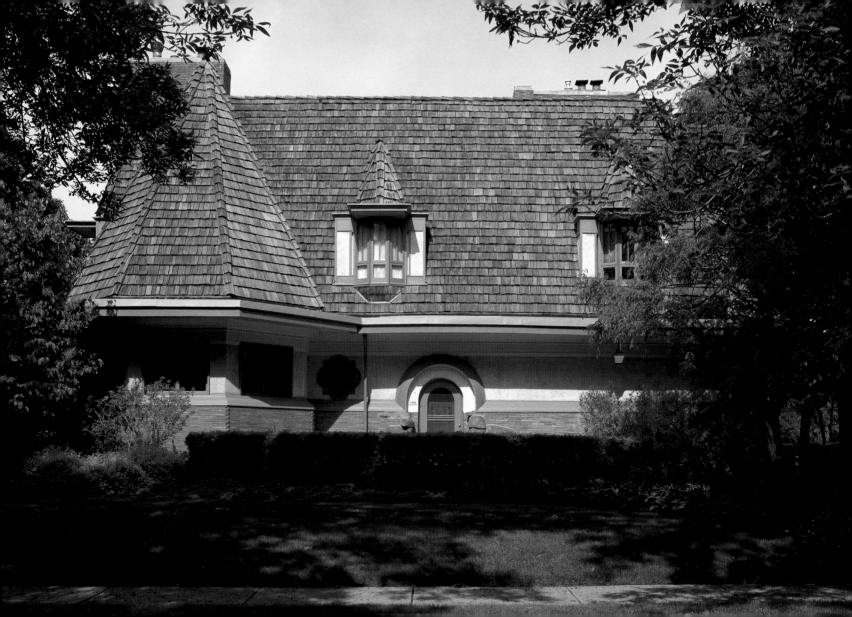

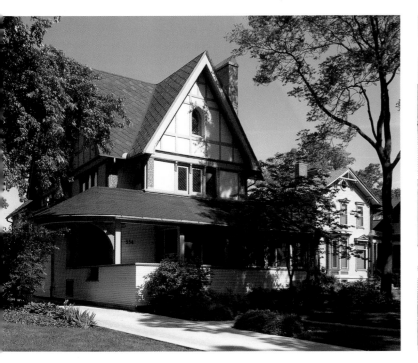

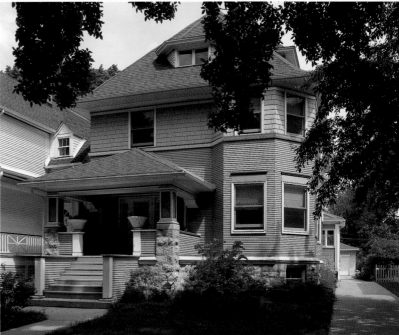

Opposite: Williams House, River Forest, Illinois, 1895; Above left: Young House Remodeling, Oak Park, Illinois, 1895; Above right: Woolley House, Oak Park, Illinois, 1894

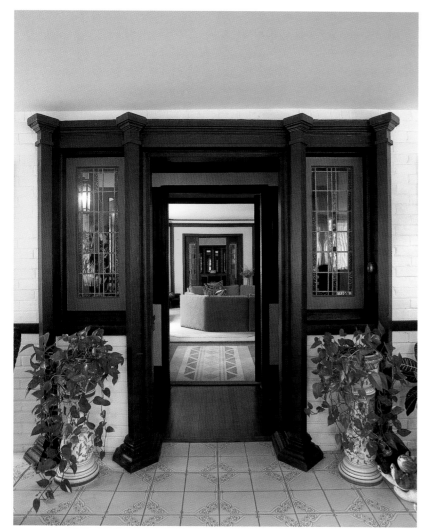

Above and opposite: George Furbeck House, Oak Park, Illinois, 1897

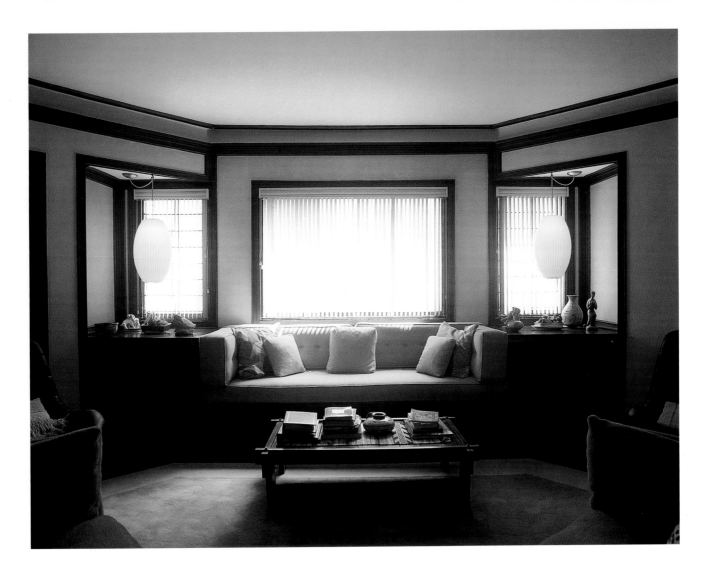

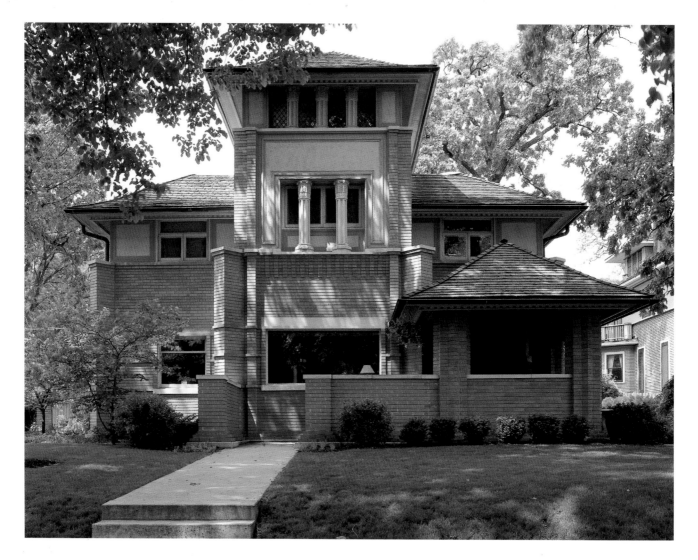

Above and opposite: Rollin Furbeck House, Oak Park, Illinois, 1897

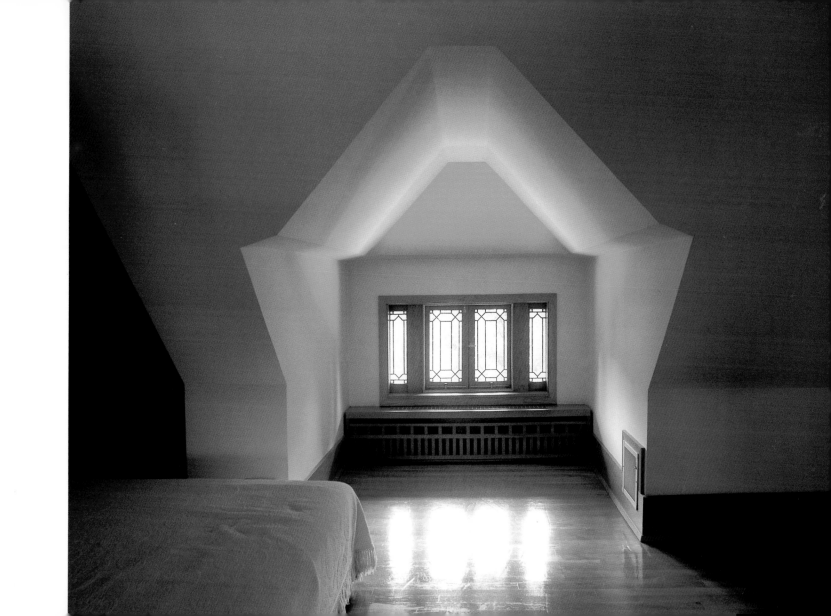

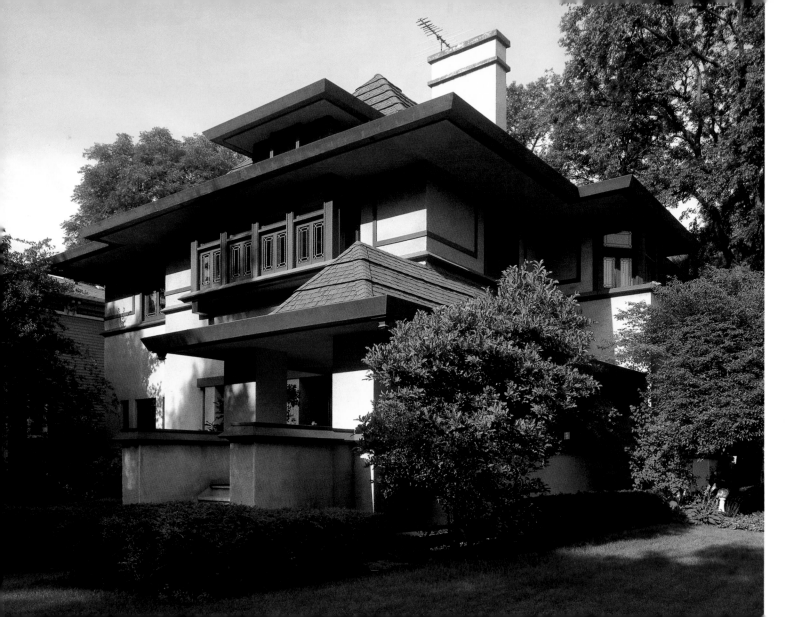

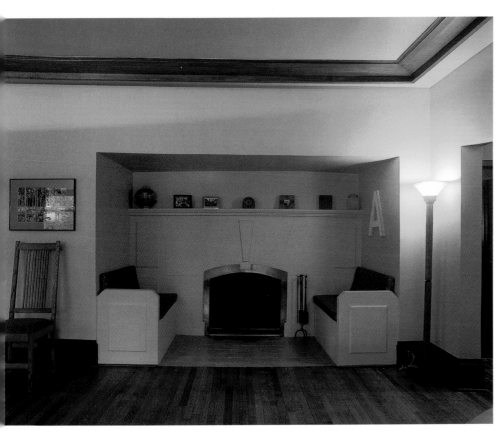
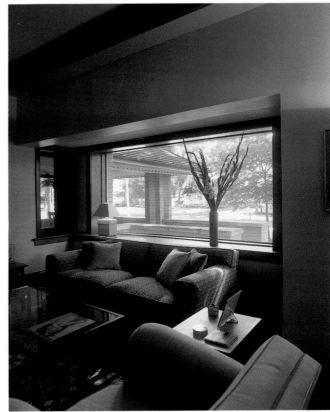

Opposite and above: Hills House Remodeling, Oak Park, Illinois, 1900

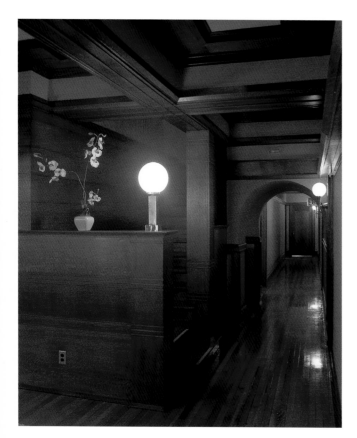

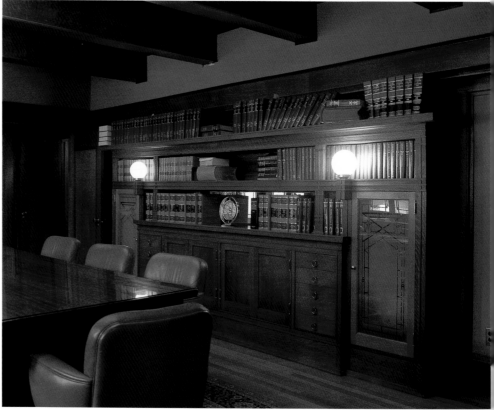

Above and opposite: Bradley House, Kankakee, Illinois, 1900

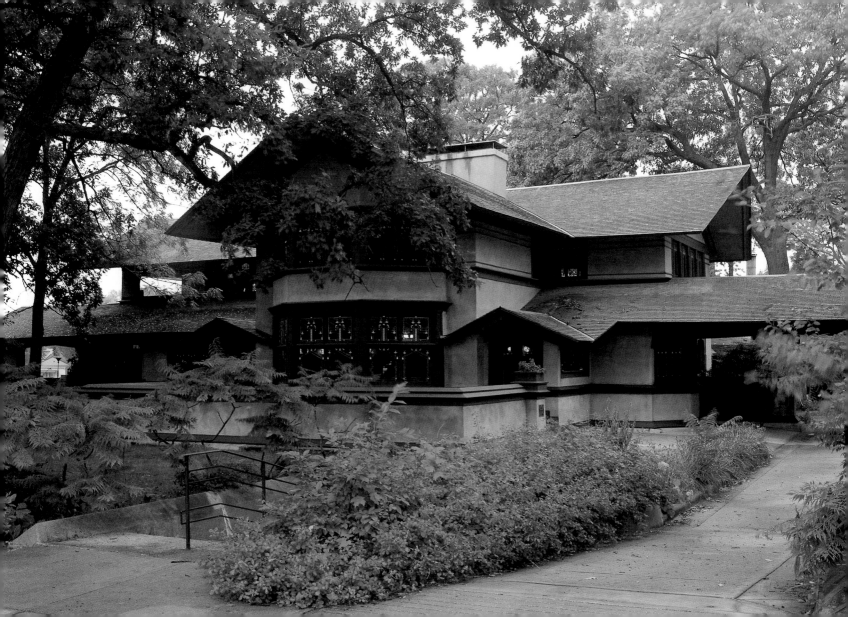

TWO:

ABSTRACTING NATURE 1902–1917

By 1901, Wright had begun a major transformation. The accomplished draftsman was replaced by a master architect, who over time assembled a team of assistants in his Oak Park Studio, and a circle of contractors and artisans with whom he would work on a regular basis—firms like Linden Glass Company and Giannini and Hilgart, the decorative arts firm; and men like Paul Mueller, the builder; Richard Bock, the sculptor; or George Mann Niedecken, the interior architect. It was Wright's skill in organizing a modern practice that allowed him to simultaneously construct dozens and dozens of Prairie houses as well as complete several major public buildings, such as Unity Temple, before World War I.

Many of his clients during this period were successful entrepreneurs, often inventors, such as Darwin D. Martin or Frederick C. Robie; some were independent women with artistic or spiritualist leanings, for example, Susan Lawrence Dana or Queene Ferry Coonley; most were politically and religiously conservative. However, they did not live in an insular world of class-consciousness, and thus chose their architect not to elevate their social status but to better their way of life.

Wright's imagination was consumed by an ideal vision of architecture at one with nature, but his sites were most often within the regularized grid of an outlying suburb instead of off in Arcadia. The majority were in the Midwest—many of them in Chicago communities such as River Forest, Highland Park, or Riverside. The essential point of Wright's doctrine—to open the house to "light, air, and prospect"—fit these locations ideally, giving their owners a serene retreat from the encroaching noise and congestion of the city.

At this period of Wright's career, the spatial plan of the Prairie house was more important than structural innovation. By analyzing the functional components of the single family dwelling, he went from what he called "the general to the particular." For instance, he categorized the public spaces (living, dining, and library) as primary and the service spaces (entry, kitchen, pantry, servant's quarters) as secondary. Using axial organization and a square grid system as ordering devices, he gave modern expression to the classical principle of hierarchy of spaces.

A major conceptual breakthrough that he made early on was the realization that mechanized heating made it no longer necessary to close rooms off from each other to conserve heat. This discovery led to the open plan in public spaces—for instance, where the living room opened to the dining room on a diagonal—while maintaining compartmentalized rooms for services. With the hearth no longer used as the

major source of heat, Wright was free to liberate it from the wall and use it as a freestanding vertical plane in space as he did at the Robie House, for instance. By treating the fireplace as a solid screen that defined but did not enclose space, he created the free plan of Modern architecture.

The other major advance represented by the Prairie house was the rejection of the wall as the traditional solid barrier between inside and outside. Rather, with the Willits House, for example, he broke the wall down into a series of elements such as solid piers, flat planes, and window bands—all geometrically organized by dark wood strips. The wall was now defined as an enclosure of space. Windows were no longer holes punched through a mass, but a light screen filtering sunlight into the interior. The movement outward toward the landscape was amplified by the addition of porches, terraces, flower boxes, and planter urns.

It is clear that by 1901, Wright had gone to school with nature, absorbing his studies of the Midwest prairies, woods, and ponds. His greatest source of inspiration was from the land itself including all aspects of the natural world: wildflowers, leaves, and grasses. The turning point came when he began to incorporate specific characteristics into his architectural language. The straight line of the horizon became the low sheltering roof, the trees and flowers formed patterns in the art glass windows, and the leaves contributed their autumnal palette to the plaster surfaces.

Wright's transition from deconstructing history to abstracting nature was accomplished partly as a result of his deepening involvement with Japanese art and architecture. The influence of *Japonisme* had intensified after his exposure in the 1880s to *ukiyo-e*, woodblock prints of the seventeenth through nineteenth centuries. Beginning in 1902, Wright began to amass hundreds upon hundreds of woodblock prints, especially the works of Hiroshige and Hokusai, his favorite artists. By the time of his first trip outside the United States, a three-month journey to Japan in 1905, he was a recognized Japanese print authority and one of the leading American collectors.

His passion for Asian art was both personal and professional. Japanese art did not strive to depict figures and objects realistically in three-dimensional space; rather, the *ukiyo-e* artist wished to portray landscapes, plants, and animals in their most generalized characteristics thus elevating them to the level of symbolism. Hokusai's abstractions of birds, fish, and flowers, for instance, suggesting the symbolic significance of specific seasons correspond to Wright's use of nature motifs as the source of a formal language in houses such as the Dana House, where geometric figures are based on the sumac shrub and the butterfly.

In March 1908, Wright summarized his domestic design philosophy in an essay, "In the Cause of Architecture," as follows: reduce the number of rooms to the essential; integrate all openings and ornament to structure; incorporate fixtures, pictures, and furniture into the building fabric; orient the house to the horizontal line of the prairie; choose colors of the earth, especially autumnal hues; leave materials natural, no applied paint; reject prevailing styles of the day. This article was amply illustrated with eighty-seven illustrations.

In 1910 Wright, dissatisfied with the printing quality of the 1908 article, embarked on a more ambitious publishing venture. He contracted with the Berlin publishing house Wasmuth Verlag to bring out two publications featuring his Oak Park Studio work: *Aüsgeführte Bauten und Entwürfe* (Executed Buildings and Designs), a deluxe edition of hand-drawn plans and perspectives in two volumes, and *Aüsgeführte Bauten* (Executed Buildings), an inexpensive book of photos. The works have been called "the most influential architectural books in the twentieth century." They were neither a work of theory, nor a manifesto in the conventional sense, but through their illustrations they served that purpose. ❖

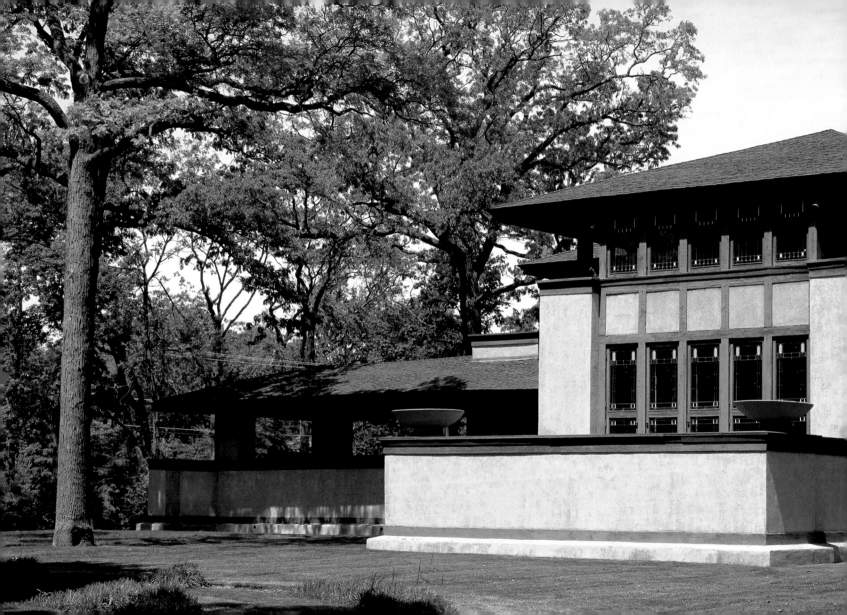

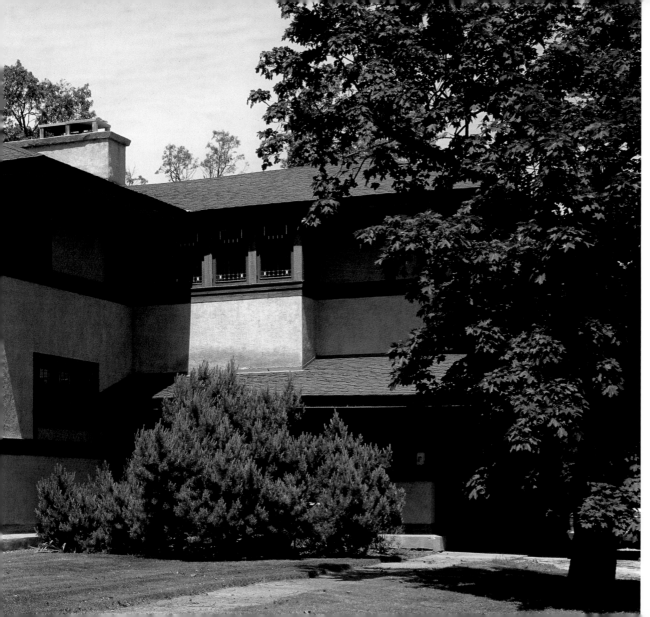

*Left, following pages,
and pages 44–45:
Willits House,
Highland Park, Illinois,
1902*

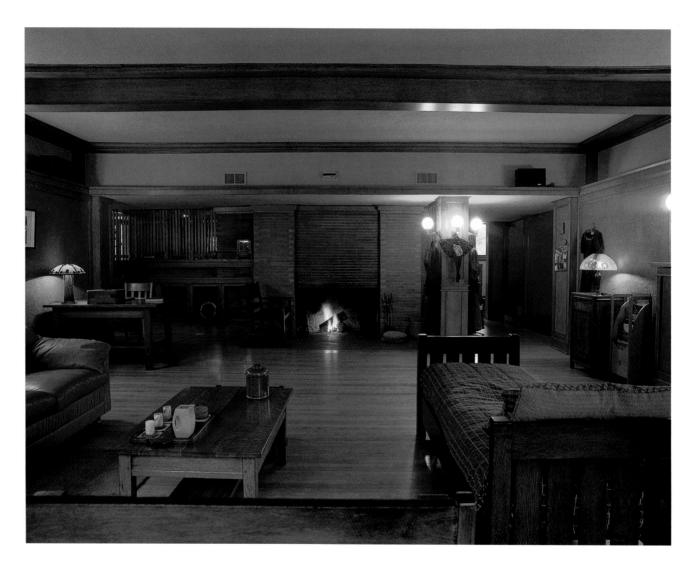

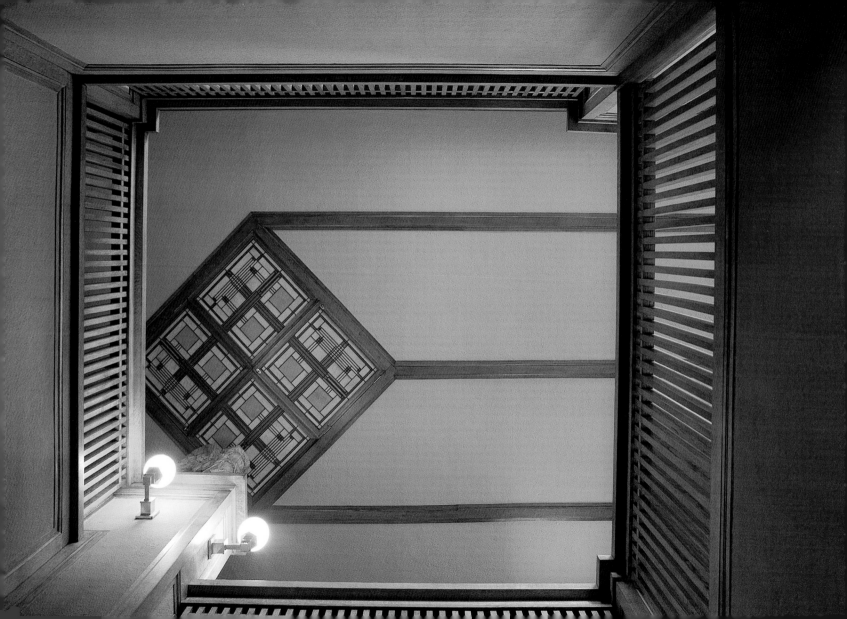

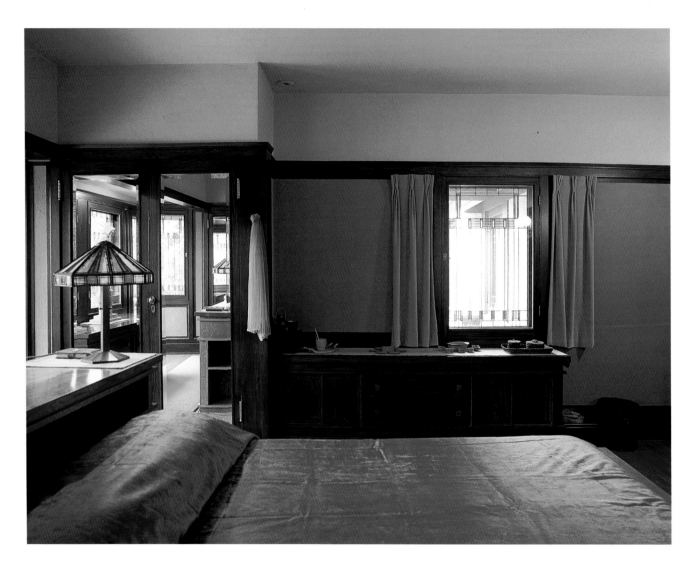

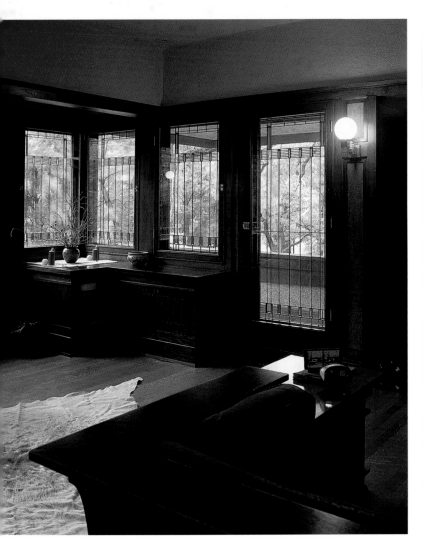

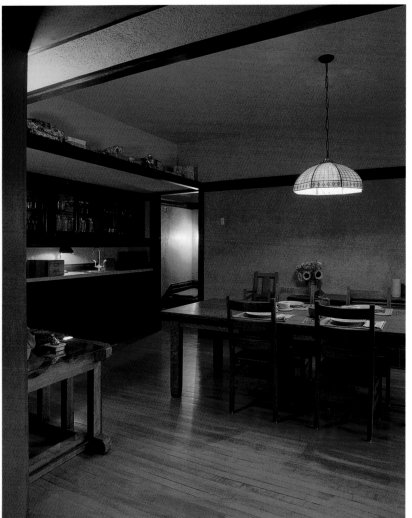

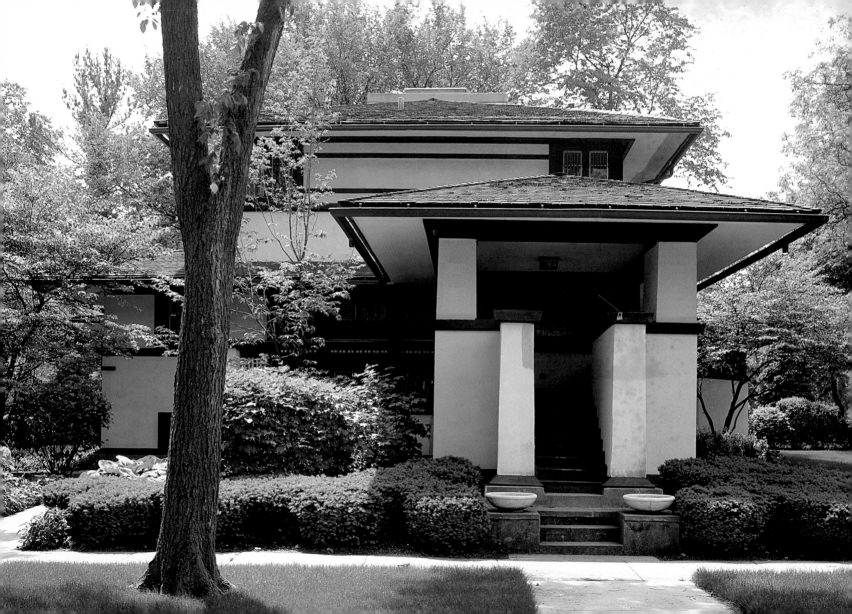

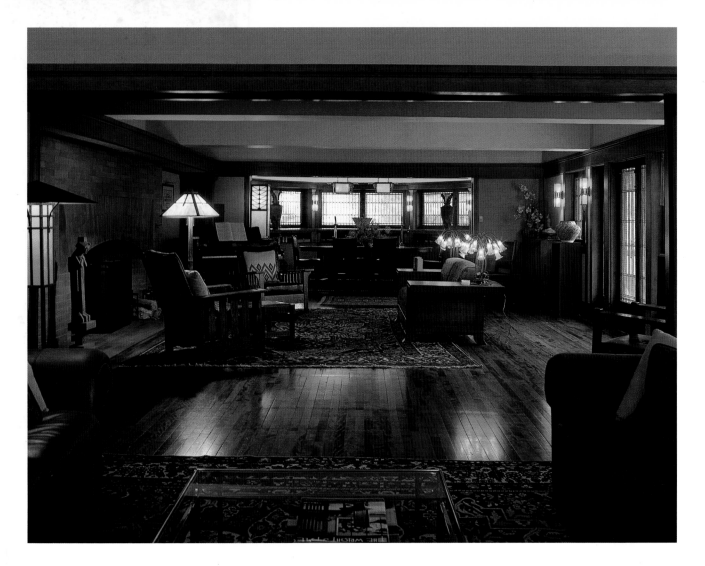

Opposite, above, and following pages: Henderson House, Elmhurst, Illinois, 1901 TWO: ABSTRACTING NATURE **47**

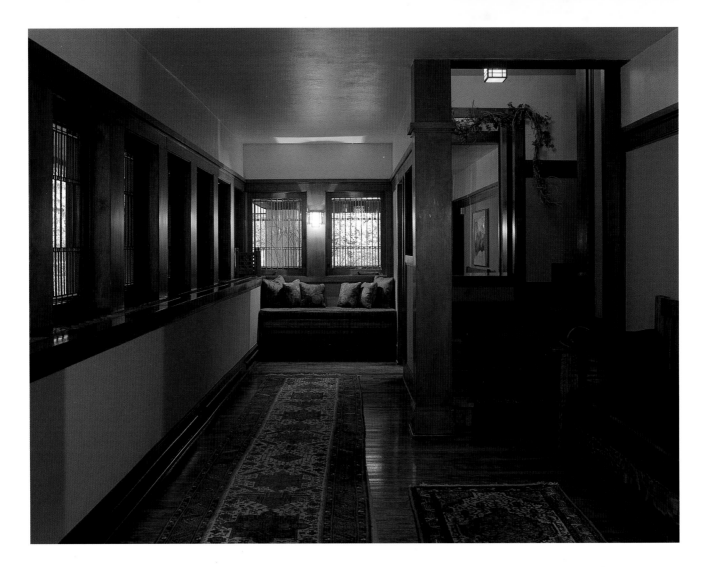

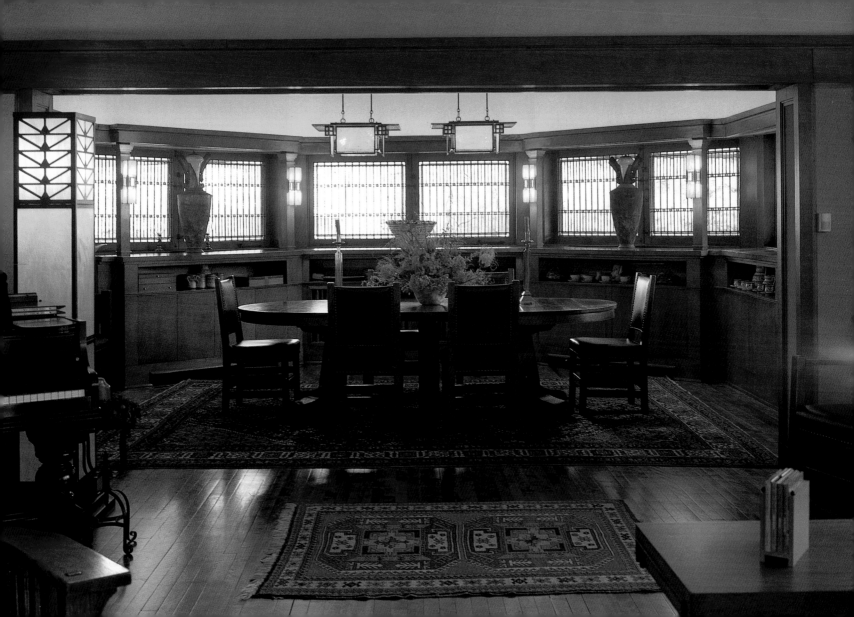

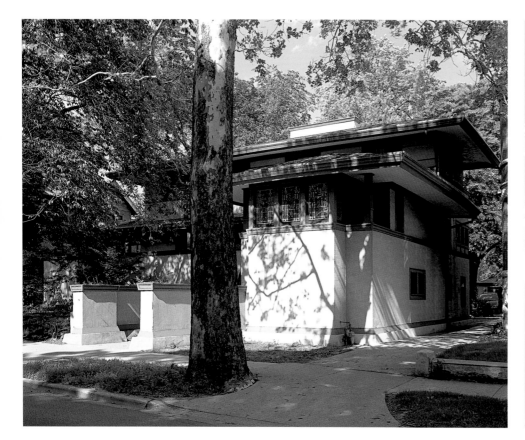

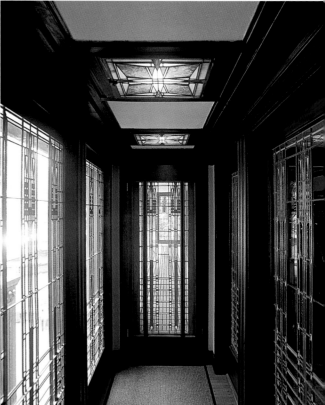

Above and opposite: Thomas House, Oak Park, Illinois, 1901

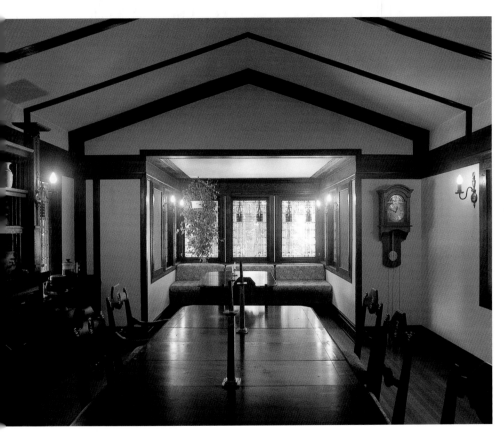

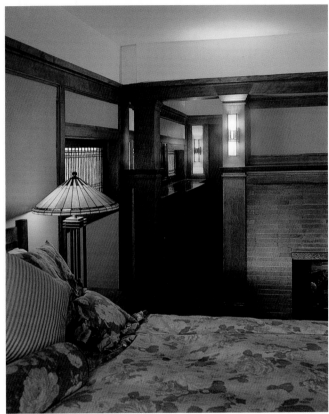

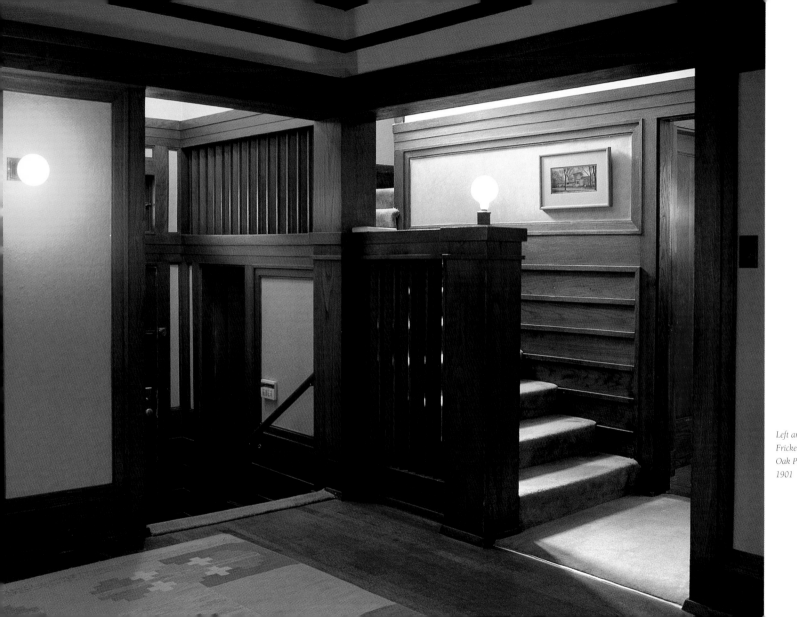

Left and opposite:
Fricke–Martin House,
Oak Park, Illinois,
1901

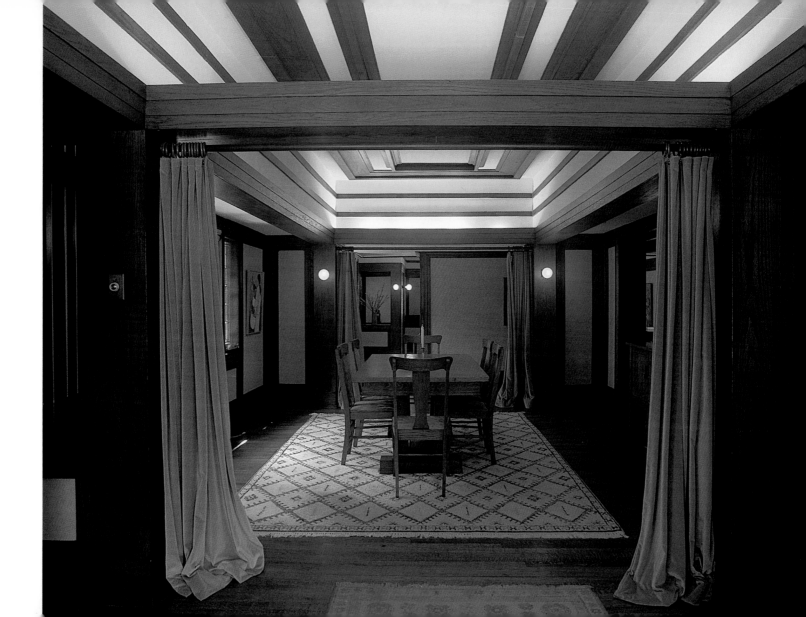

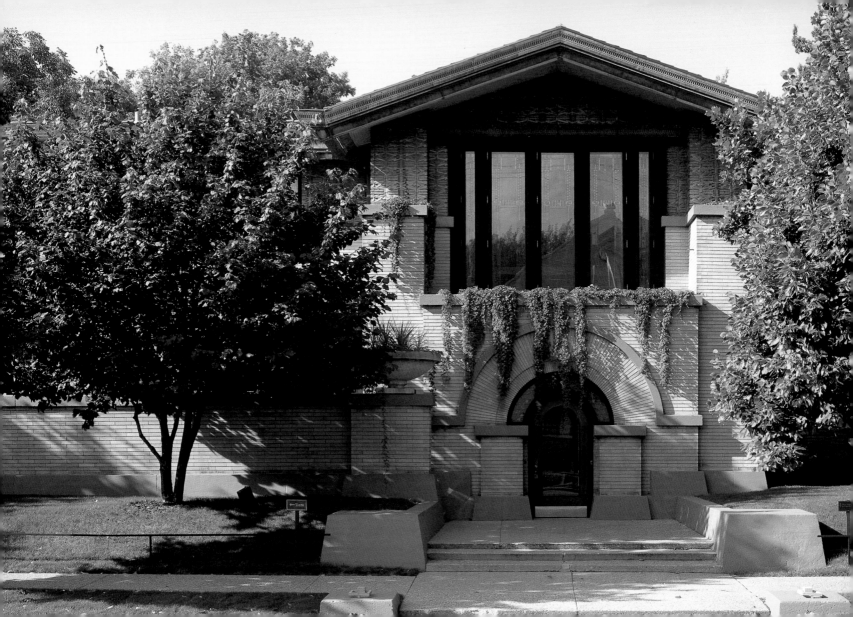

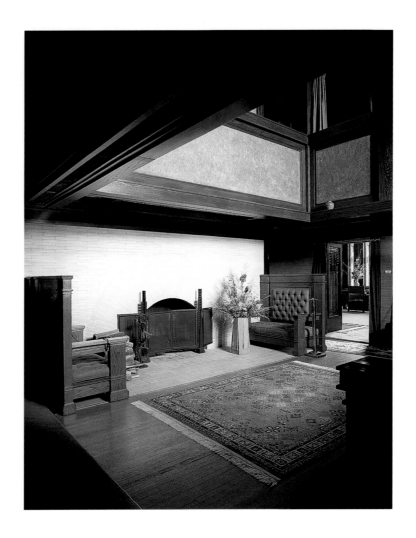

Left, above, following pages, and pages 58–59: Dana House, Springfield, Illinois, 1902

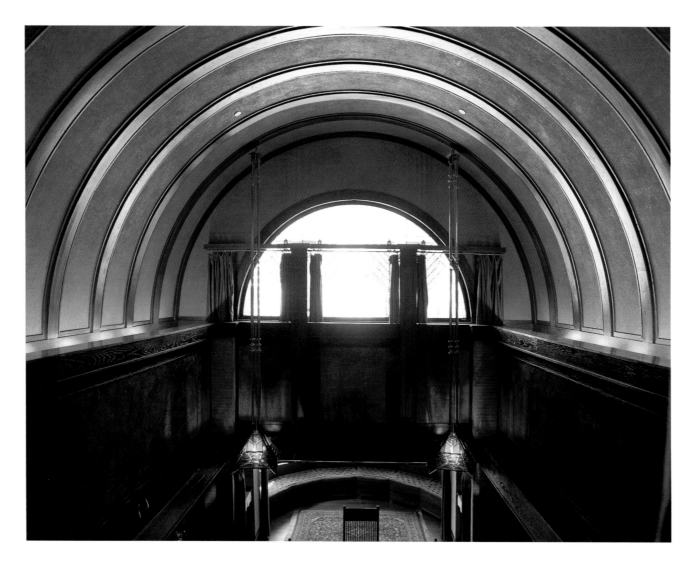

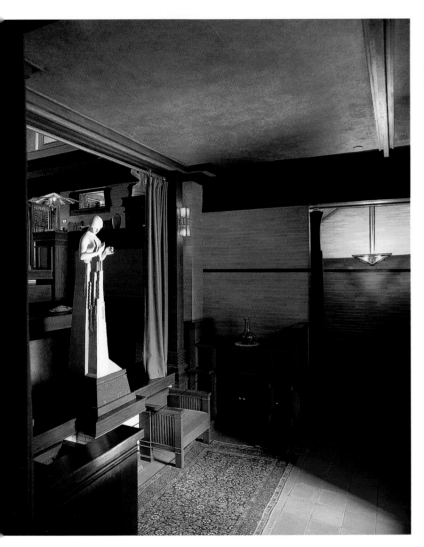
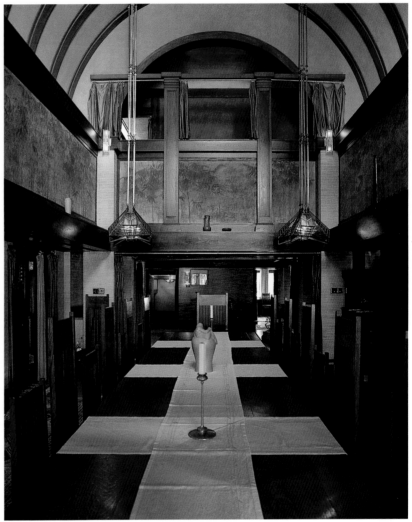

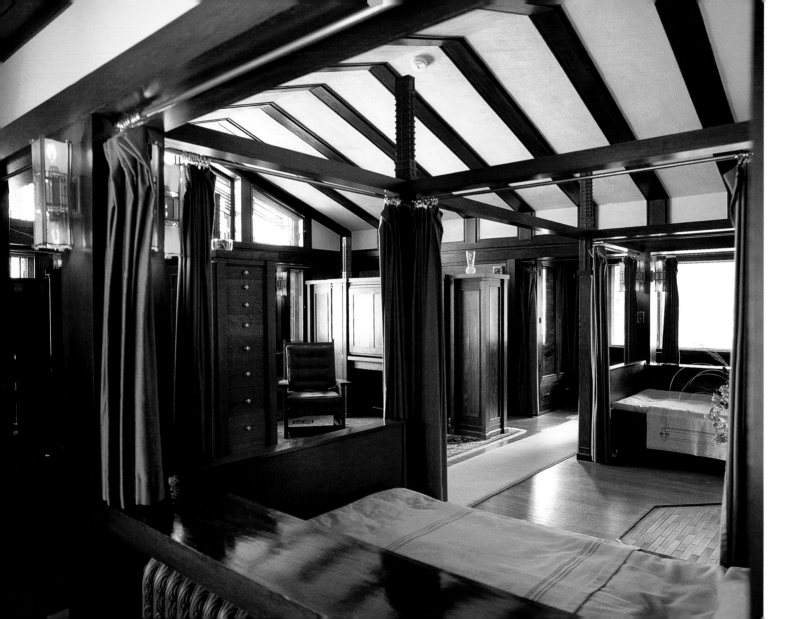

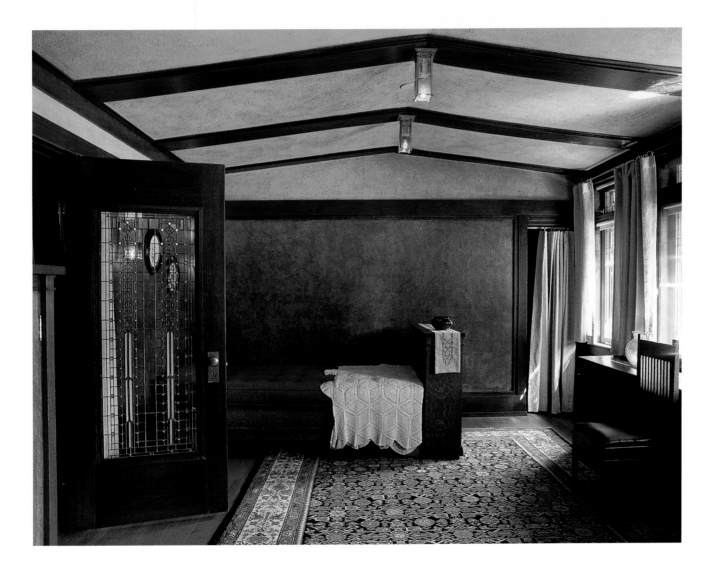

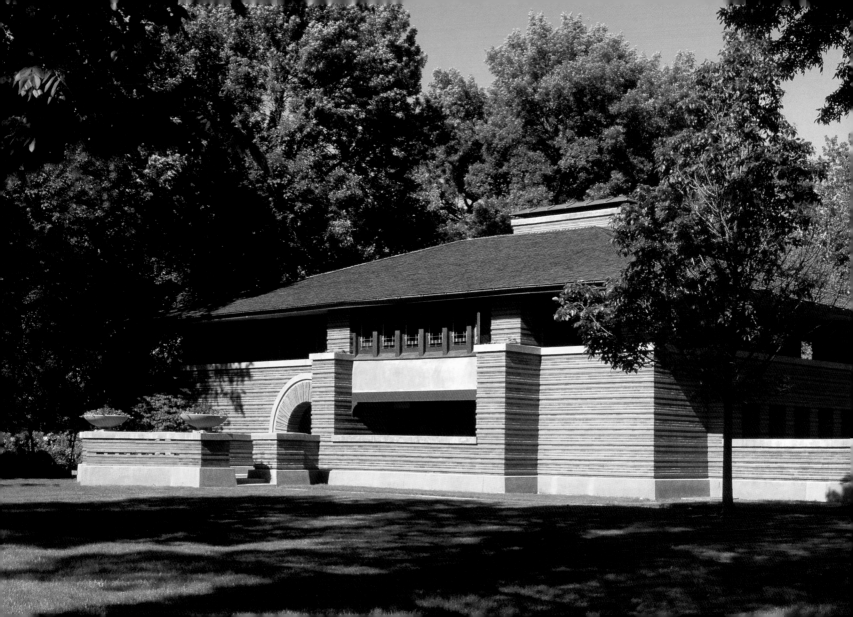

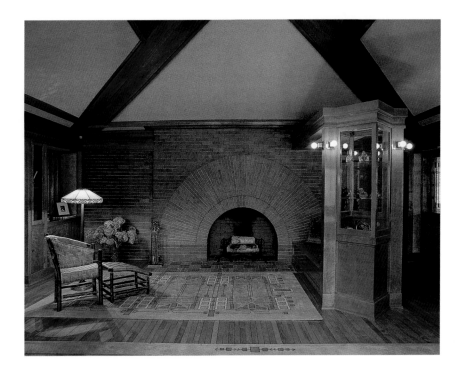

Left, above, and following pages: Heurtley House, Oak Park, Illinois, 1902

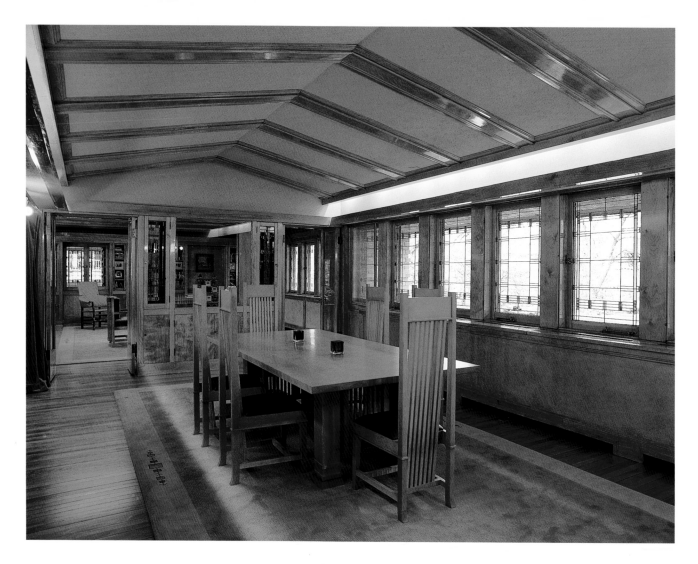

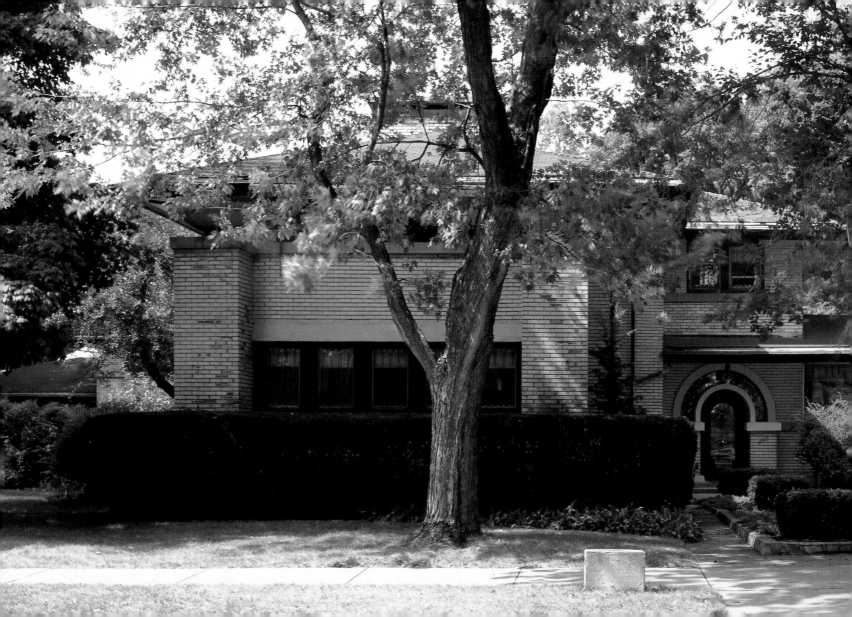

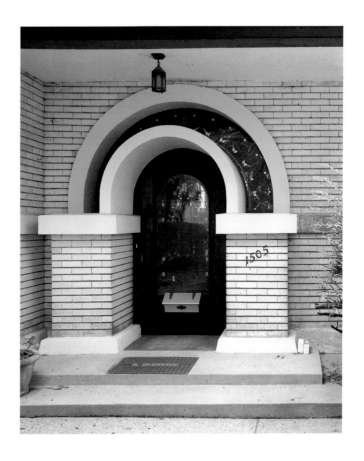

Left and above: Little House I, Peoria, Illinois, 1903 TWO ABSTRACTING NATURE **65**

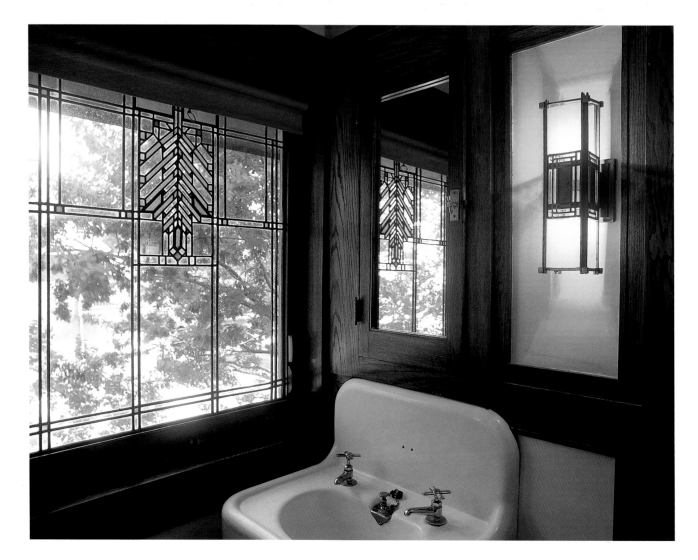

Above and opposite: Barton House, Buffalo, New York, 1903

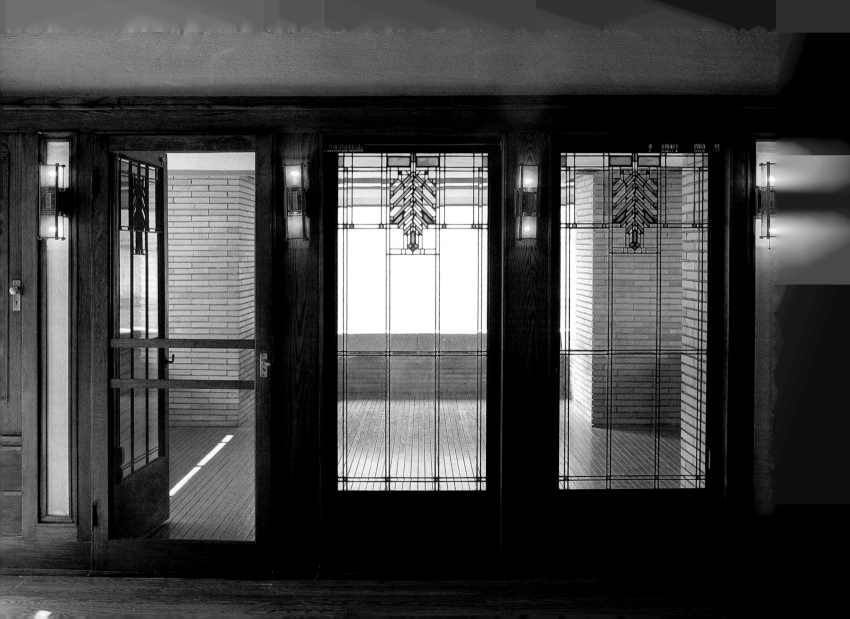

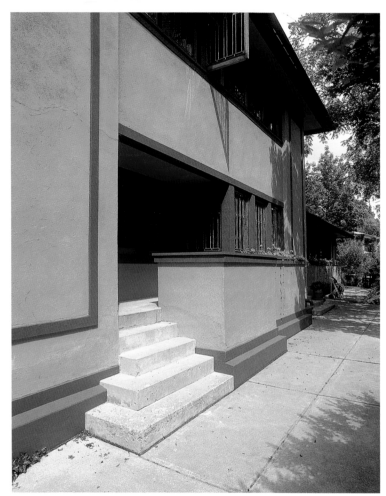

Left:
Darwin D. Martin House,
Gardener's Cottage,
Buffalo, New York, 1909

Right:
Darwin D. Martin House,
Buffalo, New York, 1904

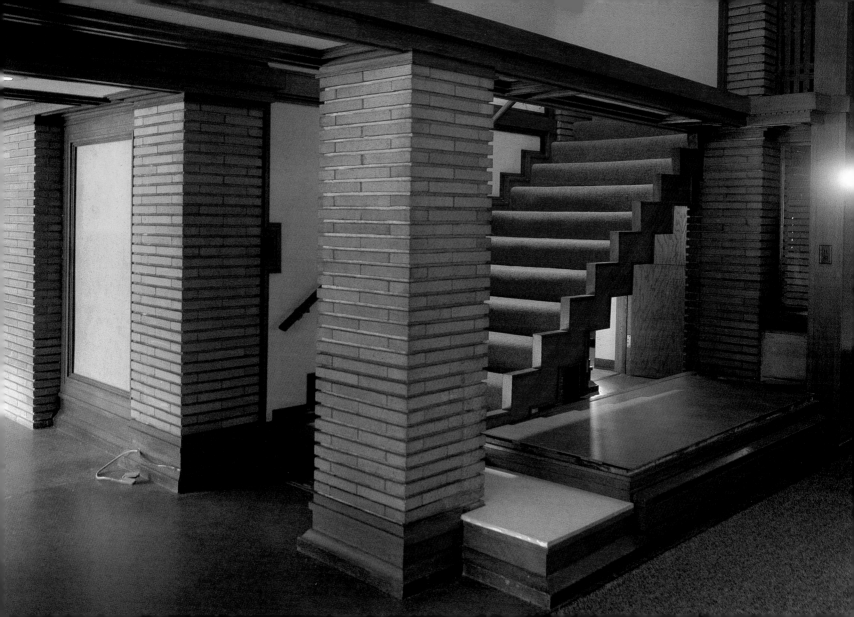

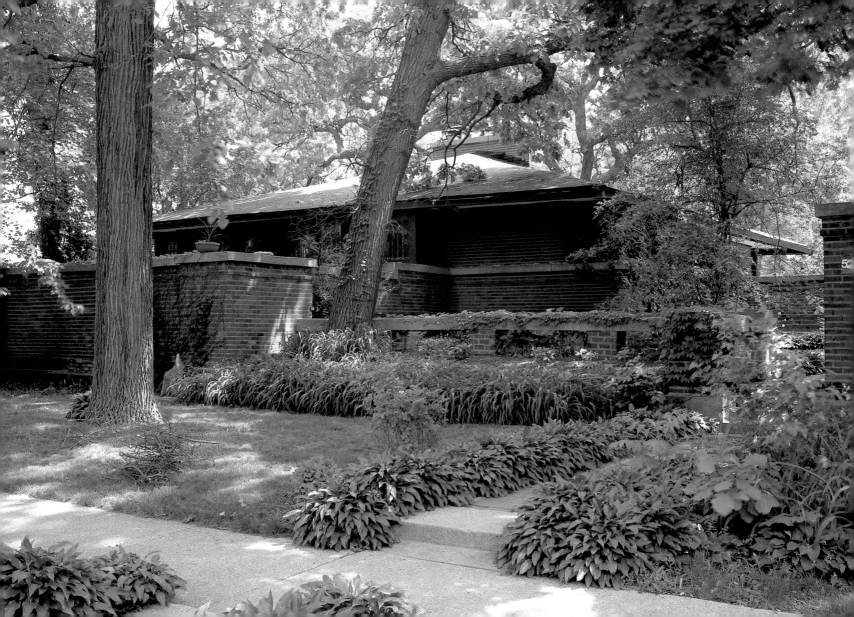

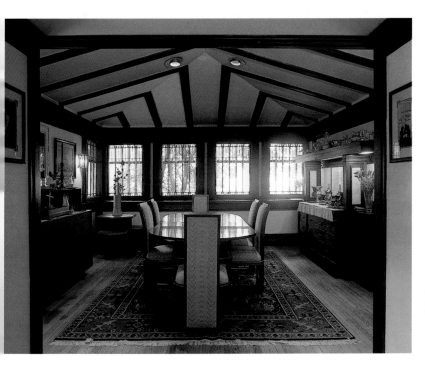

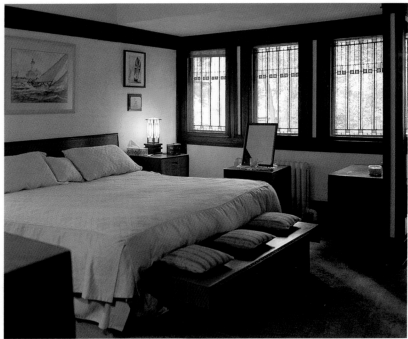

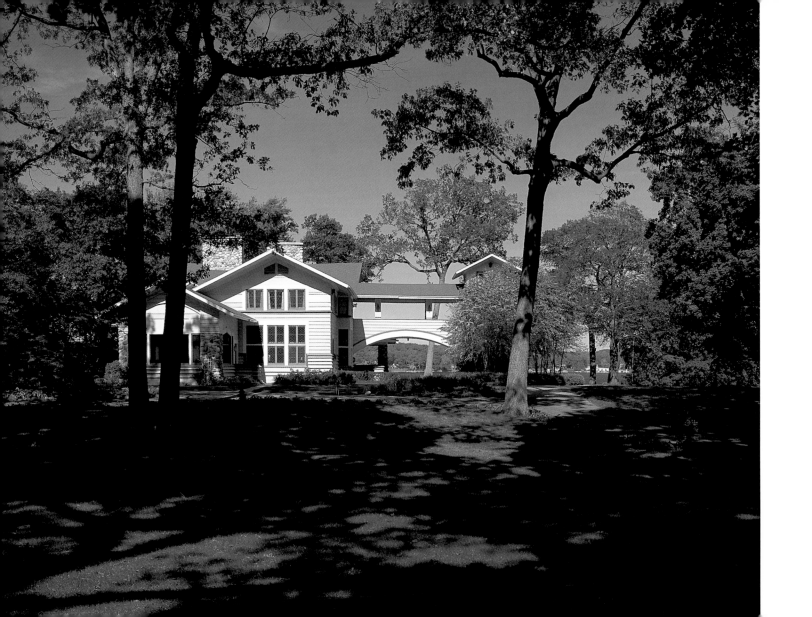

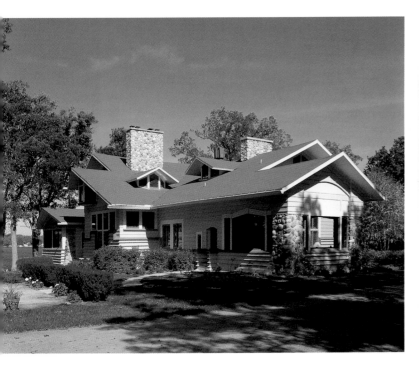

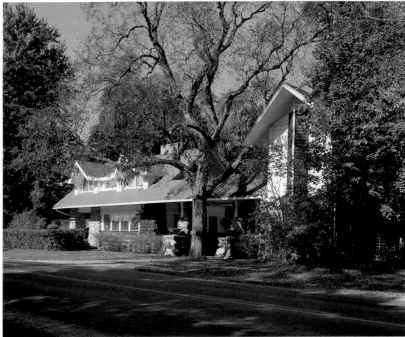

Opposite and above left: Fred Jones House, Delavan, Wisconsin, 1900; Above right: Fred Jones Gate Lodge, Delavan, Wisconsin, 1900

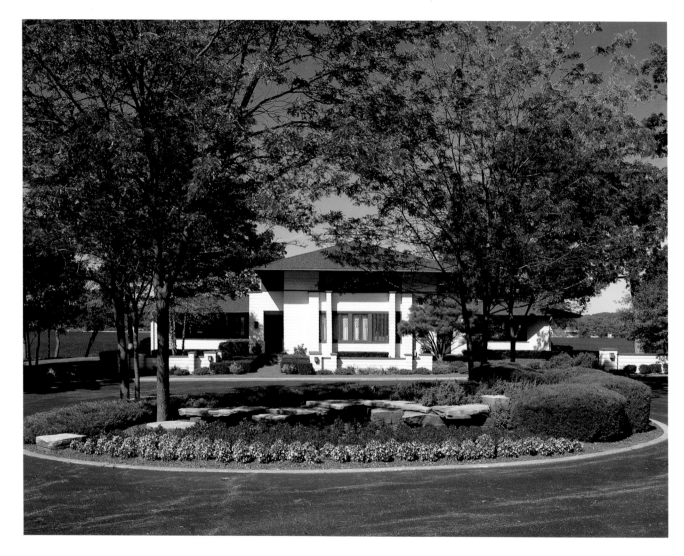

Above: A.P. Johnson House, Delavan, Wisconsin, 1905; Opposite: Gerts Cottage, Whitehall, Michigan, 1902

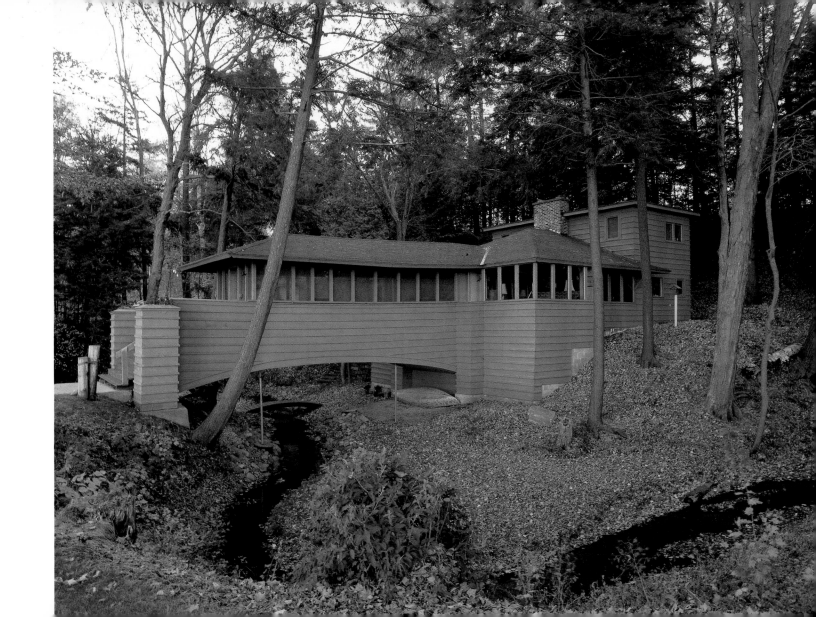

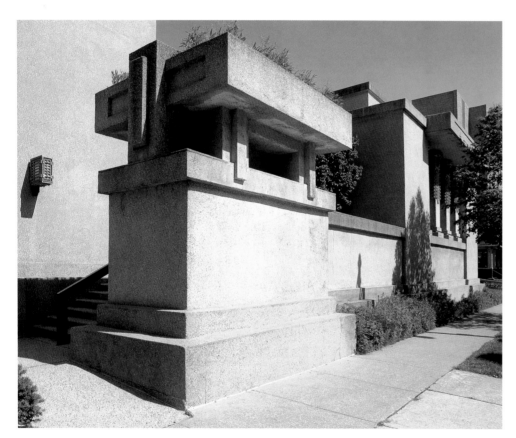

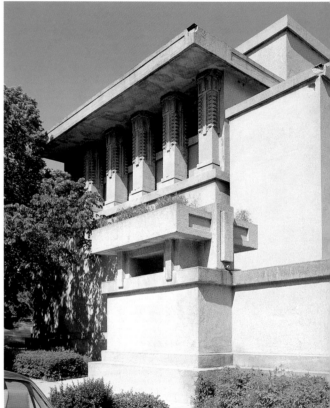

Above and opposite: Unity Temple, Oak Park, Illinois, 1905

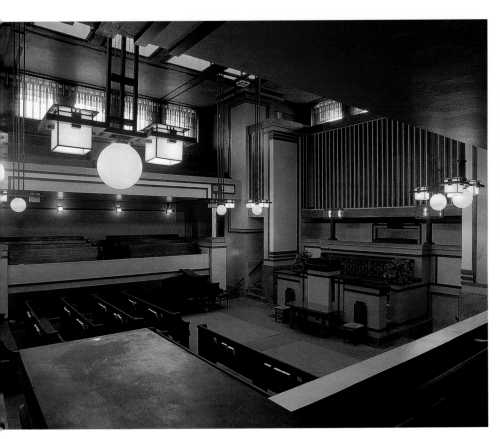

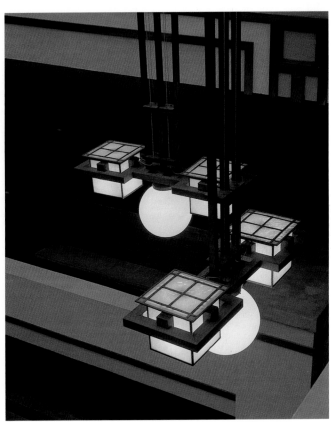

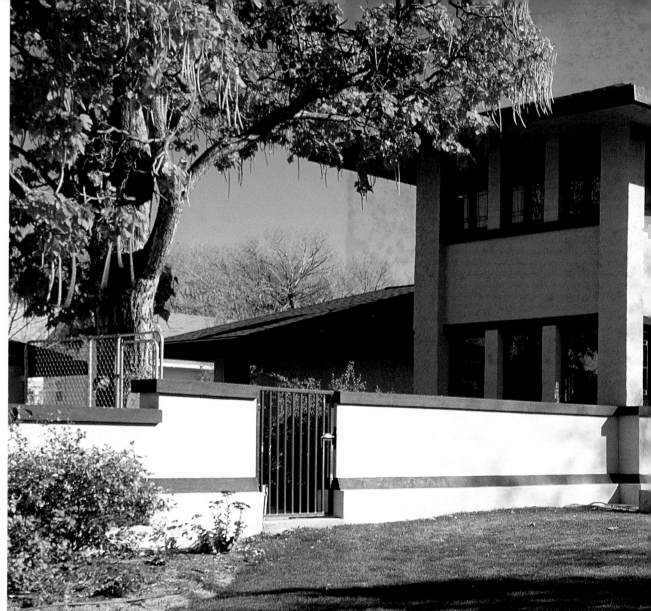

Sutton House,
McCook, Nebraska, 1905

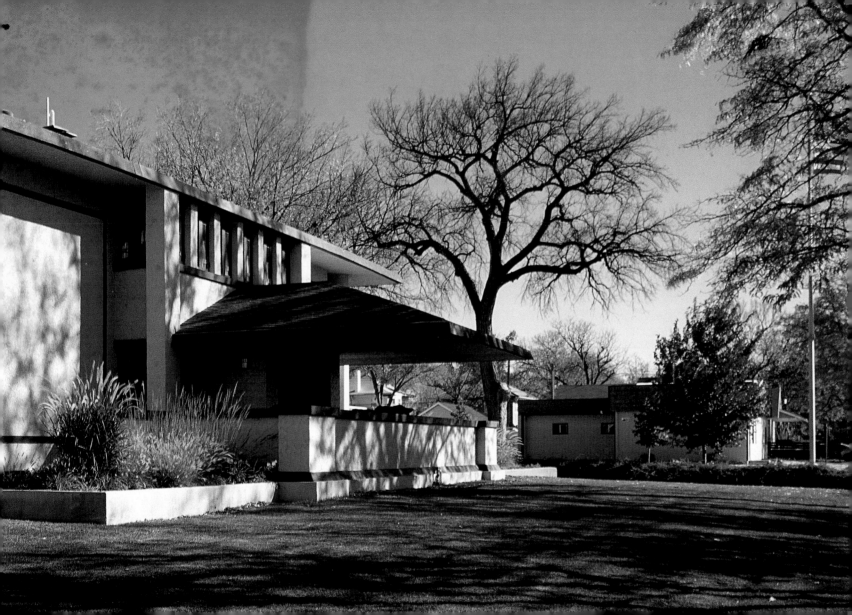

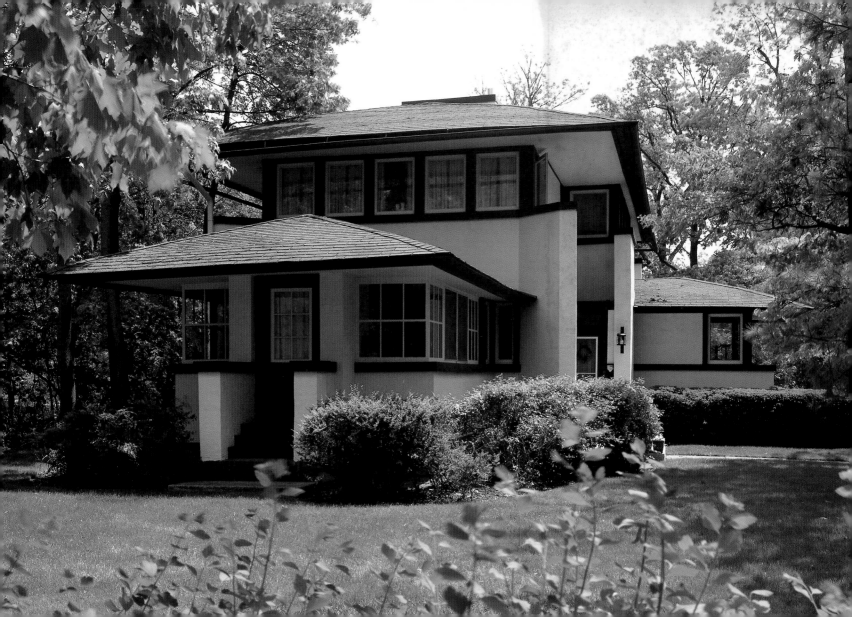

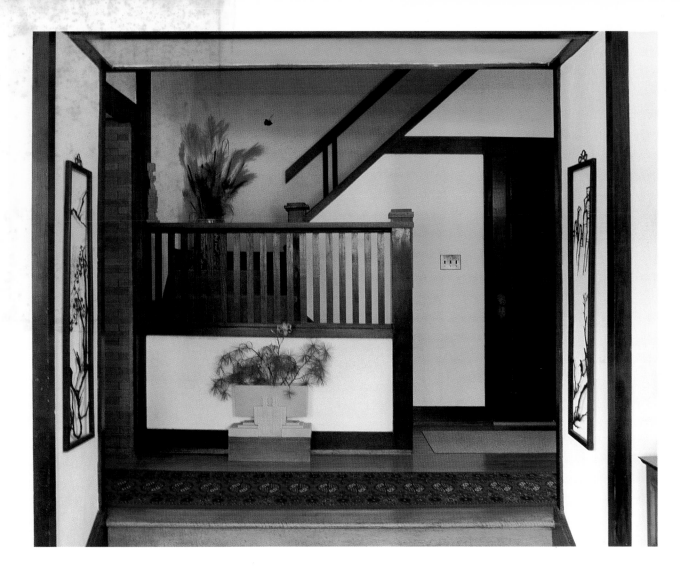

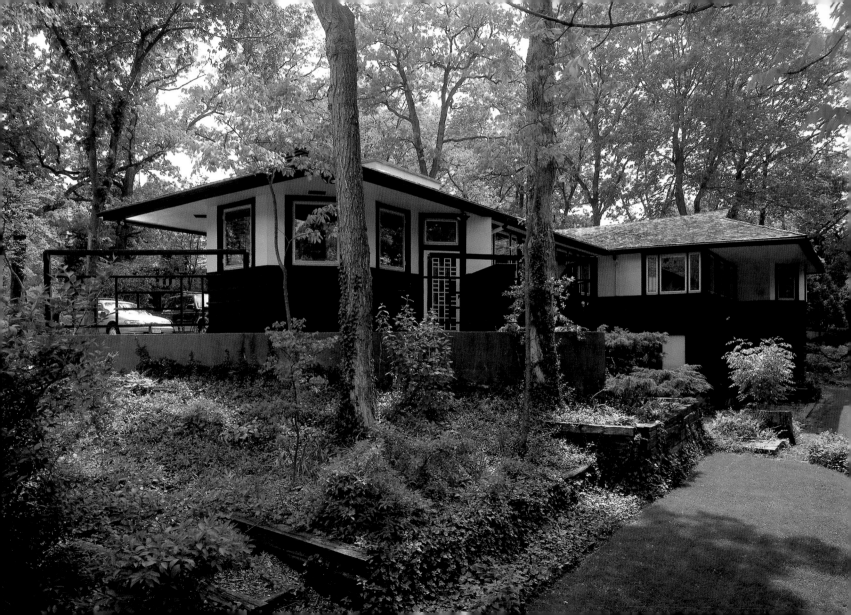

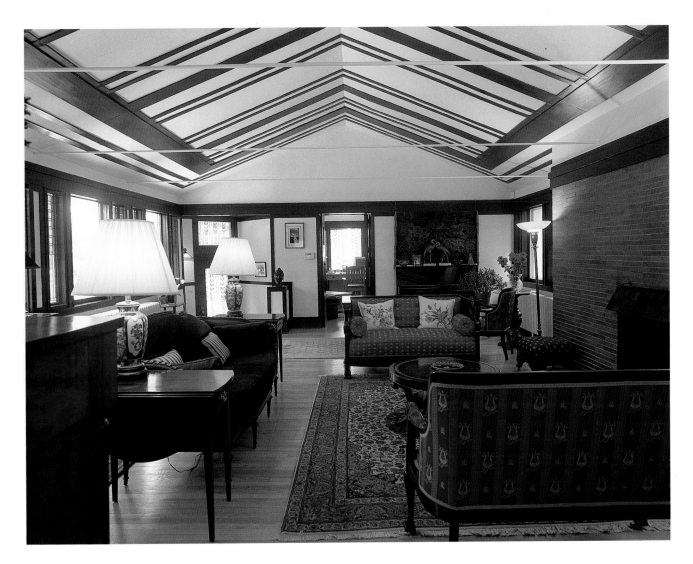

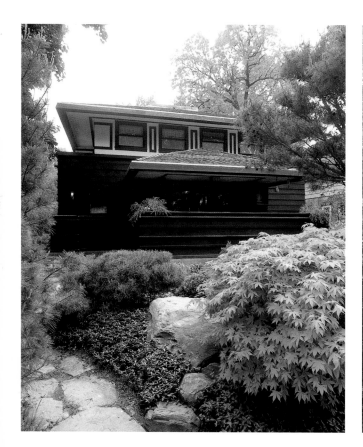

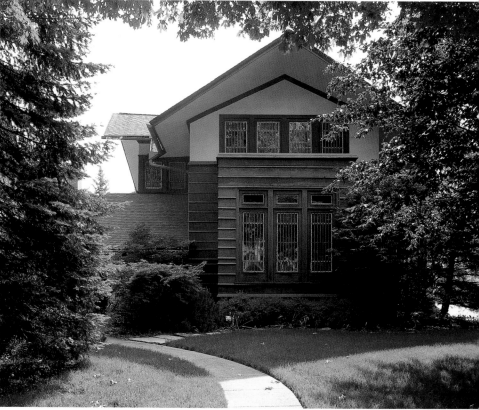

Above left: Brown House, Evanston, Illinois, 1905; Above right: Davenport House, River Forest, Illinois, 1901; Opposite: Westcott House, Springfield, Ohio, 1906

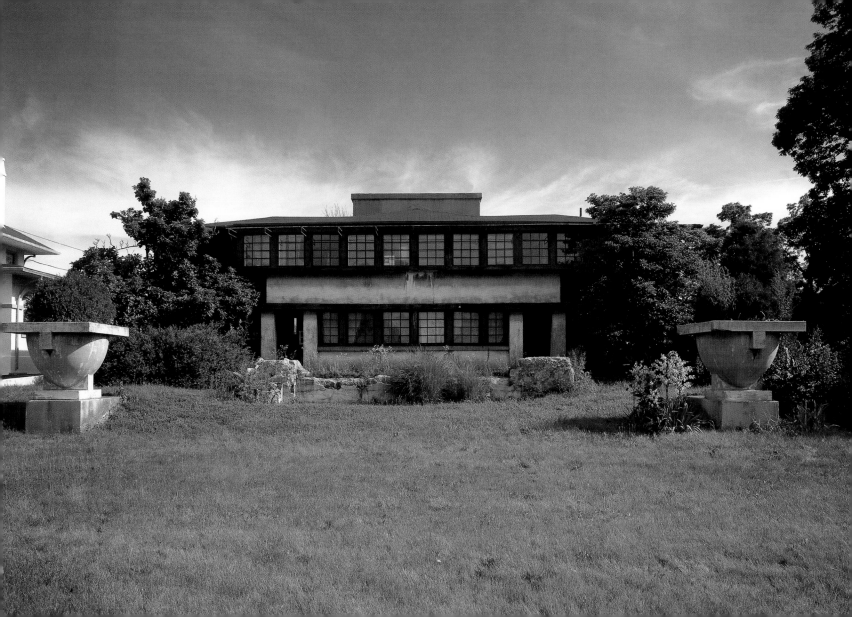

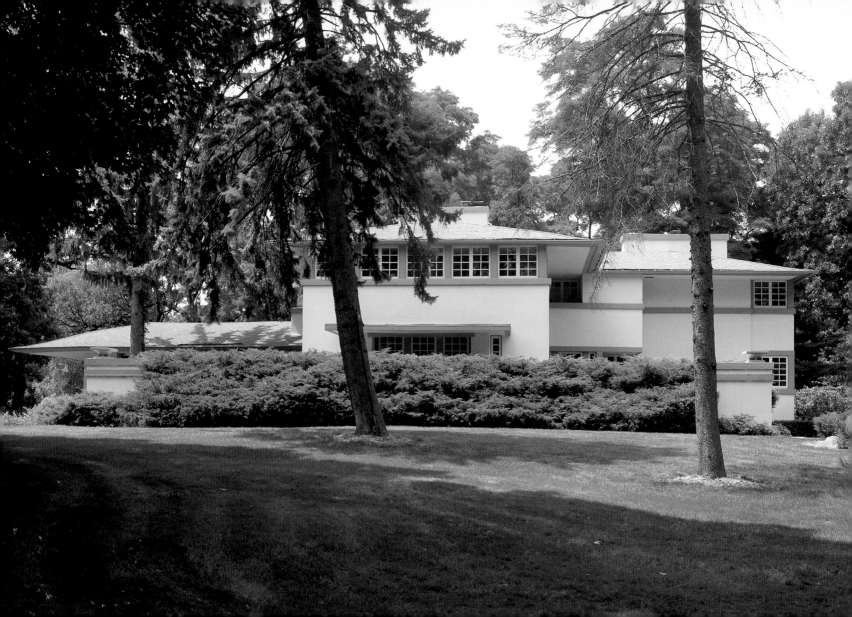

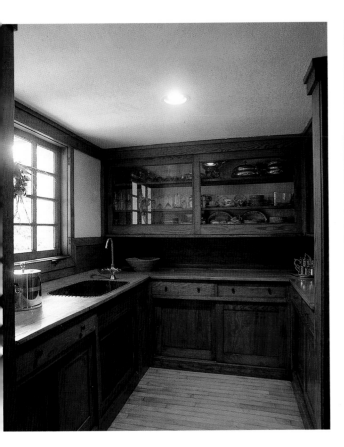

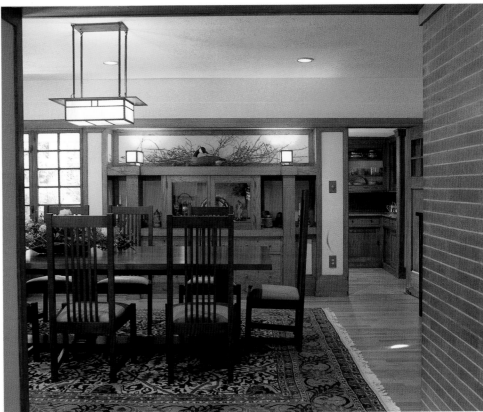

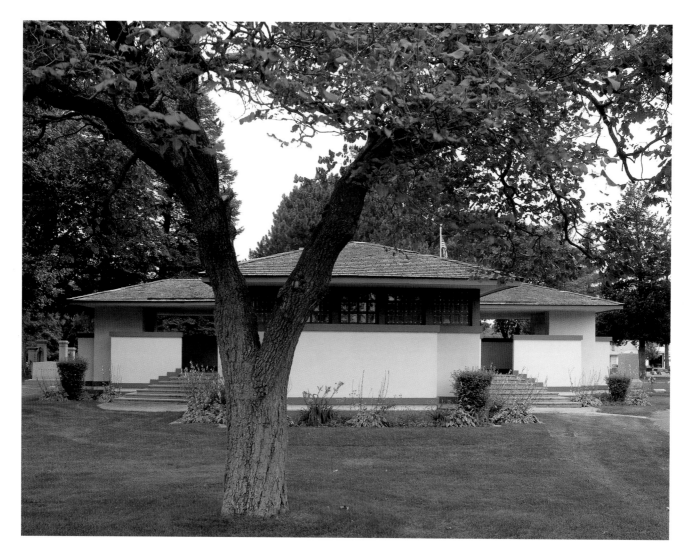

Above and opposite: William H. Pettit Memorial Chapel, Belvidere, Illinois, 1906

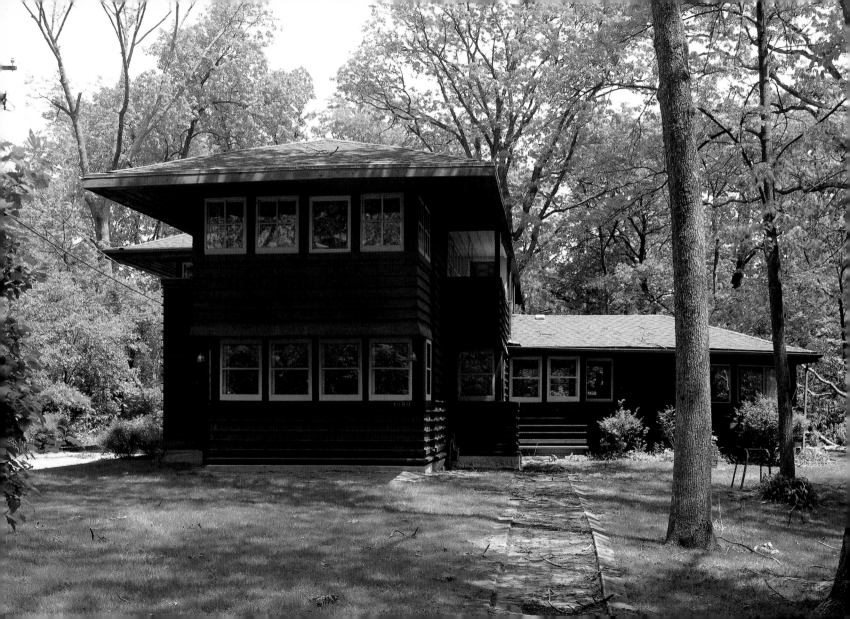

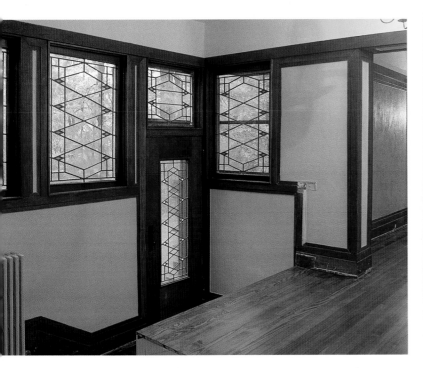

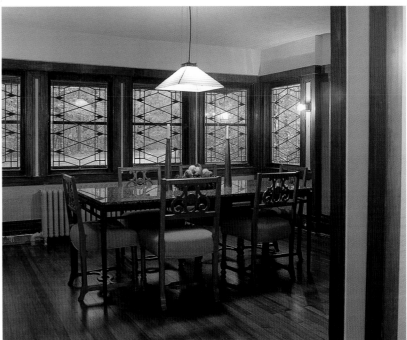

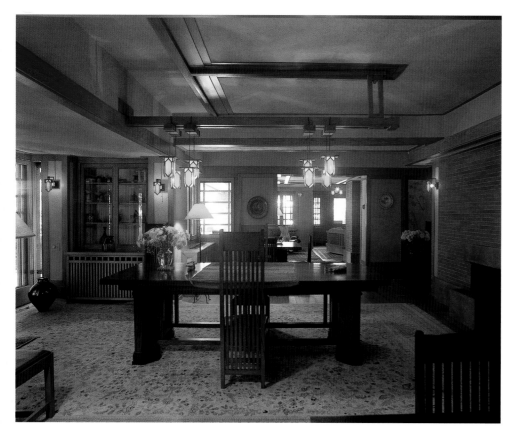

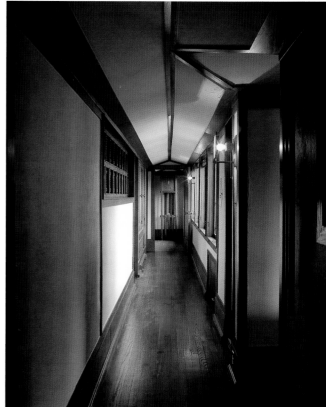

Above left: Beachy House, Oak Park, Illinois, 1906; Above right and opposite: Coonley House, Riverside, Illinois, 1907

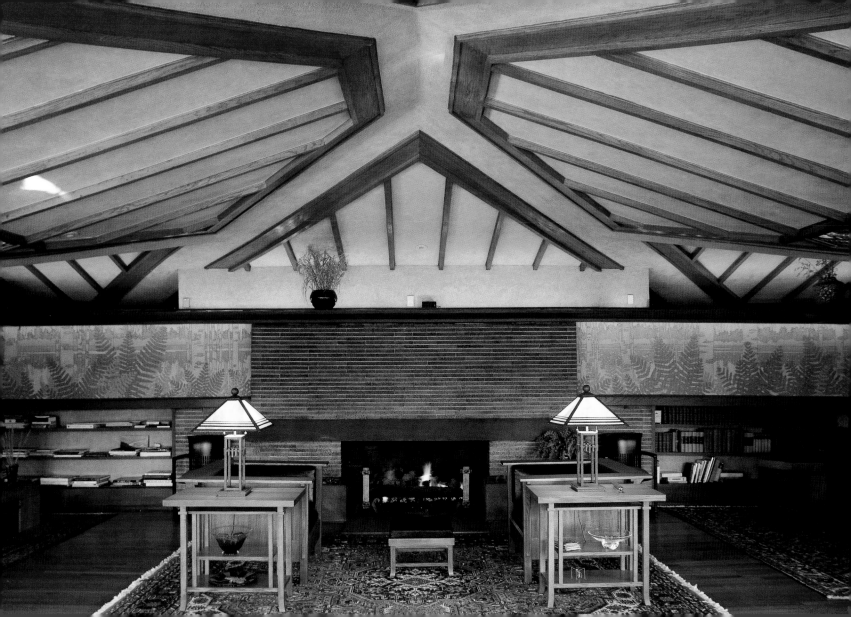

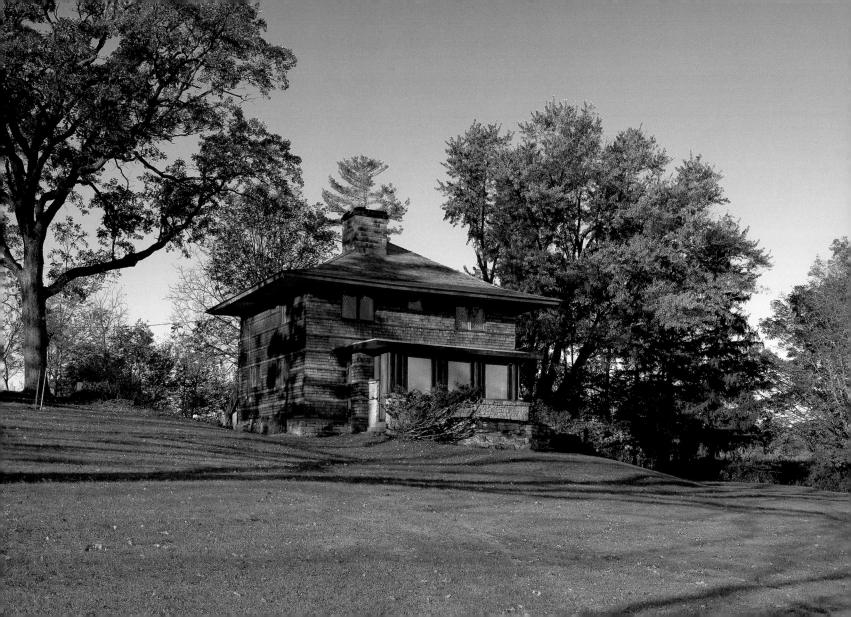

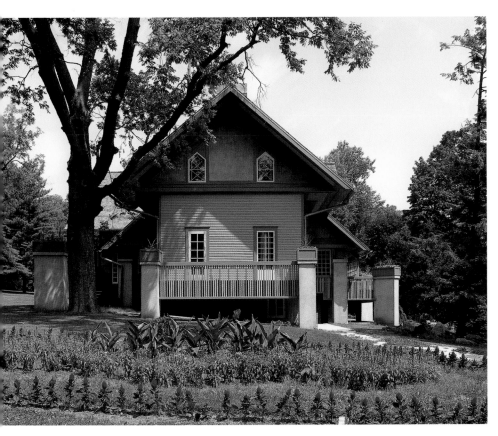

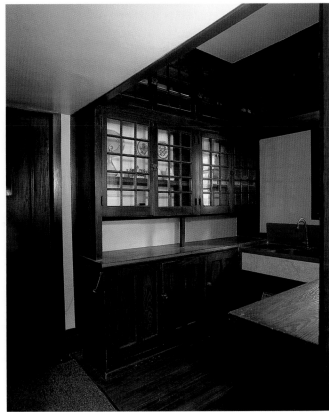

Opposite: Porter House (Tanyderi), Spring Green, Wisconsin, 1907; Above: Fabyan House Remodeling, Geneva, Illinois, 1907

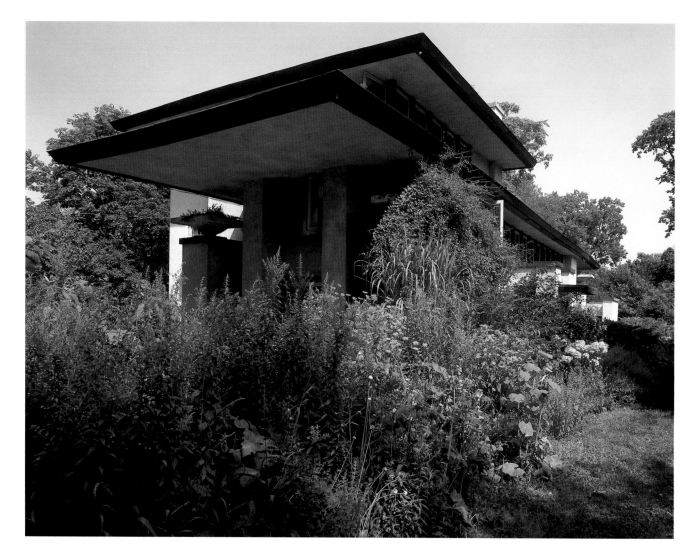

Above and opposite: Tomek House, Riverside, Illinois, 1907

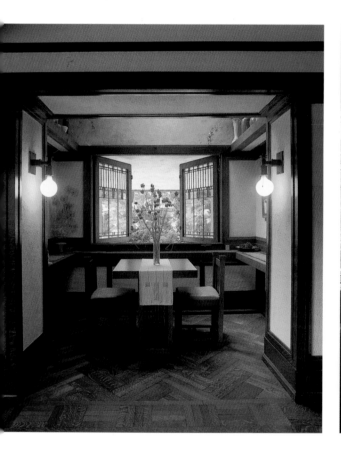

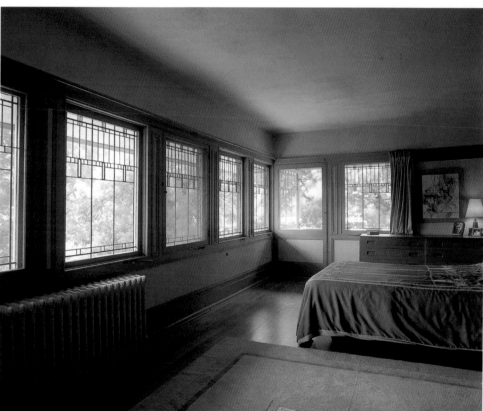

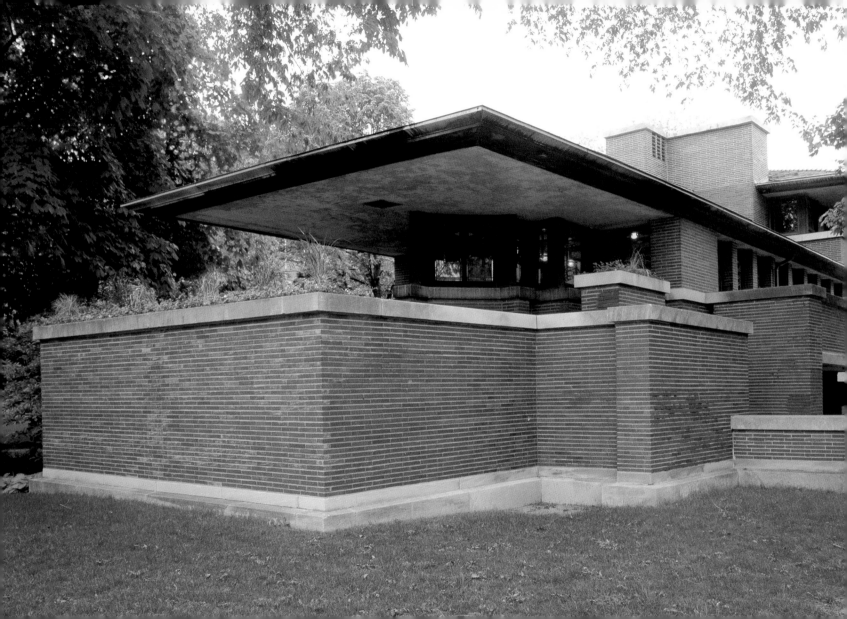

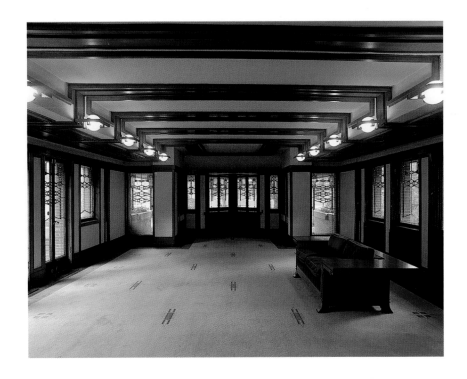

Left and above: Robie House, Chicago, Illinois, 1908

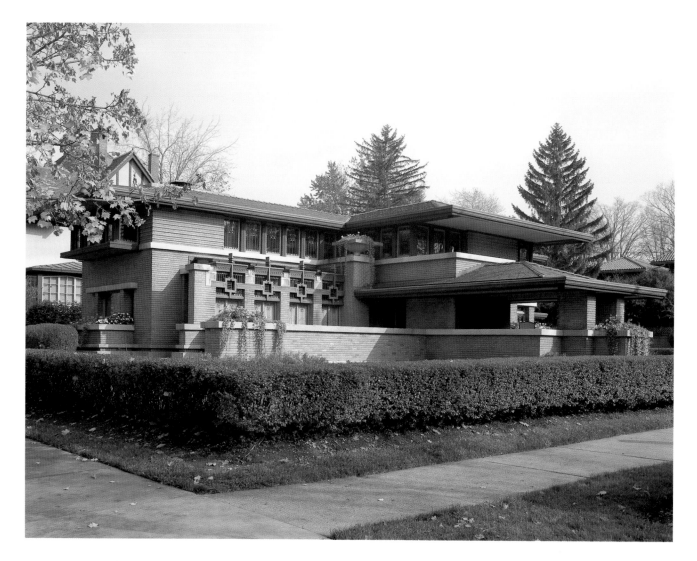

Above: May House, Grand Rapids, Michigan, 1908; Opposite: Hunt House I, LaGrange, Illinois, 1907

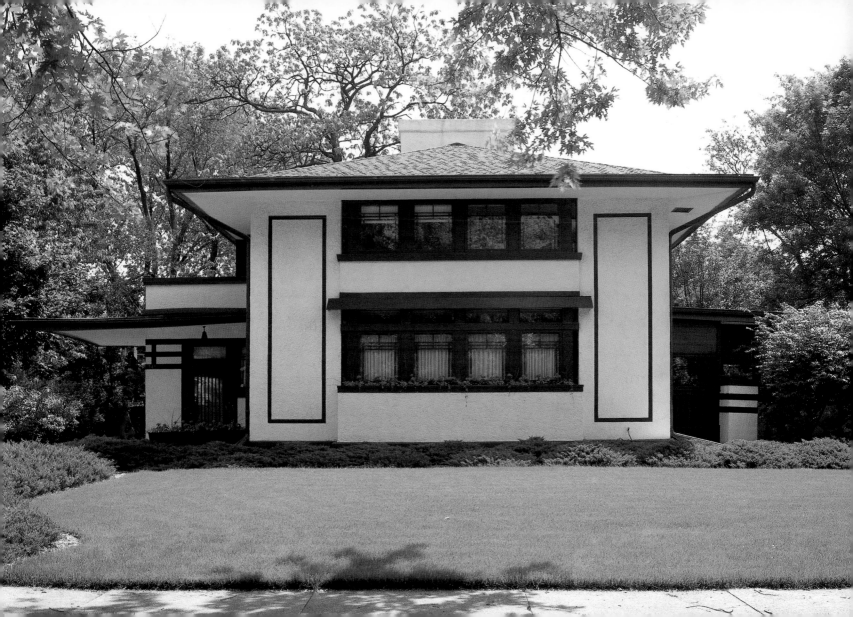

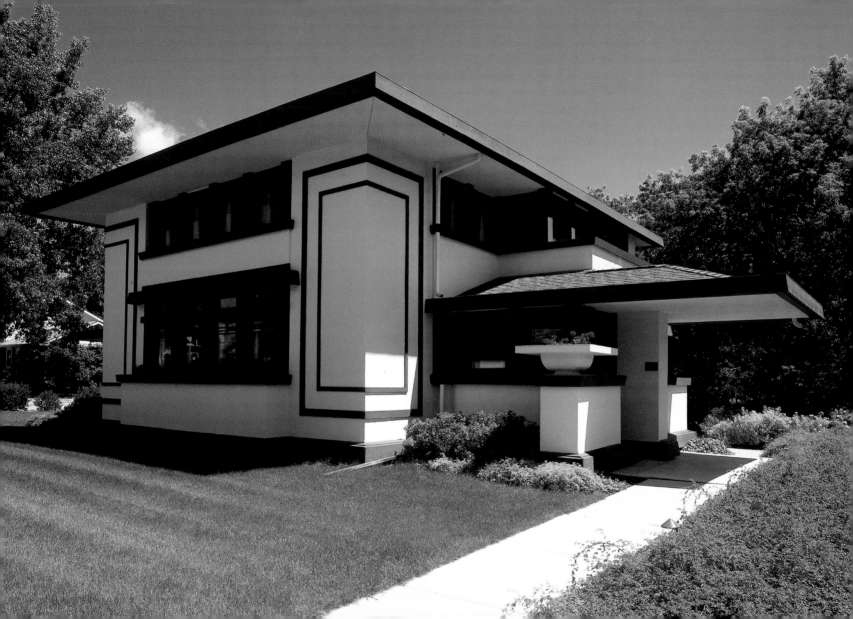

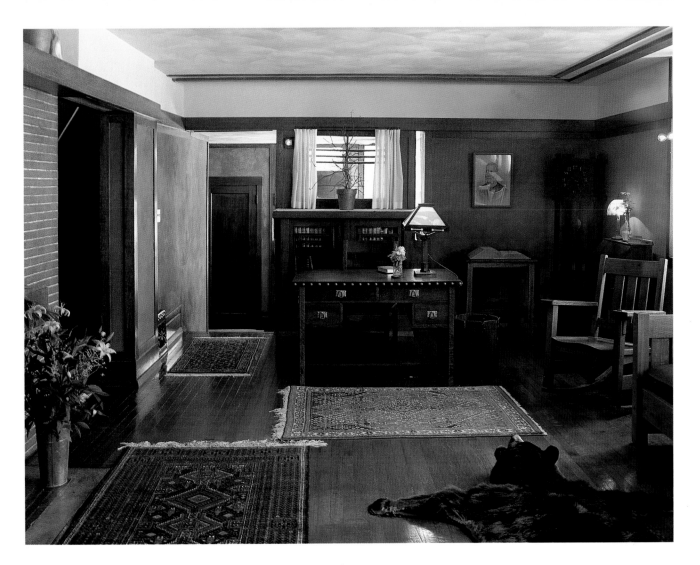

Opposite, above, and following pages: Stockman House, Mason City, Iowa, 1908

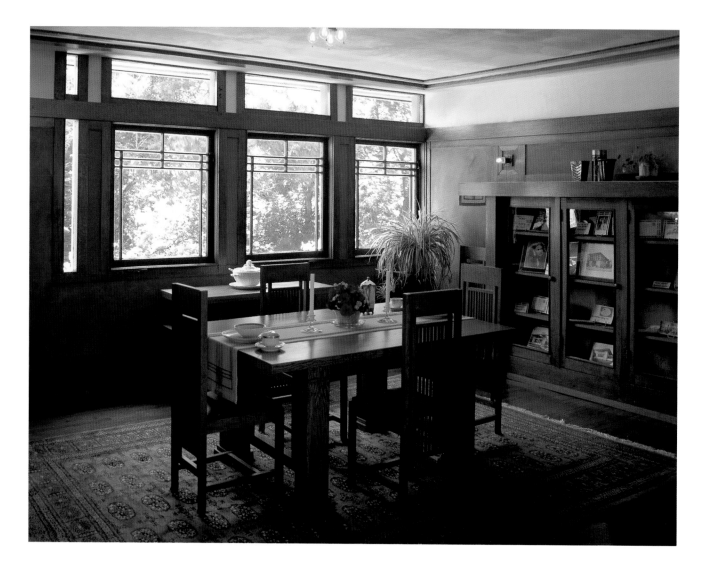

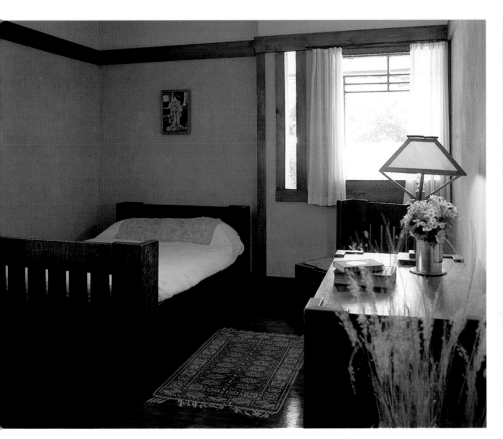
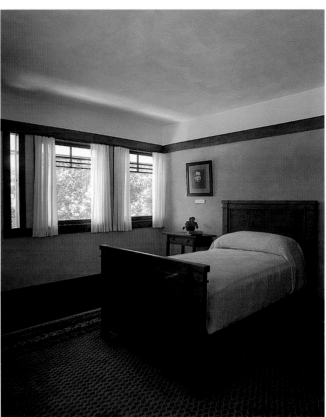

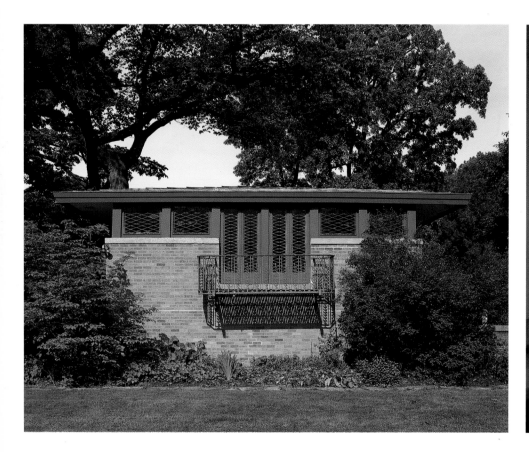

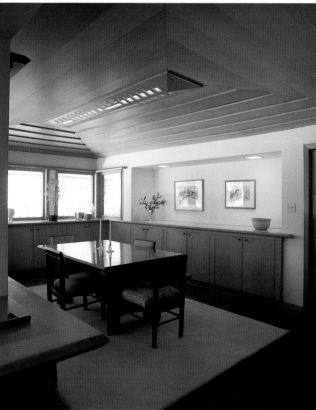

Above and opposite: Roberts House, River Forest, Illinois, 1908

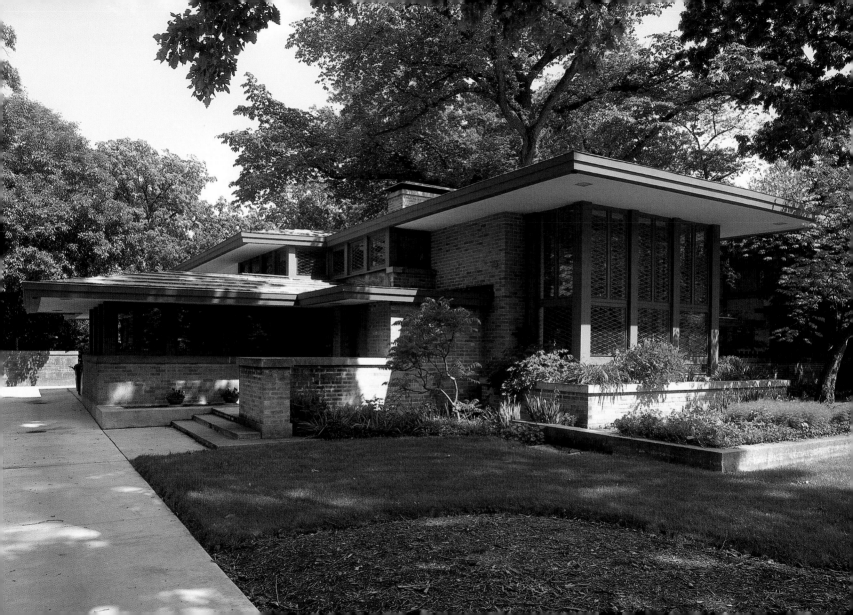

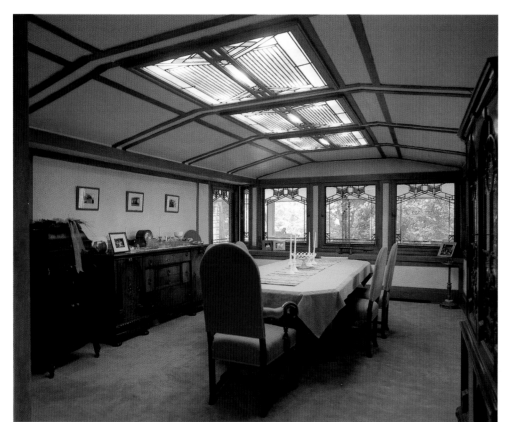
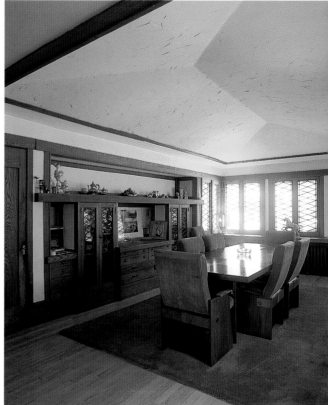

Above left: Evans House, Chicago, Illinois, 1908; Above right and opposite: Davidson House, Buffalo, New York, 1908

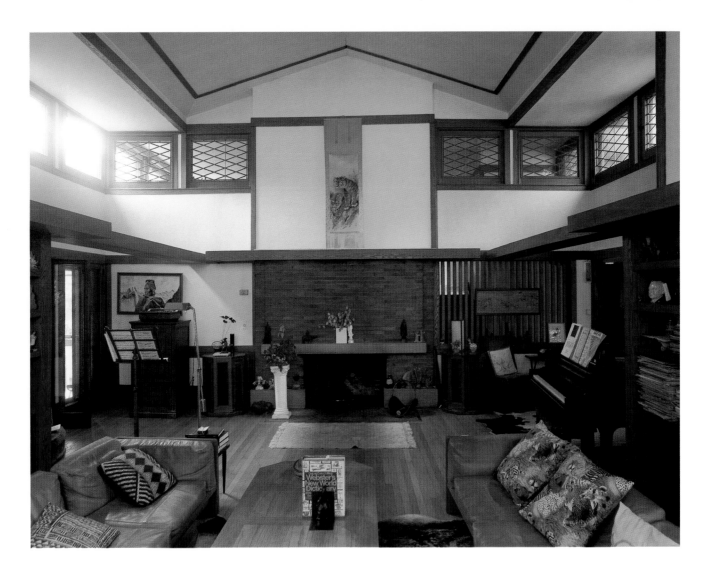

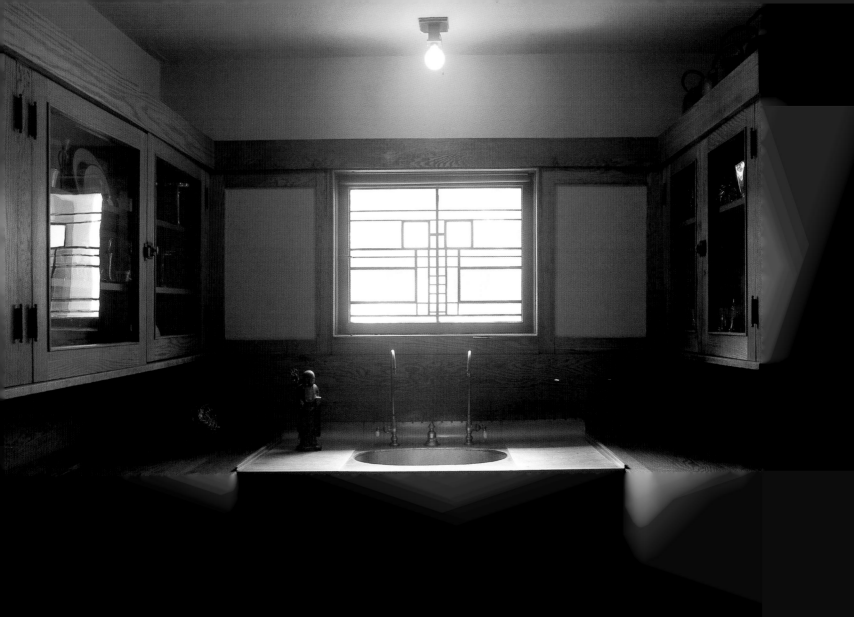

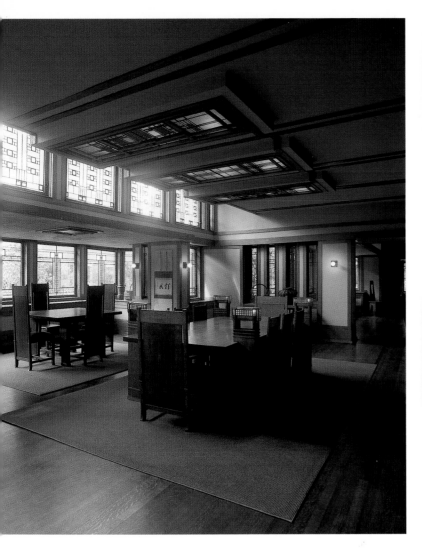

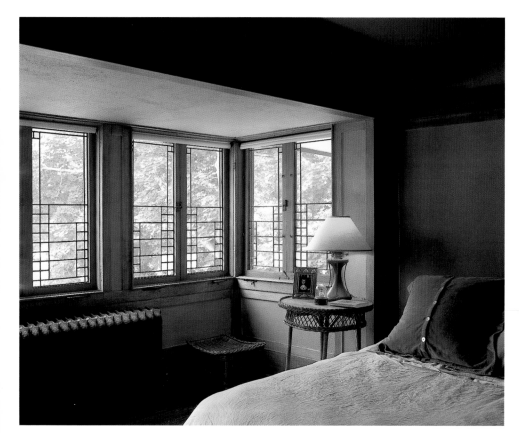
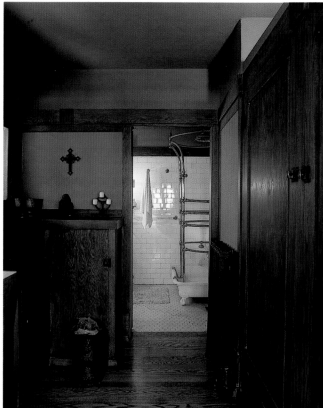

Above: Boynton House, Rochester, New York, 1908; Opposite: Stewart House, Montecito, California, 1909

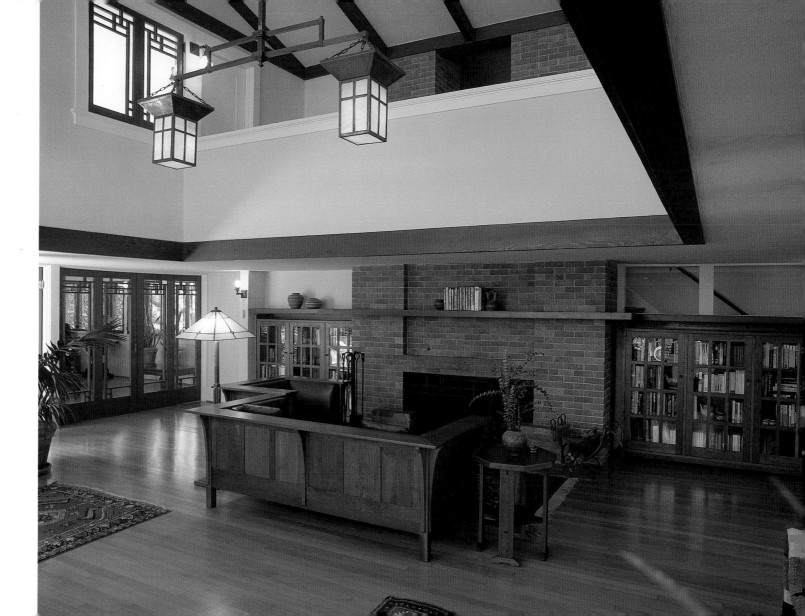

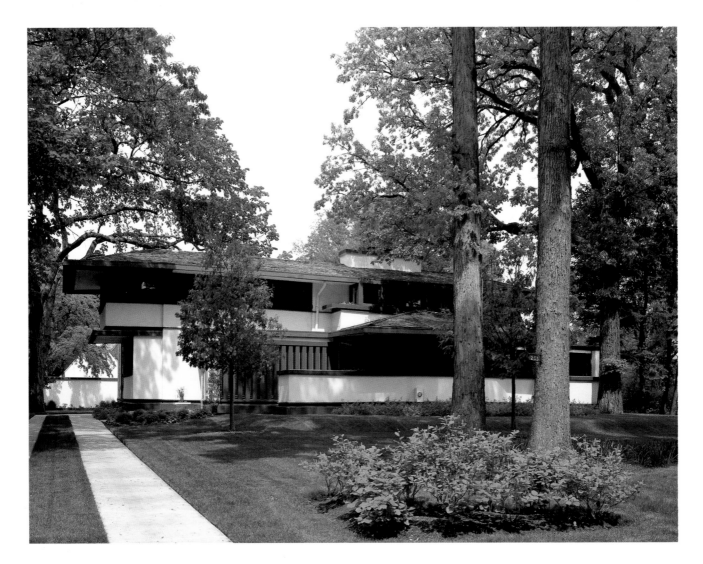

Above: Baldwin House, Kenilworth, Illinois, 1909; Opposite: Laura Gale House, Oak Park, Illinois, 1909

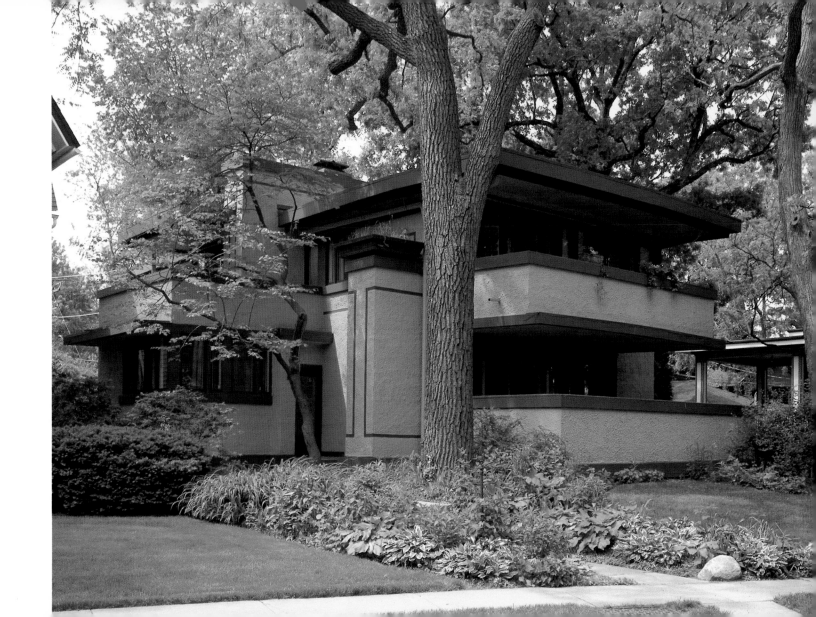

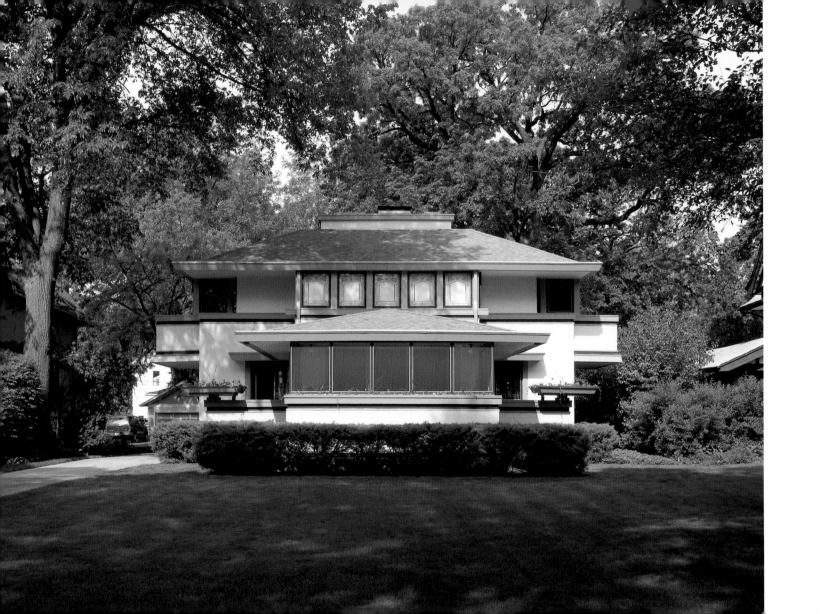

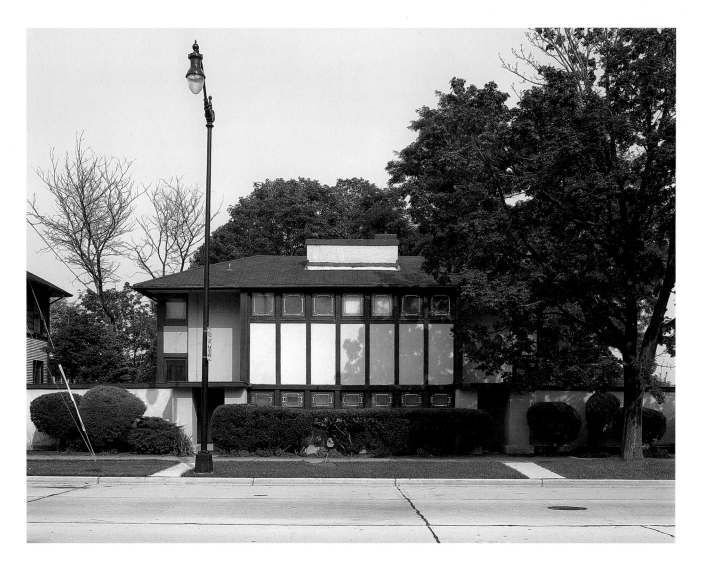

Opposite: Ingalls House, River Forest, Illinois, 1909; Above: Hardy House, Racine, Wisconsin, 1905

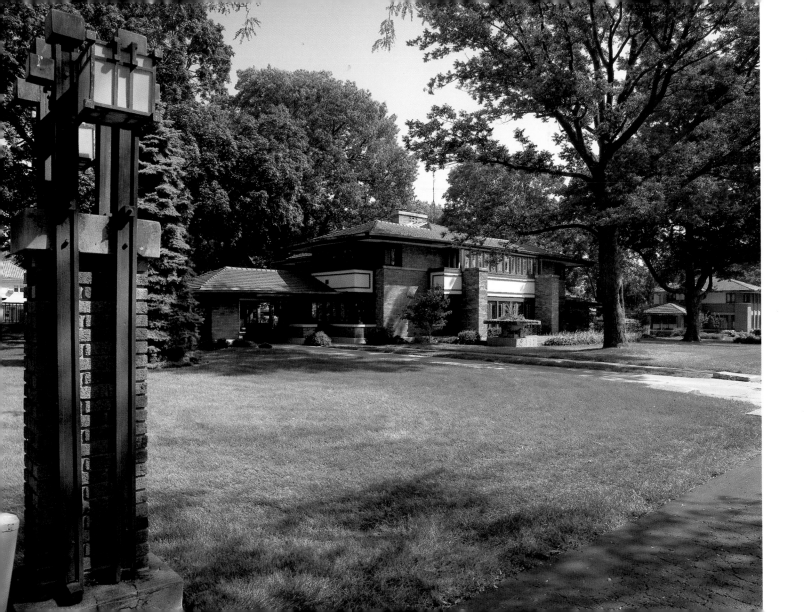

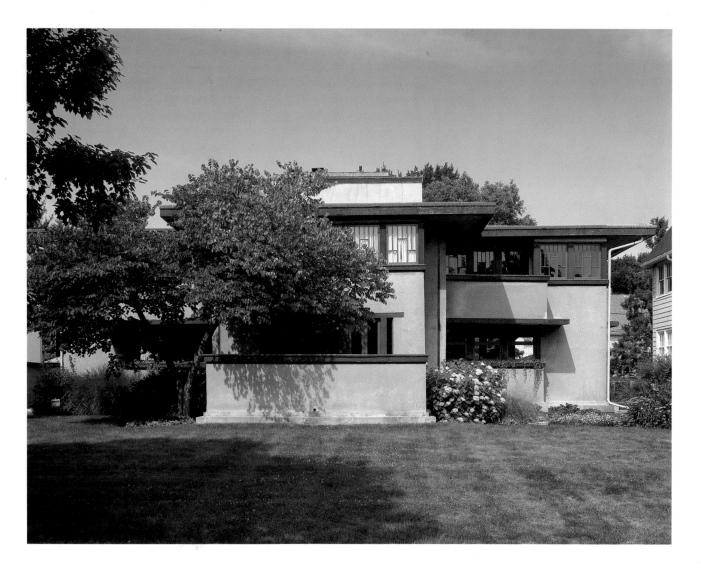

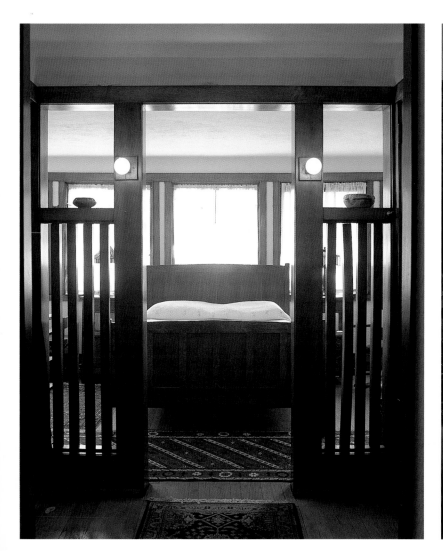
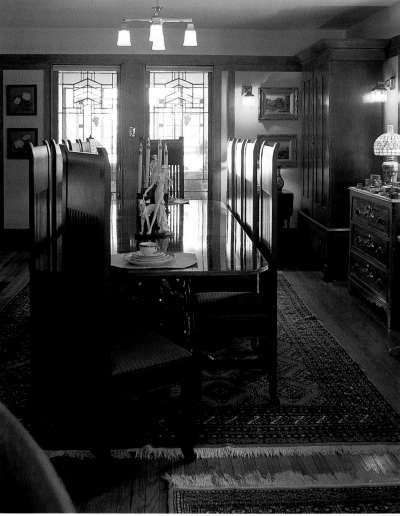

Above left: Balch House, Oak Park, Illinois, 1911; Above right: Ziegler House, Frankfort, Kentucky, 1910

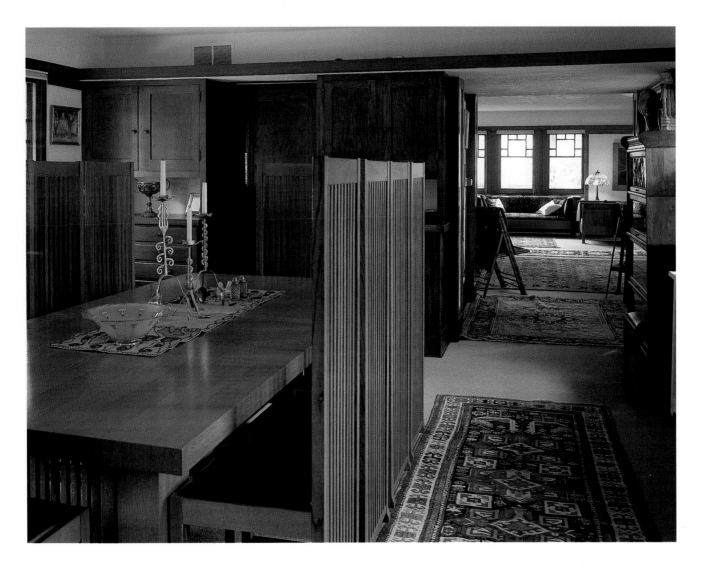

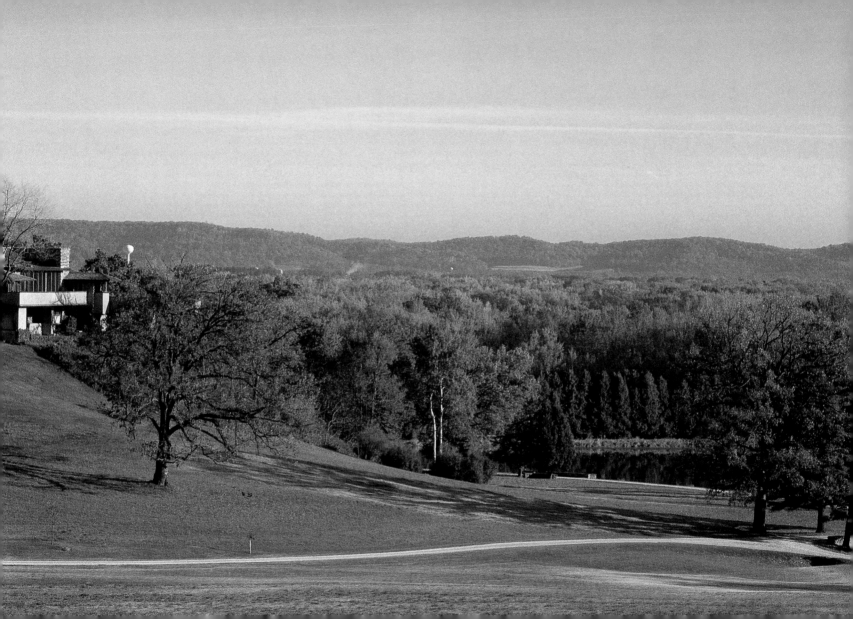

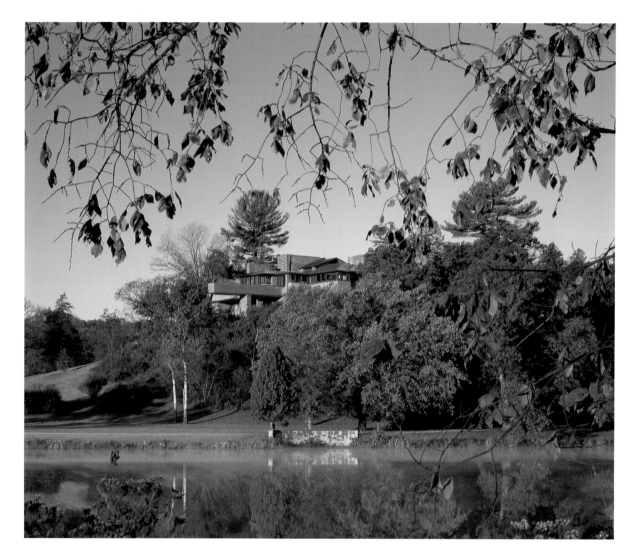

Previous pages, above, opposite, following pages, and pages 128–131: Taliesin, Spring Green, Wisconsin, 1911; remodeled in 1914 and 1925

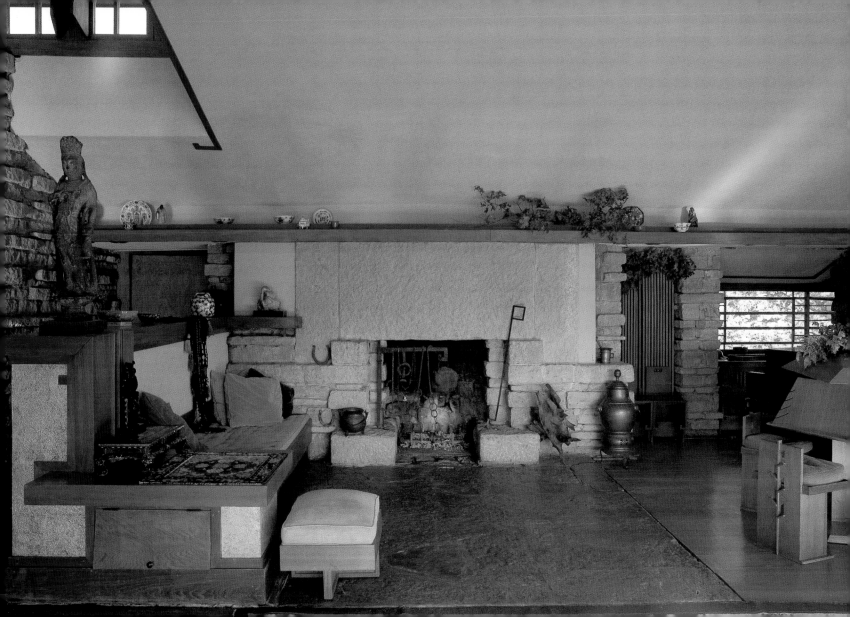

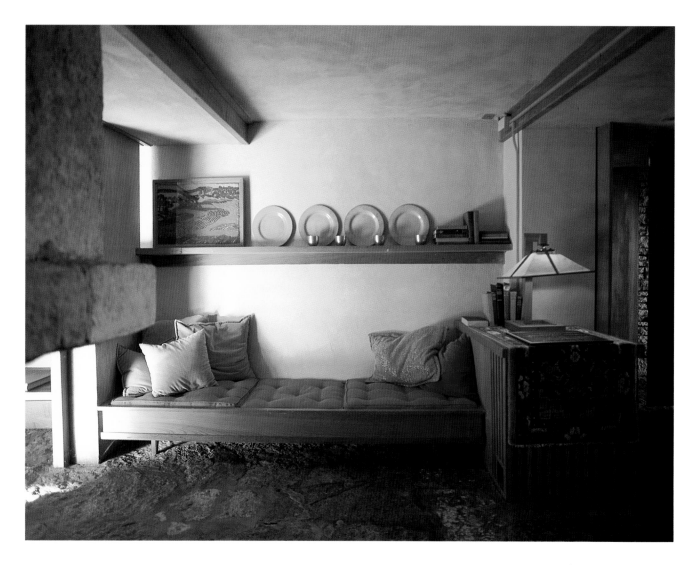

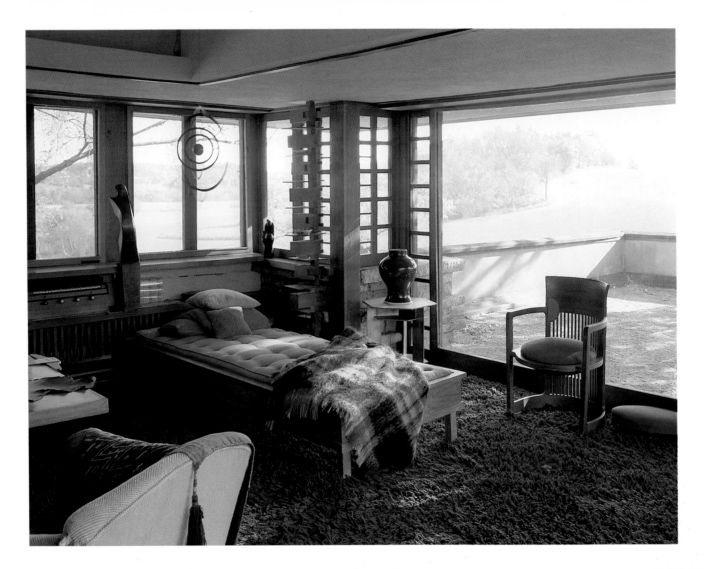

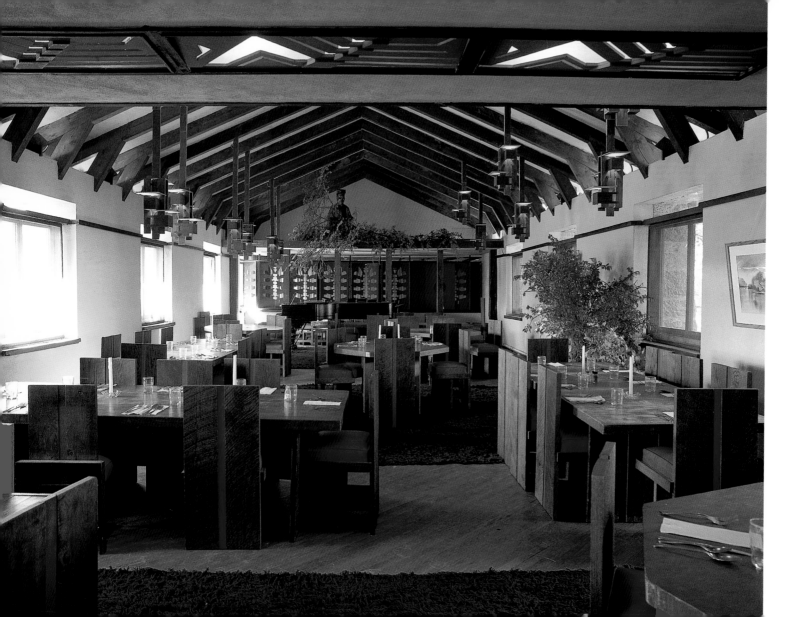

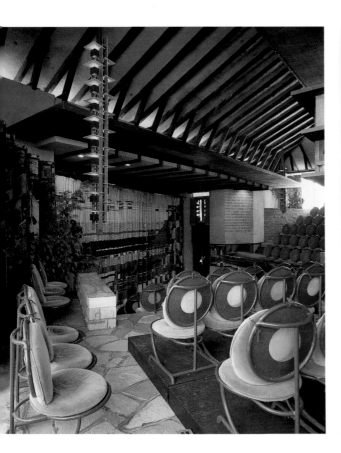

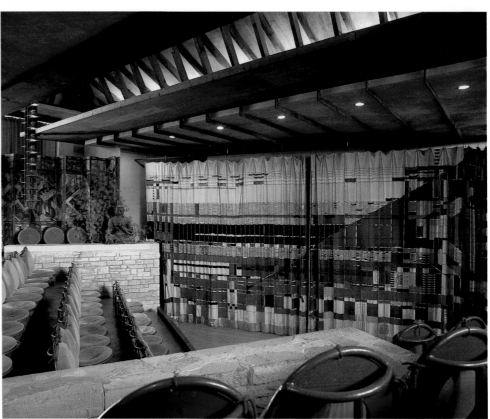

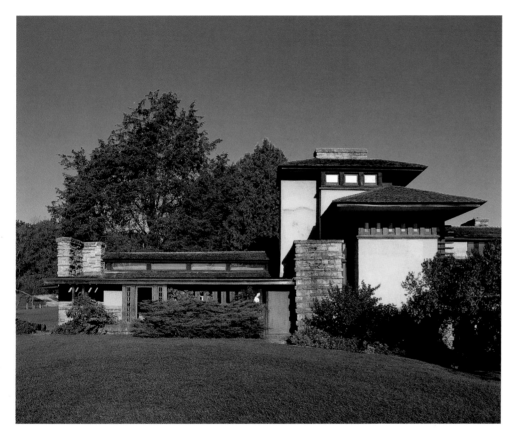

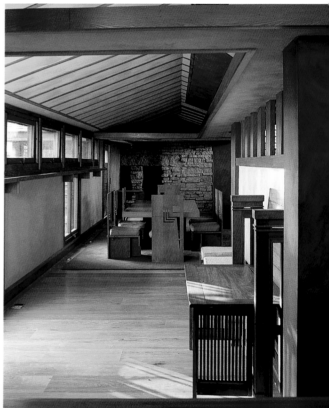

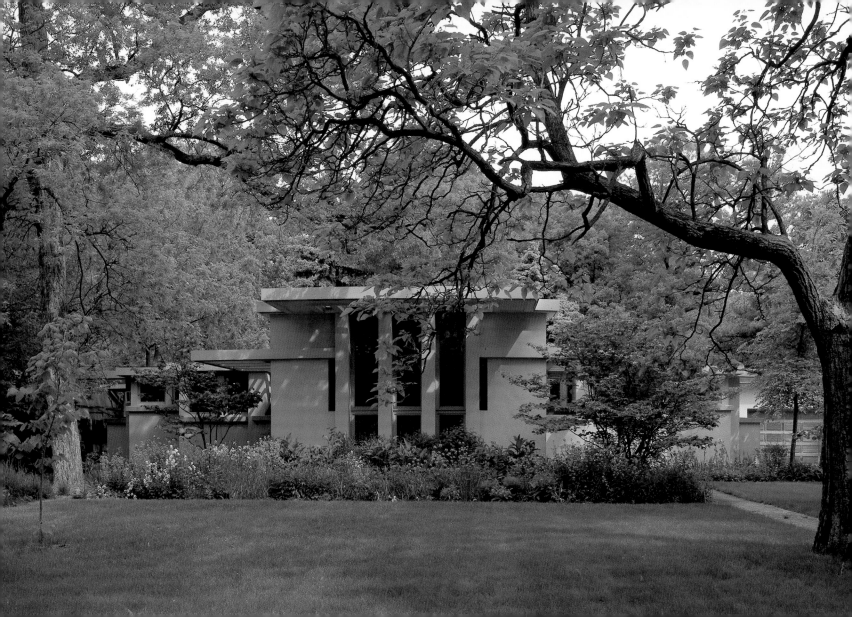

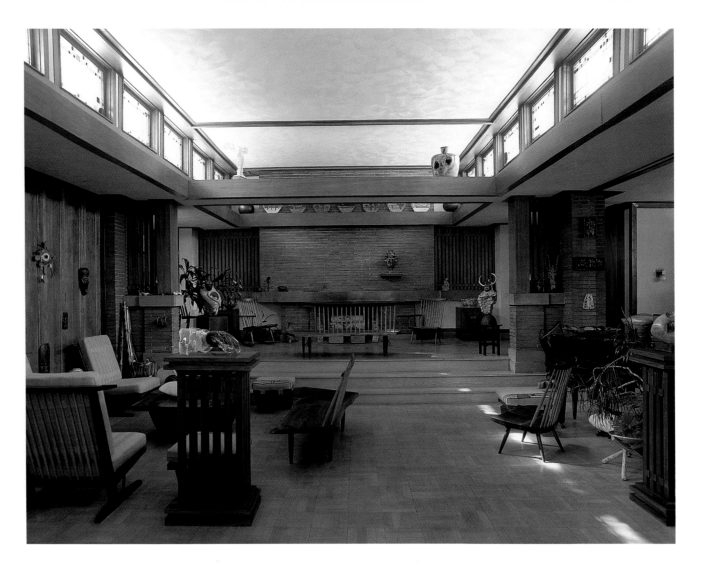

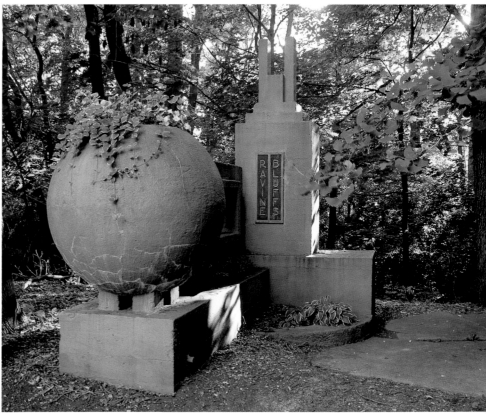

Above: Ravine Bluffs Development Sculpture, Glencoe, Illinois, 1915; Opposite: Perry House, Ravine Bluffs Development, Glencoe, Illinois, 1915

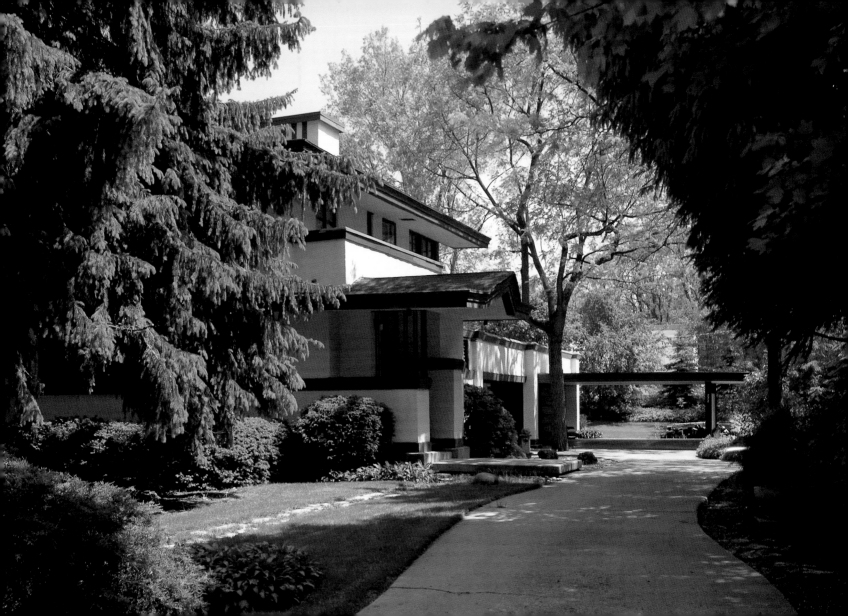

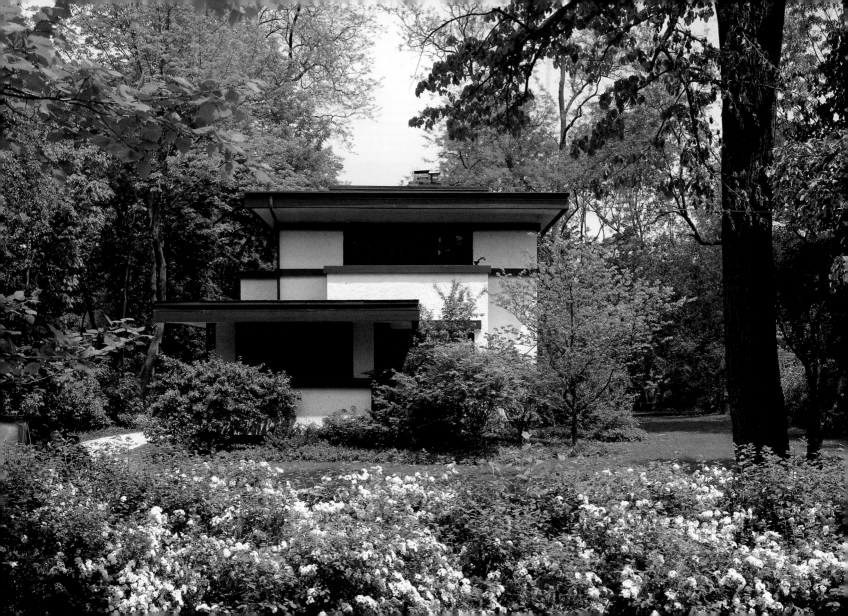

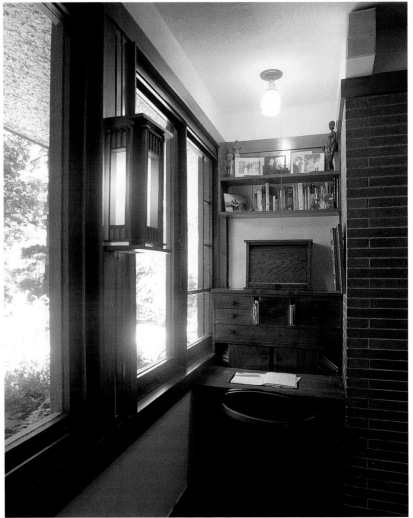

Opposite: Kissam House, Ravine Bluffs Development, Glencoe, Illinois, 1915; Above: Booth House, Ravine Bluffs Development, Glencoe, Illinois, 1915

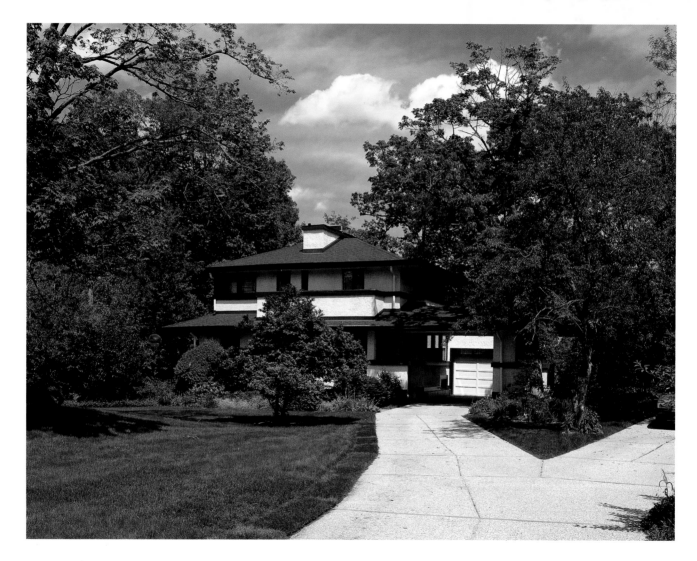

Above: Kier House, Ravine Bluffs Development, Glencoe, Illinois, 1915; Opposite: Bach House, Chicago, Illinois, 1915

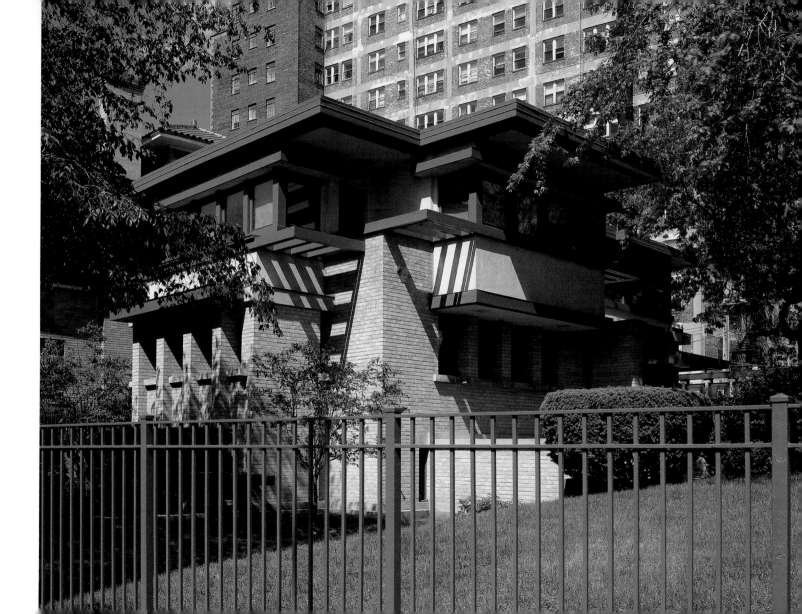

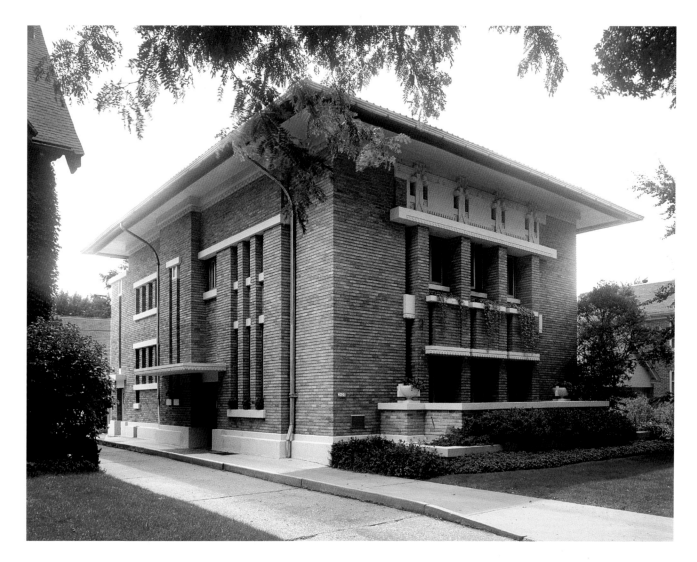

Above and opposite: Bogk House, Milwaukee, Wisconsin, 1916

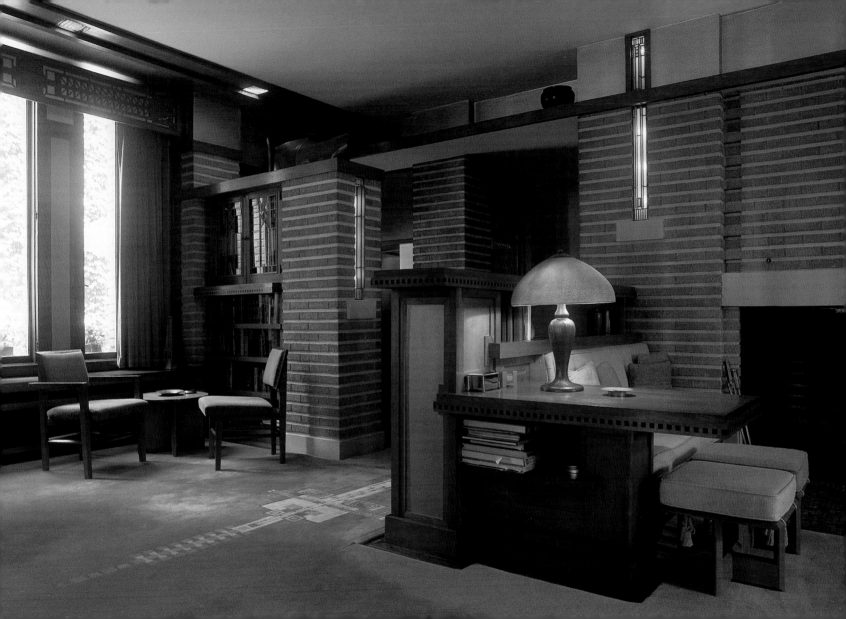

THREE:

MATERIALS
AS METAPHORS
1918–1936

If the early part of the twentieth century was a period of invention when Wright laid down many of the ideas, types, and elements that would inform his architectural vocabulary, the 1920s was a period of transition in which he explored the expressive qualities of regionalism and primitivism. Just as the Prairie houses were being studied in Europe for their universal application to the needs of modern housing, Wright set out on a journey of self-discovery that took him geographically and imaginatively a great distance from the work of the Oak Park Studio. Direct contact with Japanese culture and the landscapes of the Far West—California and Arizona—inspired him to use materials as metaphors for place.

Prior to 1911, Wright's architecture was based on an analysis of function as much as abstraction. But after departing Oak Park he frequently created unique houses usually for himself or favored clients that were poetic interpretations of materials indigenous to the site expressing his deeply held belief that the natural world was sacred. His work of the following years reflected a new duality: a reliance on industrial methods of building—reinforced concrete as a material and standardized units as a building system—and an aesthetic that emphasized the fleeting beauty found in organic materials as they weather, and even decay. At the heart of this

contradiction is the issue of nature: a Western ethos that values dominance and control versus an Eastern tendency that seeks to achieve harmony with natural elements and forces.

A combination of modern structural methods and regional identity had actually preoccupied him with the design and construction of the Imperial Hotel in Tokyo, a commission that was initiated in 1911 and continued until 1922. An abstract cube would have violated the spirit of Japan, so Wright chose to design the hotel as a tribute to the Asian civilization that he had come to revere. While he utilized some of his most sophisticated techniques of industrial construction—a reinforced concrete frame resting on a "floating" foundation of concrete piles—he also introduced *oya,* an indigenous lava stone, to tie the building to its native land. Ironically, while the Prairie houses had more to do with the lightness of Japanese villas, the Imperial Hotel with the solidity of its massive form, profusion of ornate decoration, and mysterious dim interiors was reminiscent of an ancient Chinese Imperial Palace.

If the Imperial Hotel was designed as a unique response to a foreign context, the 1920s textile-block houses were strictly ideological: an individual interpretation of the industrial idea of standardization. Wright's goal was to provide a custom-designed, fireproof dwelling filled with

space and light; but to reduce the overall cost to the client, he introduced the machine-age concept of a standard unit and the radical notion of unskilled labor. His solution was a 16-inch-square concrete block with semi-circular grooves on four sides. To reduce the weight, the blocks were made concave, 3½ inches thick on their edges and 1½ inches in the middle. When placed end upon end and row over row, the grooves formed a cage of circular hollow channels, horizontally and vertically, throughout the wall. Slender steel rebar, measuring ¼ inch, was placed in these channels, which were filled with grout—resulting in a solid monolithic wall. The essential grid of crisscrossed reinforced steel bars is what led to the title "textile block."

In keeping with his vision of the building growing up and out of the ground like a plant, he called for decomposed granite taken directly from the site to be mixed with Portland cement and water to create a dry mix. Workers, who in 1924 were paid by the piece (15 cents for each plain block), made the units by hand tamping the mix into a mold.

The walls were double wythe—the blocks used on the exterior and interior, both patterned and plain faces, creating one inch of air space for drainage in between. The two layers were tied together with wire. Although a traditional masonry wall such as brick depends on a visible mortar bed for cohesion of its assembled units, Wright completely eliminated the use of mortar.

Although the buildings were built of concrete they often impart a patina of age as if the material was decomposing and returning back to nature from which it came. This attitude derives from a strain of Japanese aesthetics with its origins in Zen Buddhism and its embrace of death and the transience of all things, but it has always been a source of consternation for Western critics for whom durability and permanence are taken for granted in architecture.

During this period Wright would simultaneously address both Modernism with its Western bias in science and reason, and Japanese aesthetics, grounded in attitudes about nature worship and intuition, increasingly synthesizing the two views in one work thereby creating an architecture that was startlingly new and extraordinary.

No work exemplifies this more than the country house for Liliane and Edgar J. Kaufmann, Fallingwater. The existing natural features—a stream, broken rock ledges, a two-tiered waterfall, large boulders, a profusion of oaks and rhododendrons—created an ideal setting for a twentieth century villa in a water garden. In form and materials, Fallingwater is both complex and contradictory. It combines coarse variegated limestone laid up in courses to mimic the rock ledges below with daring cantilevered balconies of smooth reinforced concrete. While the house appears to grow up out of its site, at the same time its commanding presence declares itself a man-made object. It is both organic and industrial. It romanticizes nature while romanticizing technology. No work is more expressive of Wright's synthesis of his adopted Eastern viewpoint and his inherited Western values. ❖

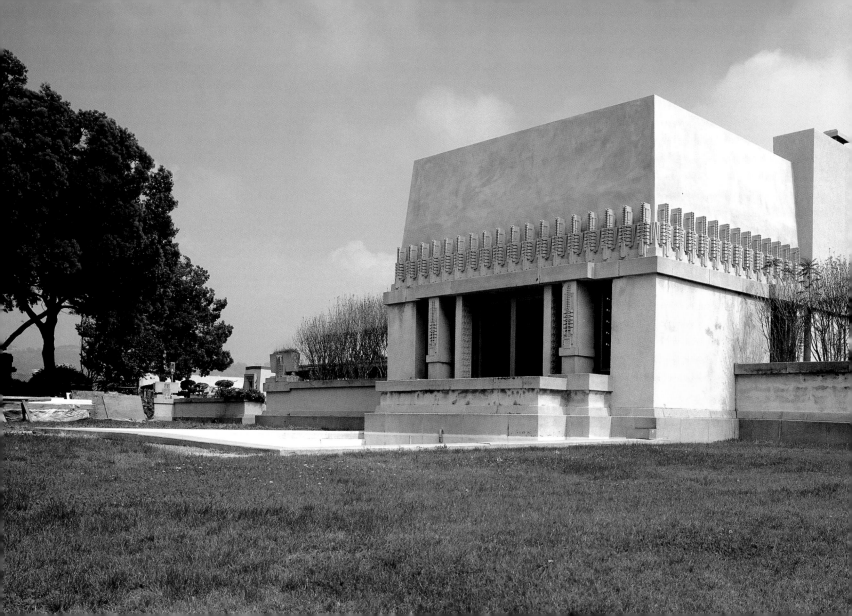

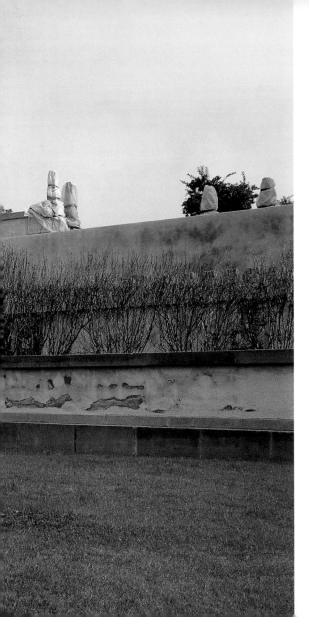

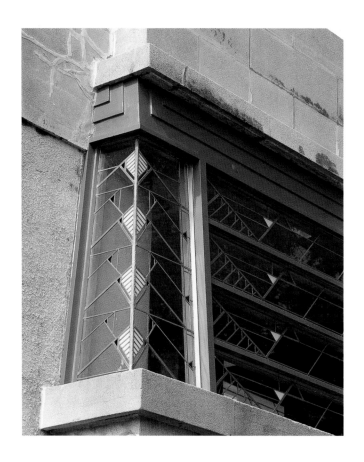

Left, above, and following pages: Barnsdall House (Hollyhock House), Los Angeles, California, 1919

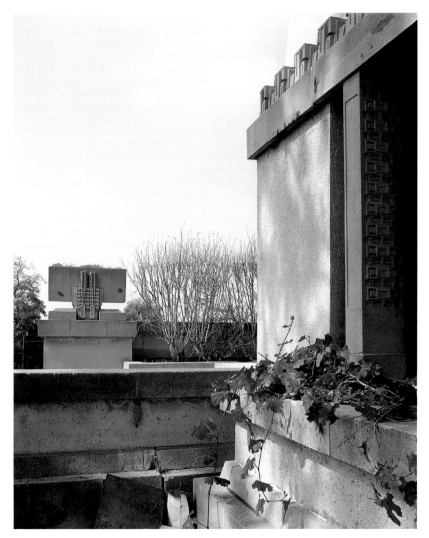
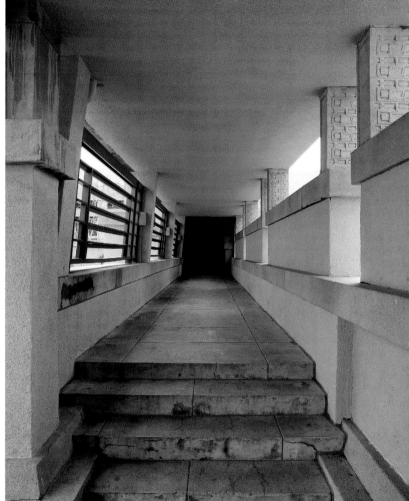

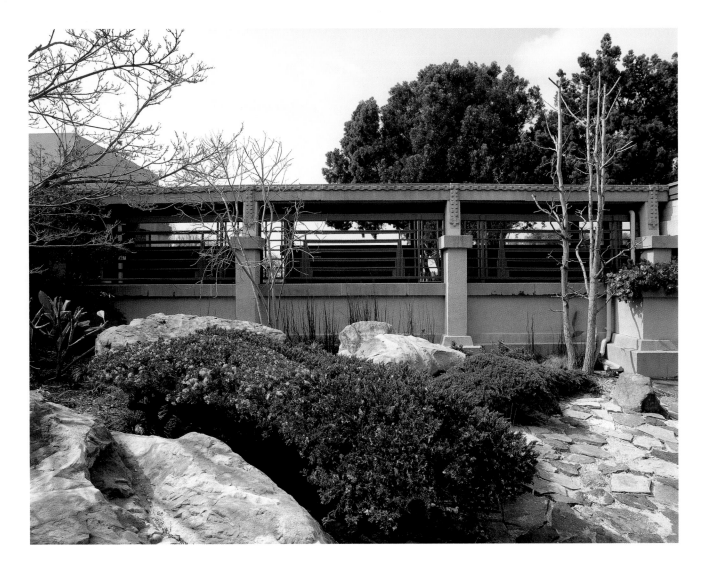

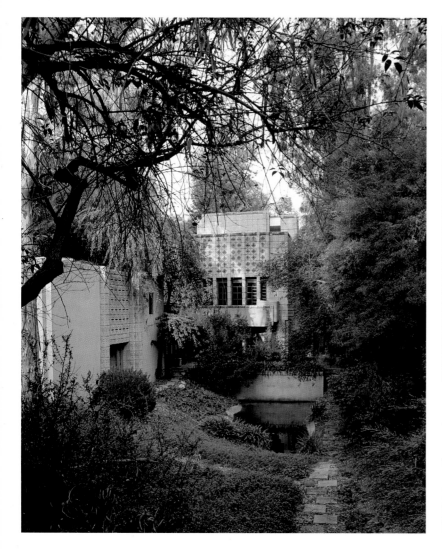
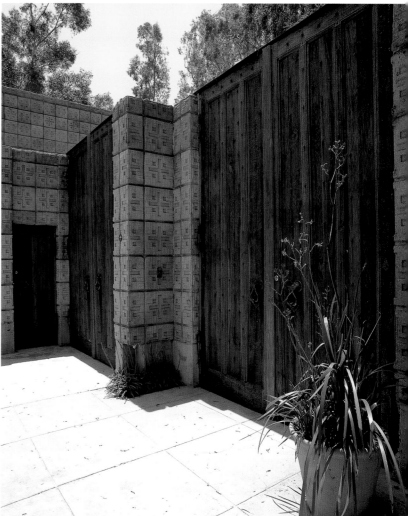

Above and opposite: Alice Millard House (La Miniatura), Pasadena, California, 1923

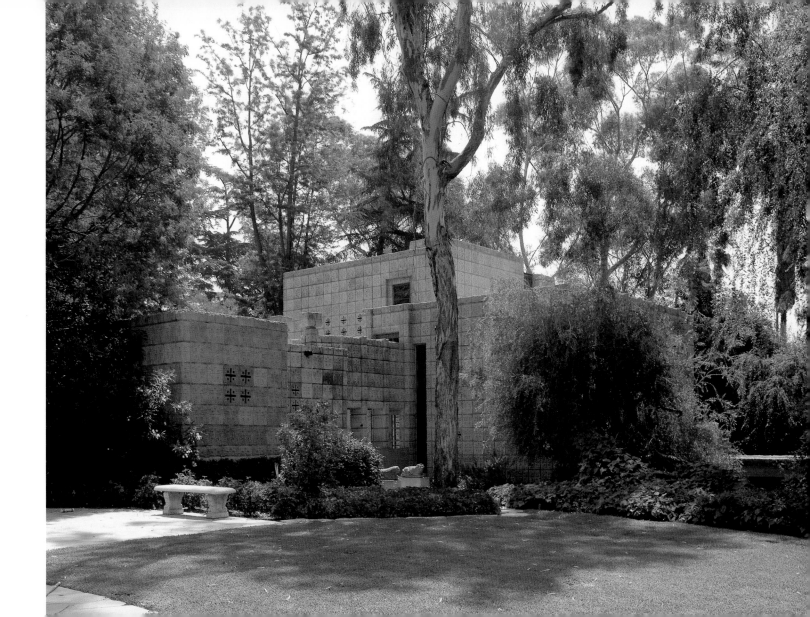

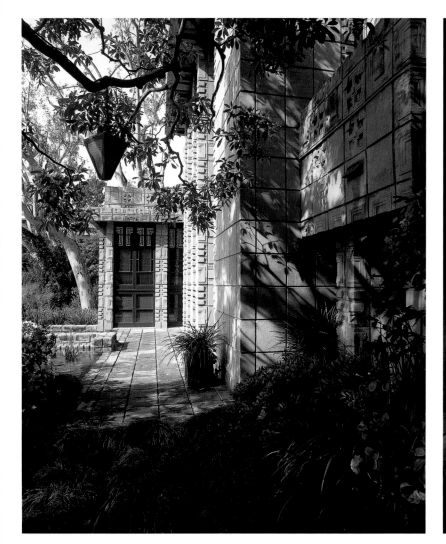
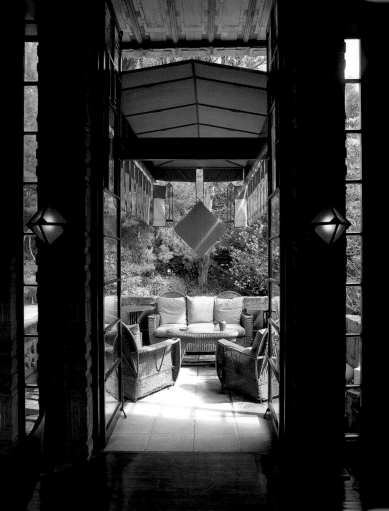

Above, opposite, following pages, and pages 154–155: Storer House, Los Angeles, California, 1923

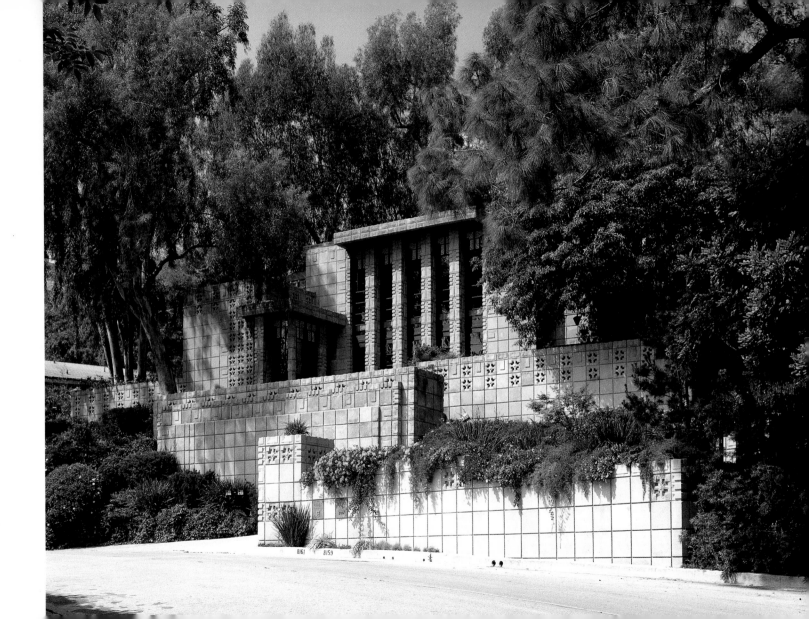

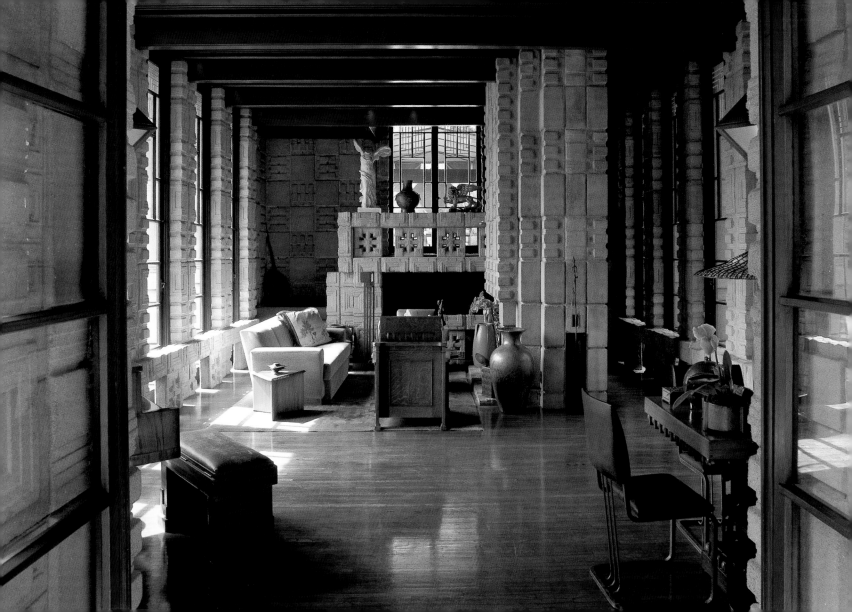

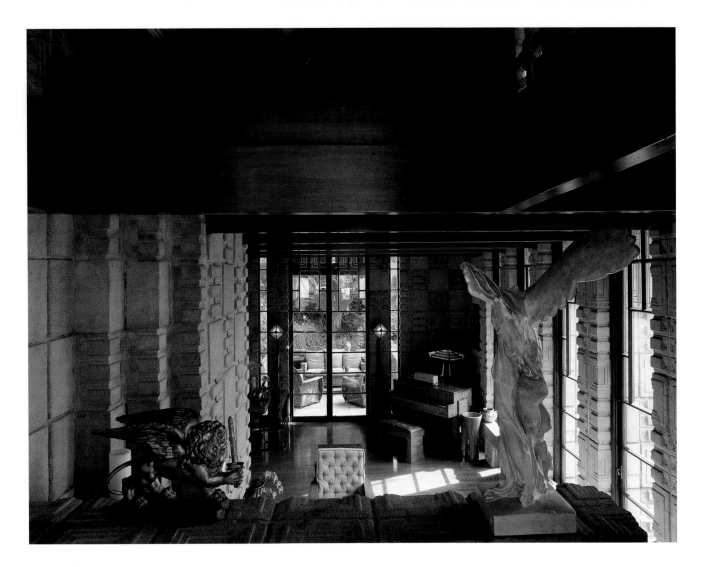

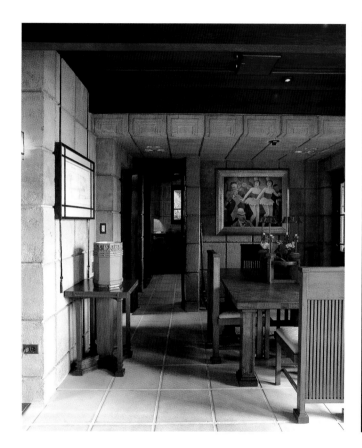

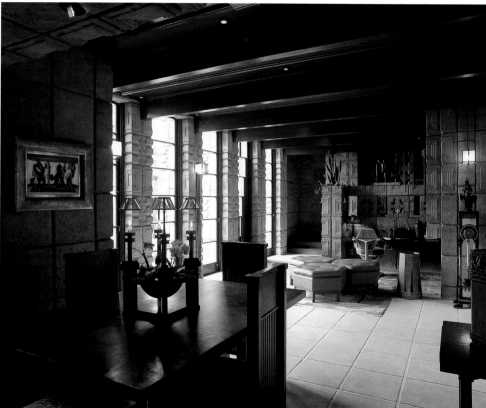

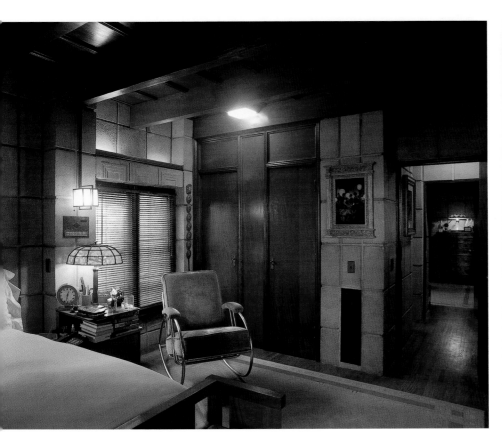
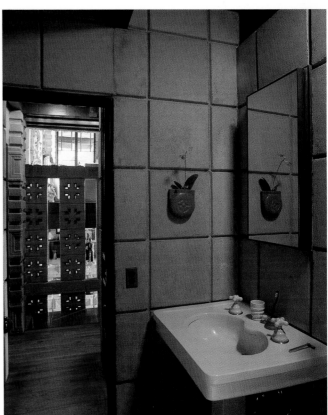

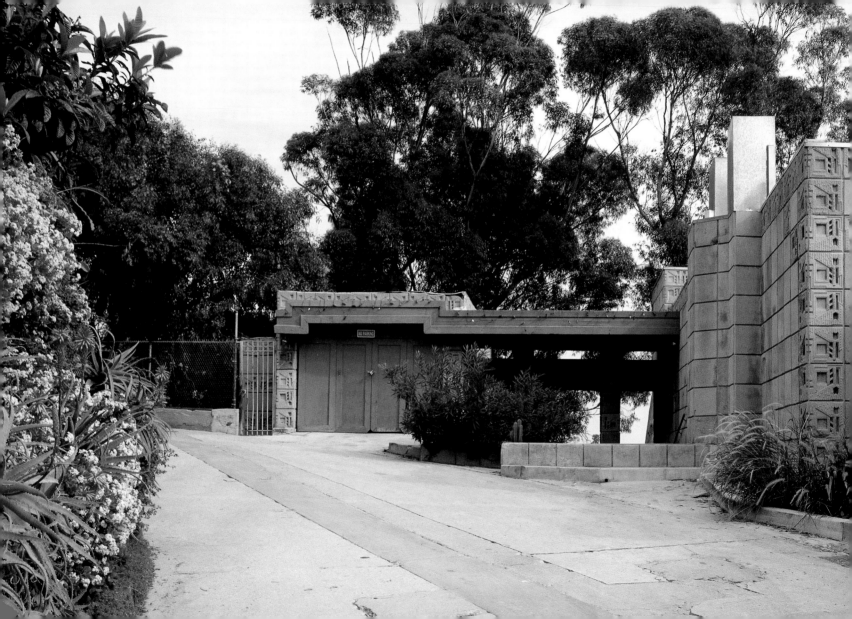

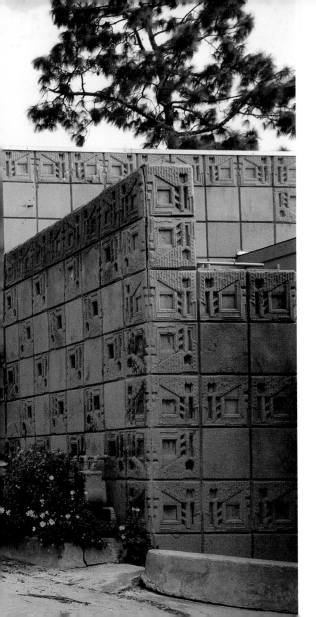

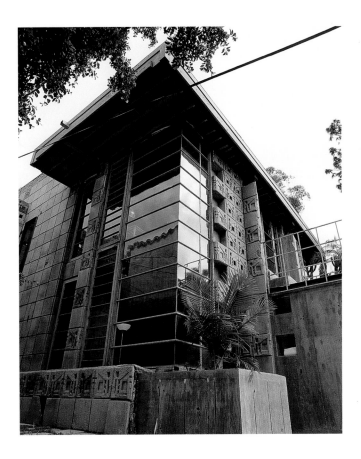

Opposite, above, and following pages: Freeman House, Los Angeles, California, 1924 THREE MATERIALS AS METAPHORS **157**

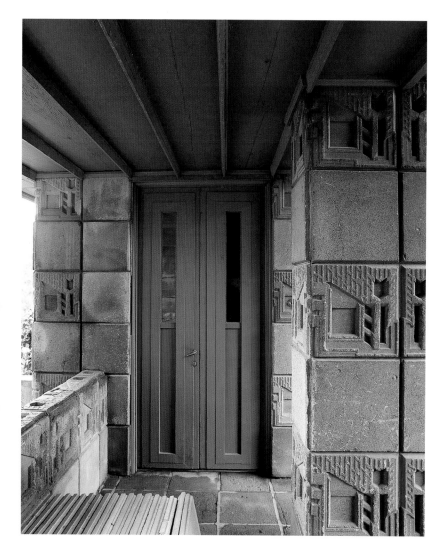

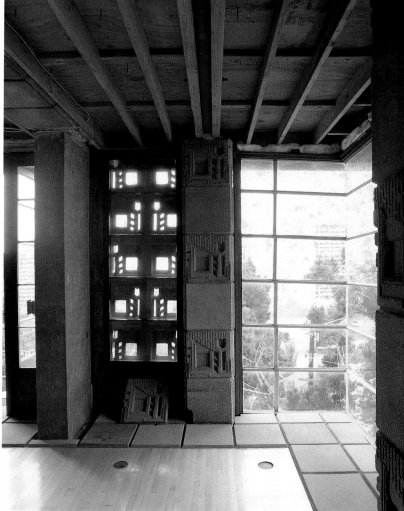

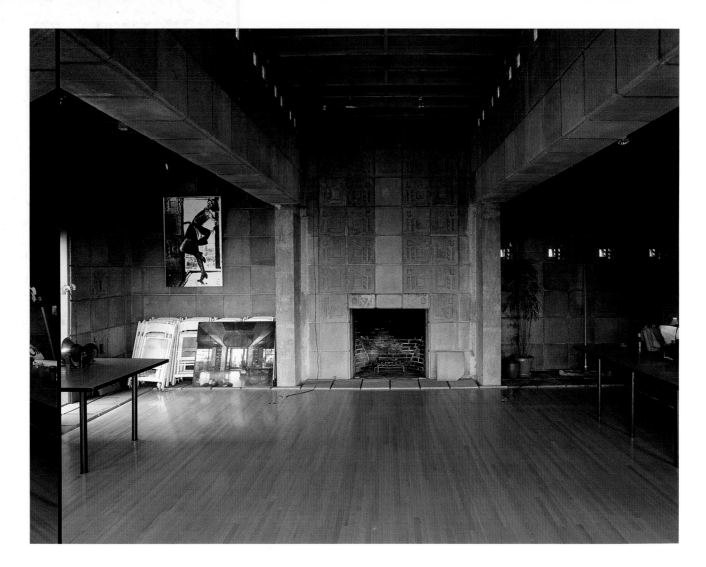

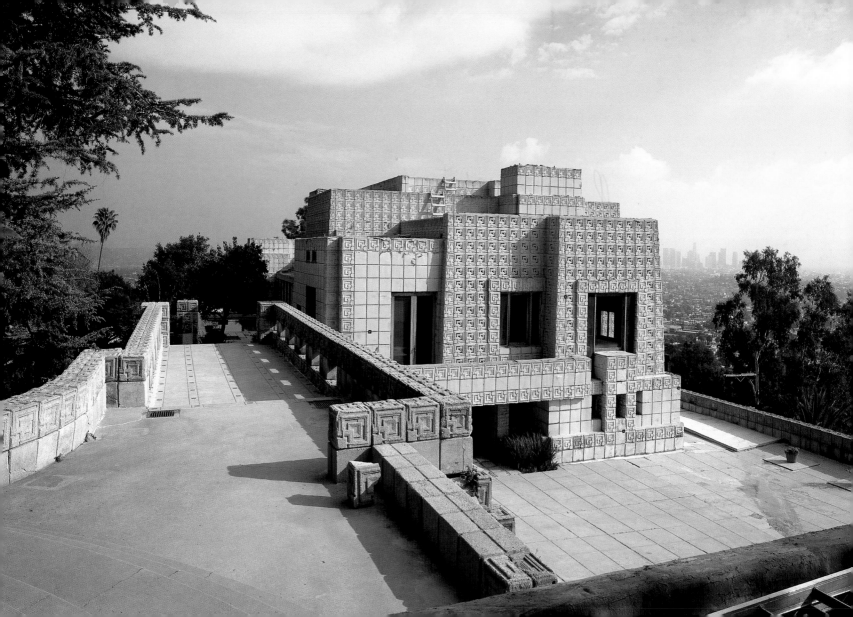

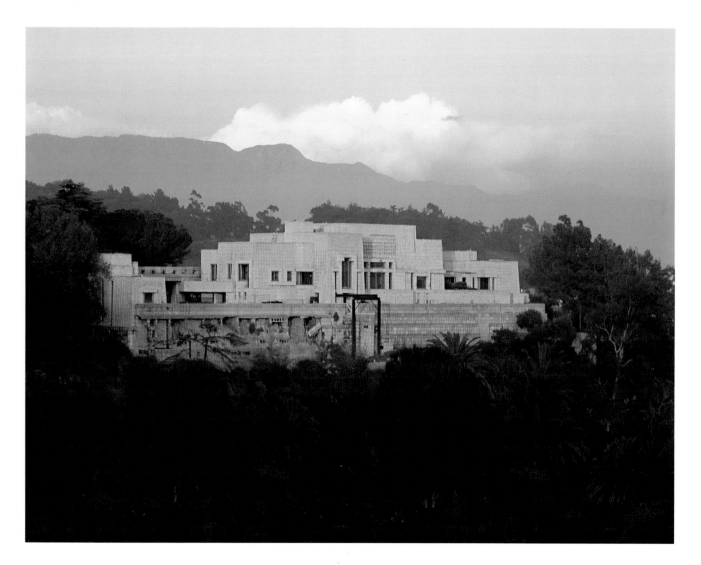

Opposite, above, following pages, and pages 164–167, Ennis House, Los Angeles, California, 1924 THREE MATERIALS AS METAPHORS **161**

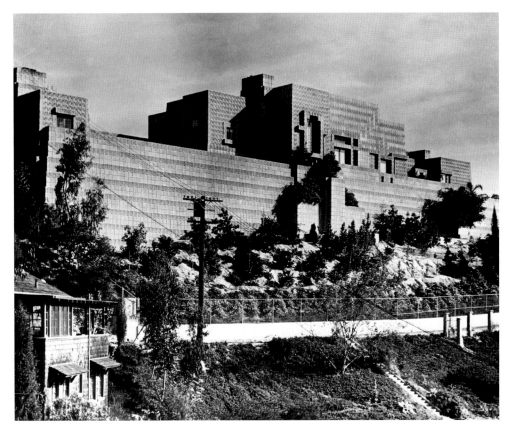
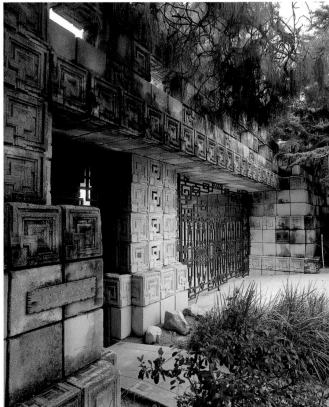

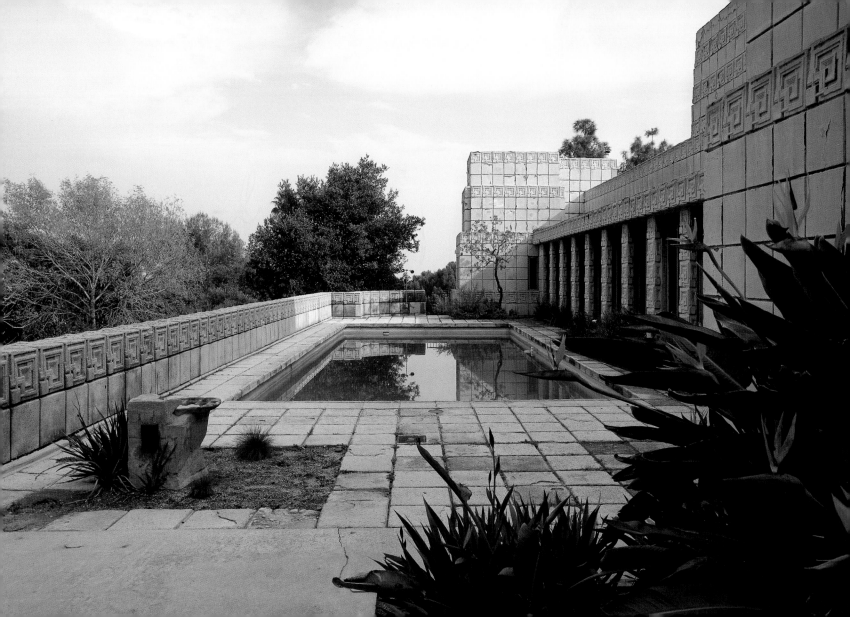

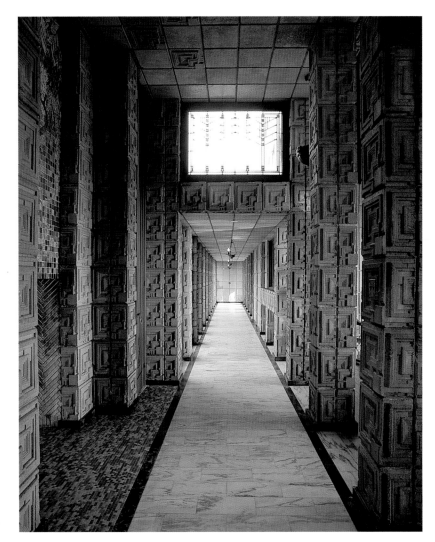
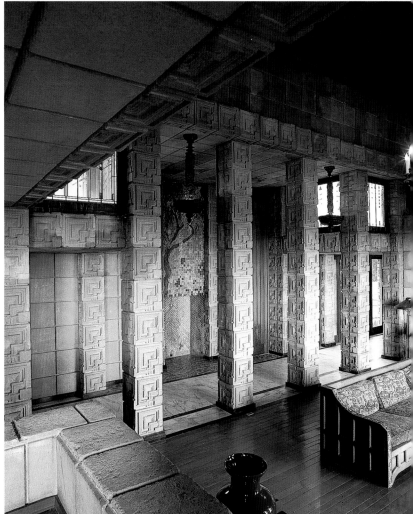

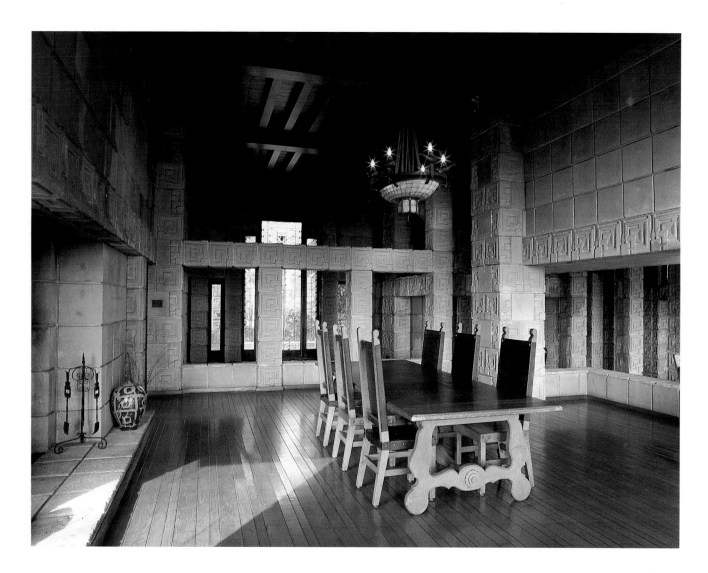

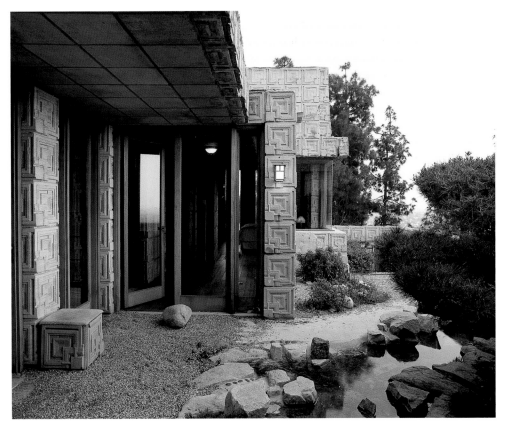

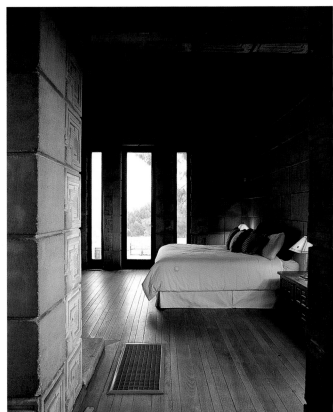

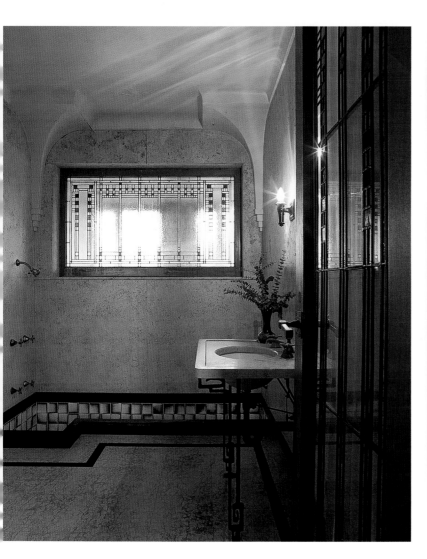
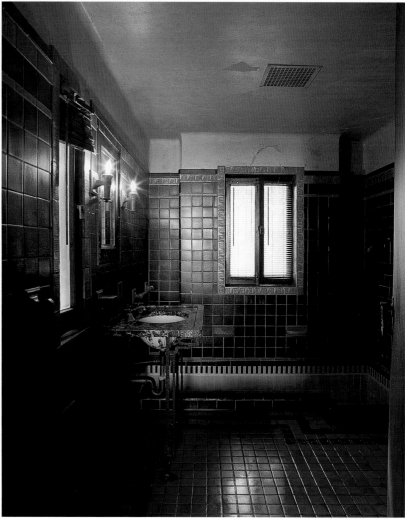

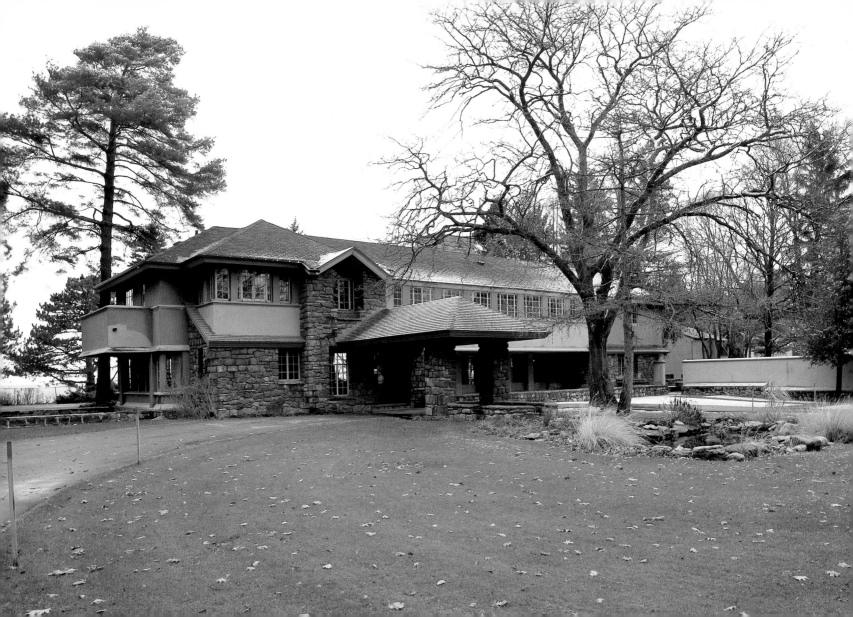

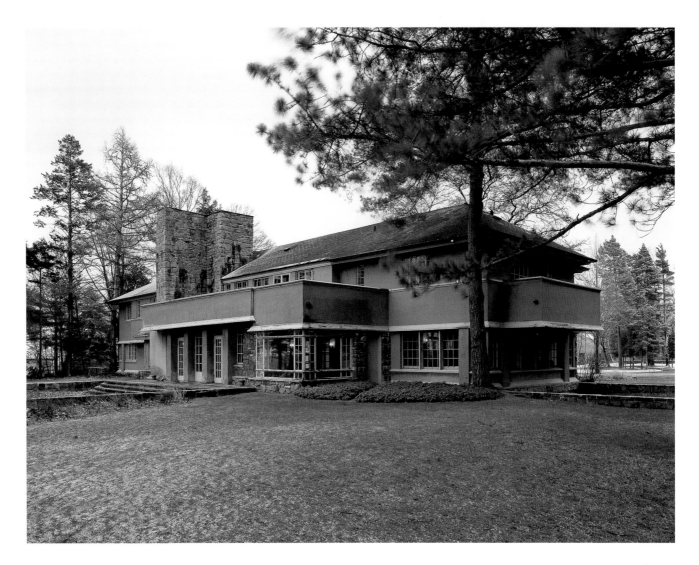

Opposite, above, and following pages: Isabelle Martin House (Graycliff), Derby, New York, 1926

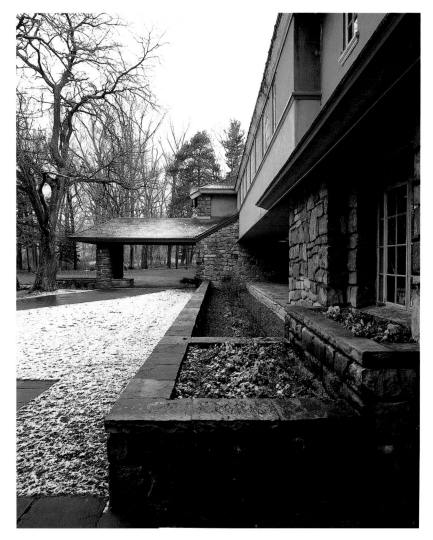
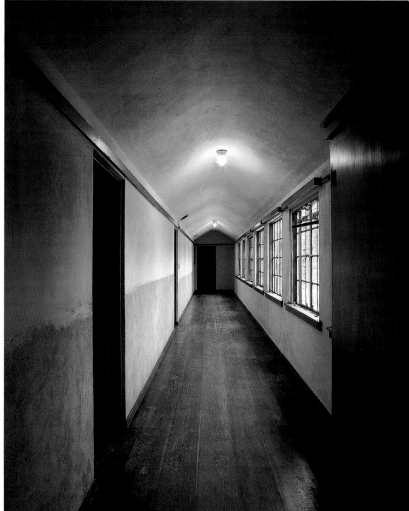

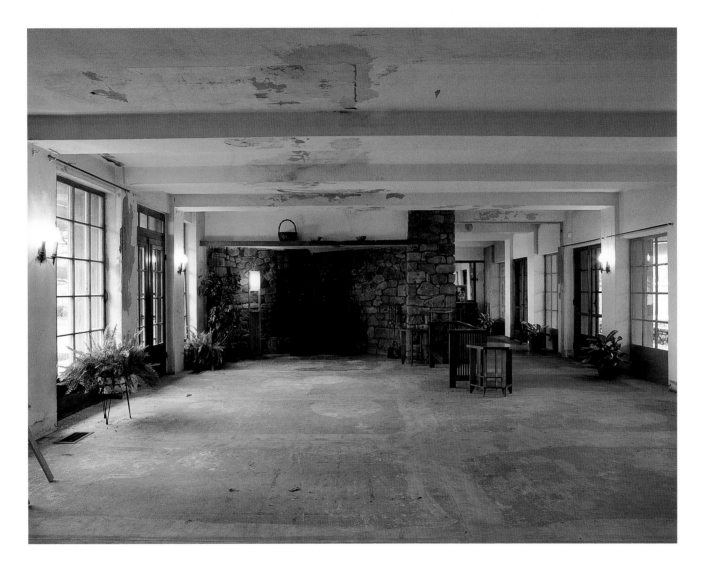

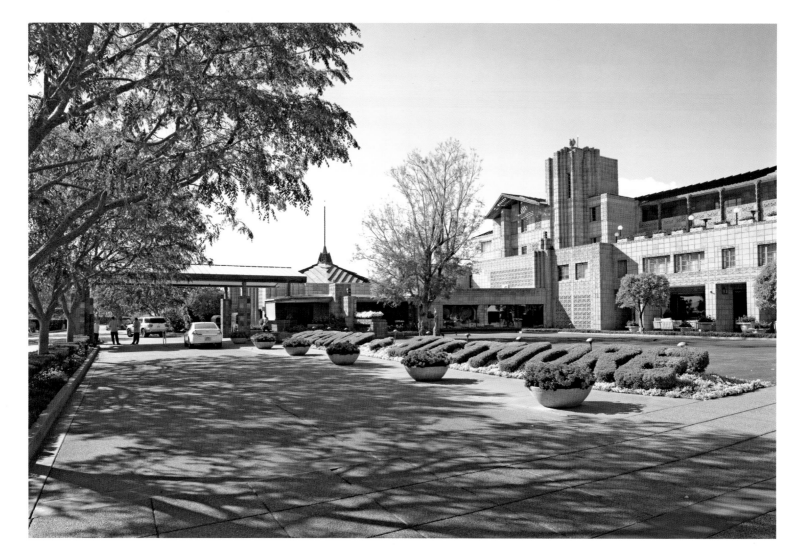

Above and opposite: Arizona Biltmore Hotel (Albert McArthur, architect; Frank Lloyd Wright, consulting architect), Phoenix, Arizona, 1927

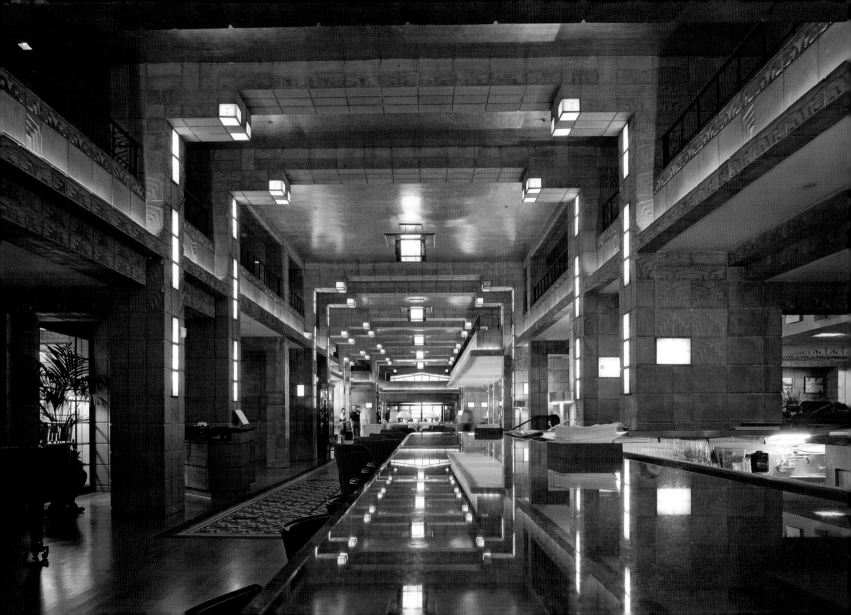

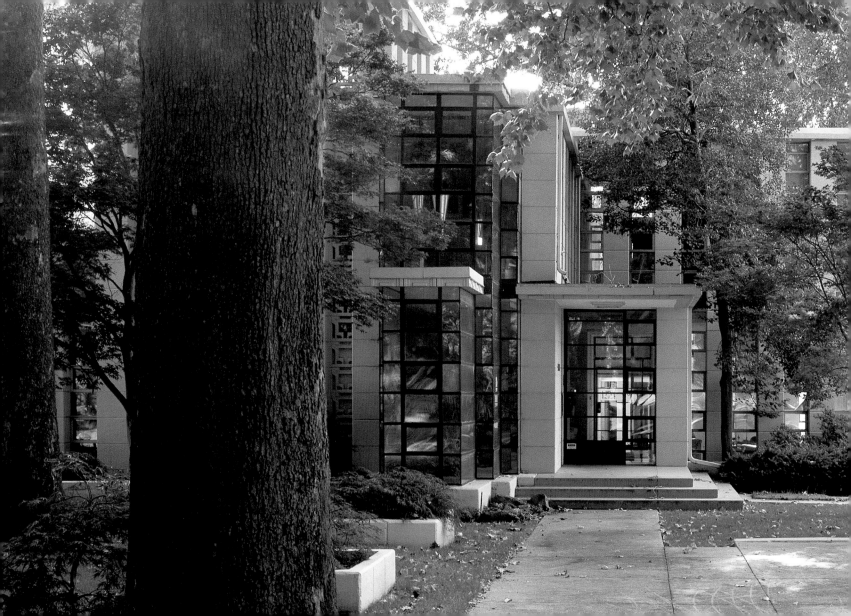

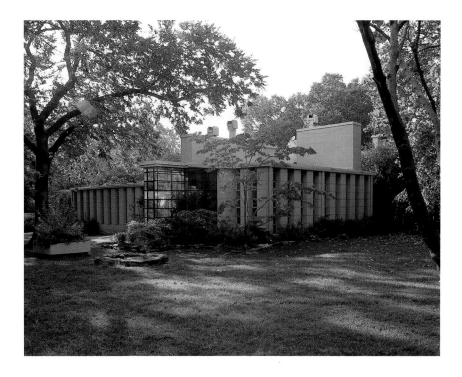

Left, above: Richard Lloyd Jones House (Westhope), Tulsa, Oklahoma, 1929

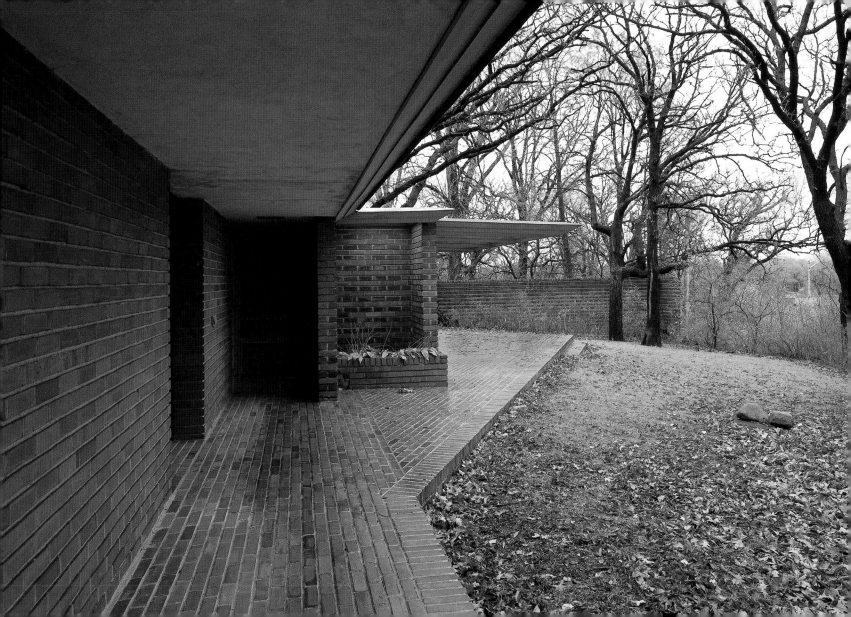

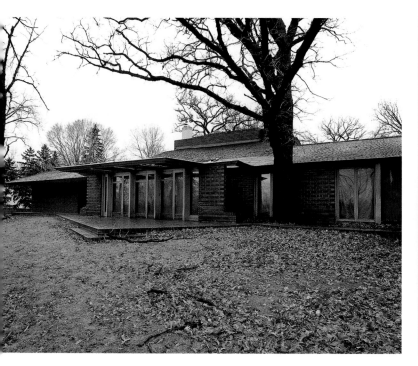

Opposite, above, and following pages: Willey House, Minneapolis, Minnesota, 1934

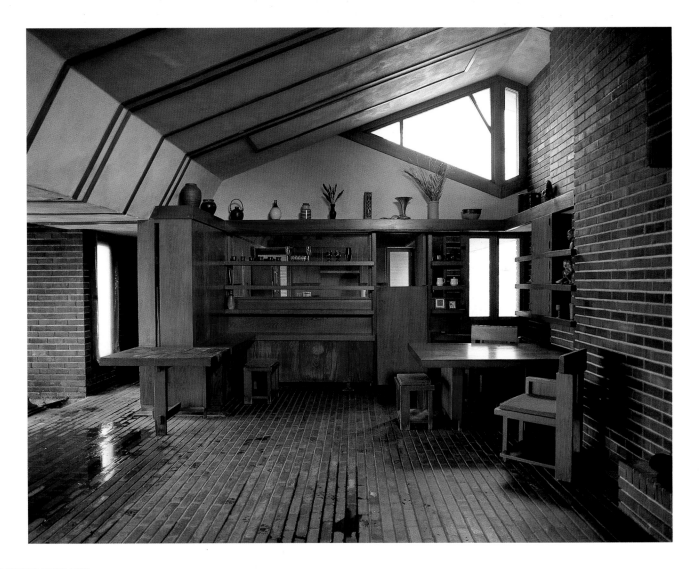

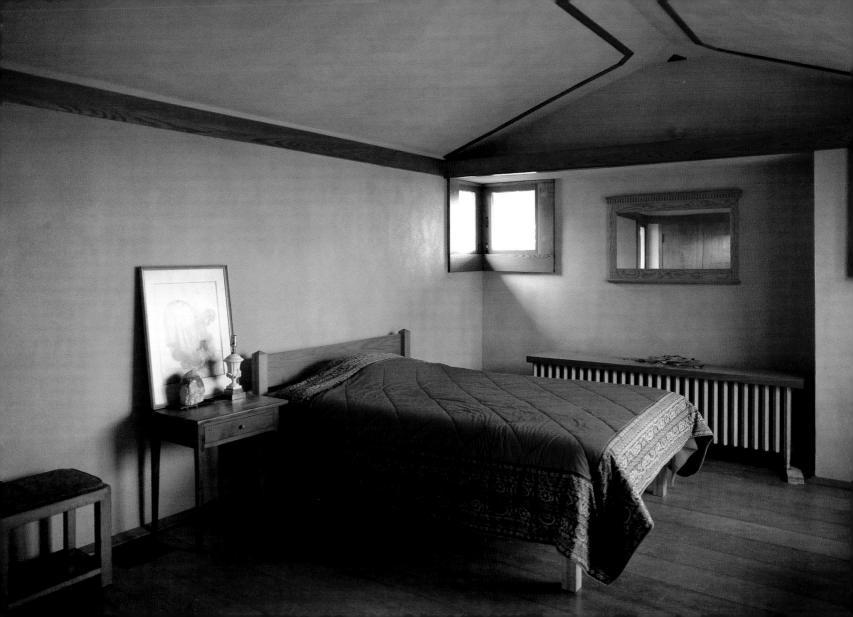

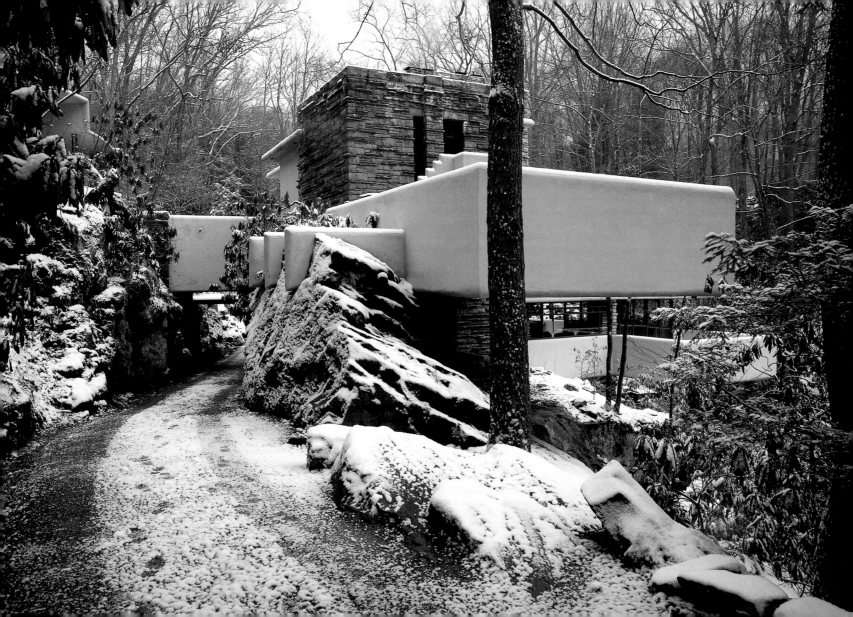

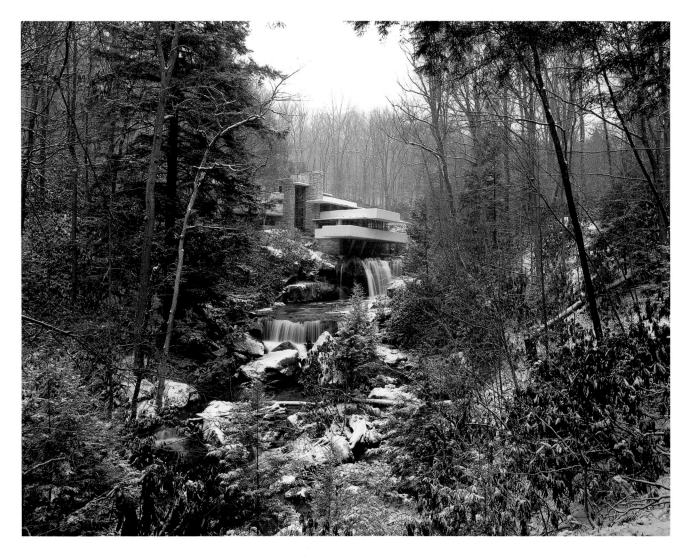

Opposite, above, following pages, and pages 184–185: Kaufmann House (Fallingwater), Mill Run, Pennsylvania, 1934

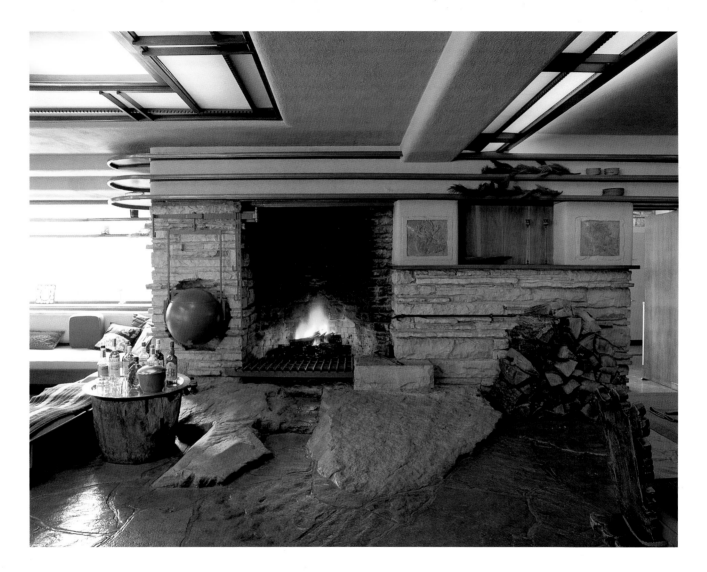

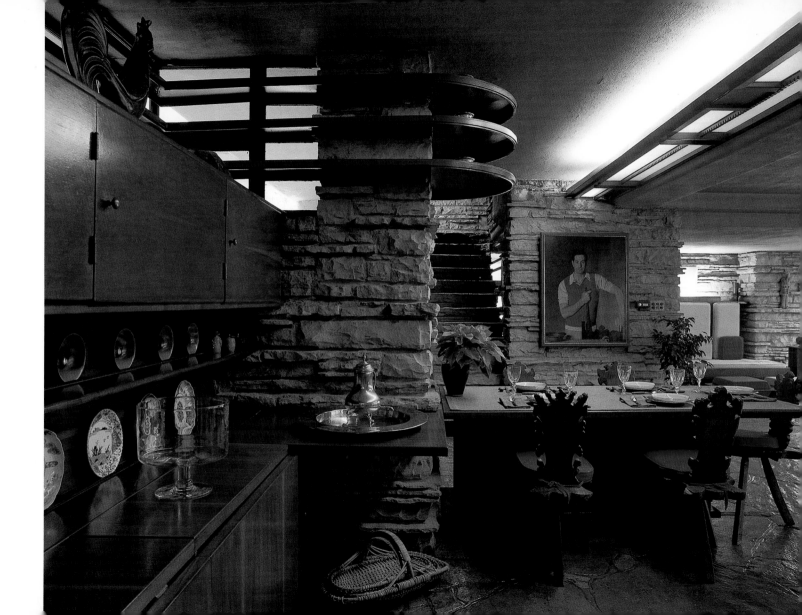

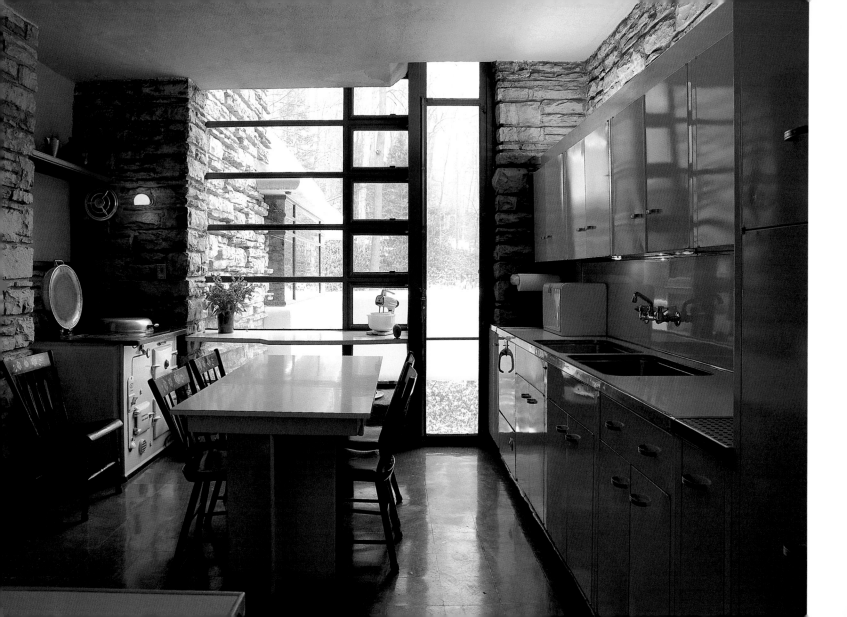

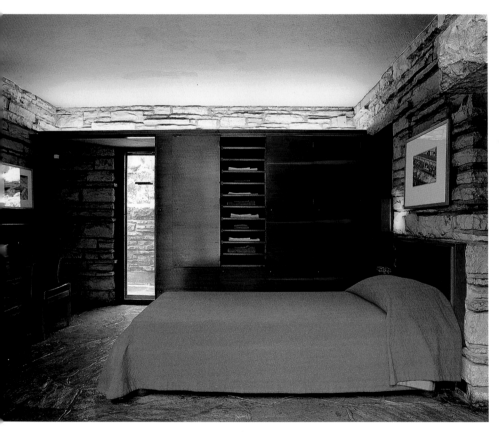
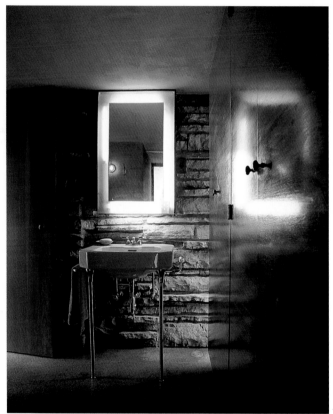

FOUR:

BUILDING USONIA
1937–1959

In the first decades of the twentieth century Wright had applied rationalist methodology to the architectural transformation of the single-family dwelling and public institutions such as office buildings and churches, in the 1930s he applied the same approach to urban planning. During these years, he was formulating a new strain of thought as a result of the turbulent economic and political conditions brought on by the Great Depression. The architect laid out the principles of his ideal community in a model and some text panels, which he exhibited at the International Arts Exposition at Rockefeller Center, New York, in 1935. He called the proposal "Broadacre City" to emphasize the singular point that citizens would live in open space surrounded by light and in direct contact with nature. It examined the general case of a hypothetical four-square-mile section of land including manufacturing, farming, transport, housing, and culture.

Based on the idea of decentralization, Broadacre City assumed that the entire nation would be crisscrossed by great arterial superhighways. It called for a pattern of low-density settlement across the American landscape that would allow every family a minimum of one acre of land, one automobile, and access to telecommunications. Low-density was maintained by having each building—whether public or private—surrounded by generous plots of parkland or agricultural fields. "Light, air, and prospect" would be made available to everyone, while avoiding high-density or urban development, which Wright felt was an outmoded pattern more suited to the Middle Ages than the machine age. Broadacre City was Wright's critique of traditional cities such as London, Berlin, and New York, which he believed did not benefit from the freedom the automobile introduced to modern living.

Nature was the essential element of his planning scheme: most of the area of the settlement would be given over to farms, private gardens, parkways, and open space. Throughout his childhood in rural Wisconsin, he had been taught that nature was an emblem of a higher moral order. "God is the great mysterious motivator of what we call nature," Wright declared, "and it has often been said by philosophers that nature is the will of God. And I prefer to say that nature is the only body of God we shall ever see."

Wright was unable to carry out his Utopian vision of decentralization on a large scale, given the economic and political reforms it required. As a result, he welcomed opportunities to extend the benefits of his Usonia (a new term coined to stand for United States of North America) to an increasingly mobile American society in the late 1930s. Usonian houses were built in every region

of the nation and whether in Arizona or Michigan, Wright used indigenous materials to anchor the building to its native locale.

In 1936, after several years of investigation into methods to lower the cost of housing, he succeeded in building a $5,000 Usonian house for Herbert and Katherine Jacobs, a young couple with children. In its completed form, the house contained numerous innovations in the areas of plan, structure, construction system, the use of materials, and the relationship between building and landscape. The compact L-shaped plan contained two wings (one for the living room and dining alcove, the other for bedrooms and study), with kitchen and bath at the corner of the L. To lower the cost even further, Wright eliminated the garage by substituting a covered shelter called a carport.

He had singled out conventional construction trades and the unions that were tied to them as the source of rising costs in building. He deconstructed the process step by step and came up with an entirely new systematized approach. It called for the fabrication of a flat concrete pad, embedded with radiant heating elements, as the foundation and finished floor. The house would be constructed in stages from brick fireplaces to wood sandwich walls to framing to glass infill to roofing. He eliminated layers of materials—lathe, plaster, paint, wallpaper, and hangings—for a few simple materials—wood, concrete, and brick—left in their natural color and texture, simply stained or waxed. The total cost included built-in seating, tables, bookshelves, cabinets, and lighting.

The genius of the architectural scheme can be seen in how it introduced so many new ideas to domestic planning. The spatial layout assumed the absence of servants, the importance of the housewife supervising the children, and an informal social life with time relaxing in the garden. The living room was multi-functional: for relaxation and reading by the fireplace, for family dining, and for entertaining large groups with buffet-style meals. The house turned a solid back to the street while opening itself up through French doors onto a generous interior courtyard and adjacent garden. Other innovations included the use of clerestory windows toward the neighbors, for light and ventilation; a flat roof; and the location of all the plumbing at the hinge of the L to cut down on the cost of piping systems. Lighting was minimal; but its ingenious design prefigured the concept of track lighting.

Wright again rethought the Usonian house in the post–World War II era when he was discovered by a new generation of returning war veterans. He responded by significantly improving the 1920s textile block system of concrete construction with a set of guidelines and plans for the do-it-yourself movement. He made the blocks lighter and simpler to manufacture by changing the shape from square to rectangular and by eliminating ornamental pattern in favor of plain blocks that were either solid or open.

In the early 1950s, he received commissions that allowed him to put his theory of the Usonian Automatic concrete block construction to the test. Several large houses can be considered impressive demonstrations of the techniques of the system; but in the smaller houses, some homeowners found the complex and time-consuming fabrication was anything but "automatic." Ultimately, however, years after the memories of the building process had faded, they declared that the results proved more than worth the effort.❖

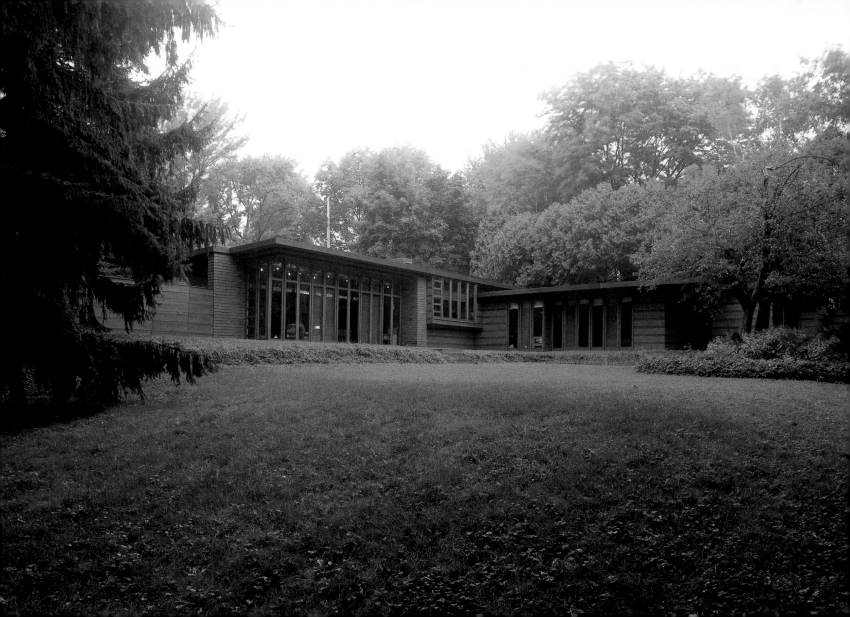

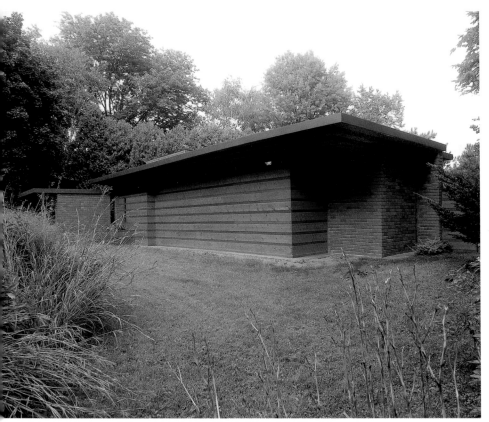

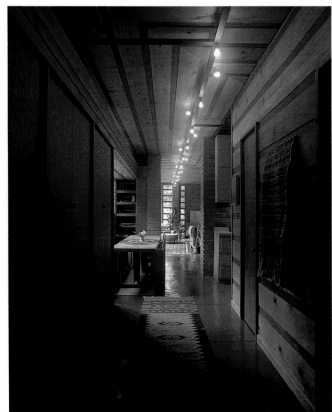

Opposite and above: Jacobs House I, Madison, Wisconsin, 1936

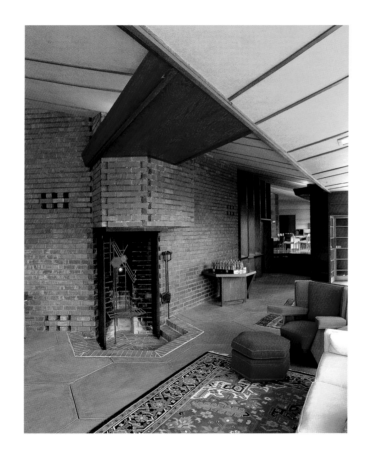

Above and right: Hanna House (Honeycomb House), Palo Alto, California, 1936

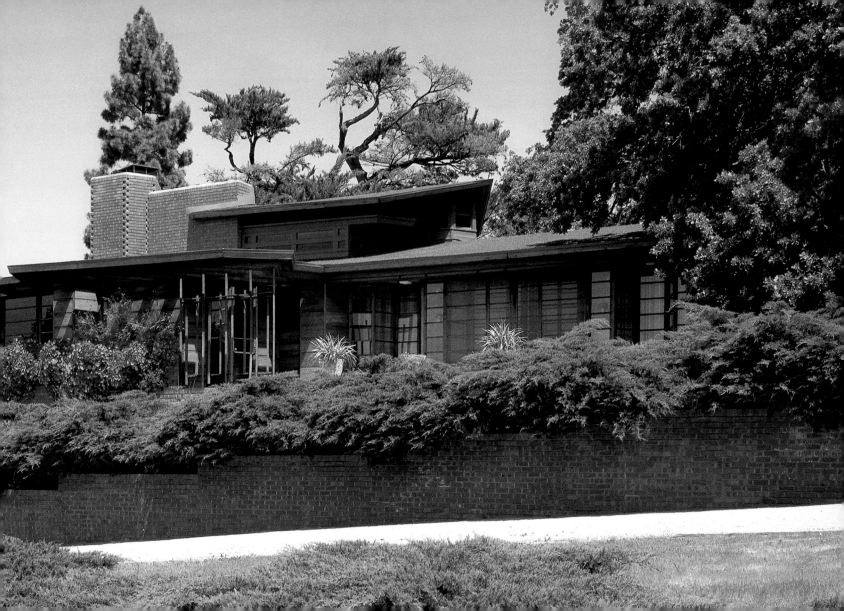

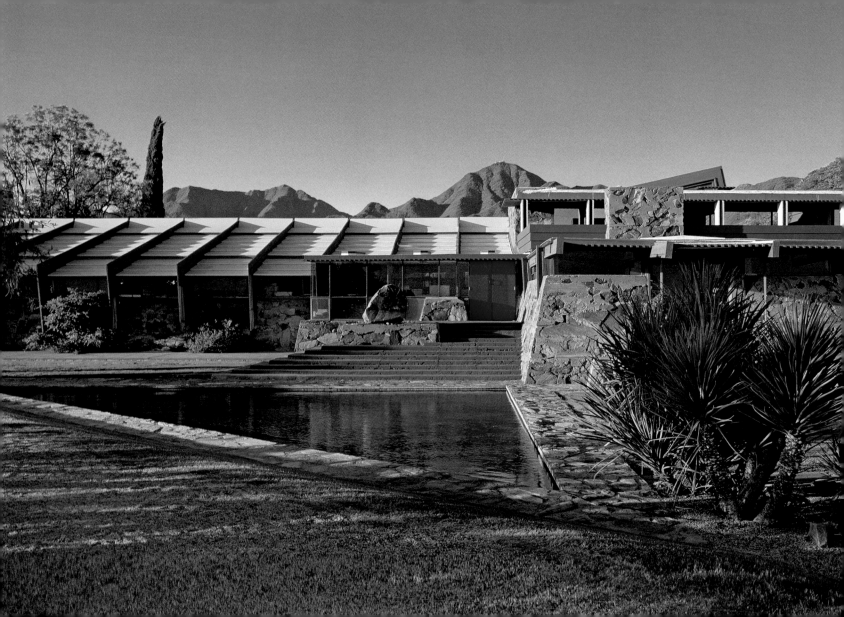

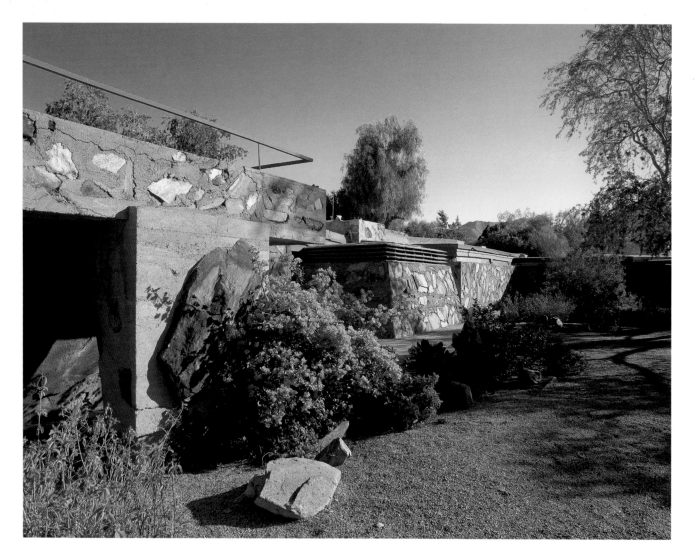

Opposite, above, following pages, and pages 196–197: Taliesin West, Scottsdale, Arizona, 1937

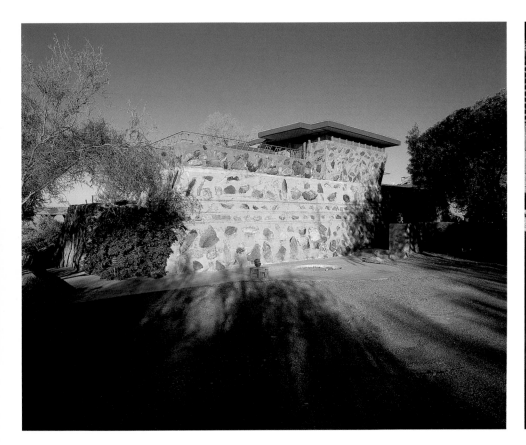
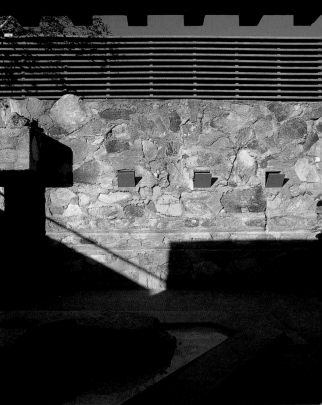

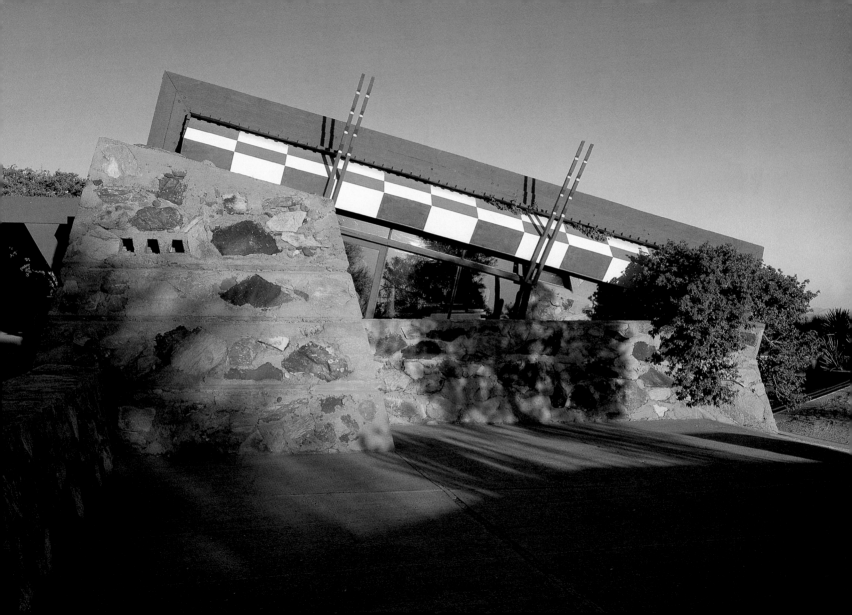

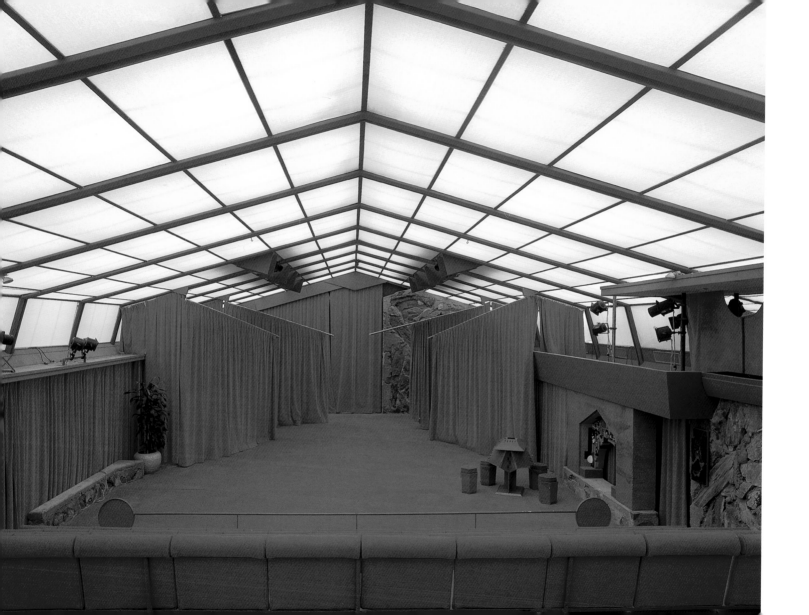

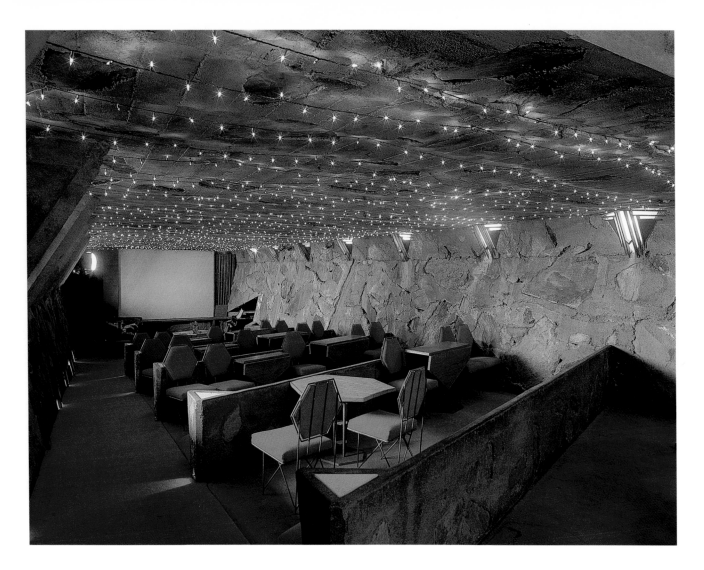

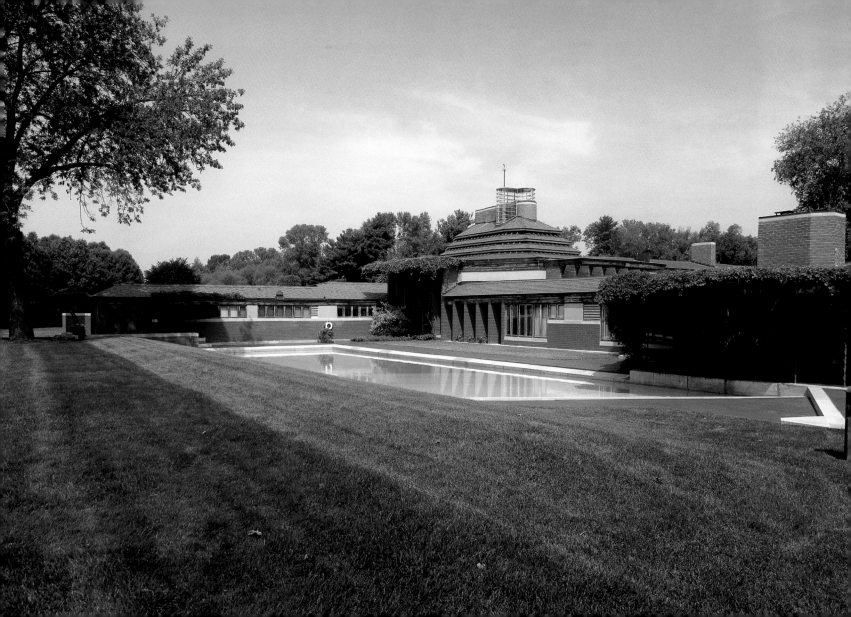

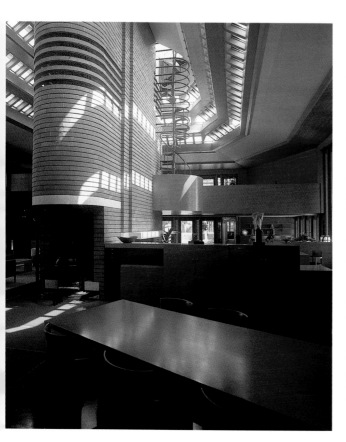

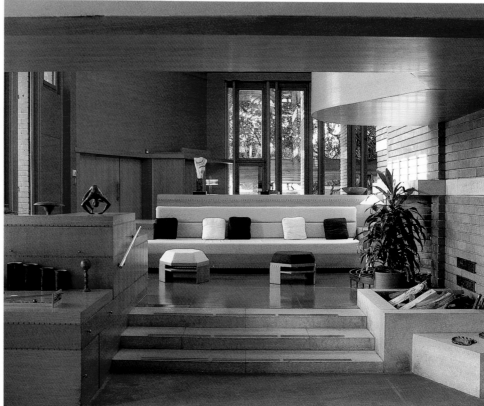

Opposite and above: Herbert Johnson House (Wingspread), Wind Point, Wisconsin, 1937

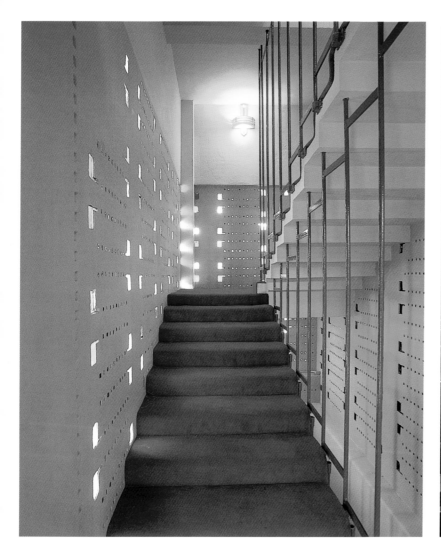
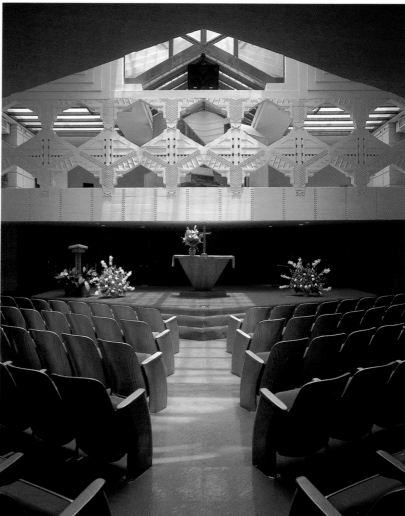

Above and opposite: Pfeiffer Chapel, Florida Southern College, Lakeland, Florida, 1938

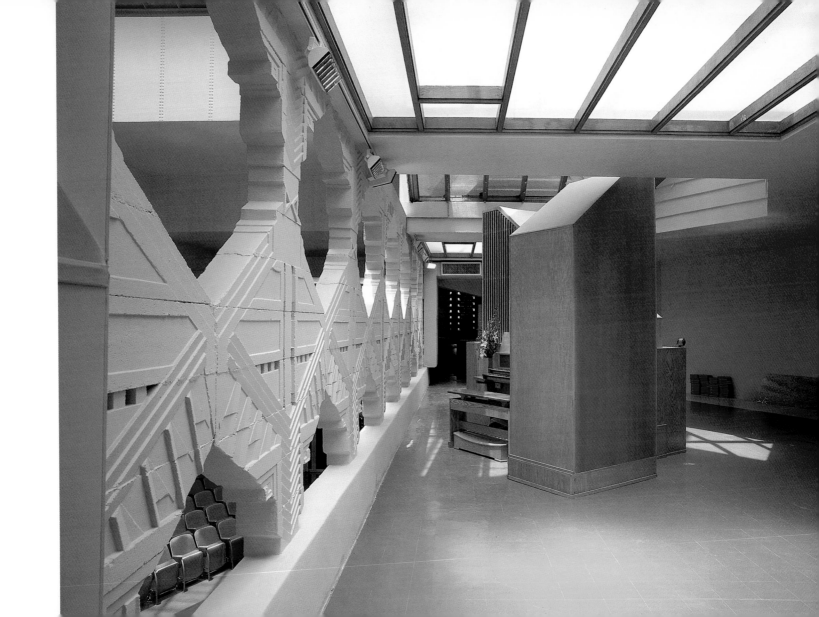

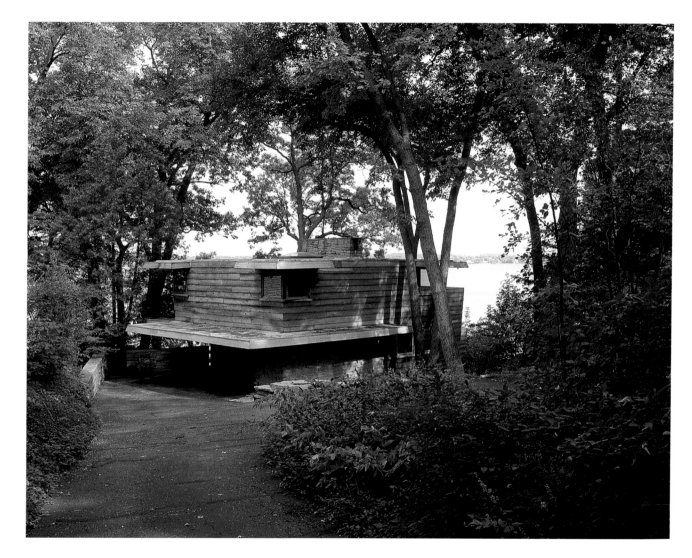

Above and opposite: Pew House, Shorewood Hills, Wisconsin, 1938

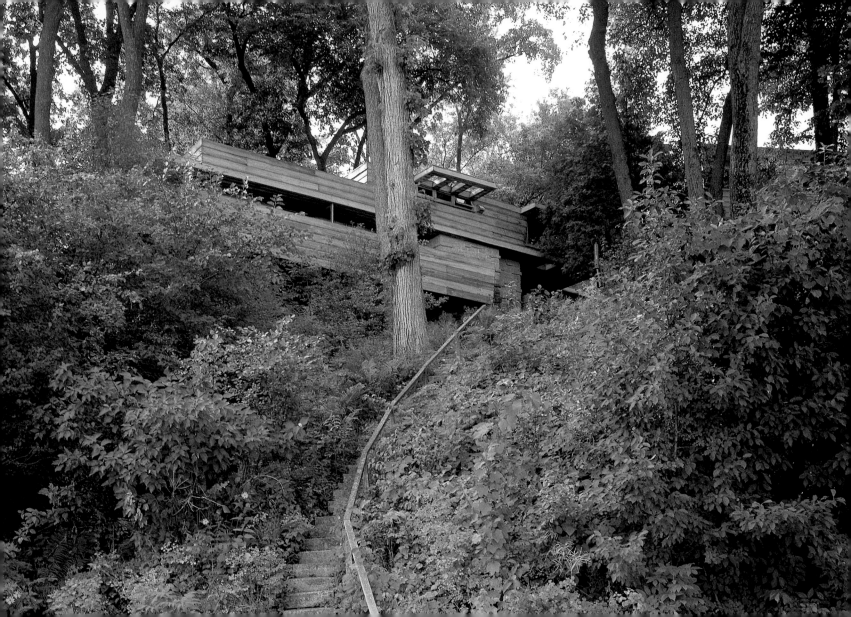

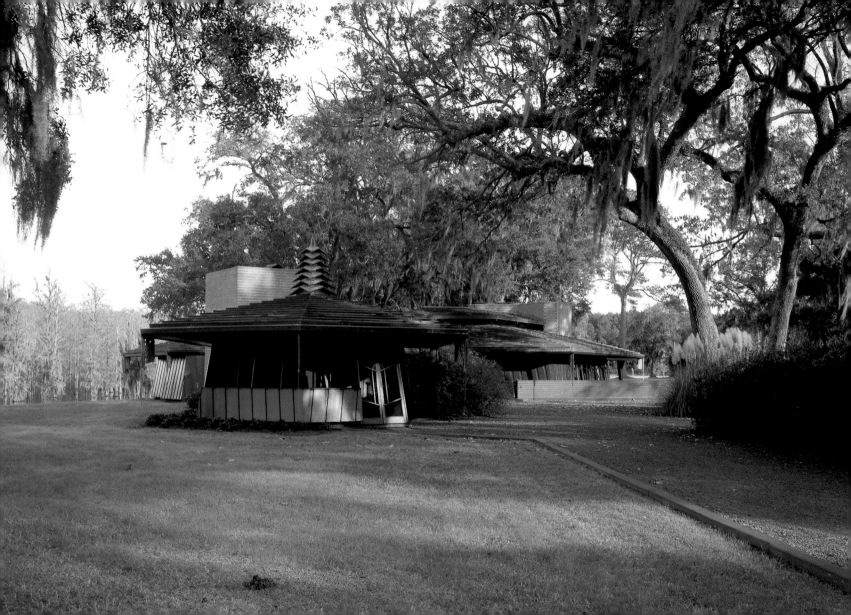

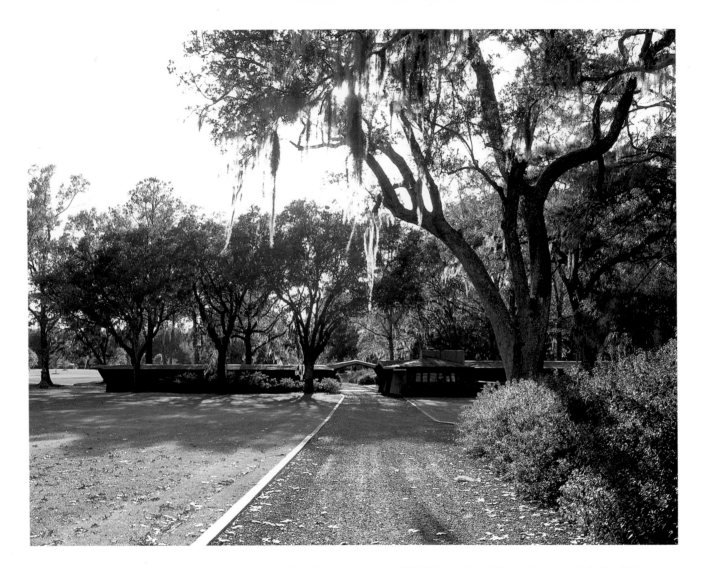

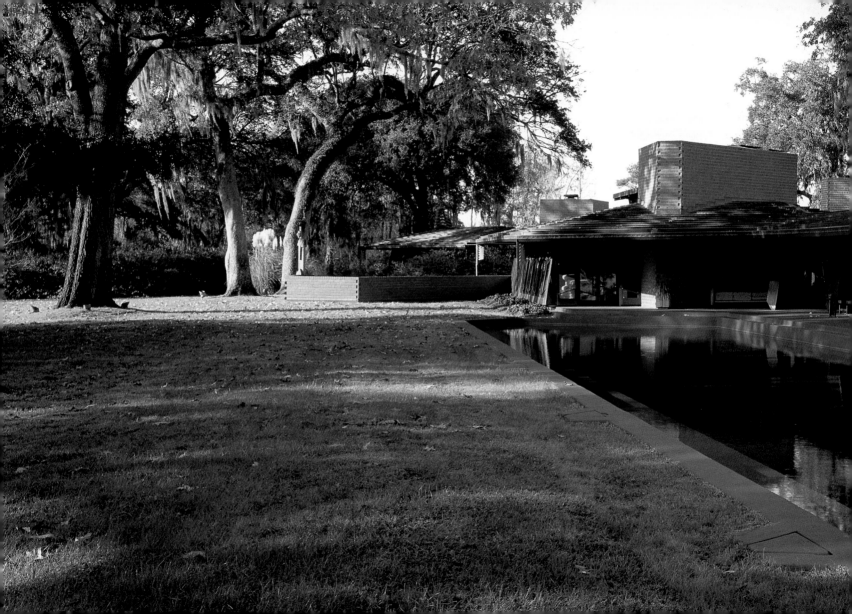

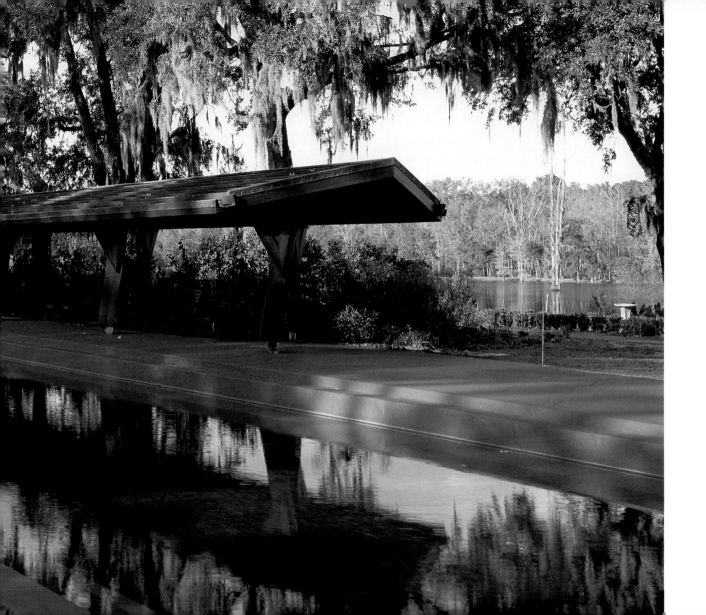

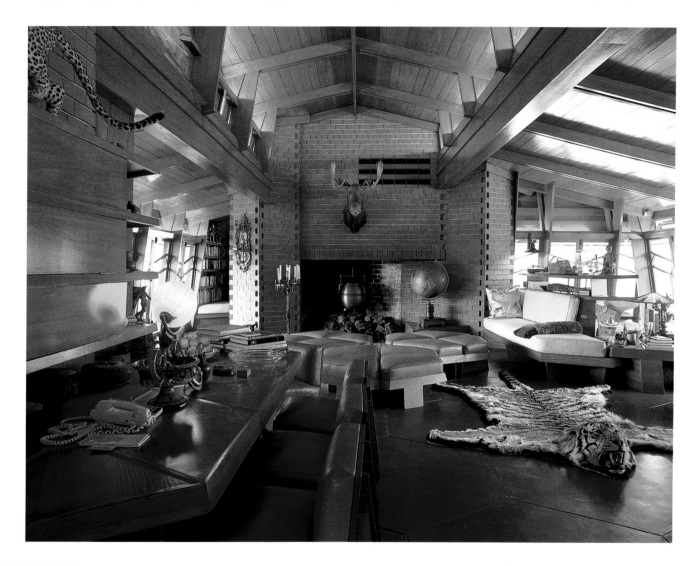

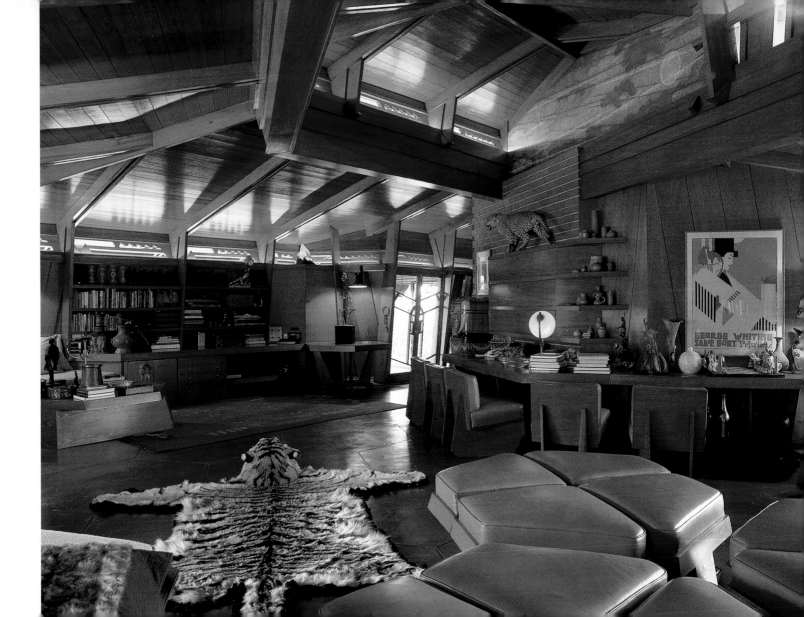

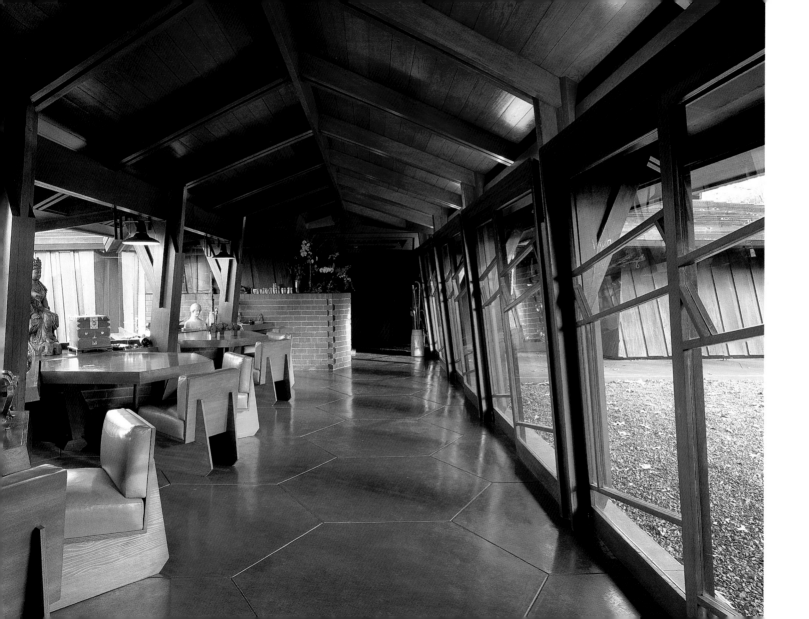

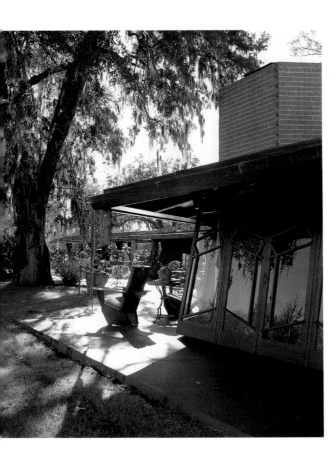

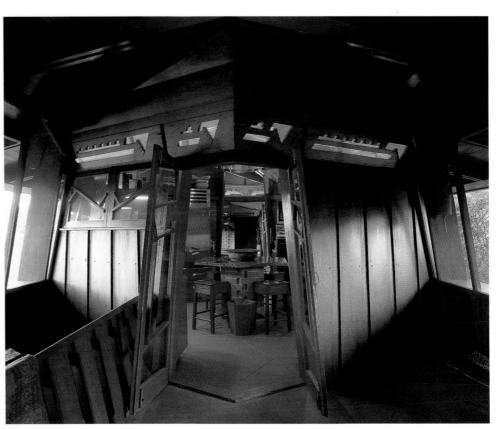

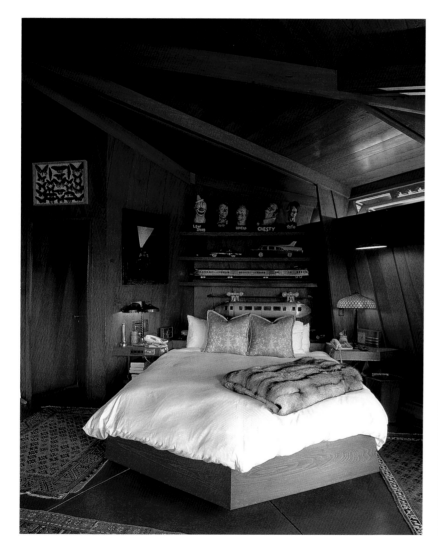

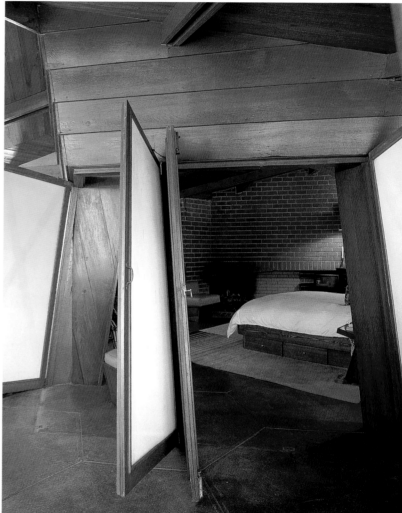

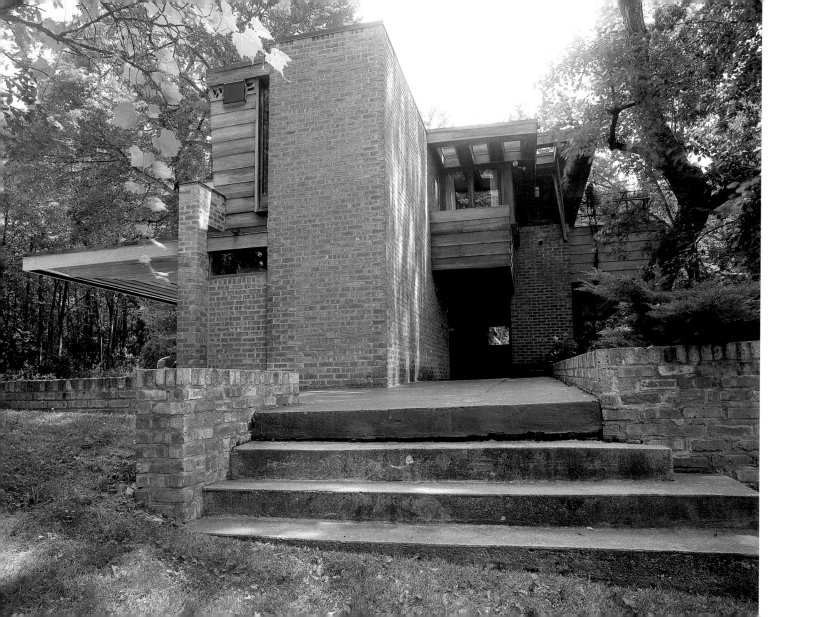

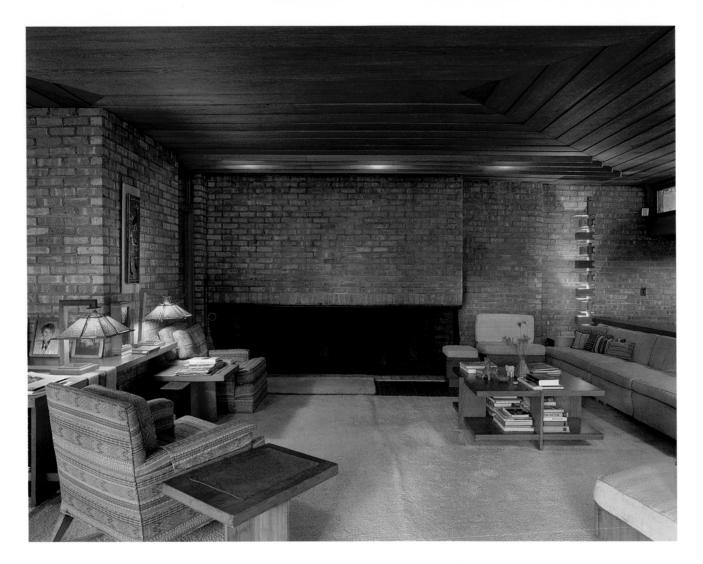

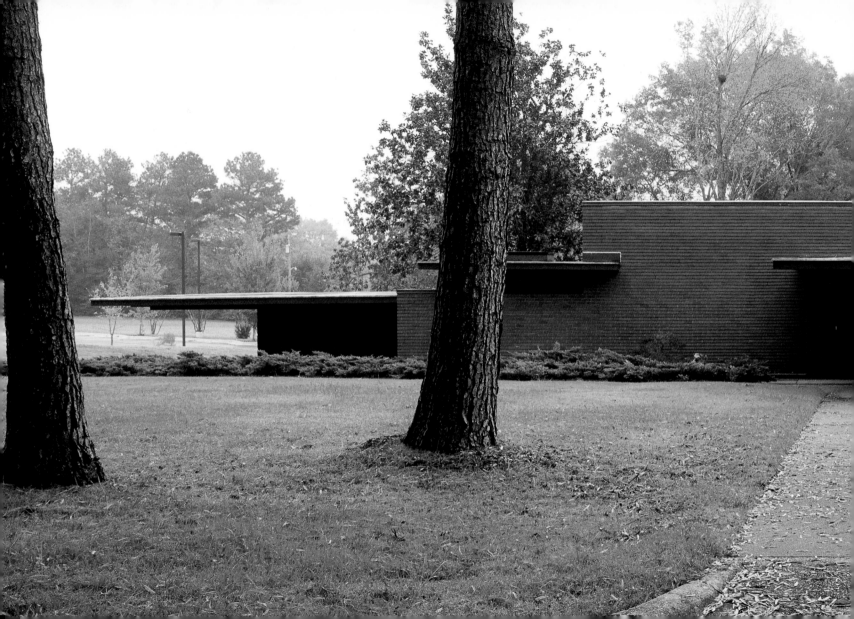

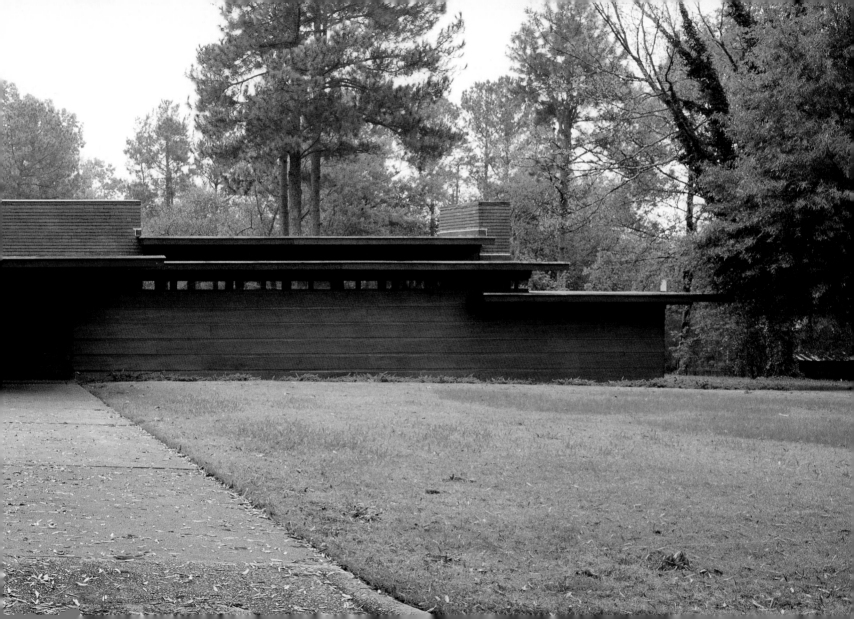

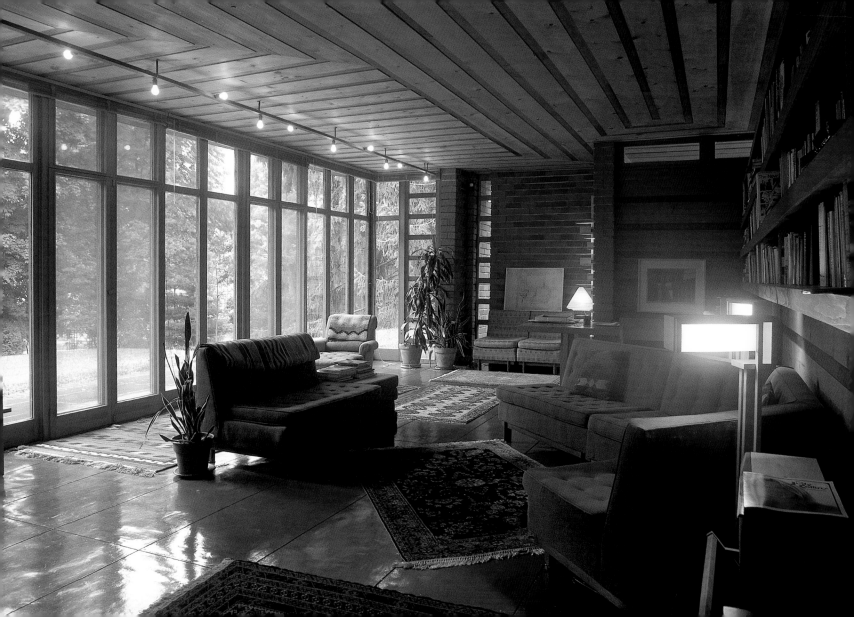

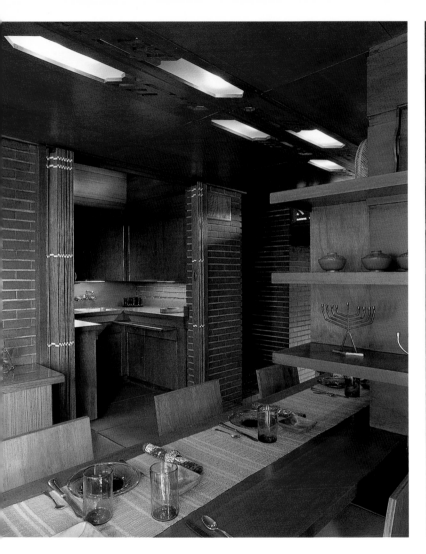

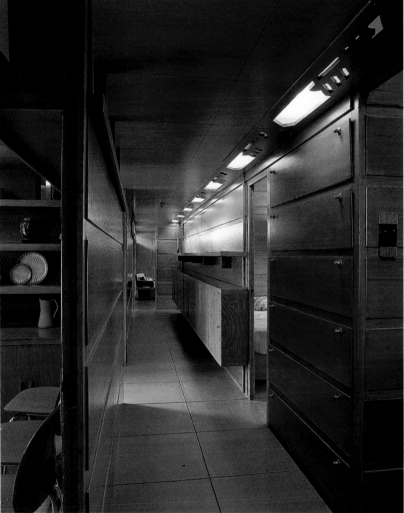

Previous pages, opposite and above: Rosenbaum House, Florence, Alabama, 1939

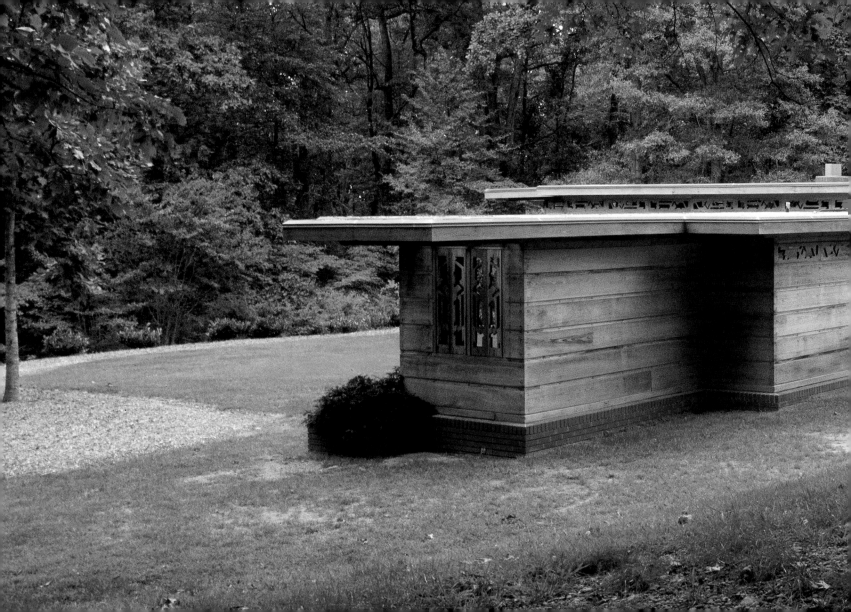

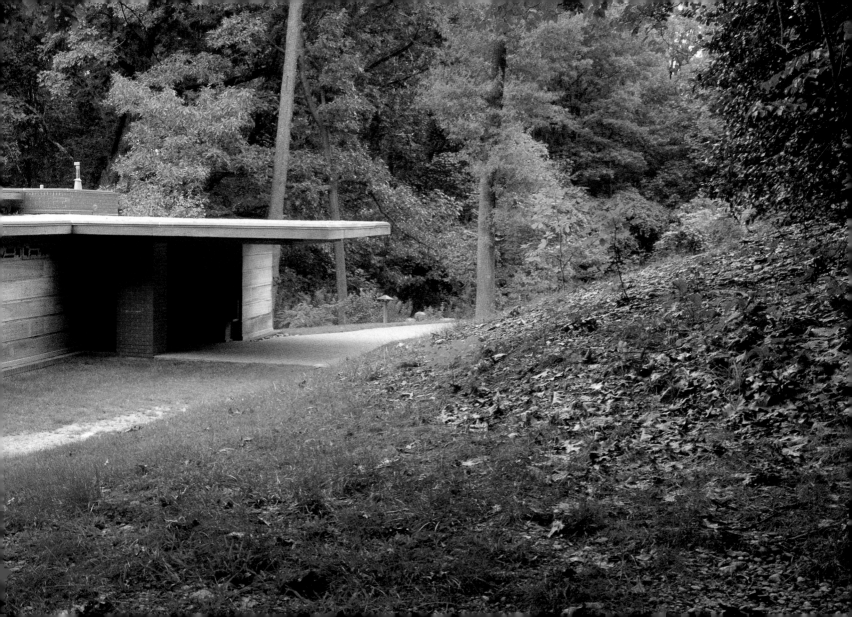

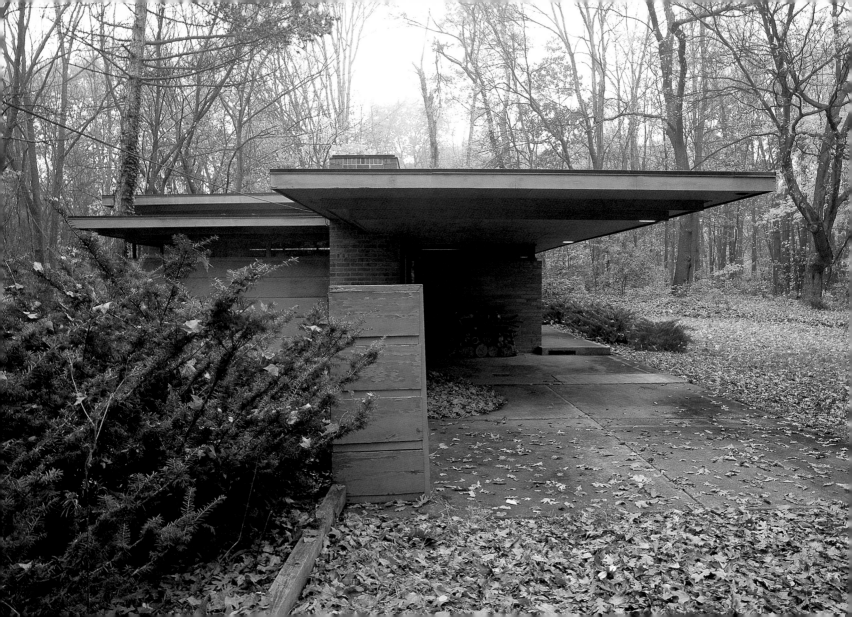

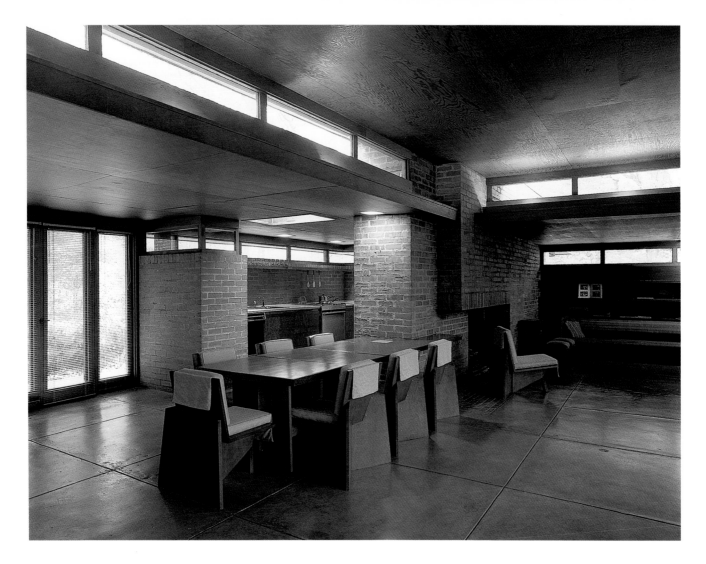

Previous pages, opposite and above: Goetsch-Winckler House, Okemos, Michigan, 1939

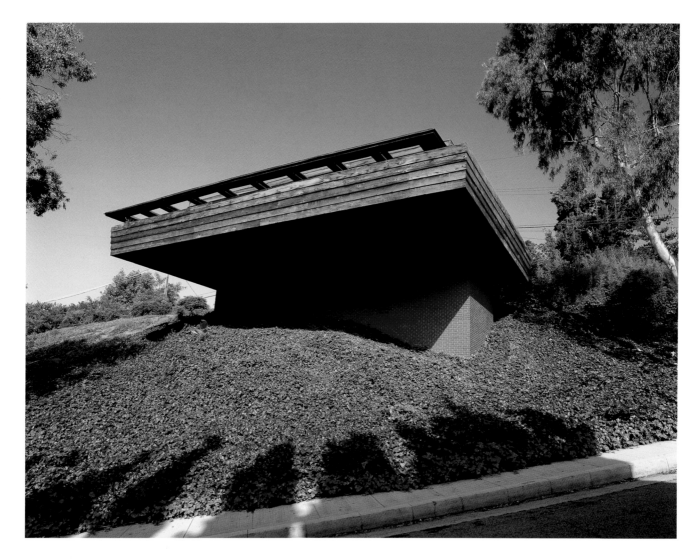

Above, opposite, and following pages: Sturges House, Brentwood Heights, California, 1939

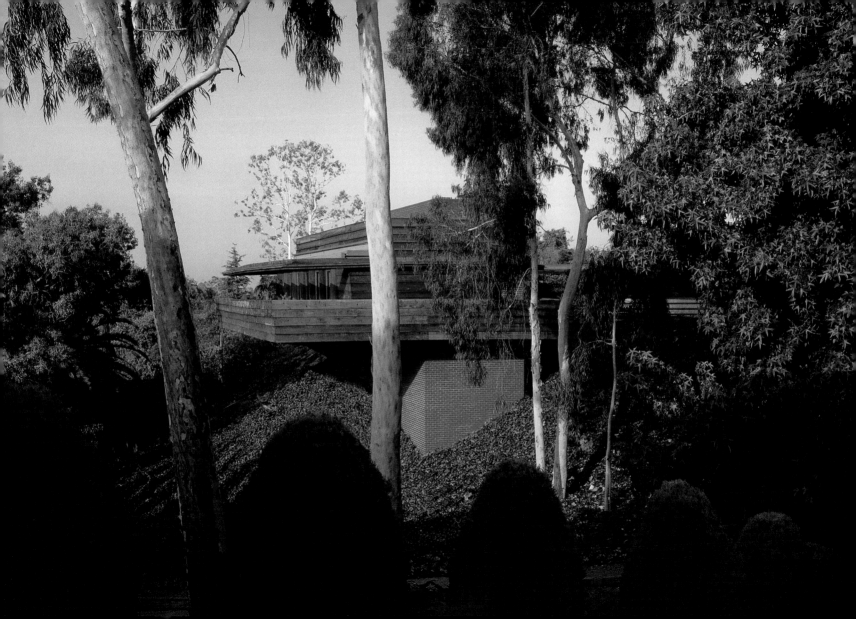

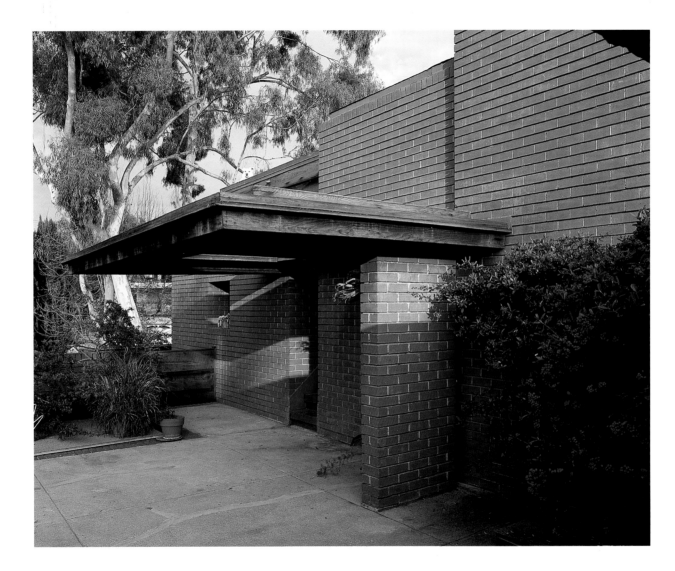

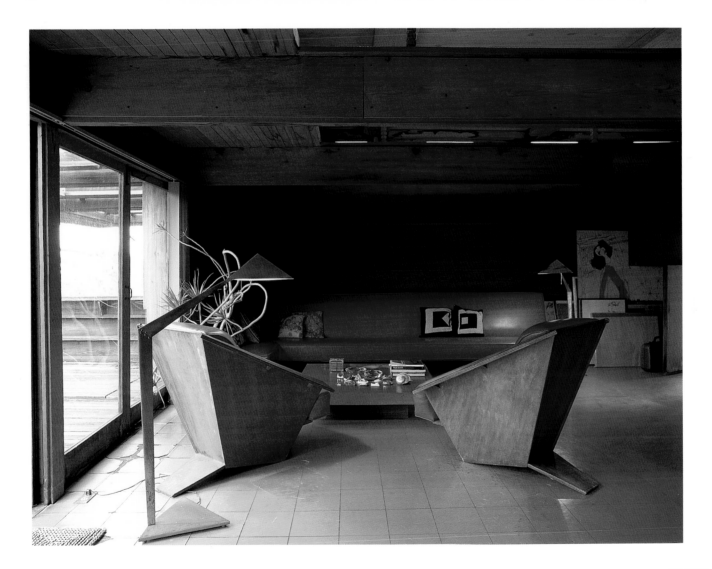

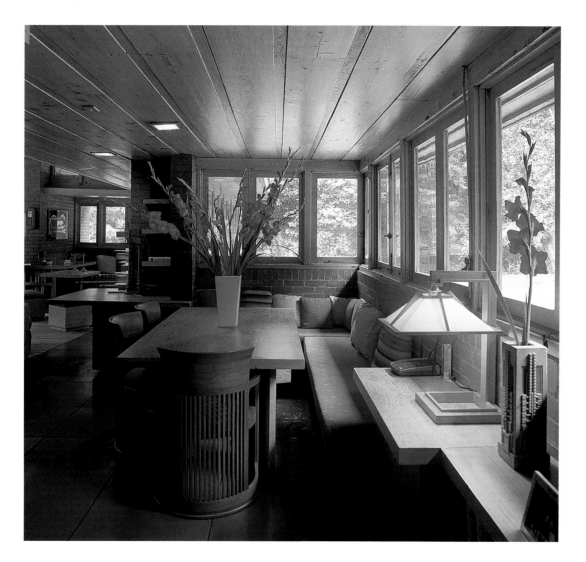

Above: Christie House, Bernardsville, New Jersey, 1940; Opposite: Baird House, Amherst, Massachuetts, 1940

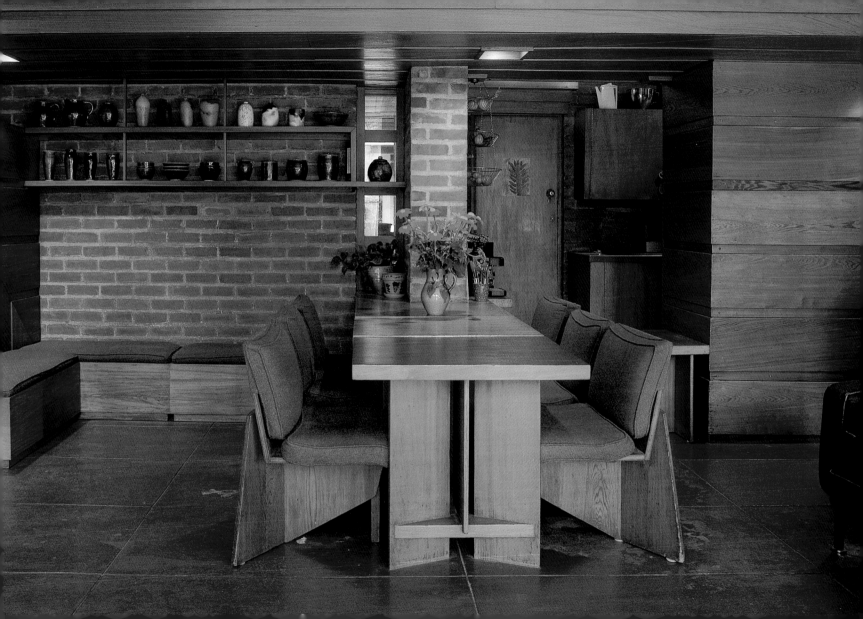

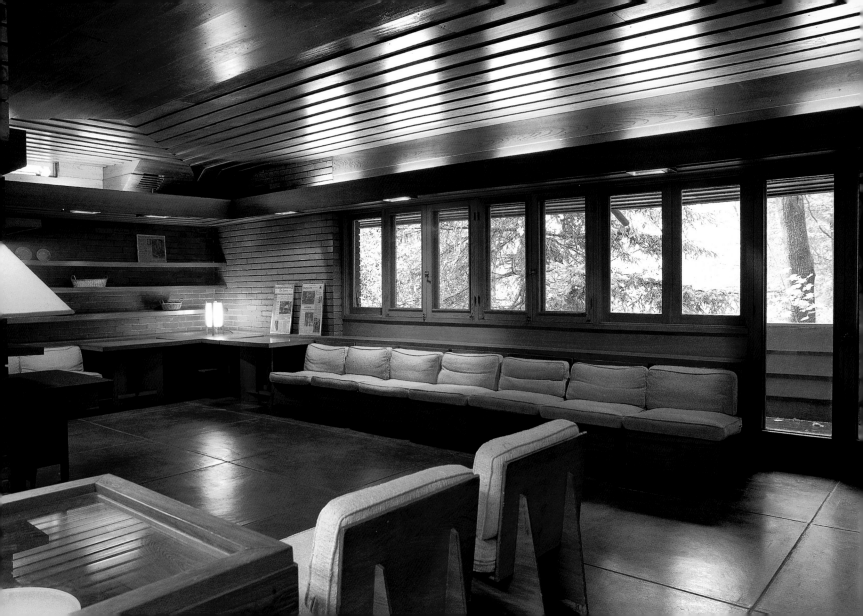

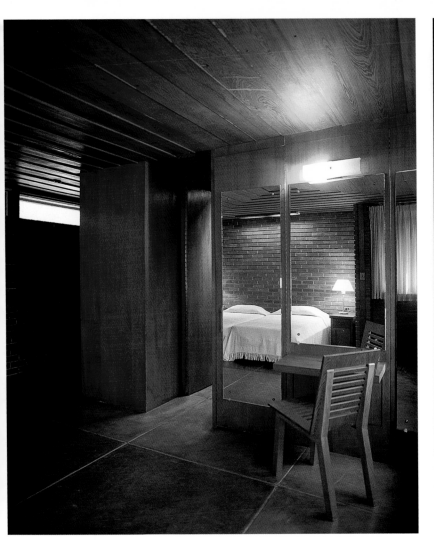

Opposite and above: Affleck House, Bloomfield Hills, Michigan, 1940

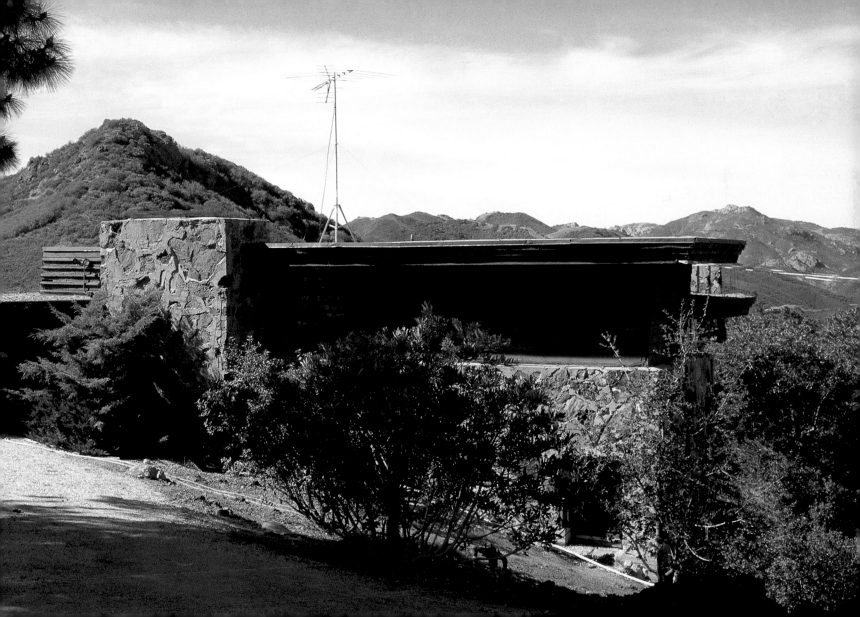

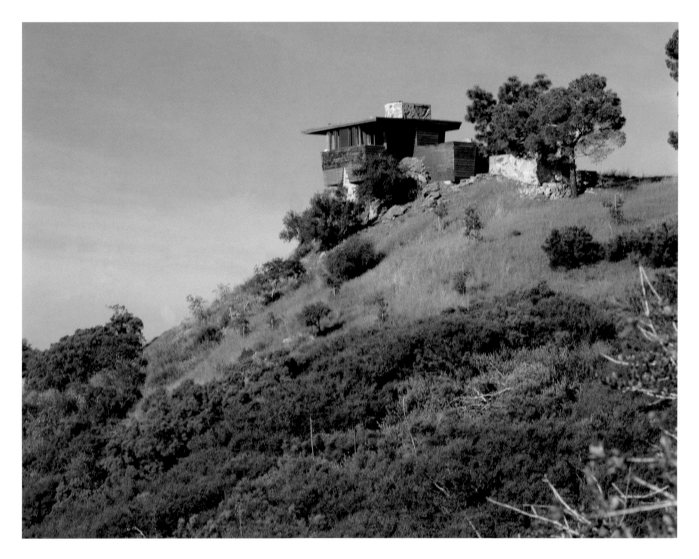

Previous pages, above, and opposite: Oboler House, Malibu, California, 1940

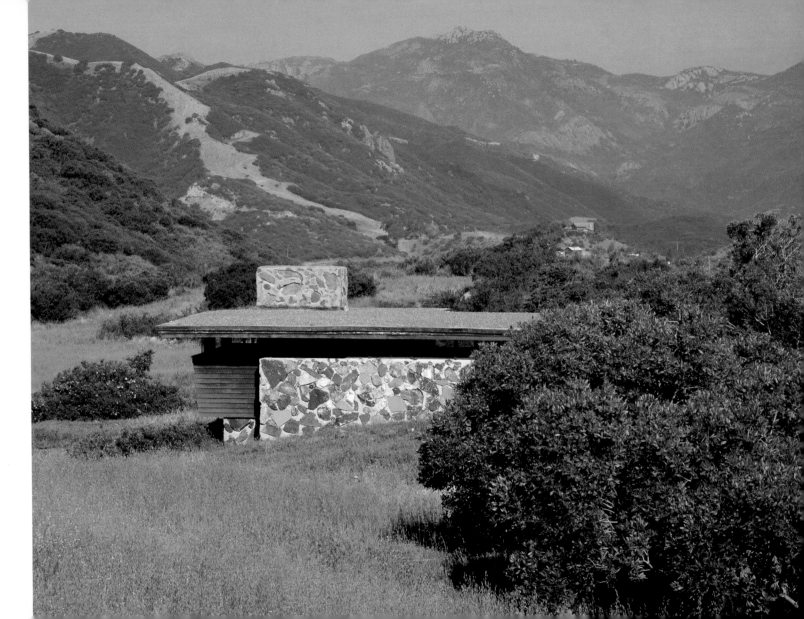

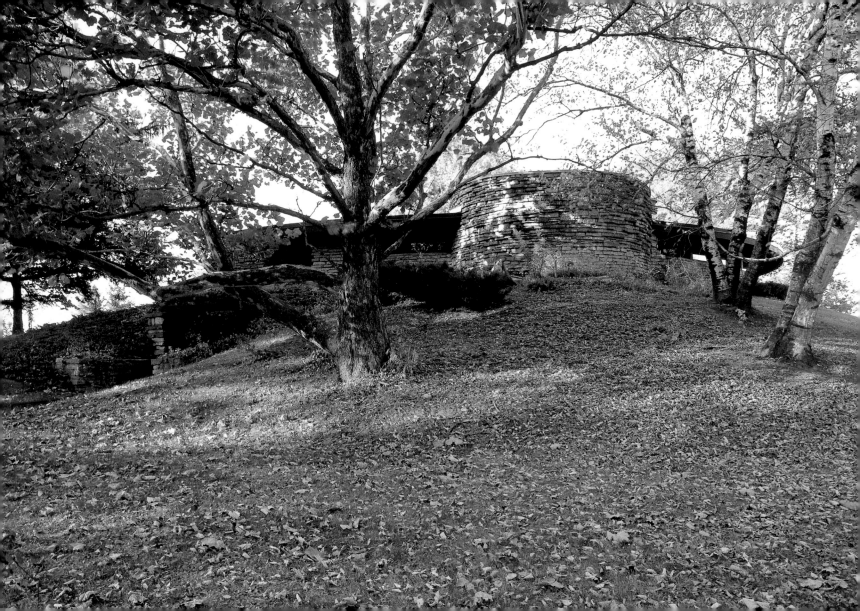

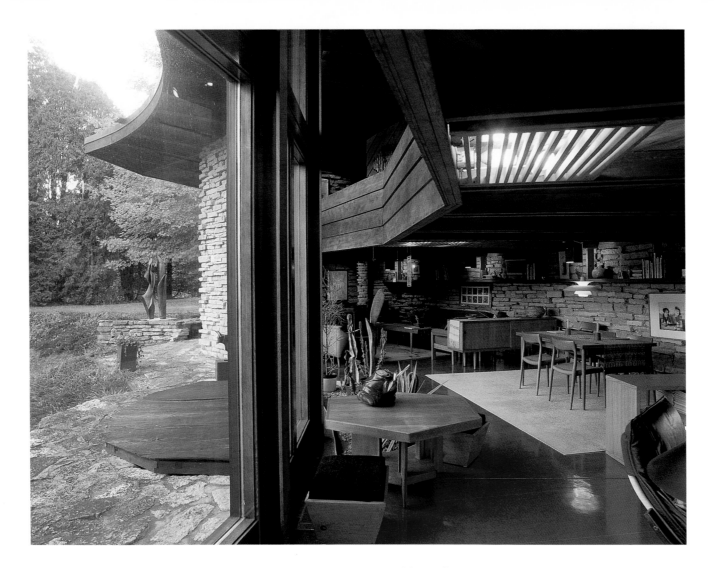

Opposite and above: Jacobs House II (Solar Hemicycle), Middleton, Wisconsin, 1944 FOUR BUILDING USONIA **237**

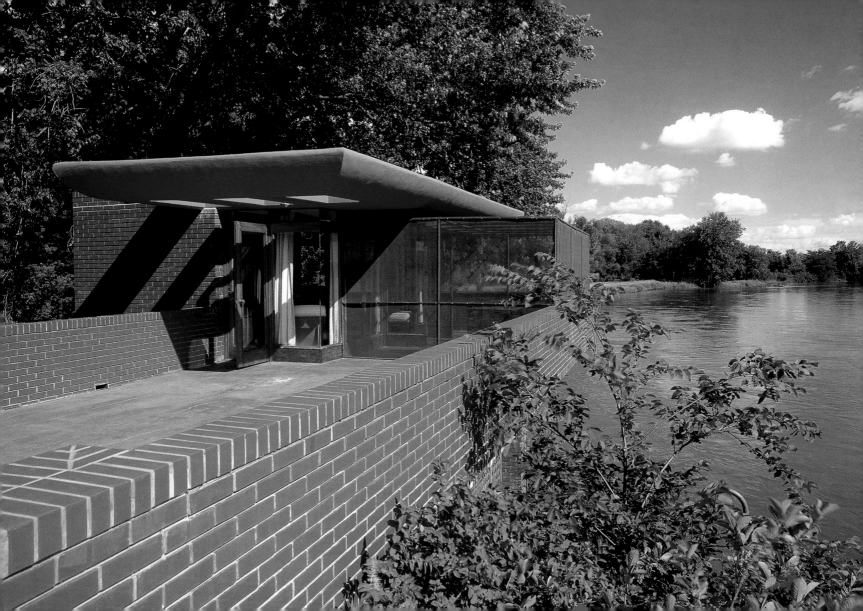

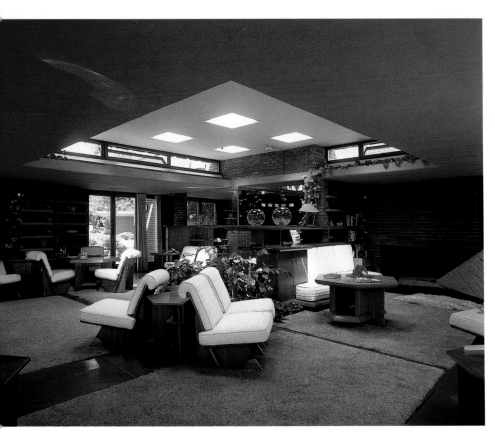

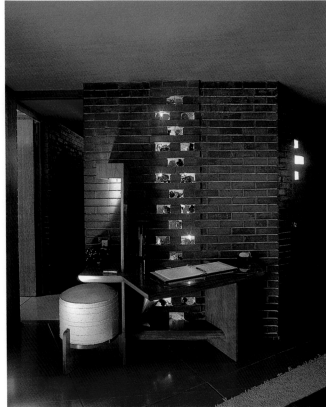

Opposite and above: Walter House and River Pavilion, Quasqueton, Iowa, 1945

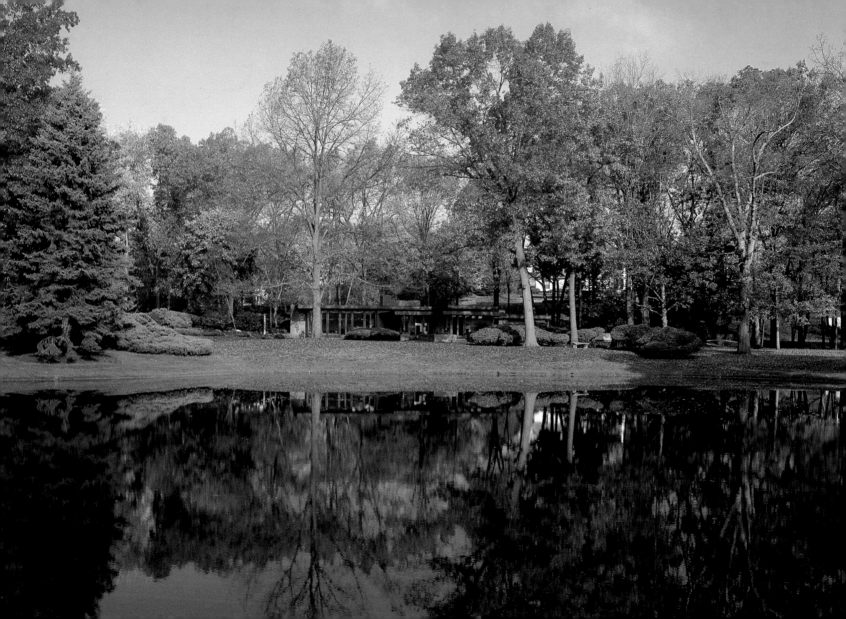

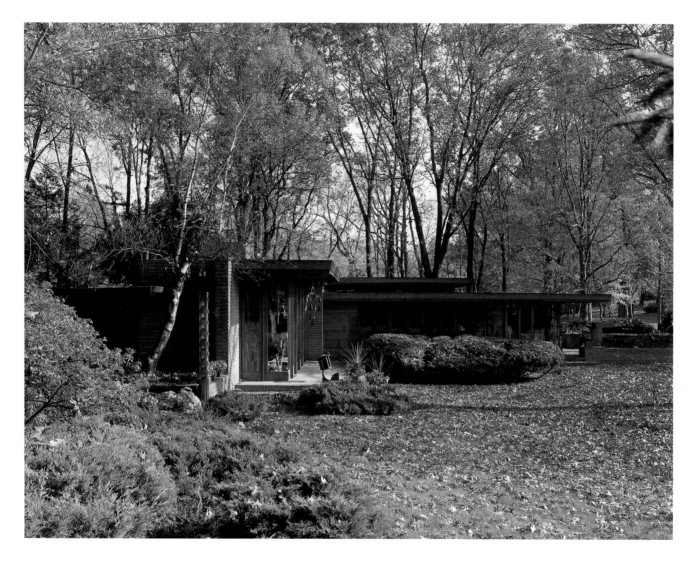

Opposite, above, and following pages: Smith House, Bloomfield Hills, Michigan, 1946

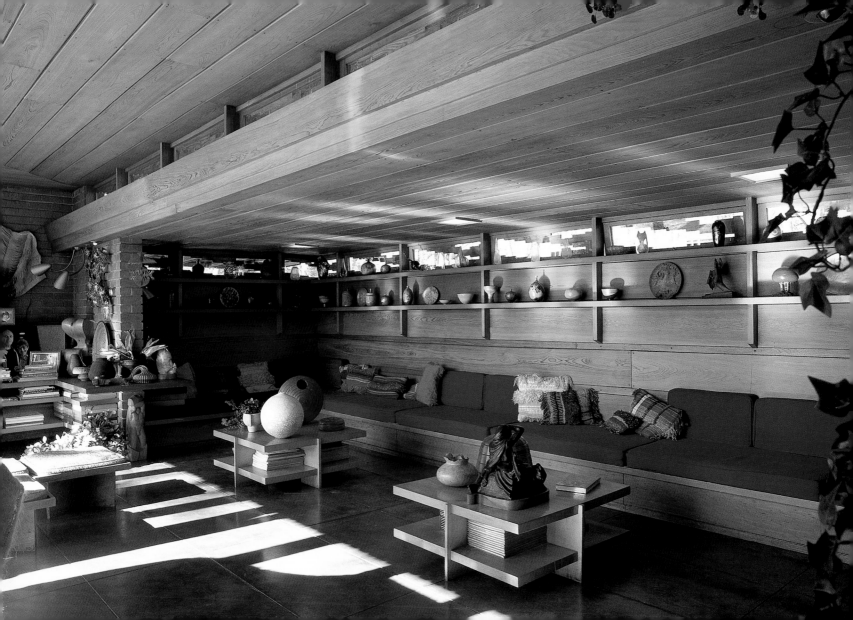

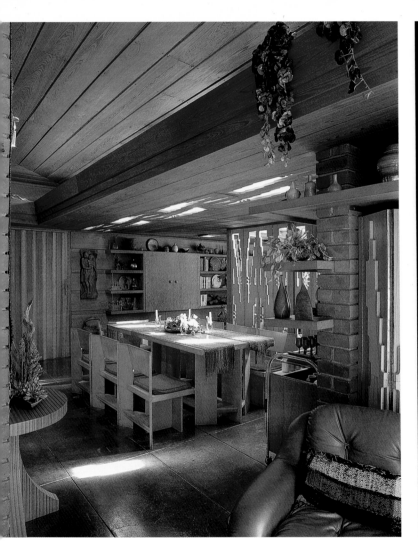

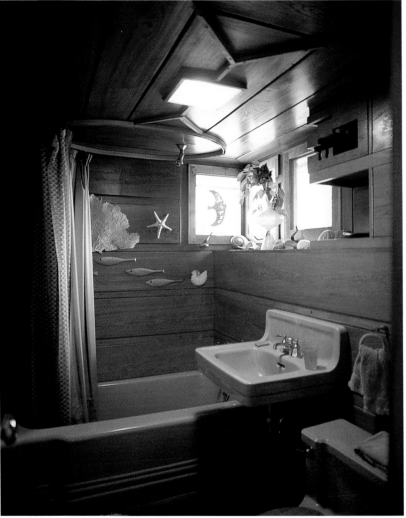

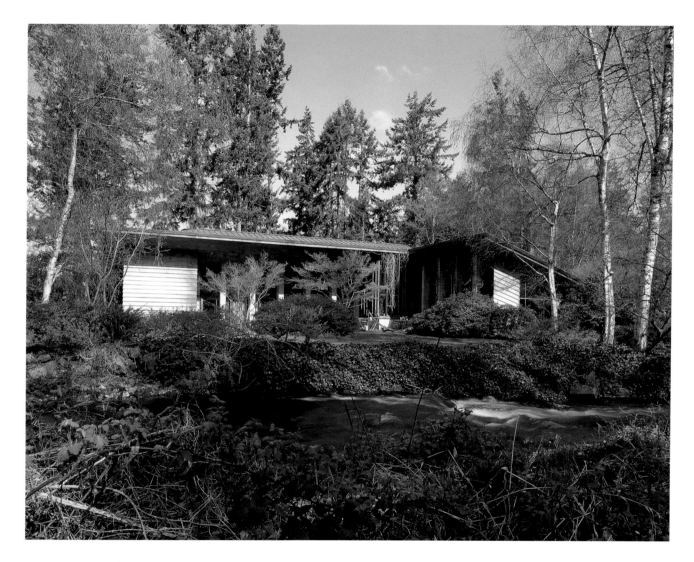

Above: Griggs House, Tacoma, Washington, 1946; Opposite: Grant House, Cedar Rapids, Iowa, 1946

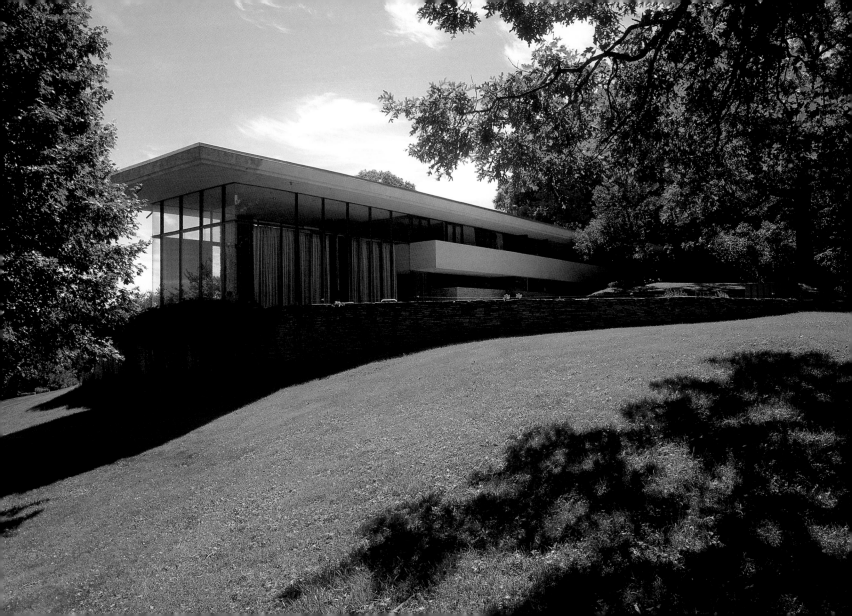

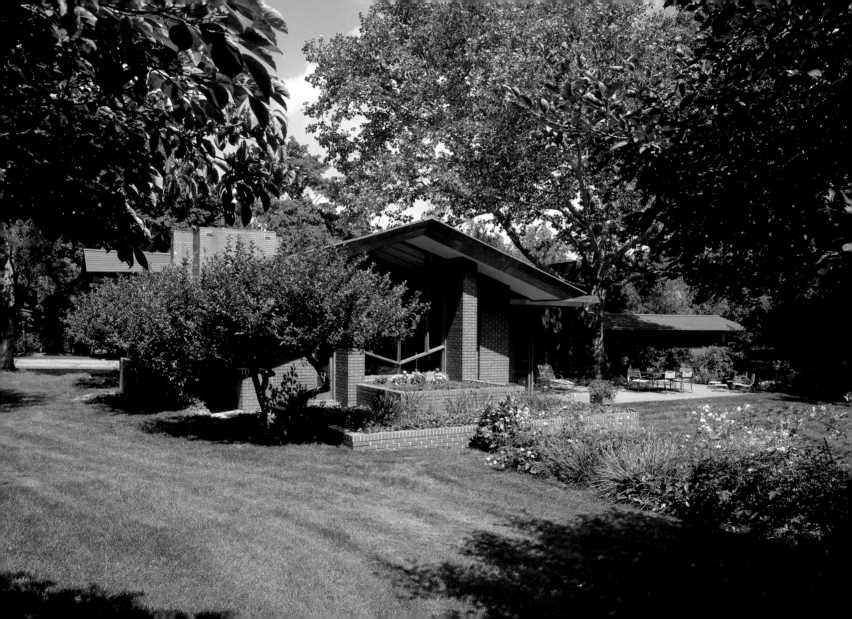

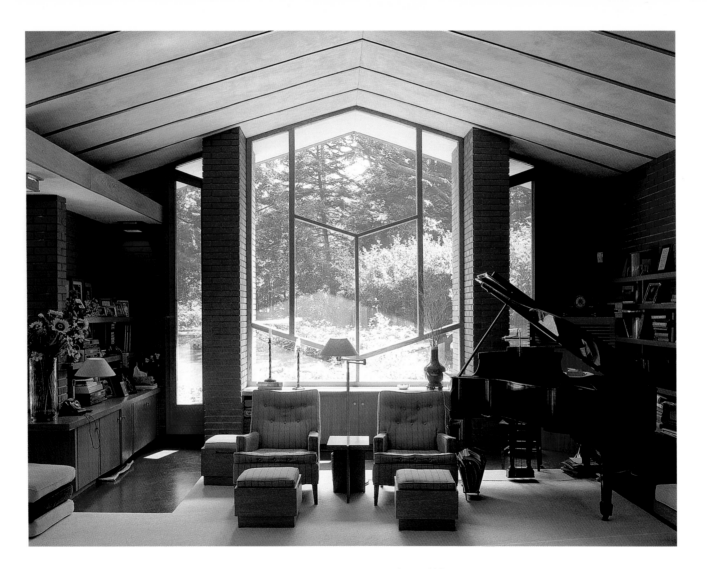

Opposite, above, and following pages: Mossberg House, South Bend, Indiana, 1946

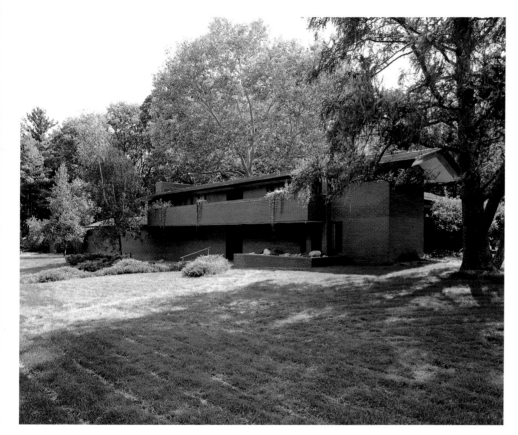
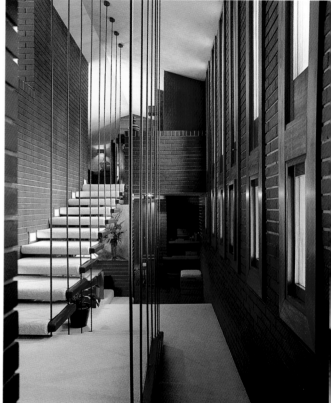

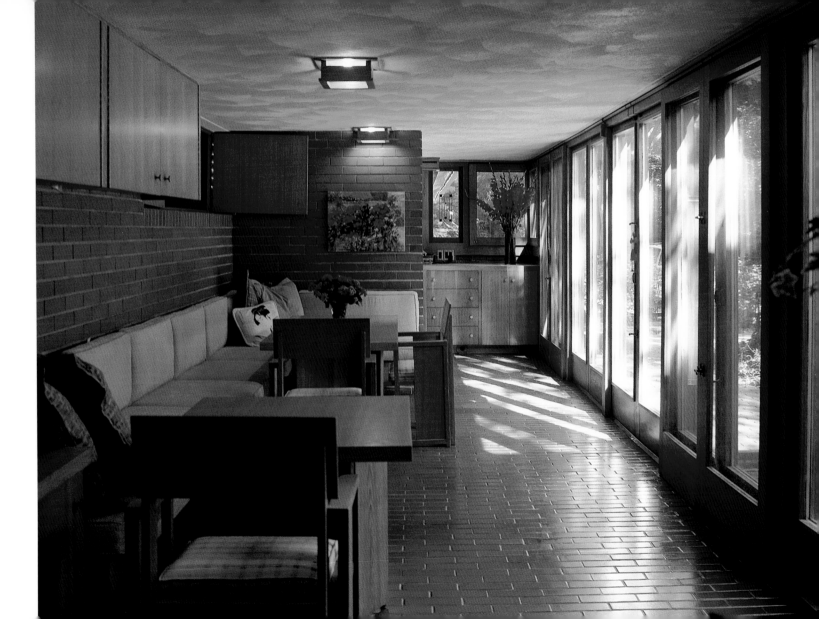

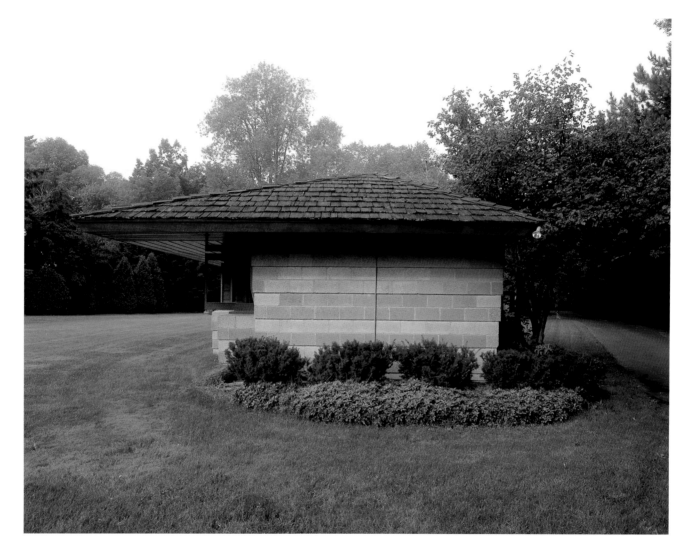

Above: Albert Adelman House, Fox Point, Wisconsin, 1948; Opposite: Lamberson House, Oskaloosa, Iowa, 1947

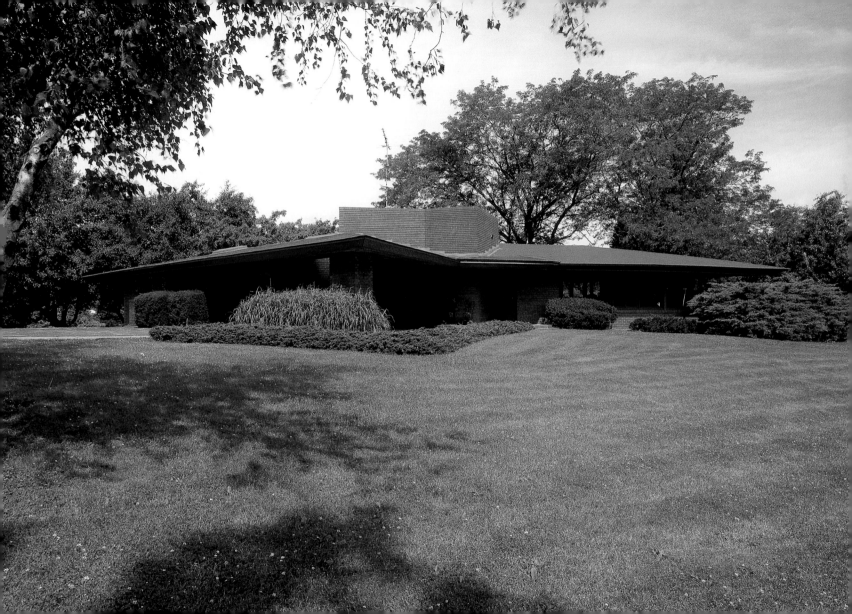

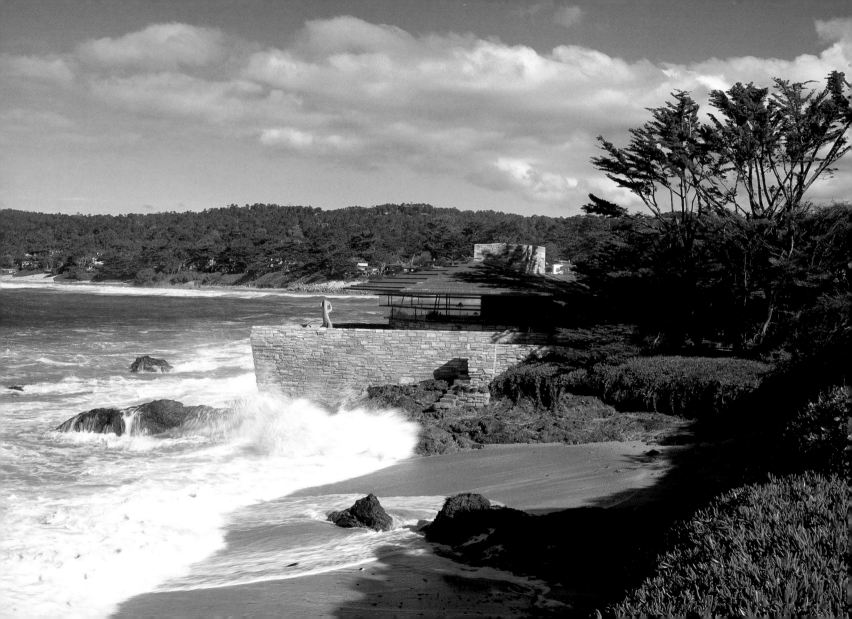

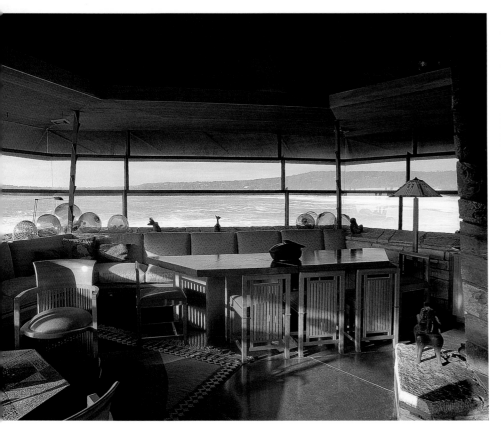

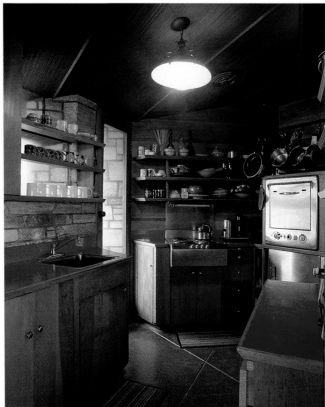

Opposite and above: Walker House, Carmel, California, 1948

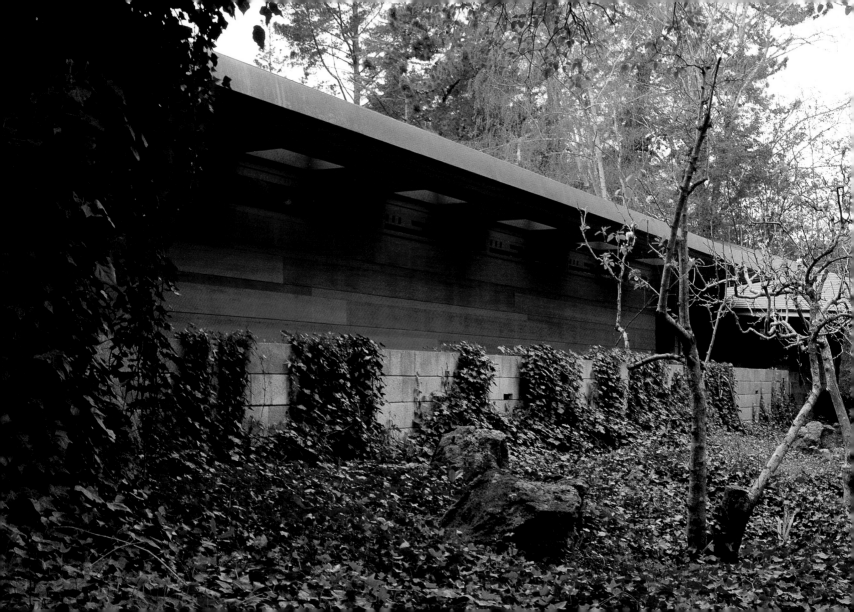

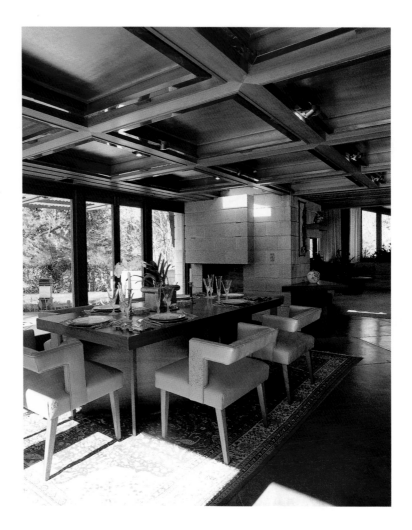

Left and above: Buehler House, Orinda, California, 1948

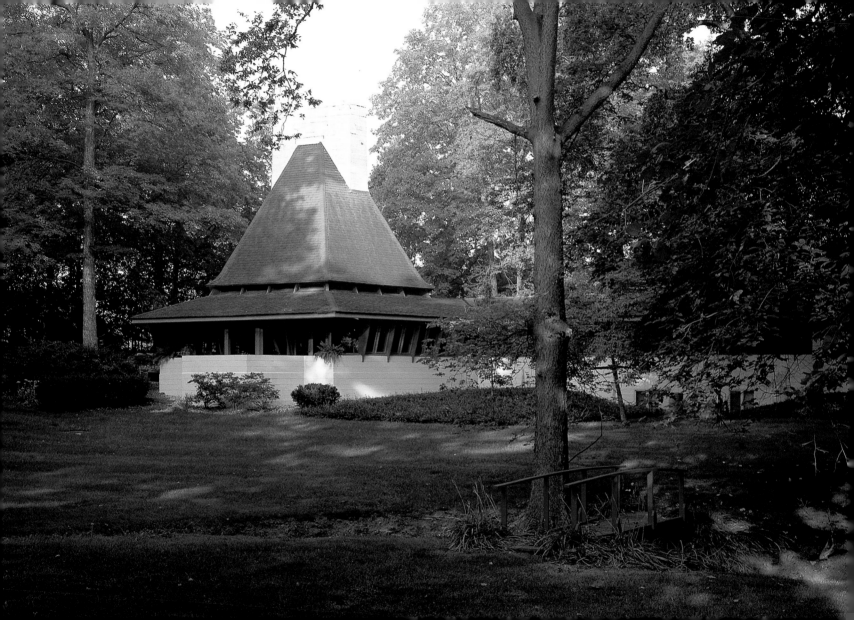

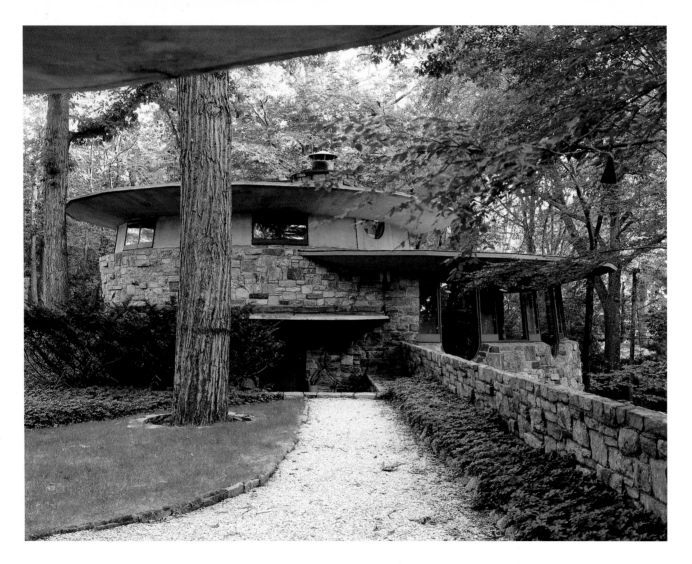

Opposite: Davis House, Marion, Indiana, 1950; Above: Friedman House, Pleasantville, New York, 1948

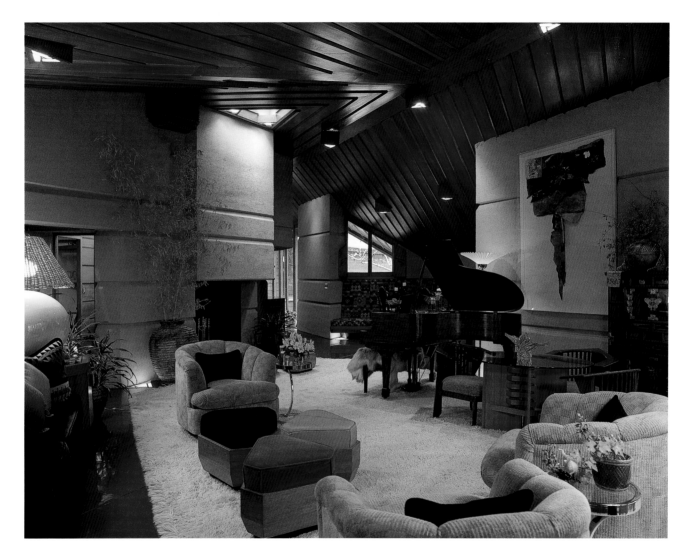

Above and opposite: Hughes House (Fountainhead), Jackson, Mississippi, 1949

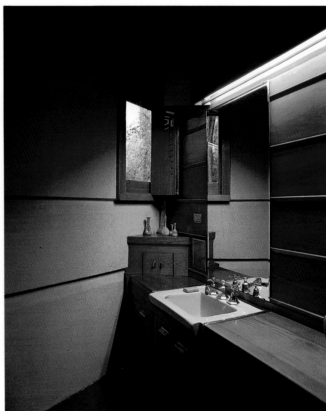

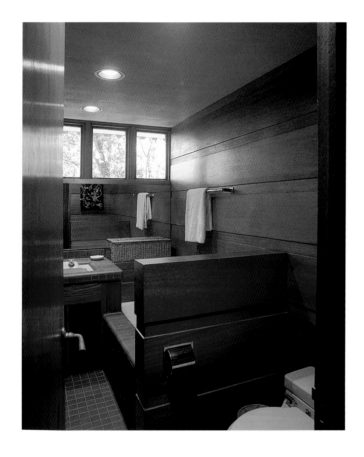

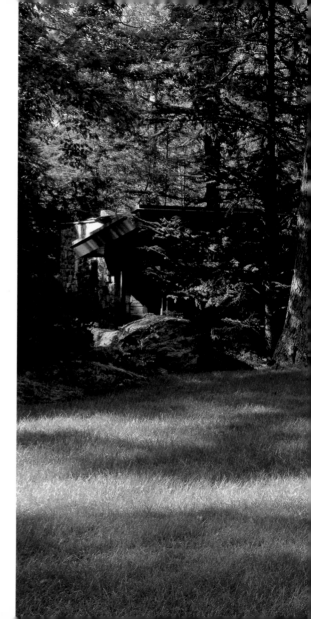

Above and right: Serlin House, Pleasantville, New York, 1949

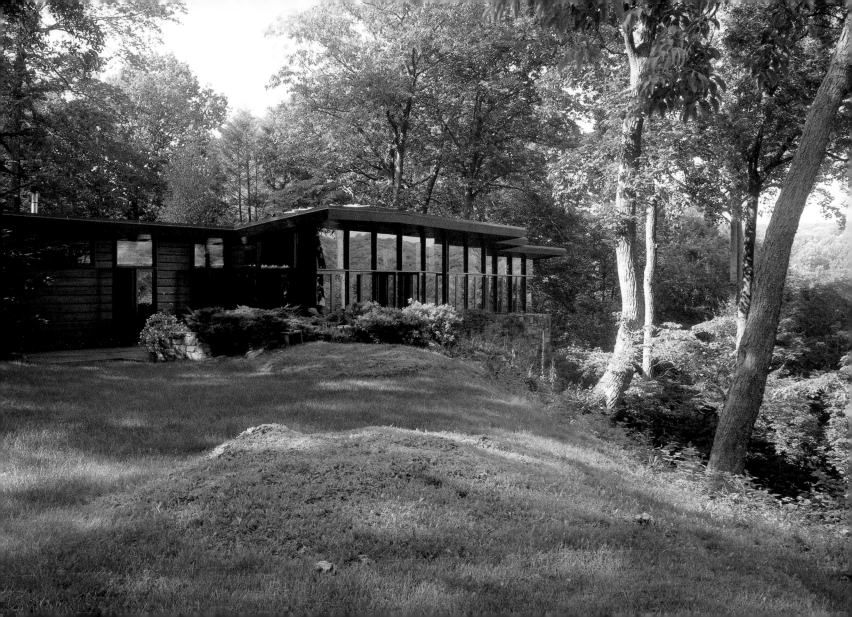

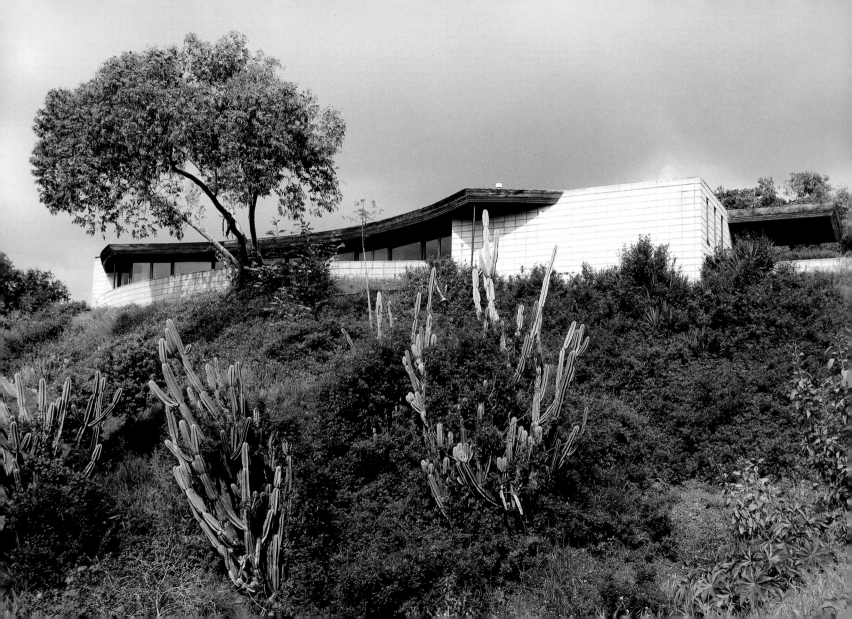

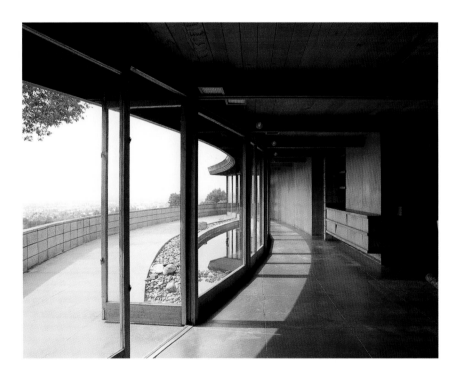

Left and above: Pearce House, Bradbury, California, 1950; Following pages: Harper House, Saint Joseph, Michigan, 1950 FOUR: BUILDING USONIA **263**

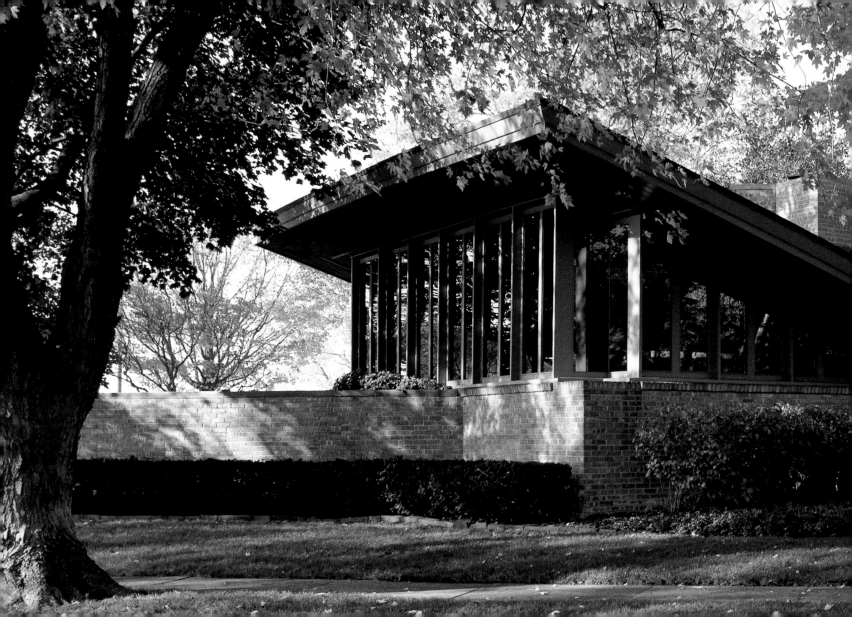

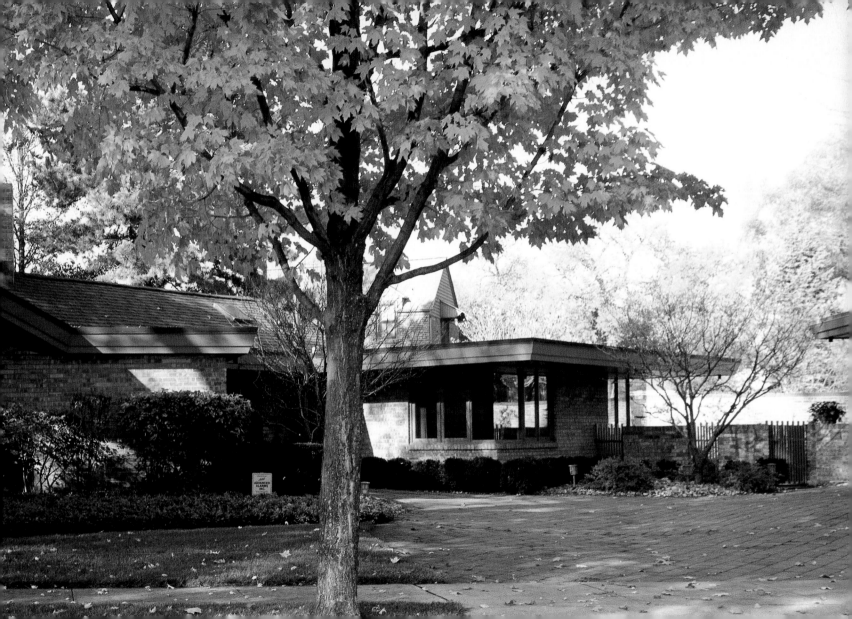

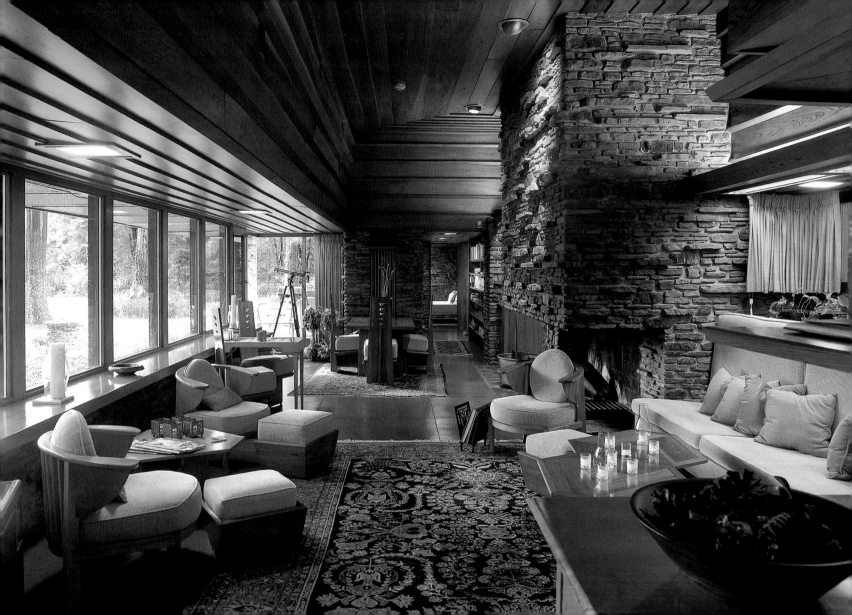

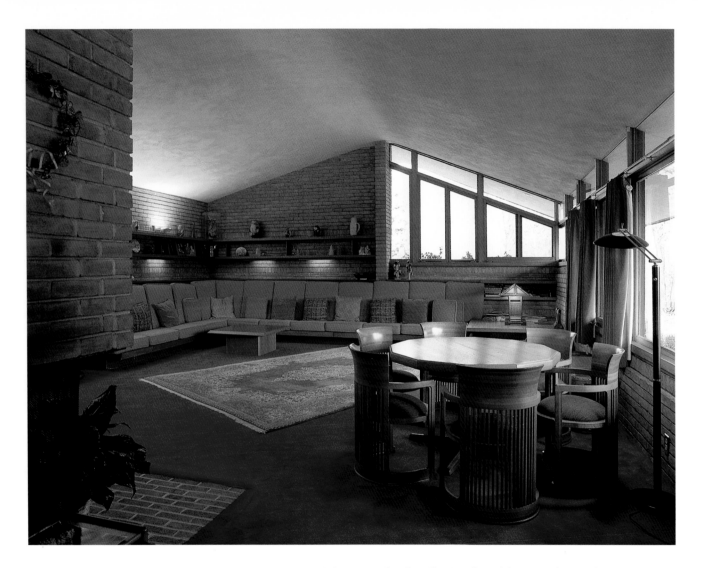

Opposite: Staley House, North Madison, Ohio, 1950; Above: Schaberg House, Okemos, Michigan, 1950

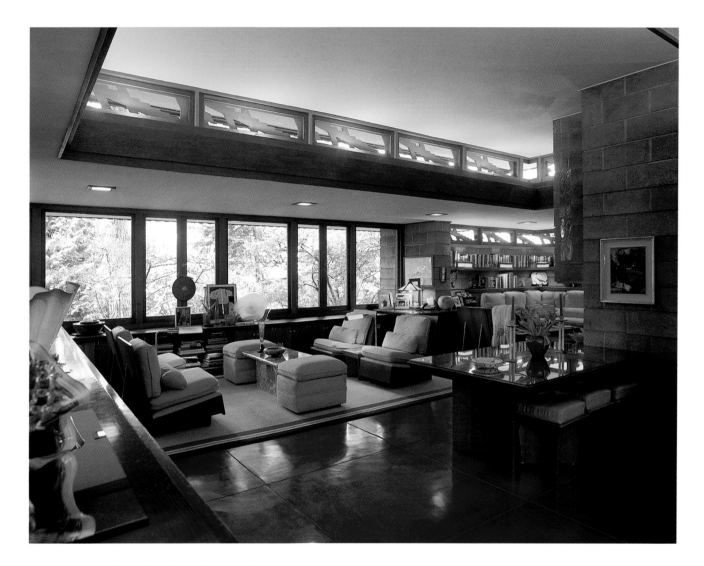

Brandes House, Issaquah, Washington, 1952

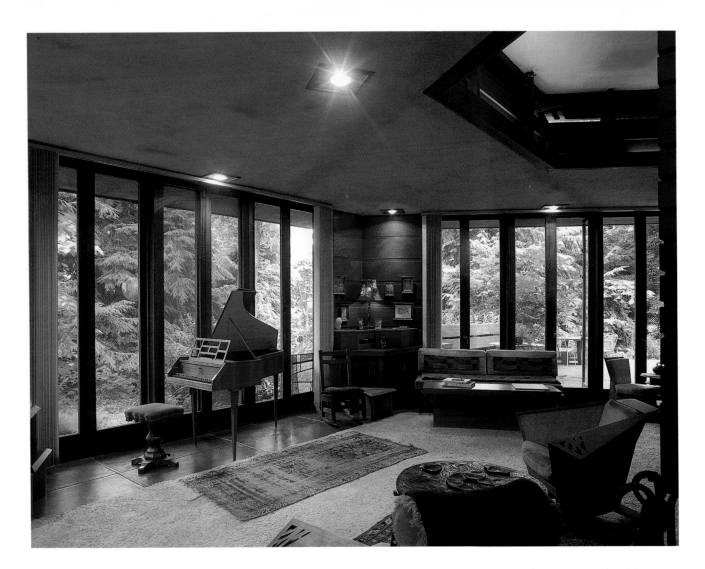

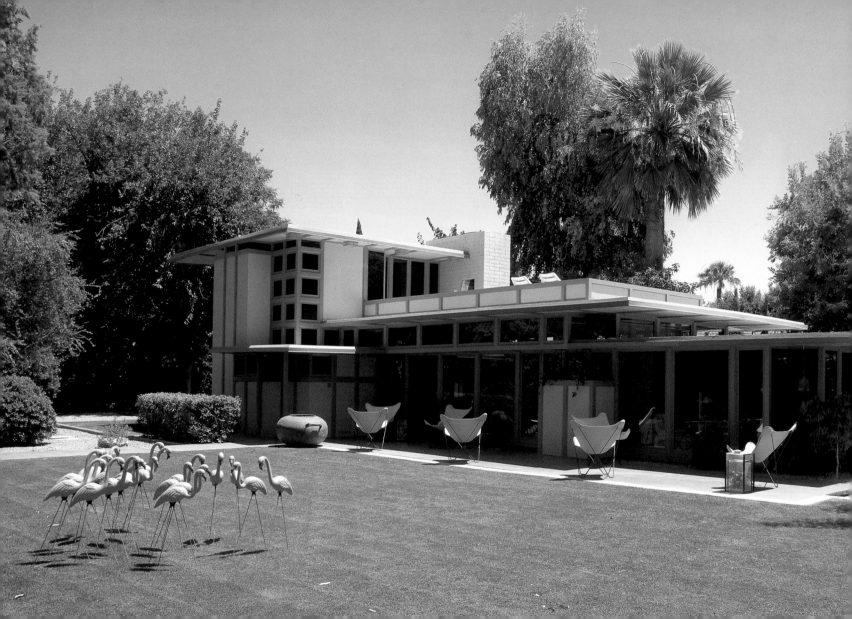

Left, above and following pages: Carlson House, Phoenix, Arizona, 1950 FOUR BUILDING USONIA **271**

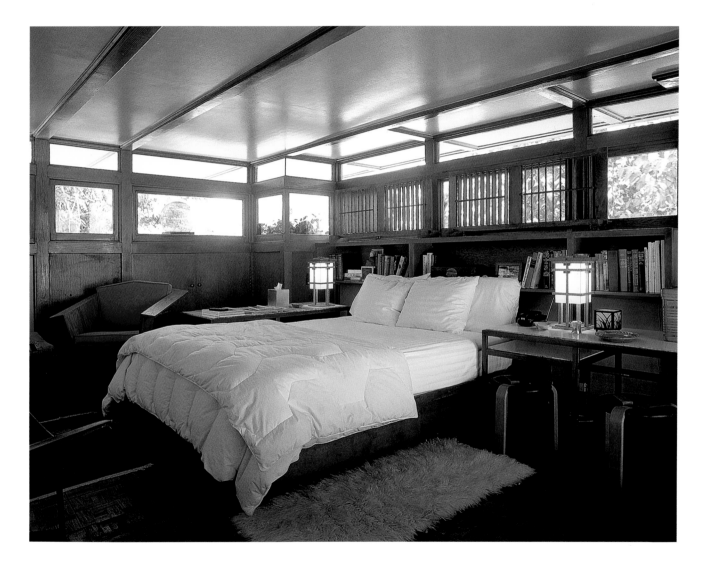

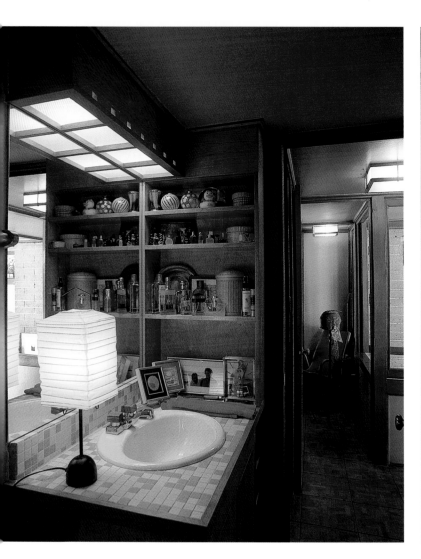

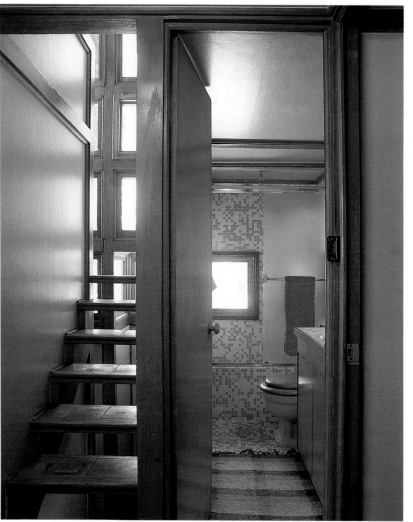

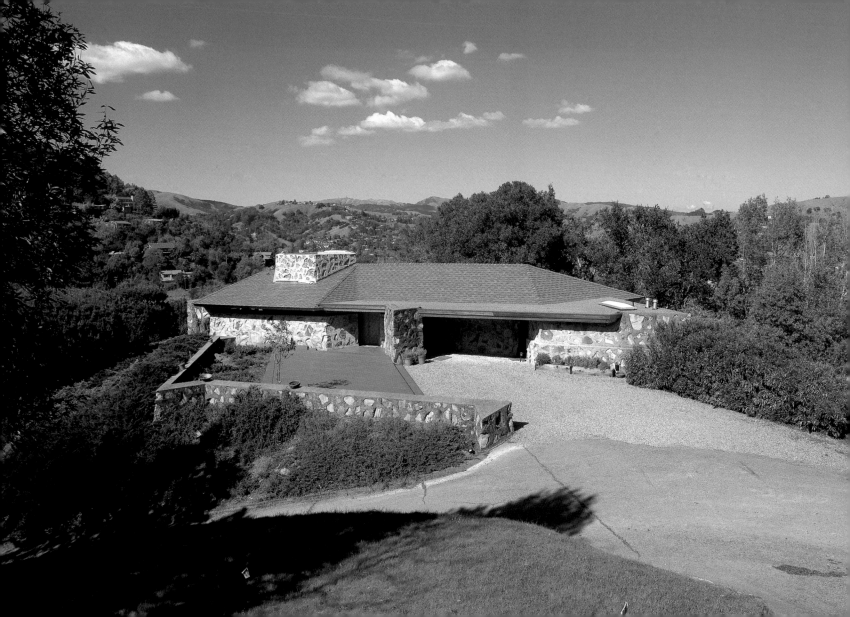

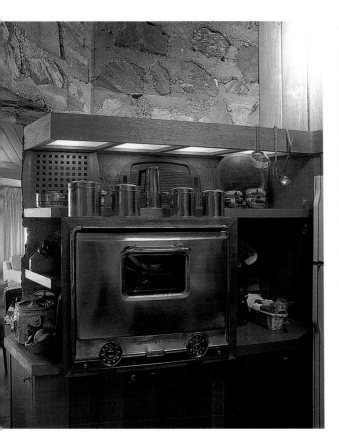
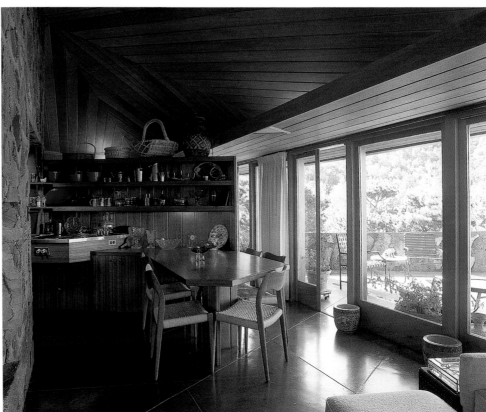

Opposite and above: Berger House, San Anselmo, California, 1950

Above, right, and following pages: Palmer House, Ann Arbor, Michigan, 1950

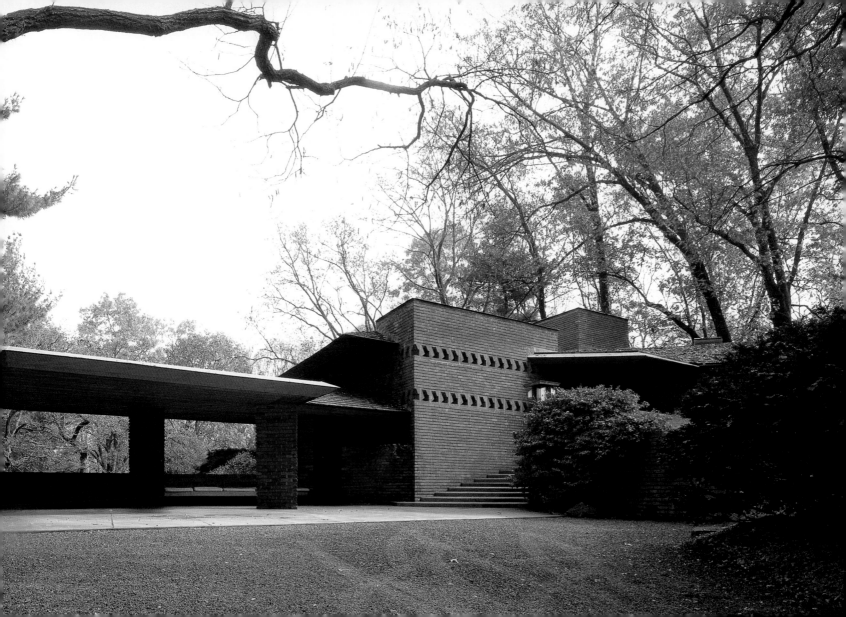

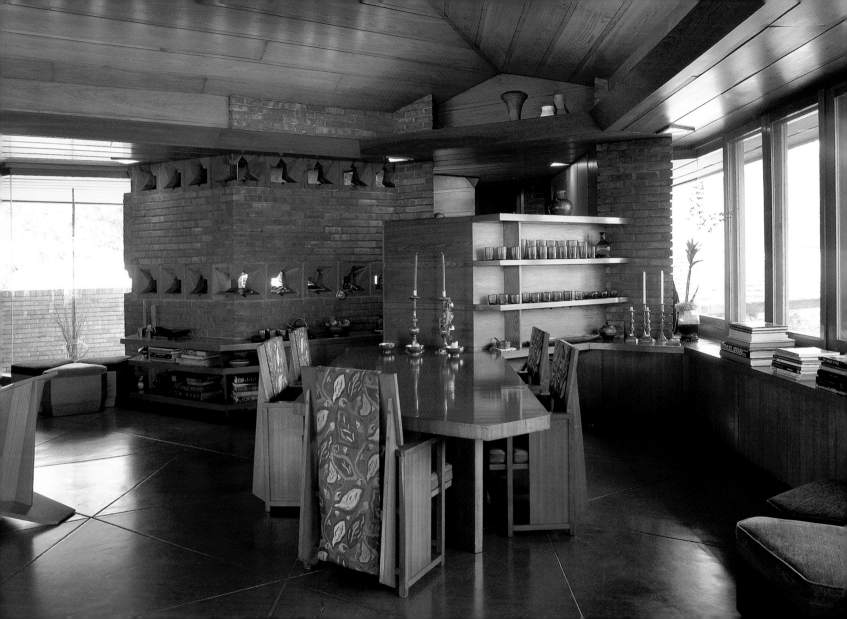

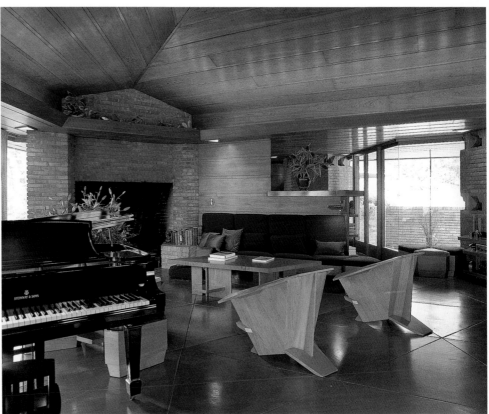

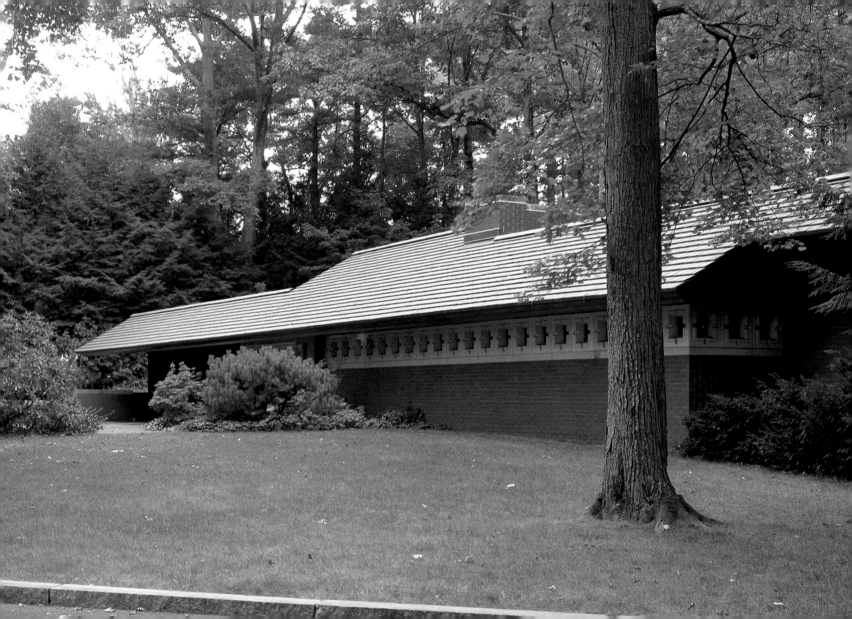

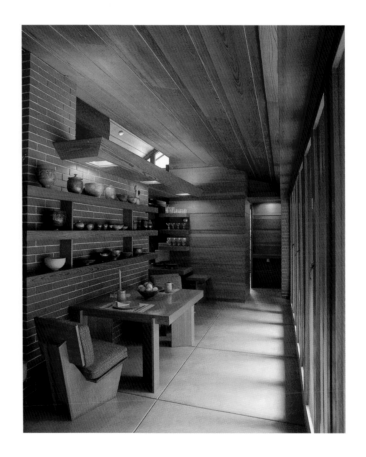

Left and above: Zimmerman House, Manchester, New Hampshire, 1950

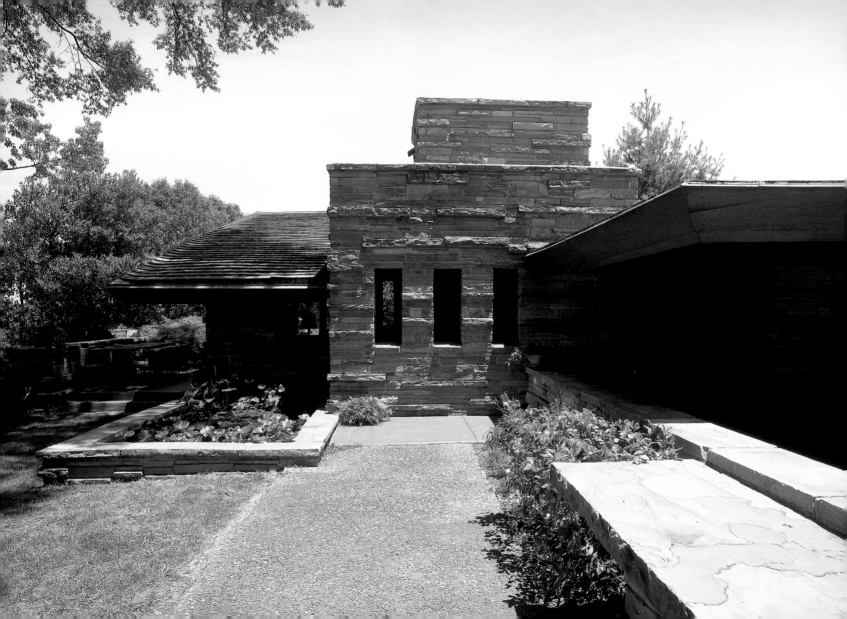

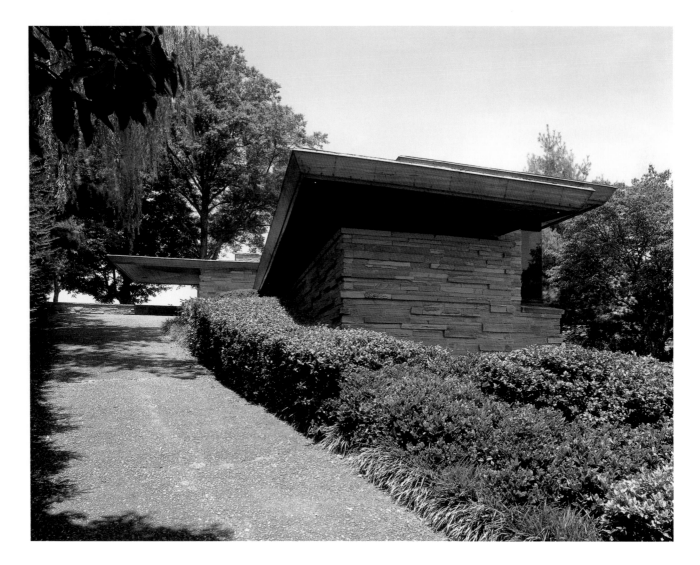

Opposite and above: Shavin House, Chattanooga, Tennessee, 1950

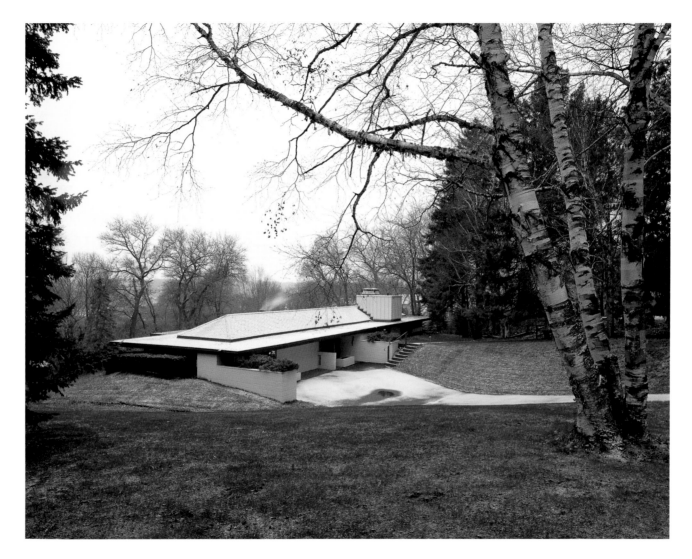

Above: Keys House, Rochester, Minnesota, 1951; Opposite: Lindholm House (Mäntylä), Cloquet, Minnesota, 1952

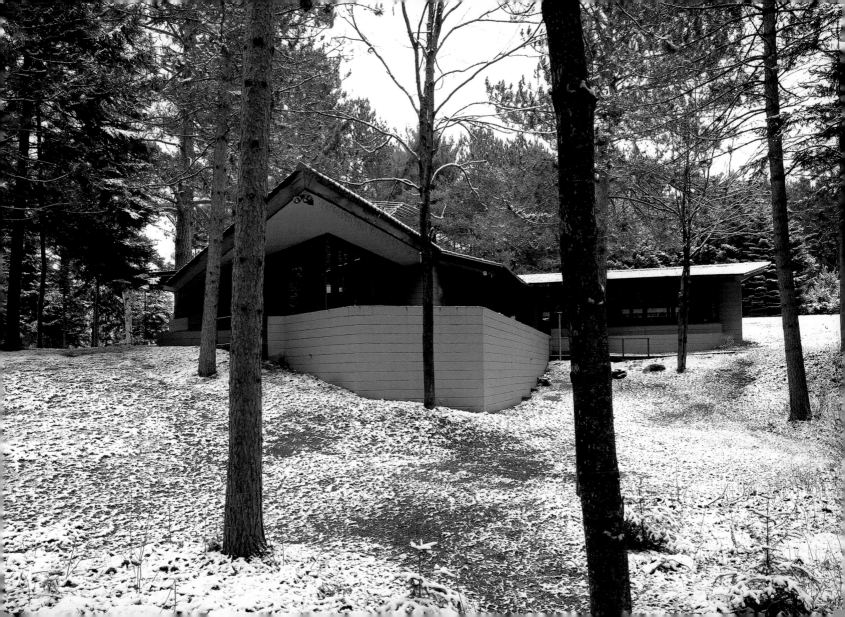

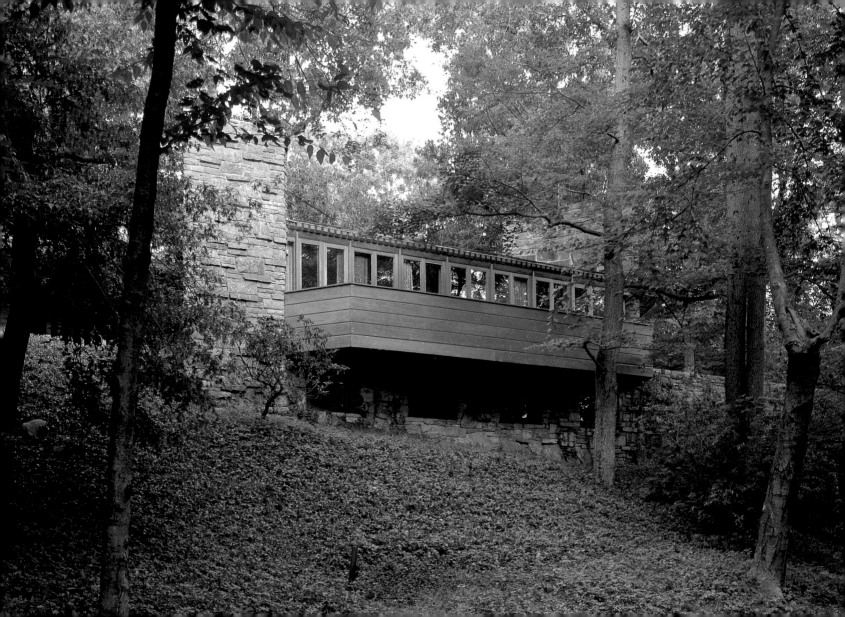

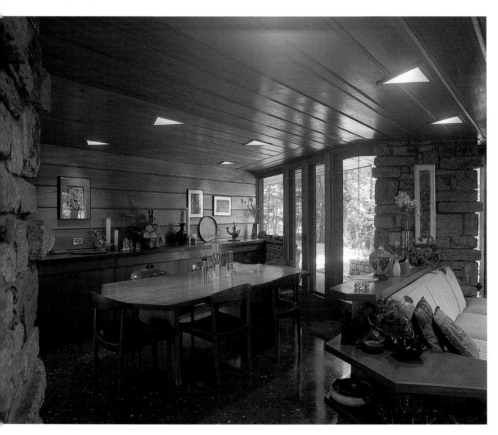

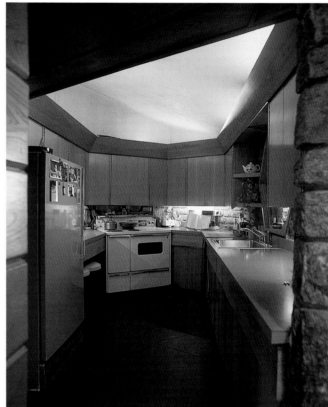

Opposite and above: Reisley House, Pleasantville, New York, 1951

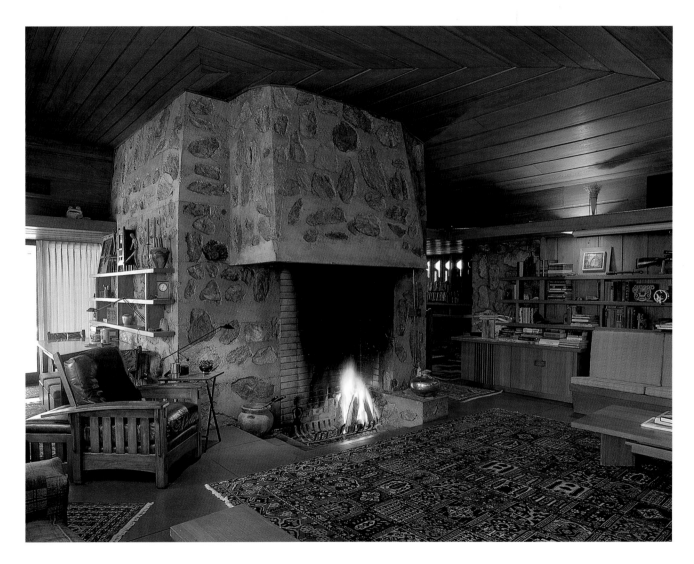

Above and opposite: Austin House, Greenville, South Carolina, 1951

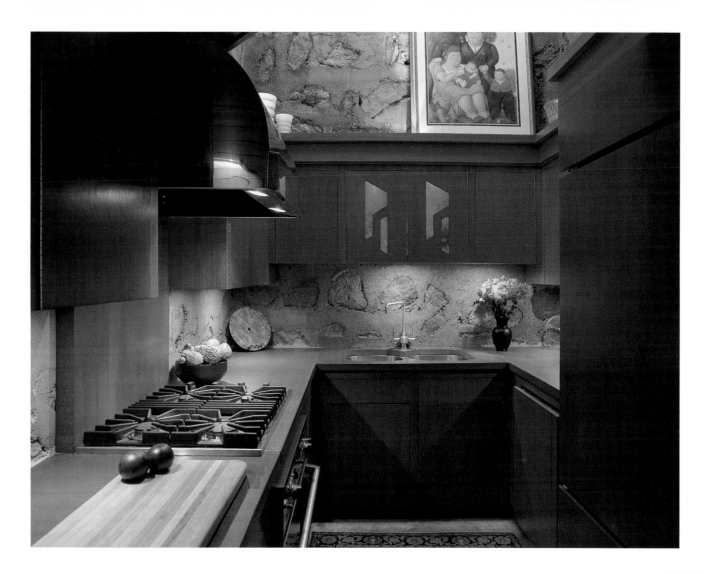

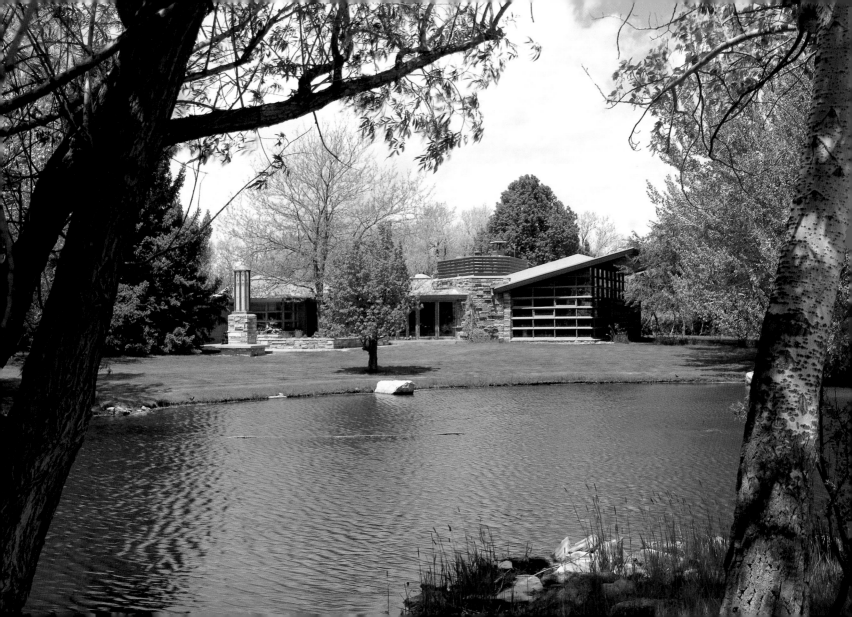

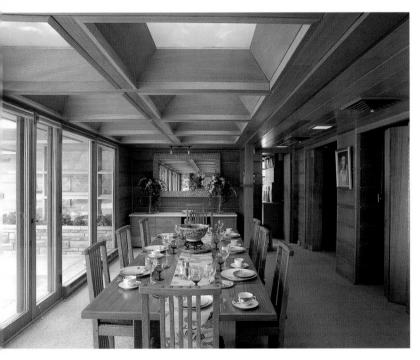
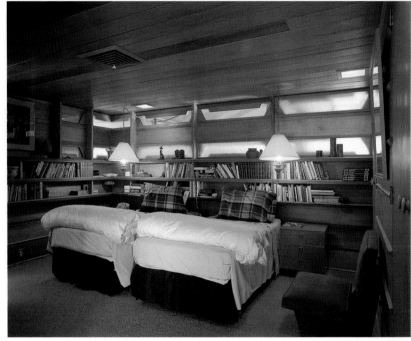

Opposite and above: Blair House, Cody, Wyoming, 1952

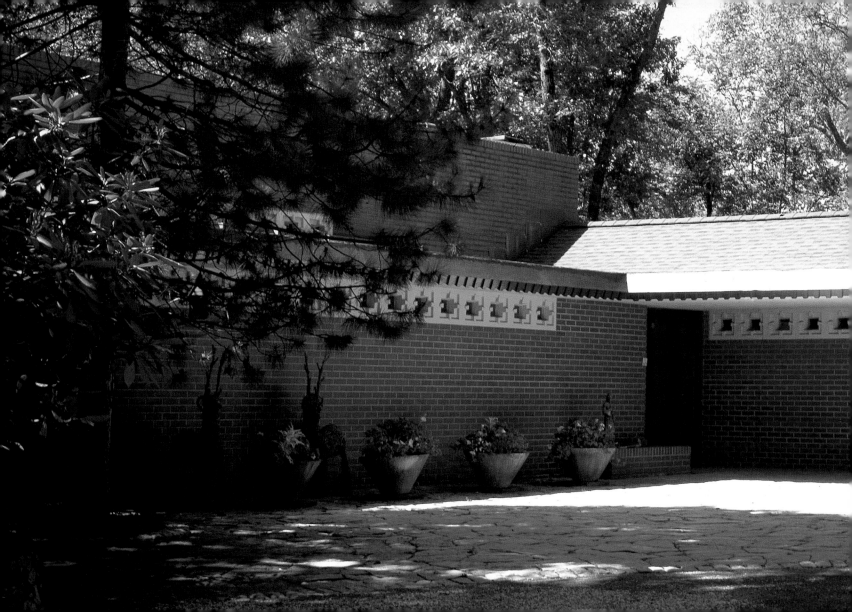

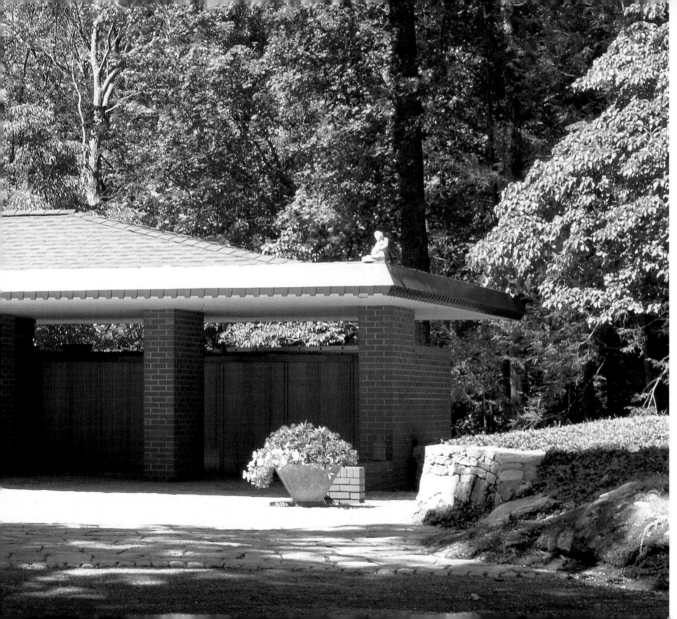

Left and following pages:
Sander House
(Springbough), Stamford,
Connecticut, 1952

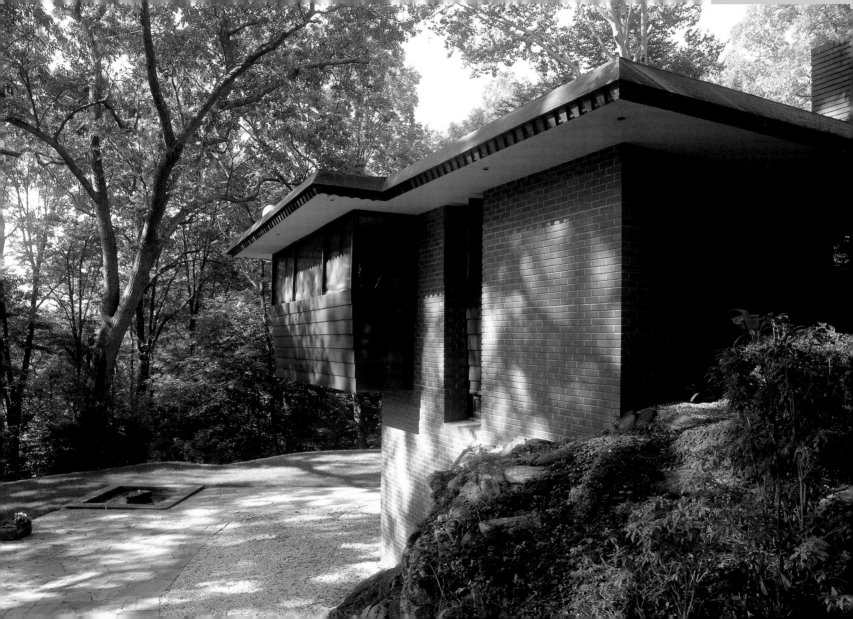

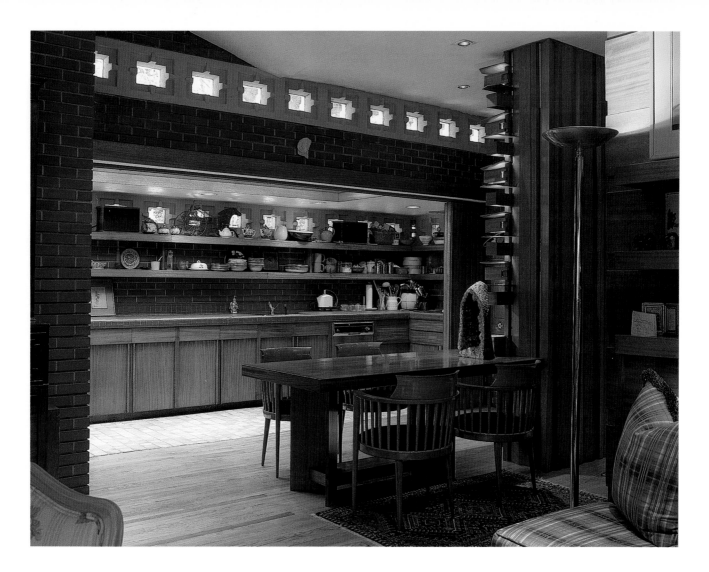

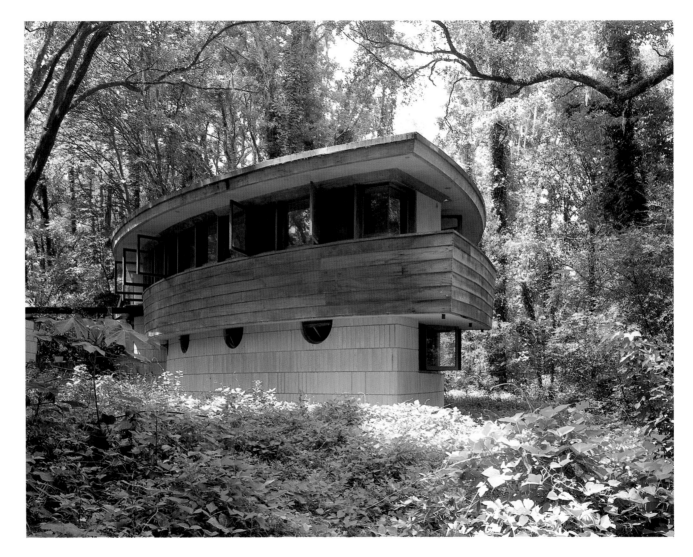

Above: George Lewis House (Spring House), Tallahassee, Florida, 1952; Opposite and following page: Greenberg House, Dousman, Wisconsin, 1954

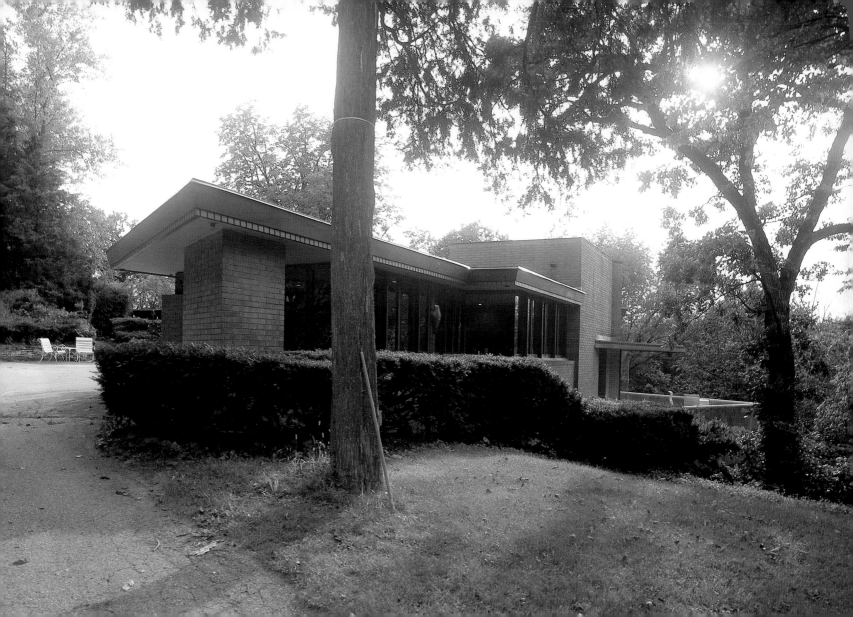

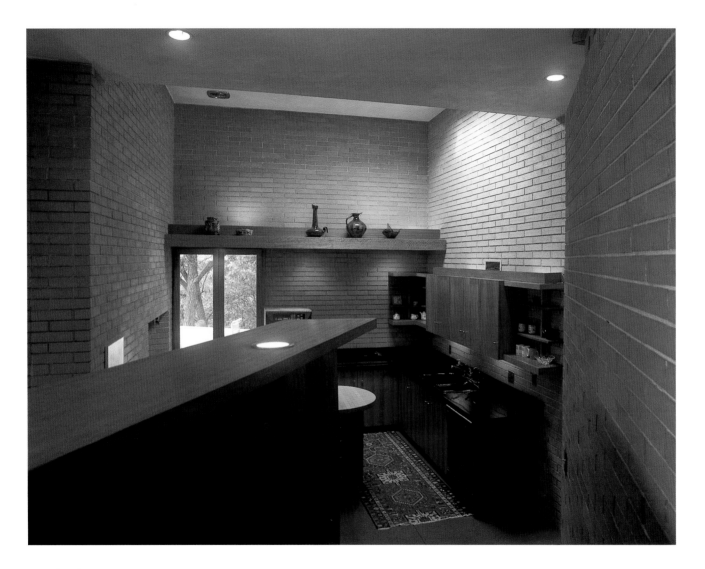

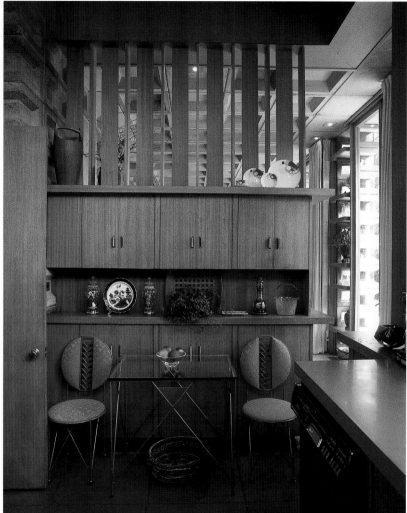

Above left: Hughes House (Fountainhead), Jackson, Mississippi, 1949; Above right: Tracy House, Normandy Park, Washington, 1954

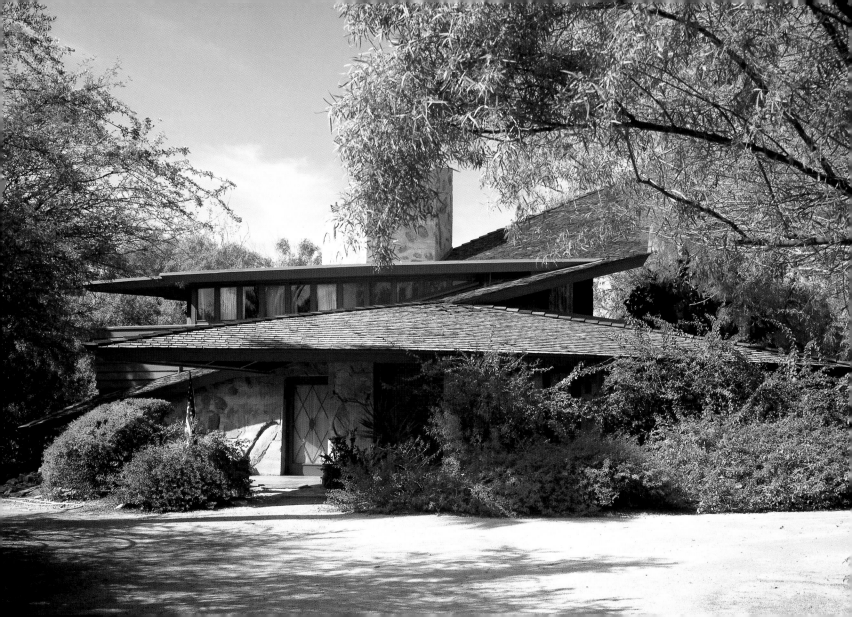

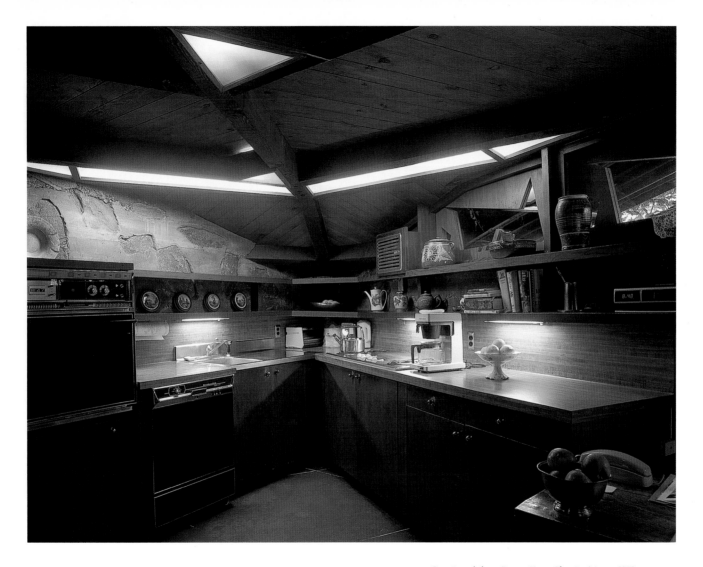

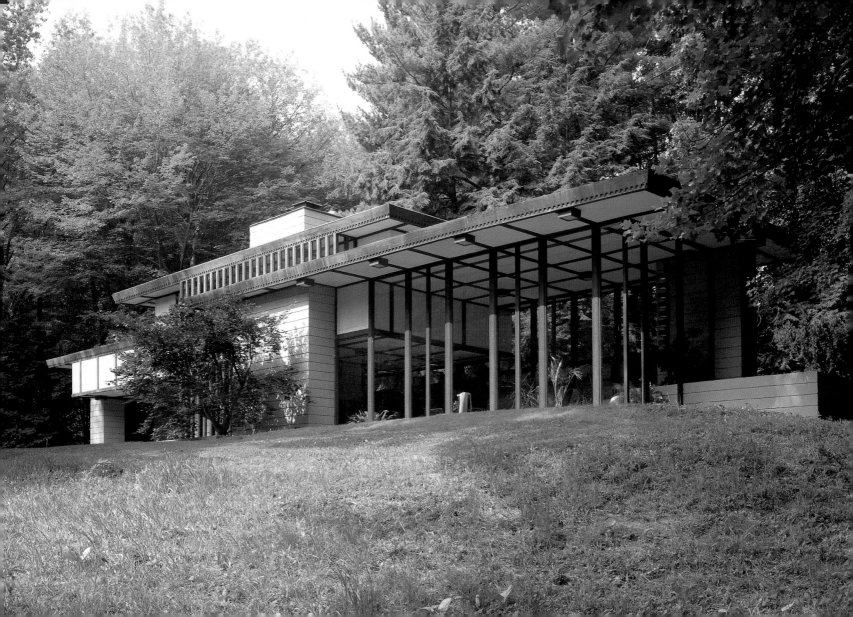

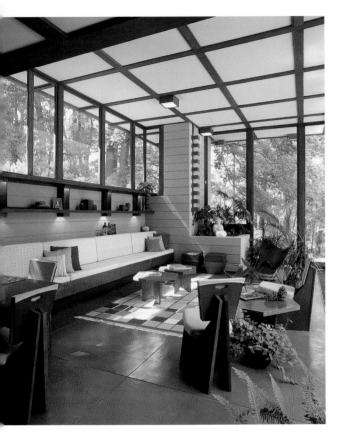

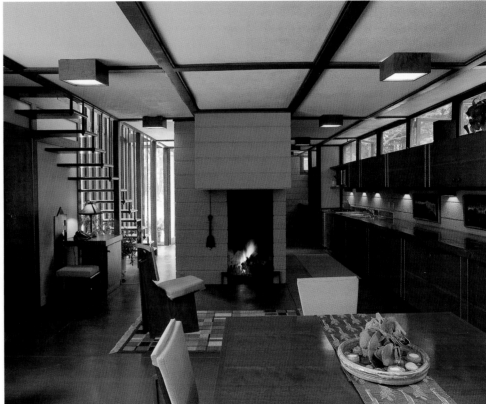

Opposite and above: Penfield House, Willoughby Hills, Ohio, 1952

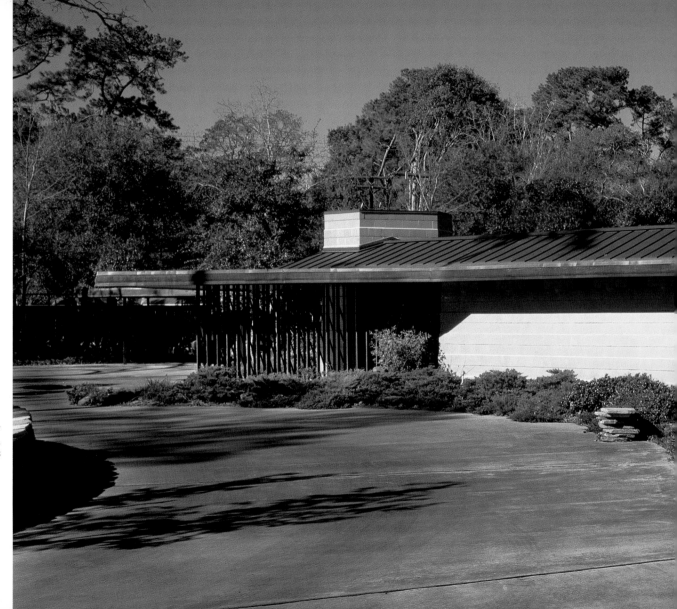

Right and following page:
Thaxton House,
Bunker Hill, Texas, 1953

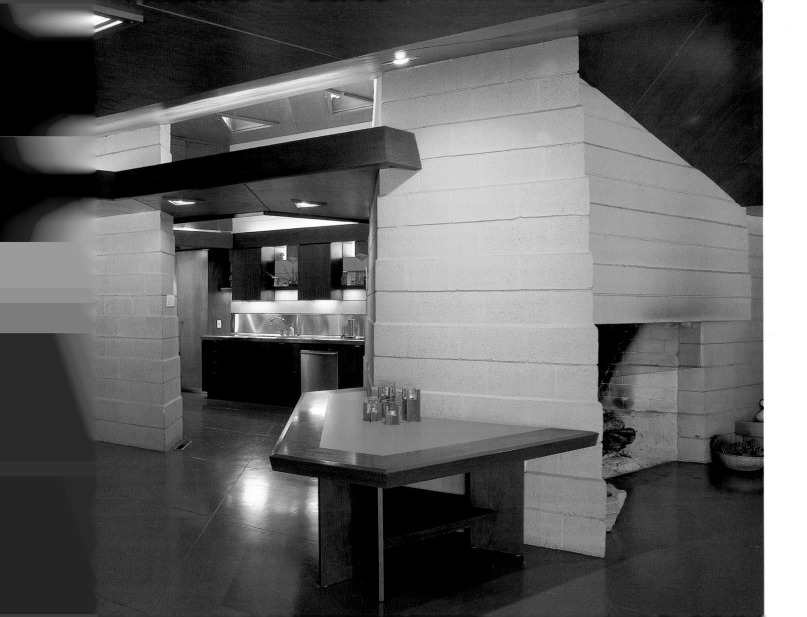

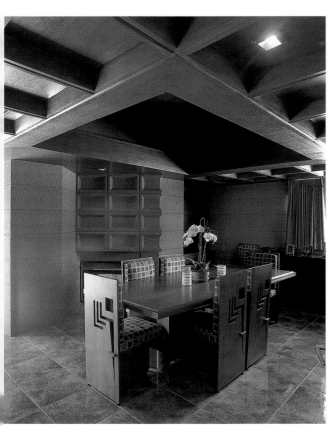

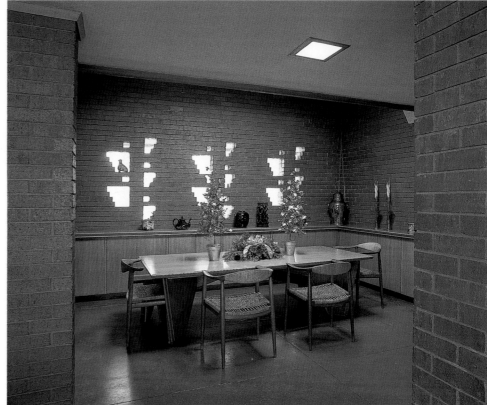

Above left: Benjamin Adelman House, Phoenix, Arizona, 1951; Above right: Kinney House, Lancaster, Wisconsin, 1951

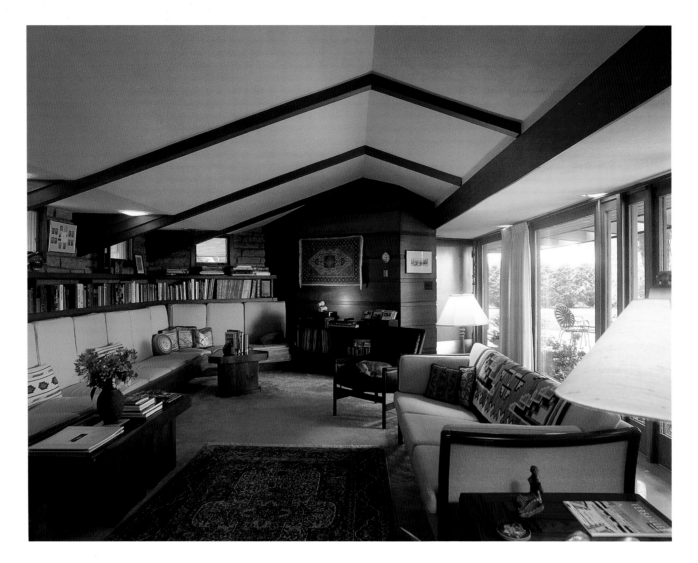

Above: Arnold House, Columbus, Wisconsin, 1954; Opposite: Christian House, West Lafayette, Indiana, 1954

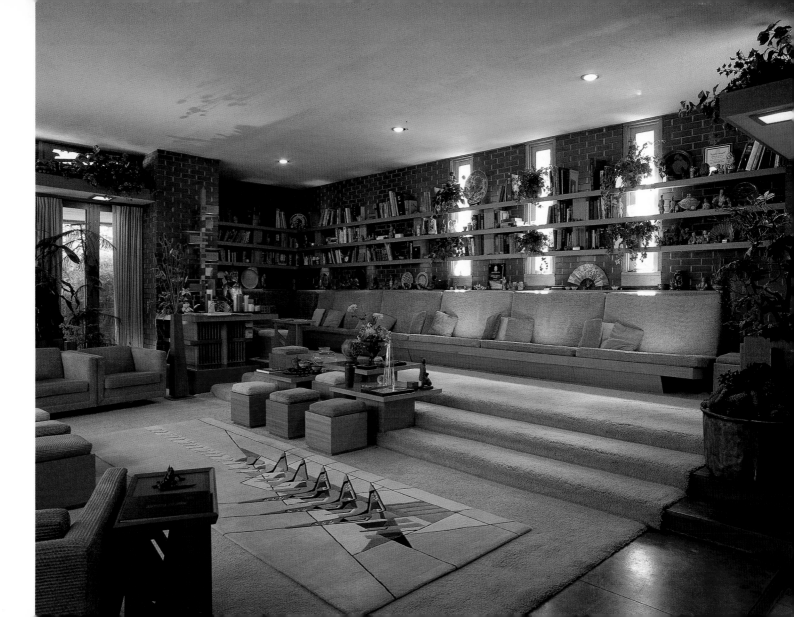

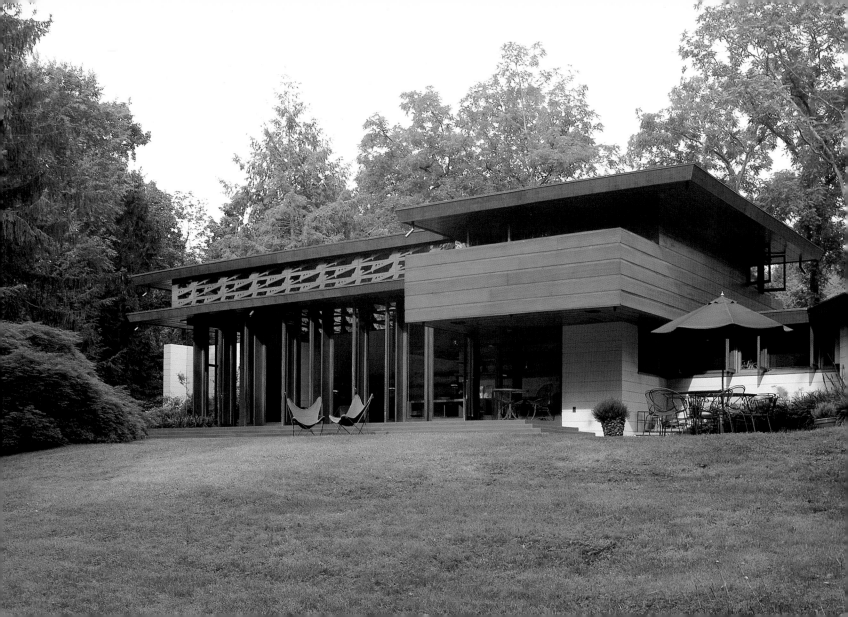

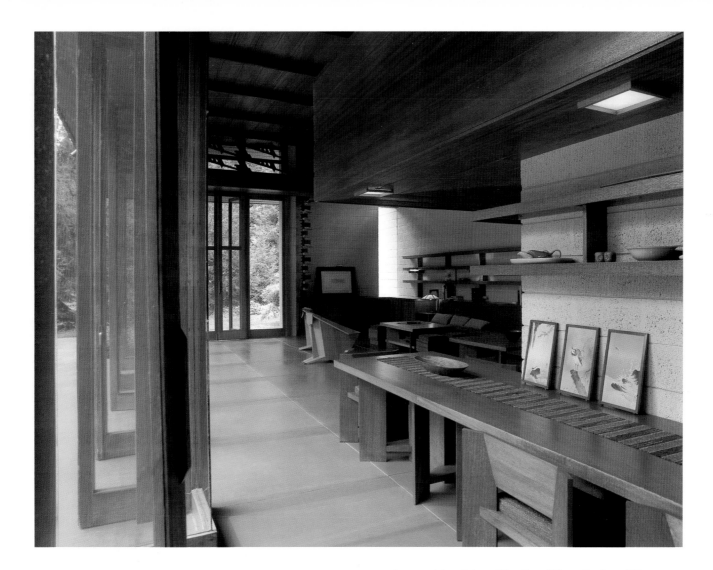

Above and right: Hagan House, Chalkhill, Pennsylvania, 1954

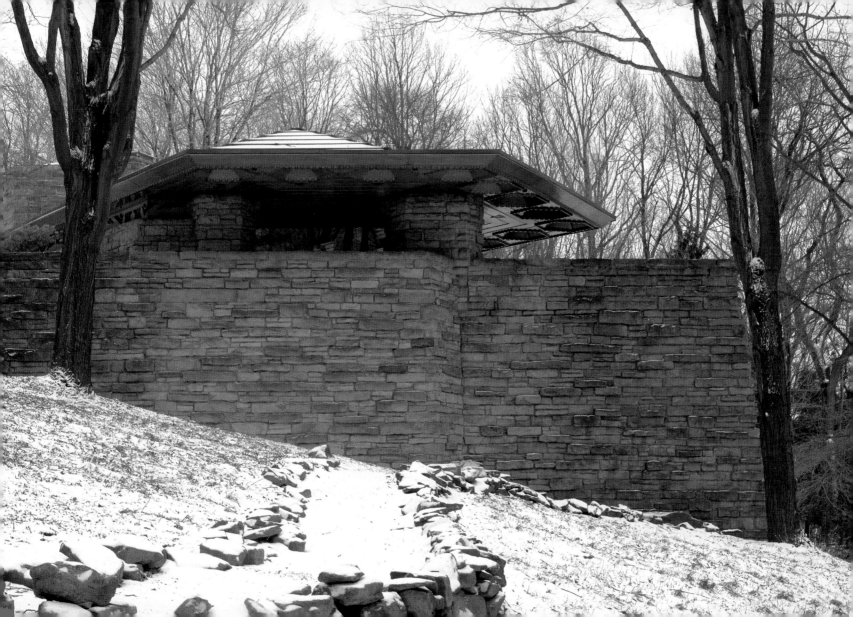

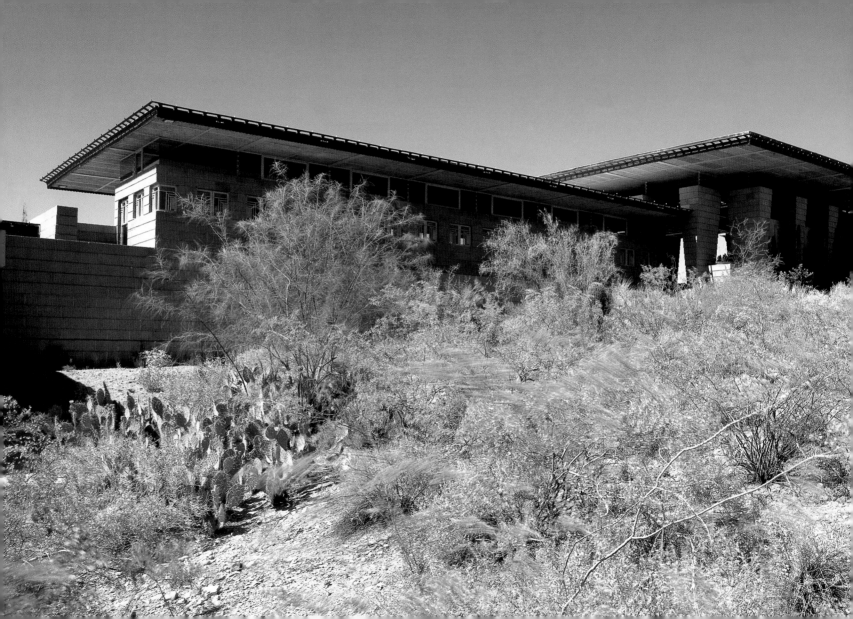

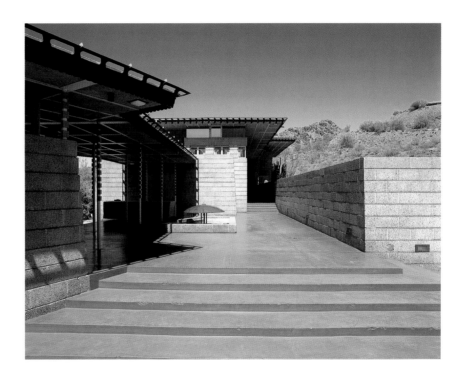

Left and above: Price Sr. House, Paradise Valley, Arizona, 1954 FOUR BUILDING USONIA **315**

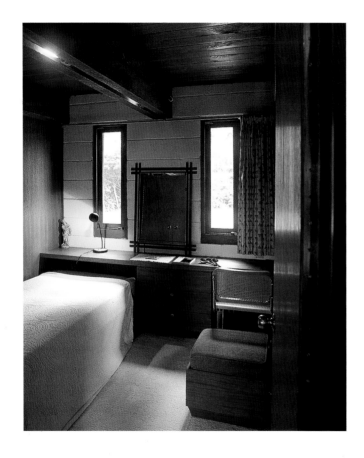

Above and right: Boulter House, Cincinnati, Ohio, 1954

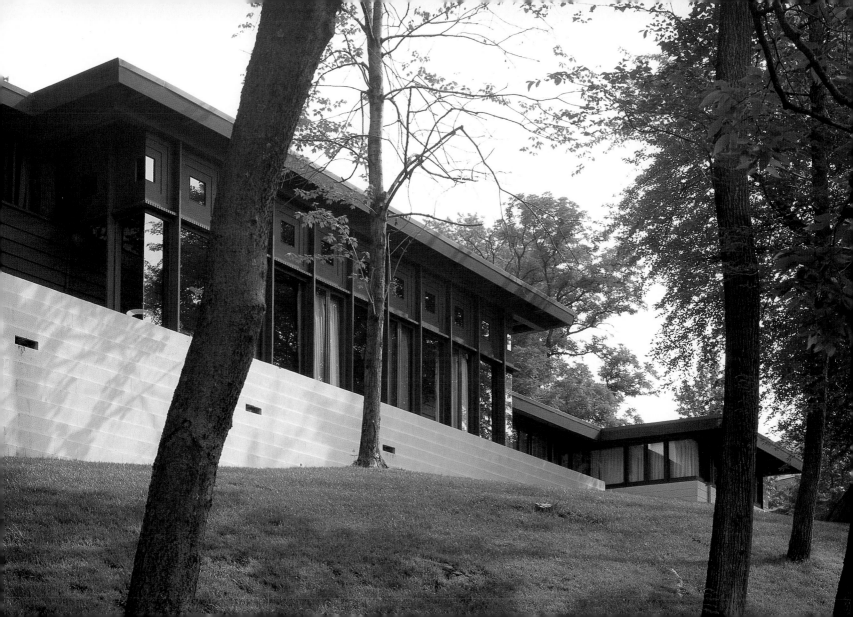

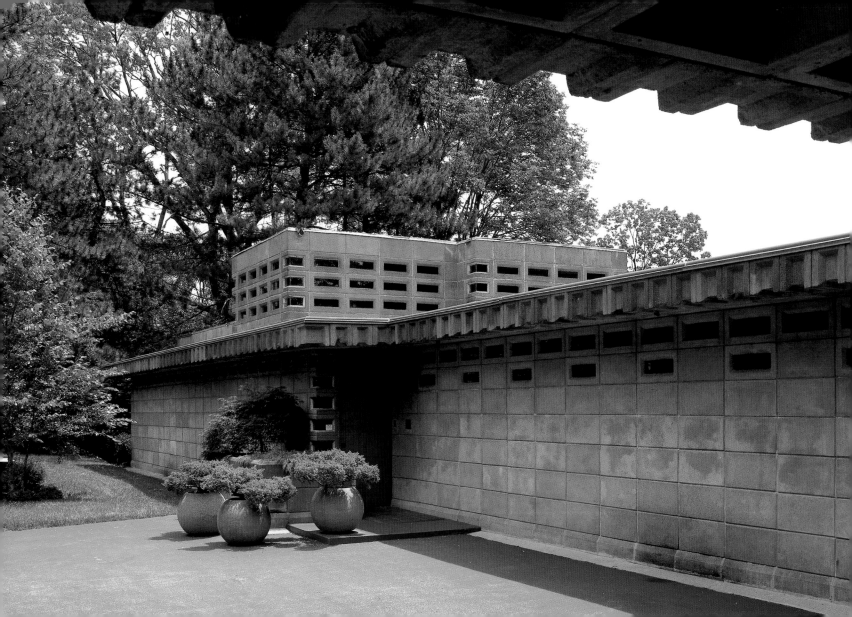

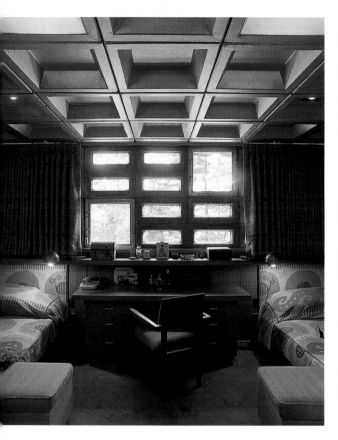

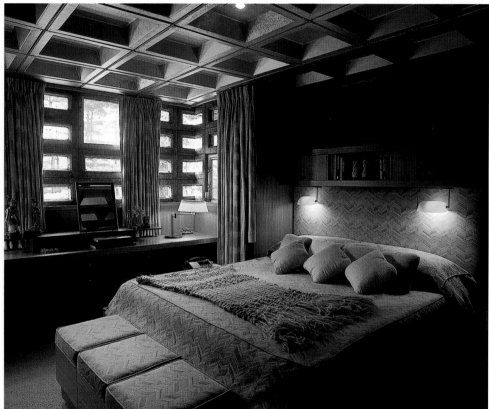

Opposite and above: Tonkens House, Amberley Village, Ohio, 1954

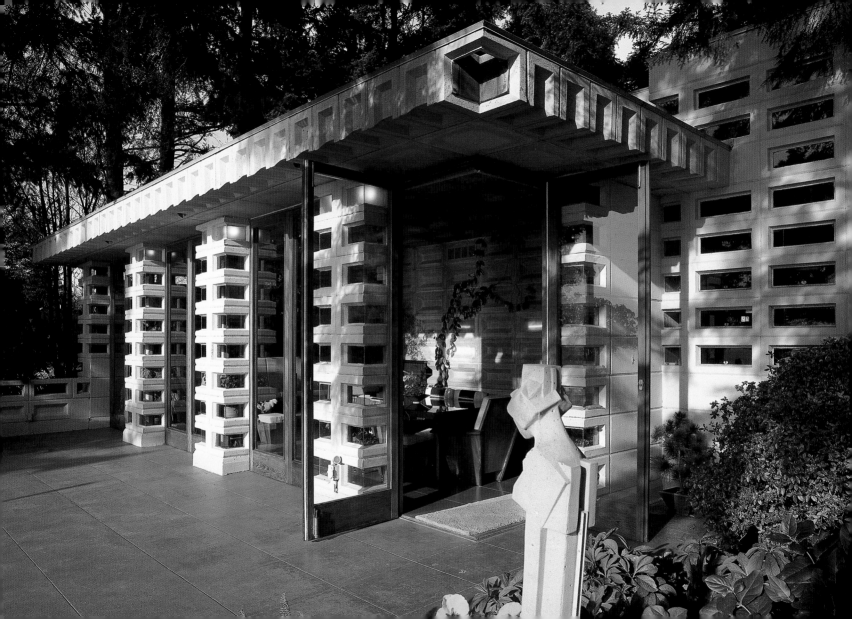

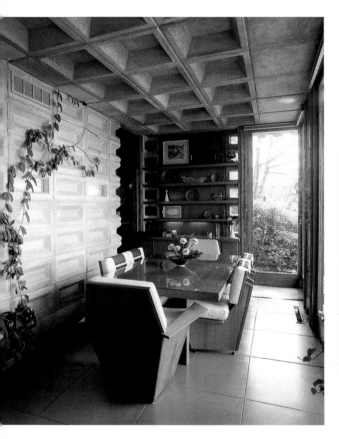

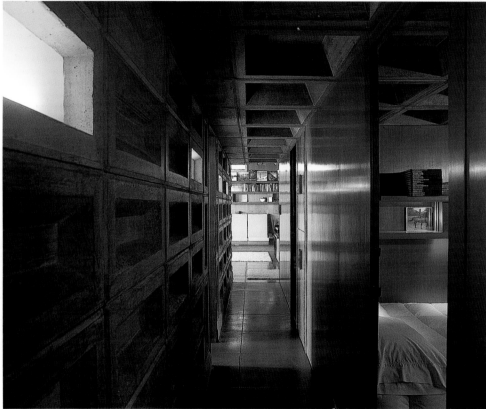

Opposite and above: Tracy House, Normandy Park, Washington, 1954

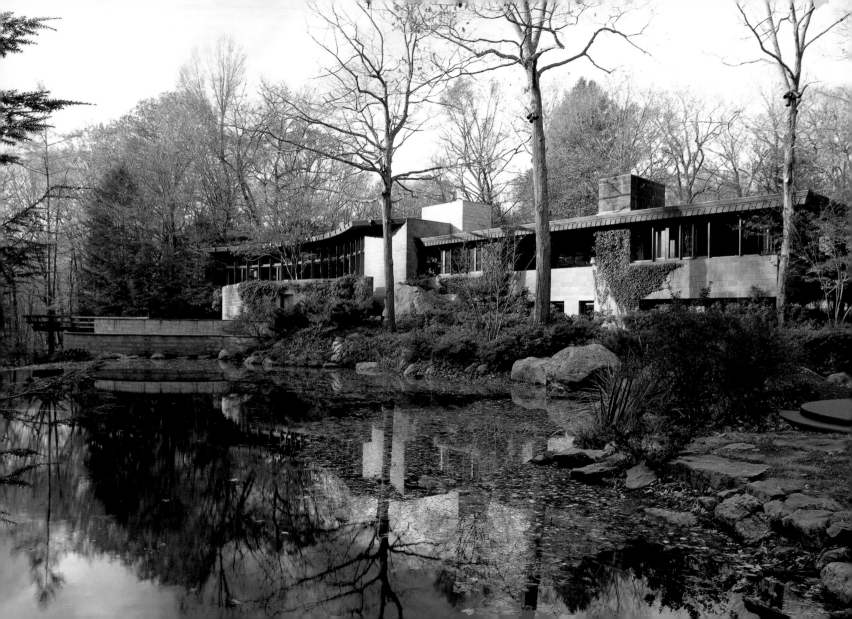

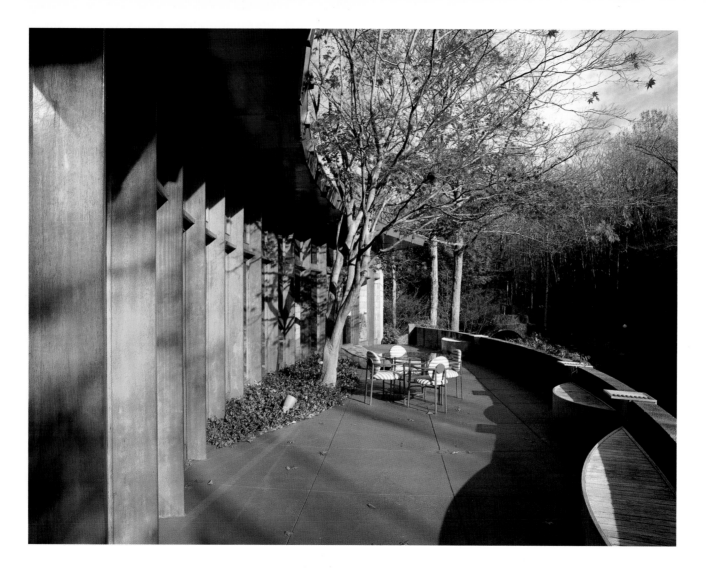

Opposite, above, following pages, and pages 326–327: Rayward House (Tirranna), New Canaan, Connecticut, 1955

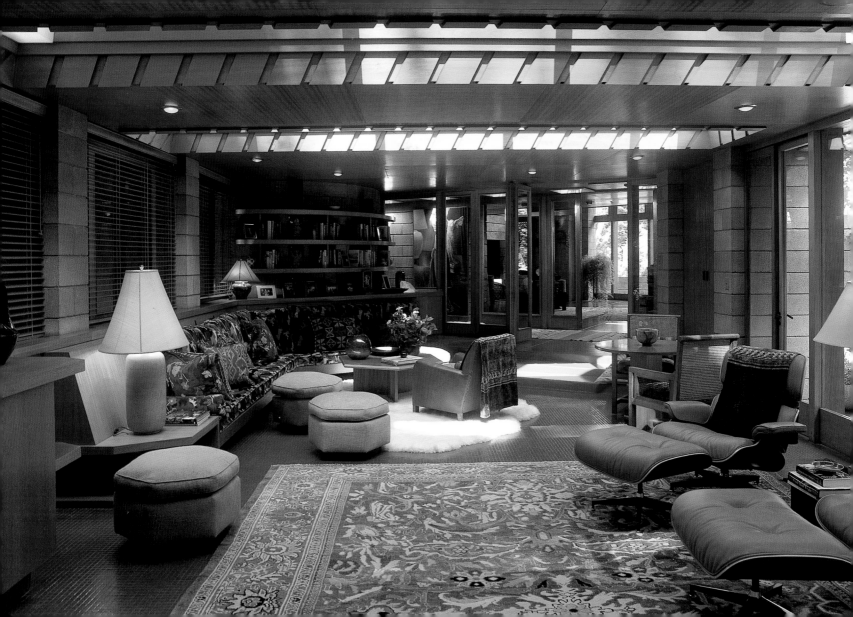

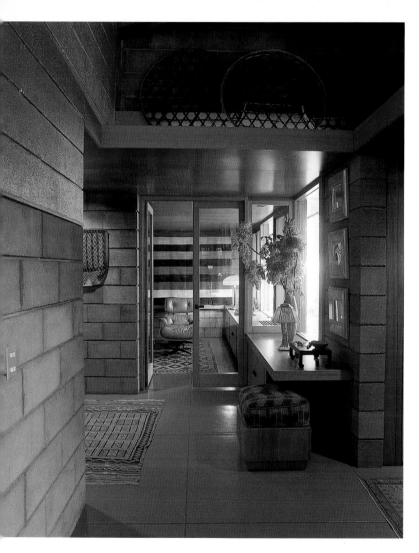

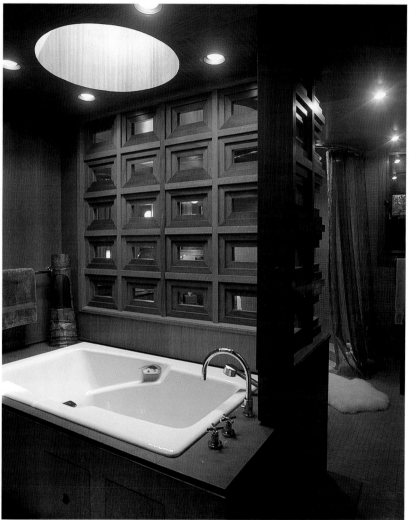

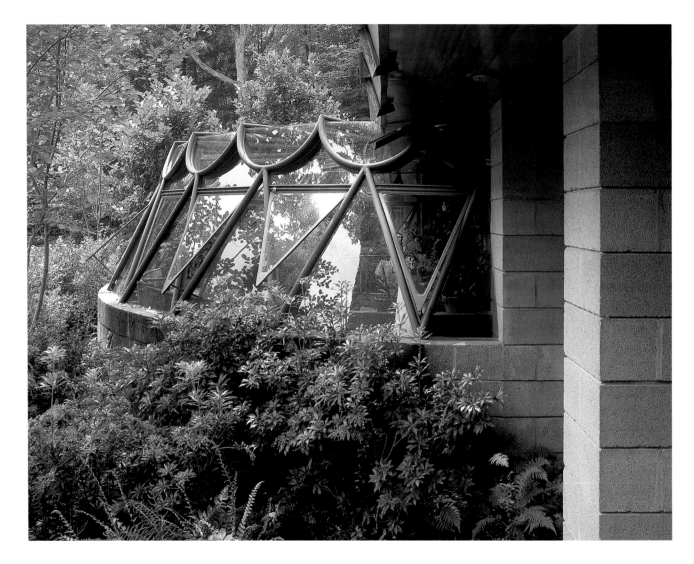

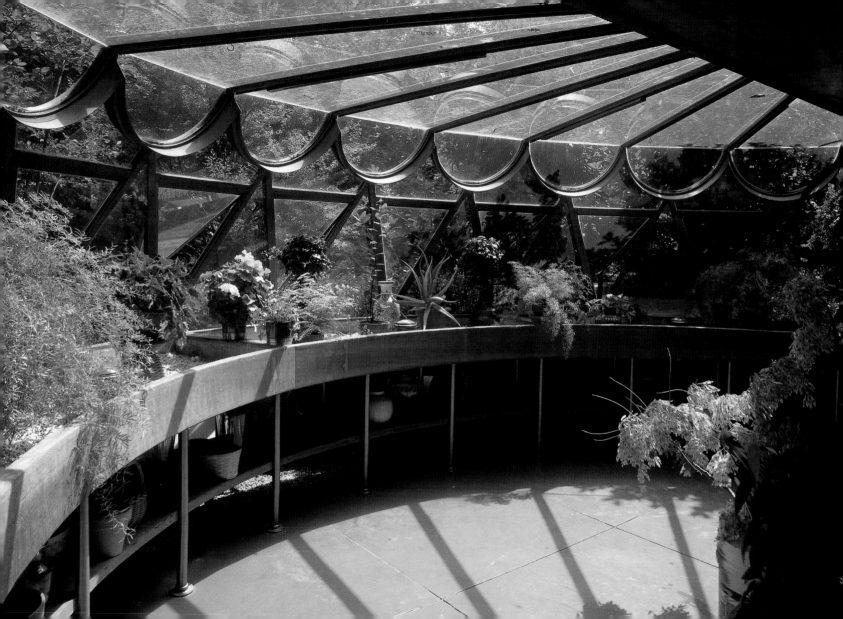

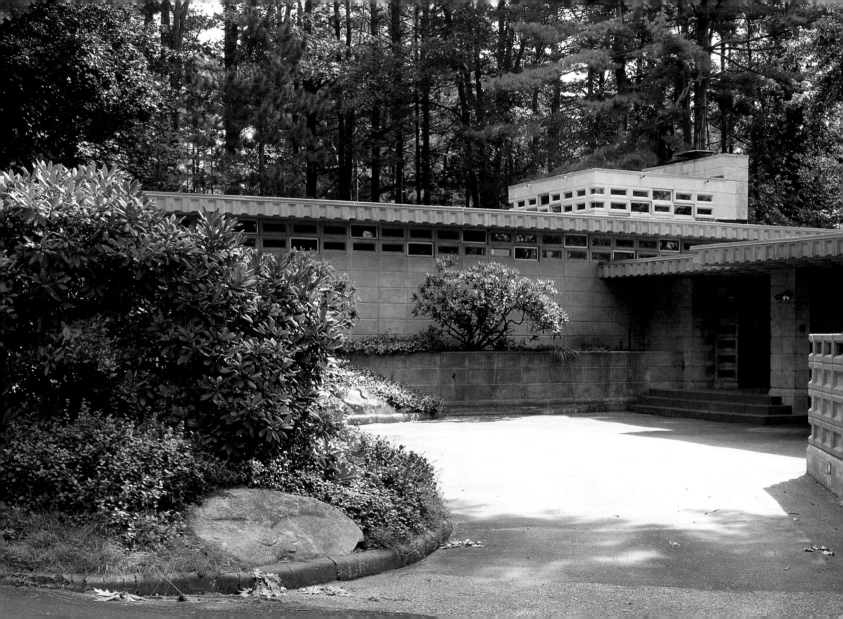

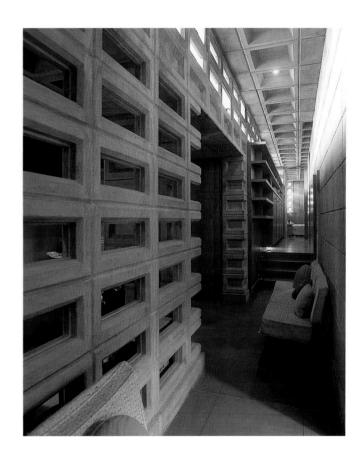

Left and above: Kalil House, Manchester, New Hampshire, 1955

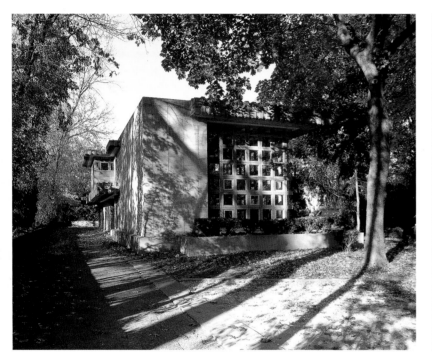

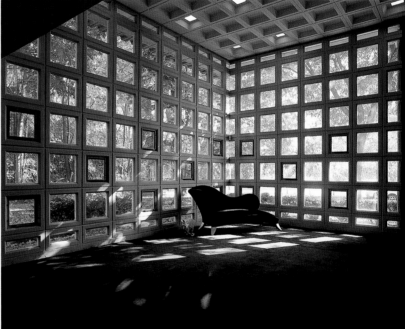

Above and opposite: Turkel House, Detroit, Michigan, 1955

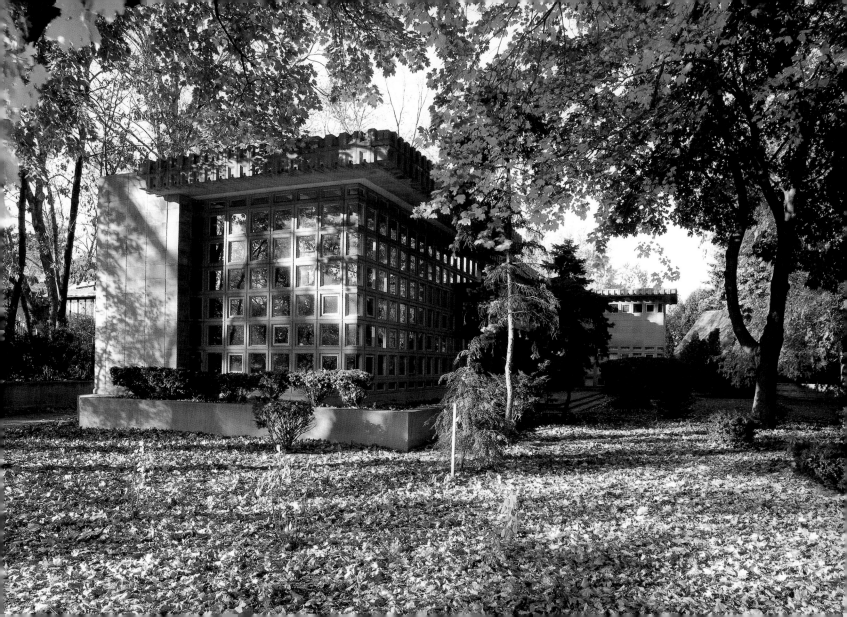

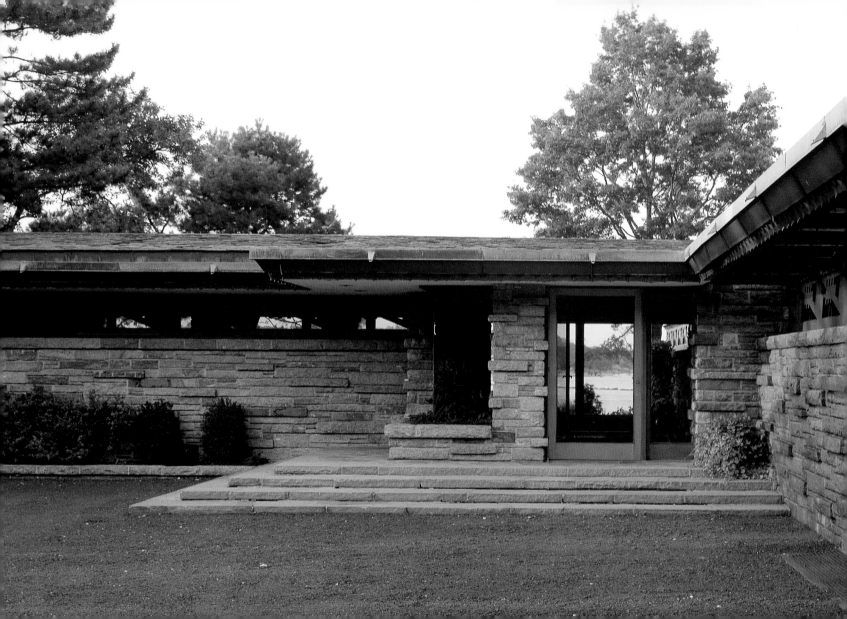

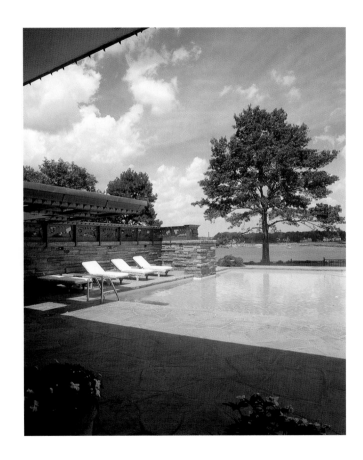

Left and above: Hoffman House, Rye, New York, 1955

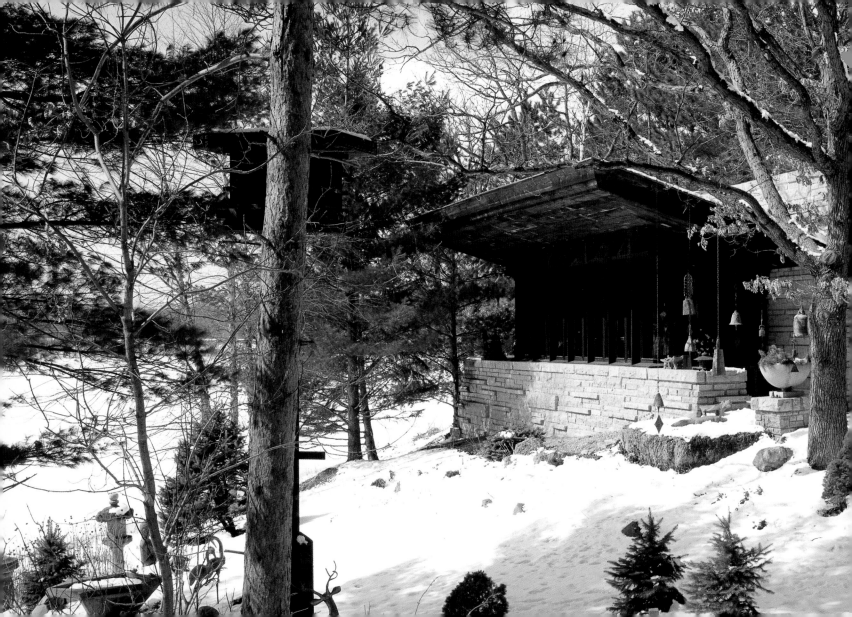

Left and following pages:
Lovness Cottage,
Stillwater, Minnesota, 1958

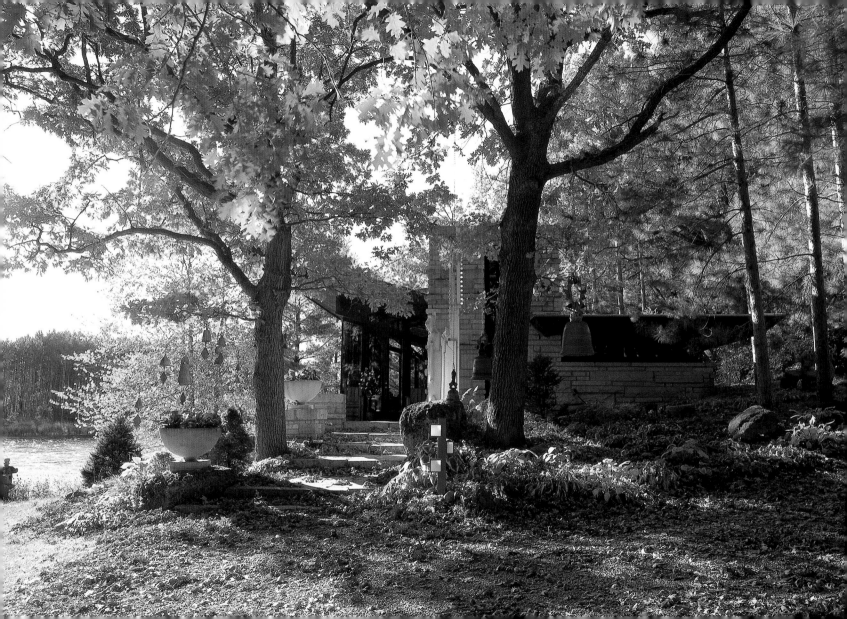

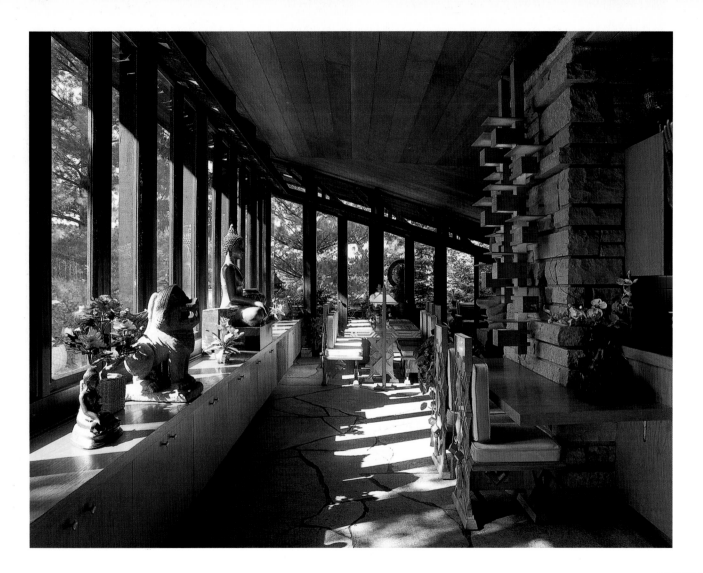

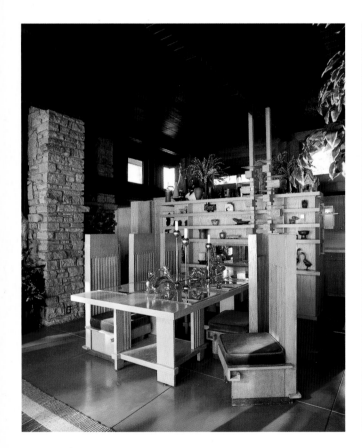

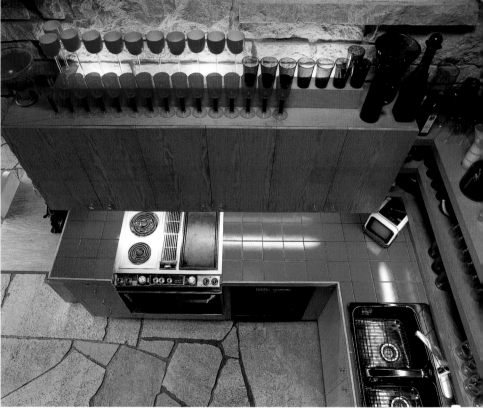

Above and opposite: Lovness House, Stillwater, Minnesota, 1955

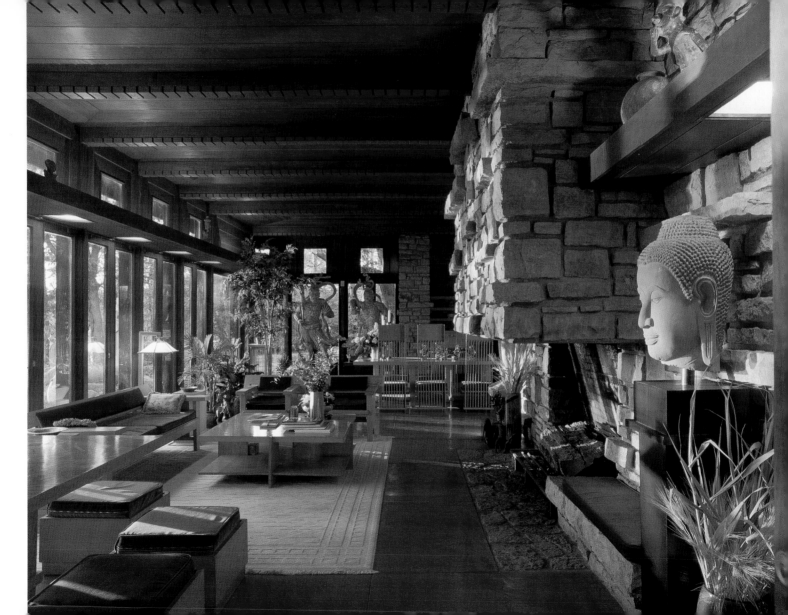

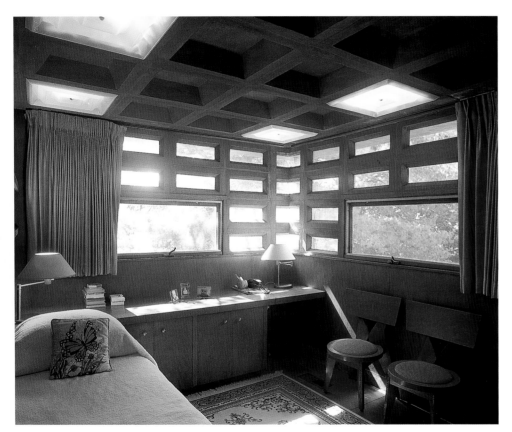

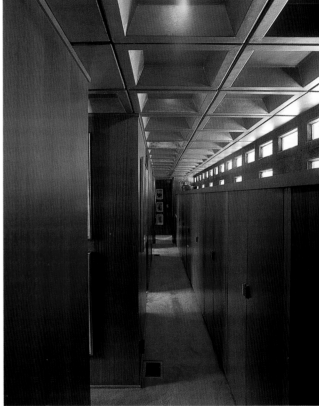

Above and opposite: Pappas House, St. Louis, Missouri, 1955

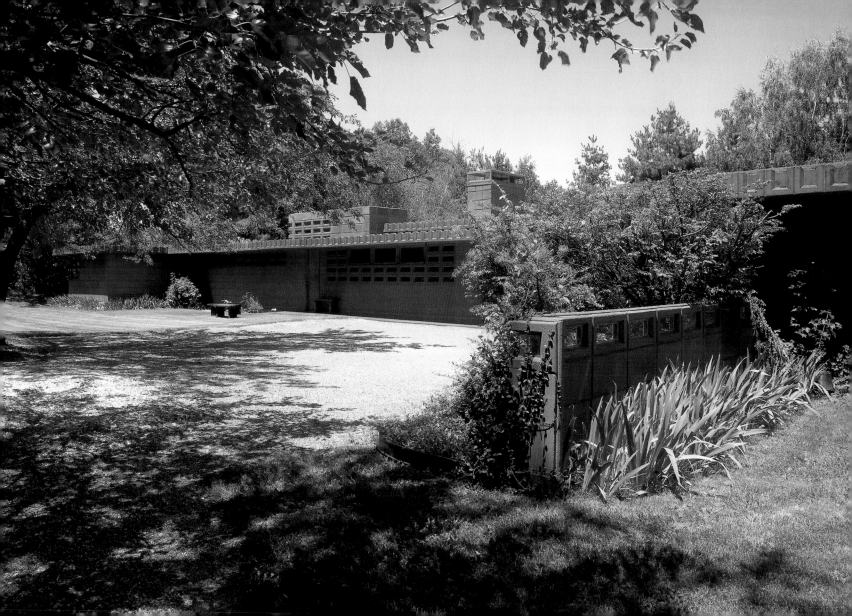

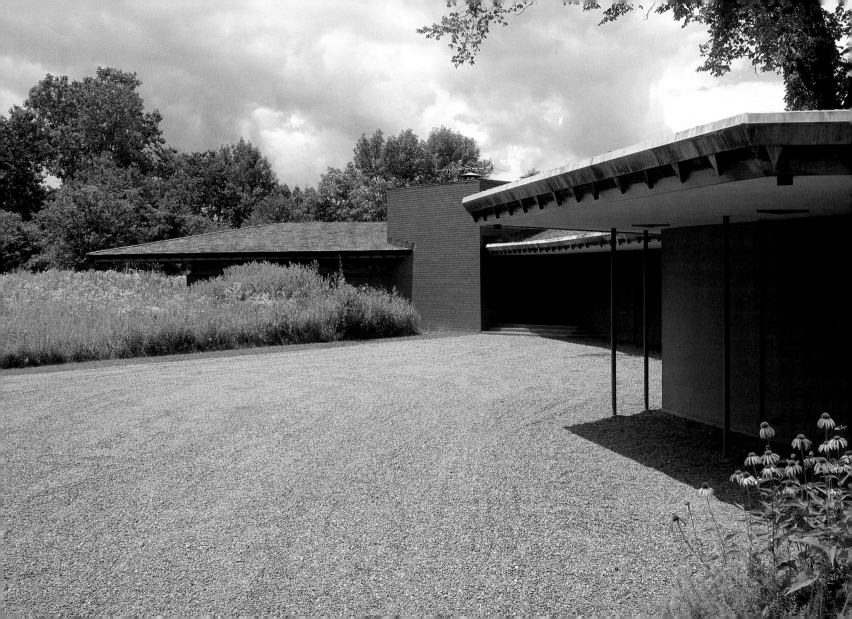

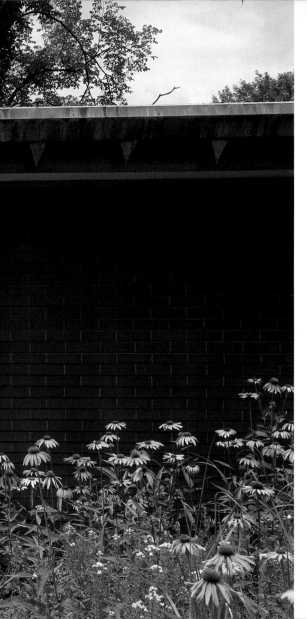

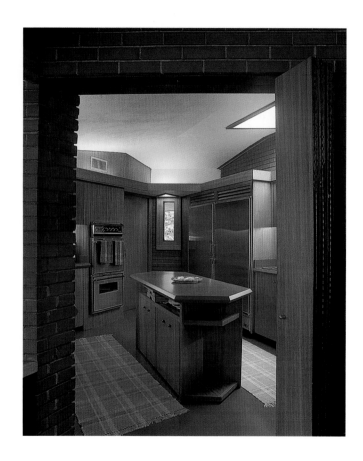

Left and above: Friedman House, Bannockburn, Illinois, 1956

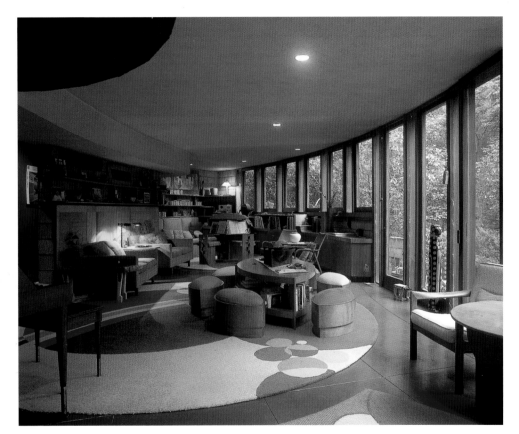

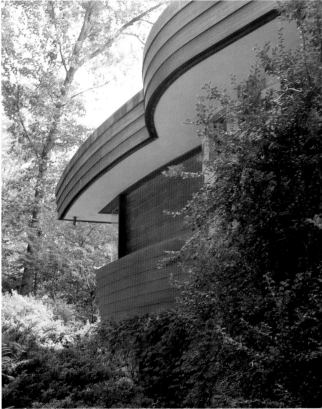

Above and opposite: Llewellyn Wright House, Bethesda, Maryland, 1956

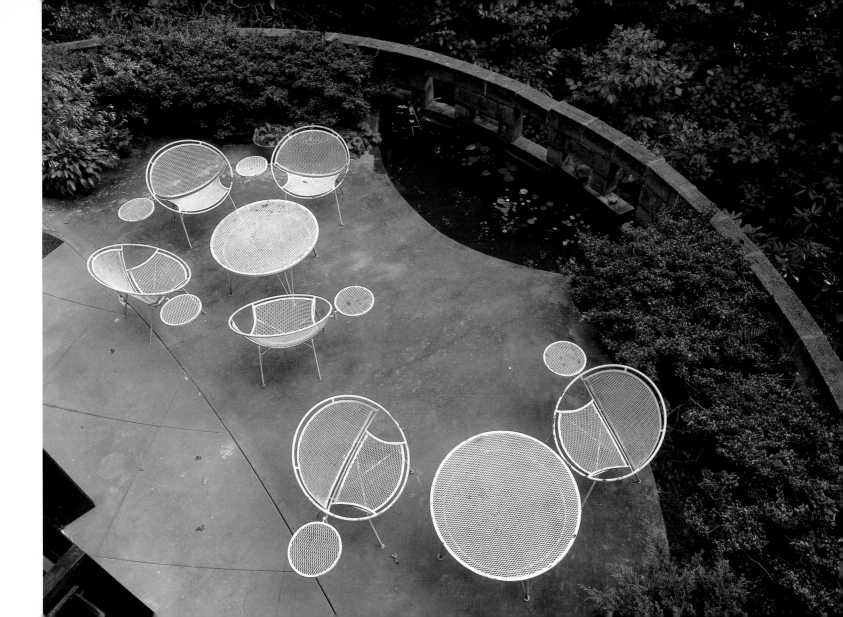

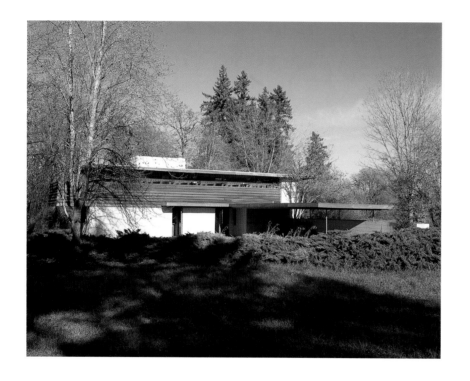

Above and right: Gordon House, Wilsonville, Oregon, 1956

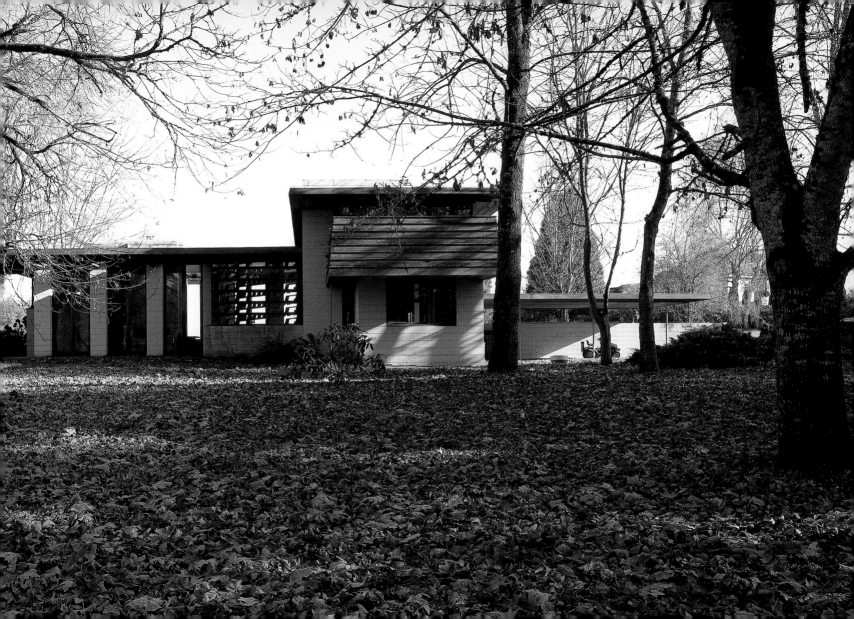

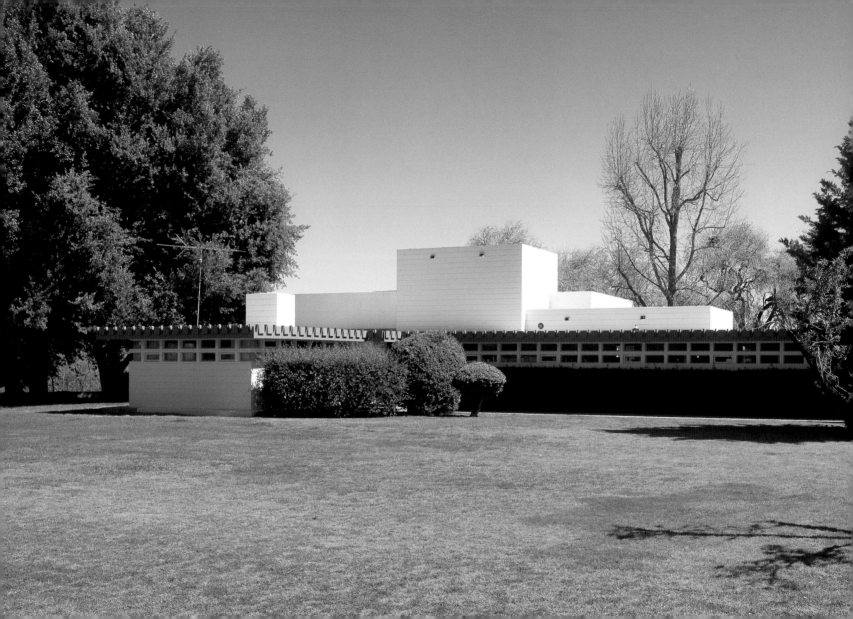

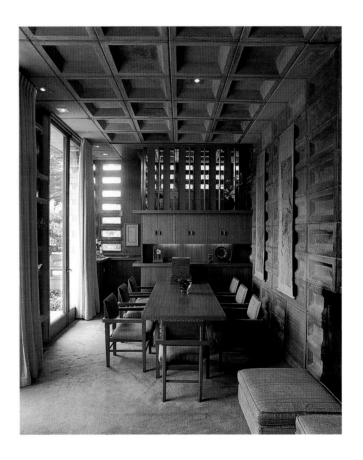

Left and above: Walton House, Modesto, California, 1957

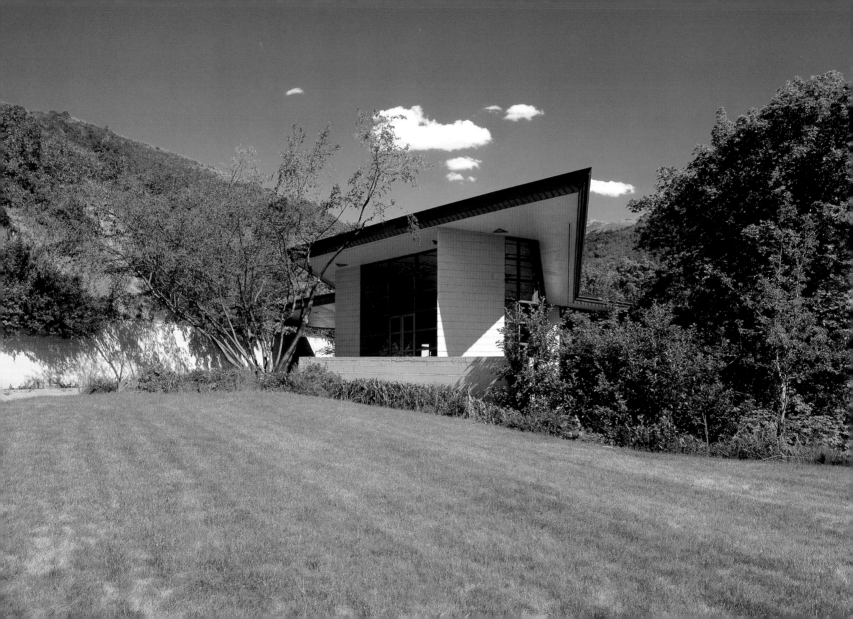

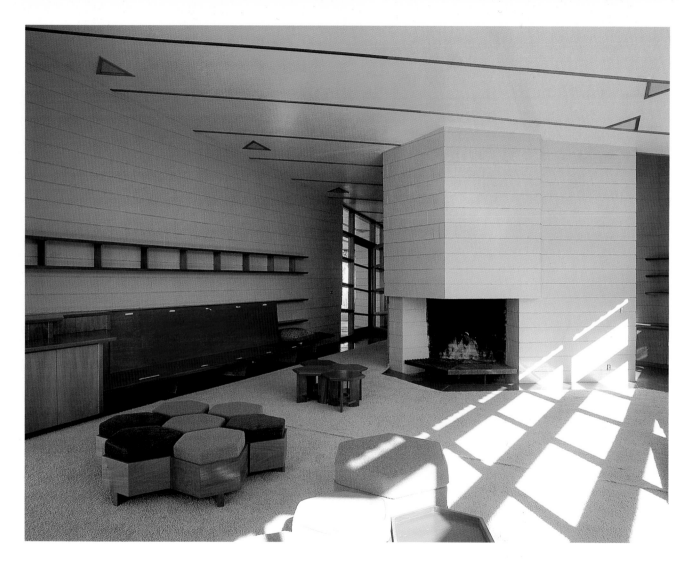

Opposite and above: Stromquist House, Bountiful, Utah, 1958

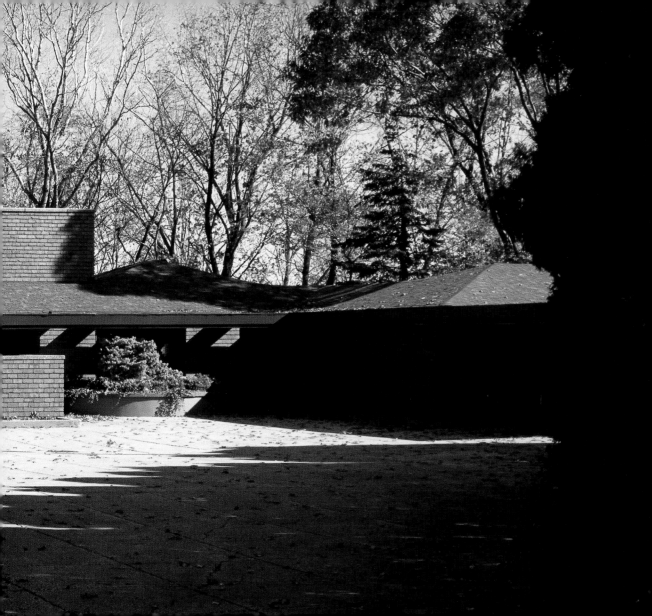

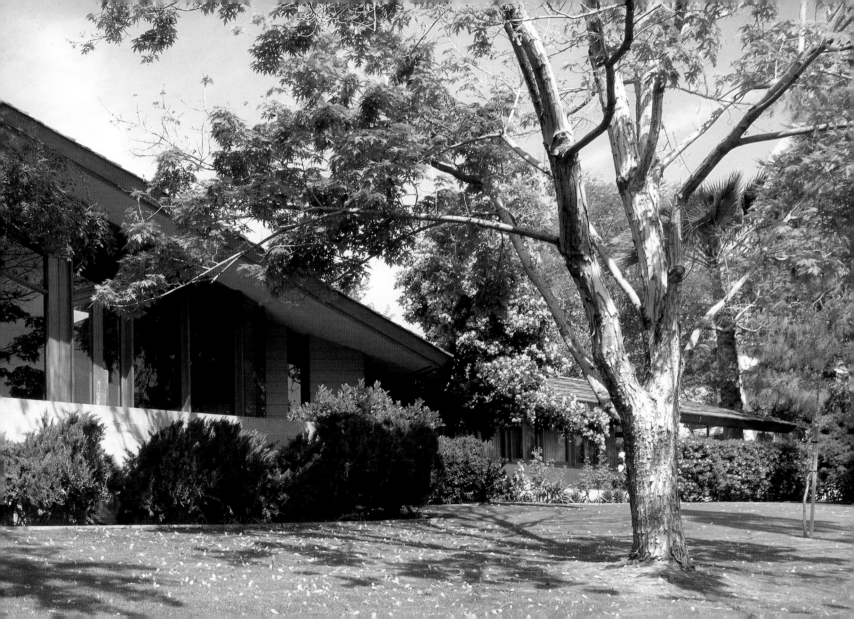

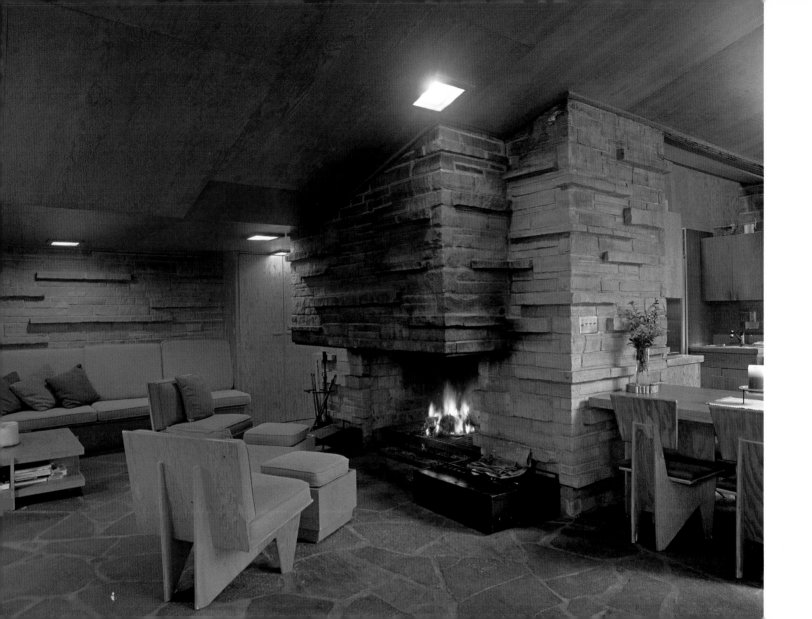

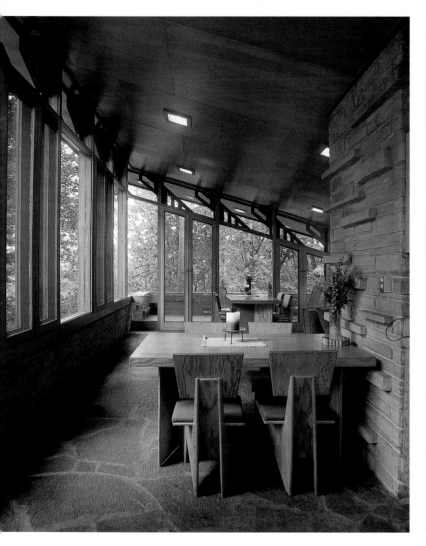

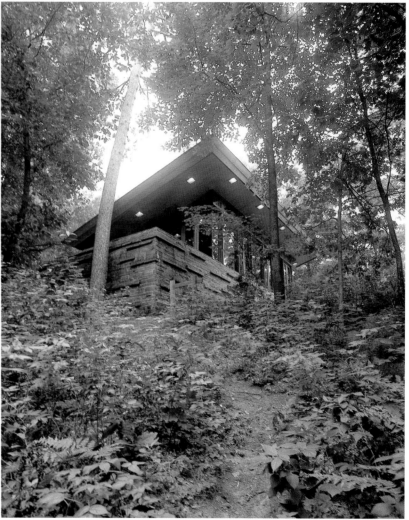

Opposite and above: Peterson Cottage, Lake Delton, Wisconsin, 1958

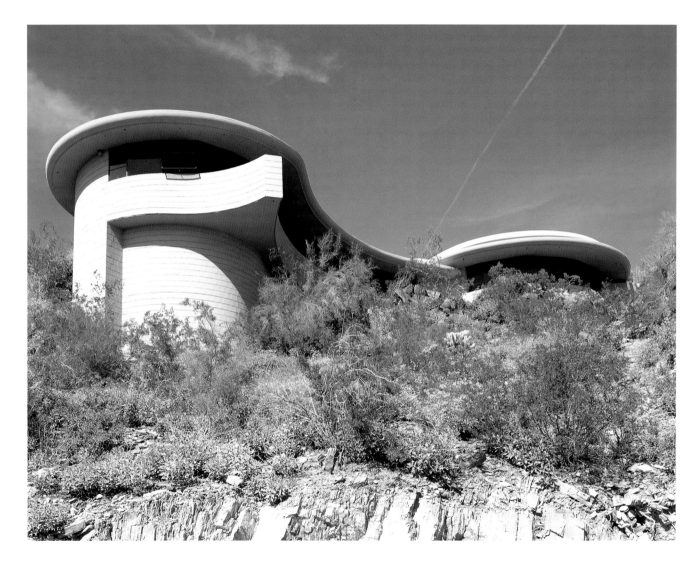

Above and opposite: Lykes House, Phoenix, Arizona, 1959

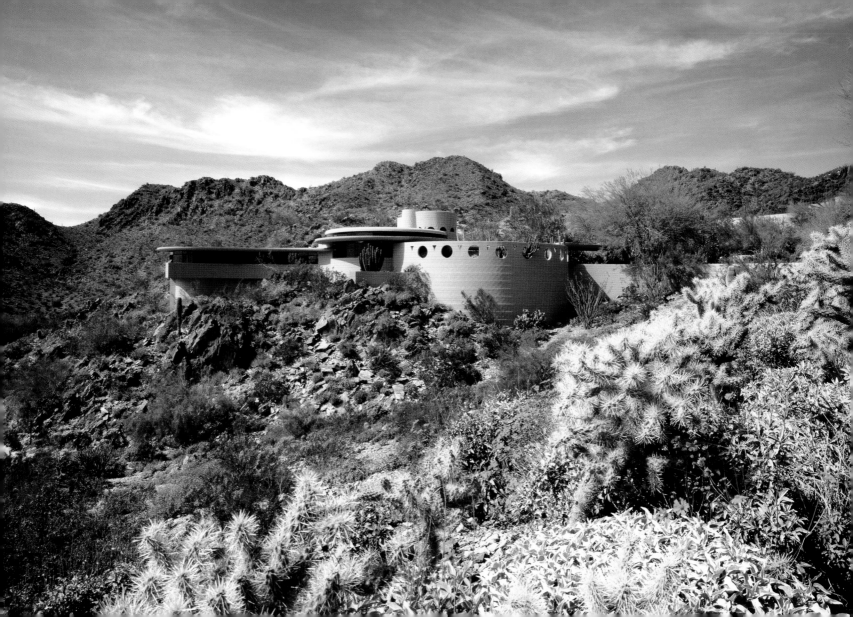

FIVE:

LEAVING A LEGACY
1948–1959

During the post–World War II building boom, as Frank Lloyd Wright entered his late eighties, he finally had the opportunity to concentrate on monumental public buildings because his studio was swamped with jobs of all kinds. The final years provided him with commissions for sacred architecture, for example, Beth Sholom Synagogue and the Annunciation Greek Orthodox Church; and a modern art museum for the collector Solomon R. Guggenheim; but, in addition, he, at last, was recognized by an American government and given the job to design a civic center in northern California. The Marin County Civic Center allowed him to realize in built form beliefs about democracy that had been central tenets of three of his most important books, *The Disappearing City* (1932), *When Democracy Builds* (1945), and *The Living City* (1957). The masterworks of this period bring to fruition formal ideas and sophisticated engineering theories that he had explored as far back as the 1920s.

Beth Sholom Synagogue stands on a slight rise in Elkins Park, Pennsylvania, not far from Philadelphia. It is a prominent landmark in the neighborhood with its luminous walls glowing against the sky, and with its prominent seven-branched menorots visible on the three main ridges of its roof. A sandwich wall—glass panels outside and fiberglass panels inside—

creates a translucent skin that makes the building appear to be filled with light, an effect that is intensified when it is viewed from the exterior at night. The six vertical planes rise up to create an irregular hexagon, a shape that evokes a mountain, indeed, the holy mountain of Mt. Sinai, a potent symbol for the Jewish people. It is necessary to go back to Wright's unbuilt projects of the 1920s to find anything comparable—his daring 1928 design for a Steel Cathedral for one hundred thousand people.

While Beth Sholom was still in construction, Wright received the commission for the Annunciation Greek Orthodox Church to stand on a flat site in the suburbs of Milwaukee, Wisconsin. His enthusiasm for the subject was linked to his early passionate interest in ancient Byzantine churches such as Hagia Sophia in Istanbul, a building that to Wright was transcendent with its resplendent dome and gold-leaf mosaic ceilings. Like Beth Sholom, the symbolic form of the Greek Orthodox Church was made possible by his mastery of advanced structural engineering, in this case, reinforced concrete rib and shell construction.

It was an ironic turn of events that Wright's grandest monumental design would be built in New York City, the subject of many of his fiercest diatribes against high-density urbanism. There is nothing quite like the Guggenheim Museum in

any of Wright's oeuvre, certainly not any of his public buildings of the 1950s, the reason being that the commission originated in 1943 when he was first approached by Hilla Rebay, the chief art adviser to Solomon R. Guggenheim, part-heir to a huge nineteenth-century mining fortune. Yet there are connections to Wright's early work. Both the bi-nuclear plan and the use of reinforced concrete as the primary material evokes Unity Temple; creating an analogy to an ancient building form—in this case, the ziggurat—recalls the archaic associations of the Imperial Hotel; but the sculptural weight and play of light and space is uniquely its own.

The main rotunda was conceived as a huge upended vessel with a ramp spiraling down from a centrally placed translucent glass dome. The museum visitor was instructed to take the elevator to the top, and then proceed to view the art collection in a downward circular motion, pausing at each level to gain insight and cosmic awareness, thereby arriving back on the ground a more enlightened individual than before. Throughout its thirteen years of design development and three years of construction, the Guggenheim Museum was subject to numerous alterations demanded by the clients and the New York building inspectors. In its completed form, Wright's original idea was intact, but the loss of crucial details is to be regretted.

Toward the end of his life, it seems clear that Wright wanted to leave a visible legacy in the form of government buildings for the capitals of his home states—Wisconsin and Arizona. However, his designs for Monona Terrace in Madison and the "Oasis" State Capitol in Phoenix were both rejected by the political establishment. By contrast, he received a warmer reception when he was asked to do a host of structures including an Administration Building, Hall of Justice, Post Office, Veterans' Auditorium and county fairgrounds in Marin County, California. It was one of the largest concentrations of public buildings in Wright's career, surpassed only by Florida Southern College in Lakeland.

In sympathy with the principles of Broadacre City, the civic center was to be built on acreage bordering a great arterial highway—an enormous site consisting of a series of rolling oak-covered hills adjacent to marshlands. The main structure—combining the Administration Building and the Hall of Justice—was conceived as two bridges spanning the hills and meeting under a domed rotunda. The main organizing feature of the Civic Center was not based on a geometric plaza of axes and grids, but a romantic landscaped setting with one prominent feature: a water course beginning in a central pool beneath the rotunda, spilling over as a stream, and meandering down the hillside until

it met a large man-made lagoon that Wright had created from the existing marshlands. He strove to emphasize the natural beauty of the site. He explained to his clients, "The good building is not one that hurts the landscape but is one that makes the landscape more beautiful than it was before that building was built." By April 1959, the master plan had been approved by the clients, with working drawings yet to commence when Wright died. Construction proceeded posthumously on the main building until its completion in 1970.

Throughout his life nature was Wright's great inspiration, but even here he tried to penetrate to general principles. Beyond the particular case of each client's requirements, he strove to construct the ideal form. Toward the end of his life he went beyond such institutions as church, college, and local government to find the archetype. As he becomes more and more a part of the historical record, his modernity means less and less. It is the timelessness of his work that continues to endure.❖

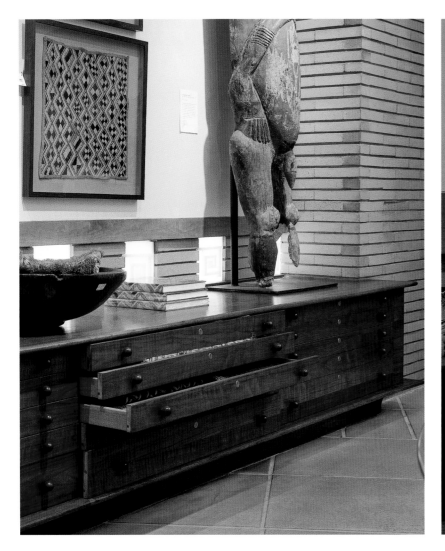

Above and opposite: V. C. Morris Gift Shop, San Francisco, California, 1948

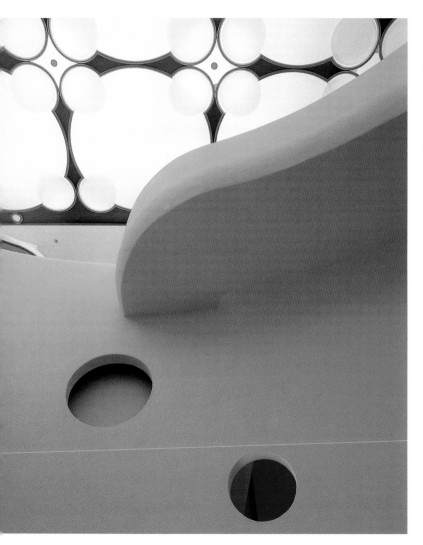

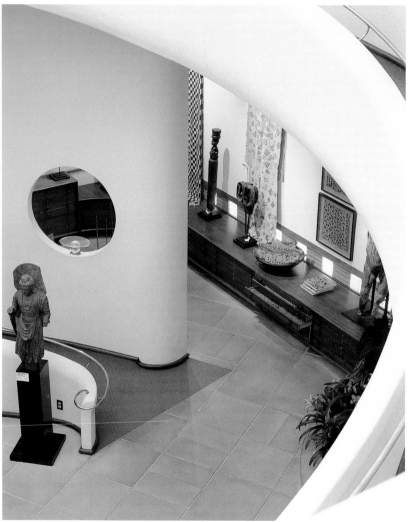

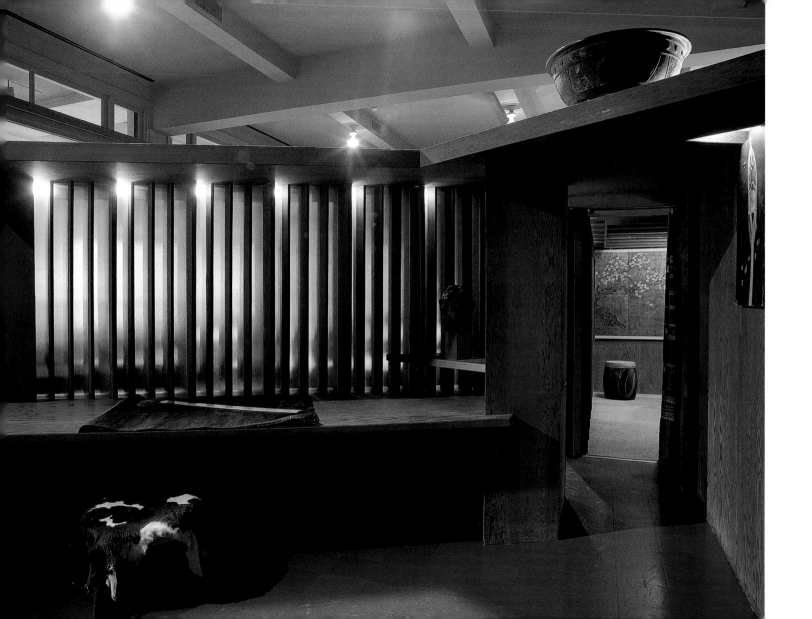

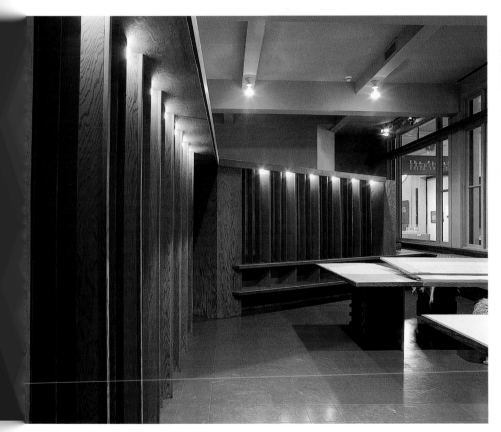
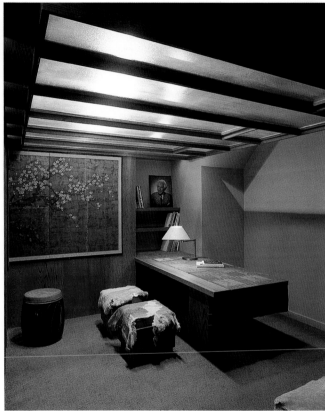

Opposite and above: Frank Lloyd Wright Field Office, San Francisco, California, 1951

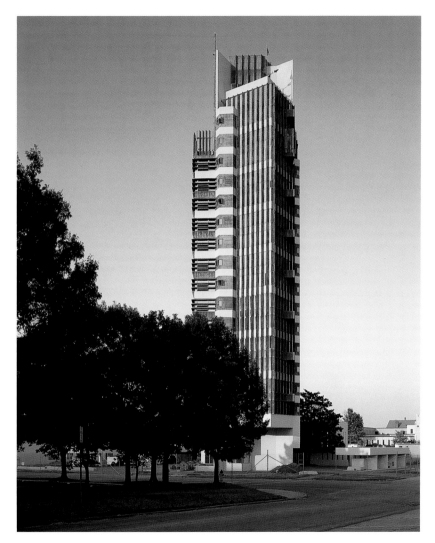
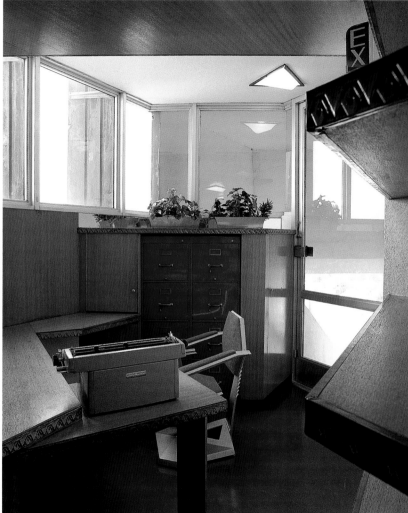

Above and opposite: Price Tower, Bartlesville, Oklahoma, 1952

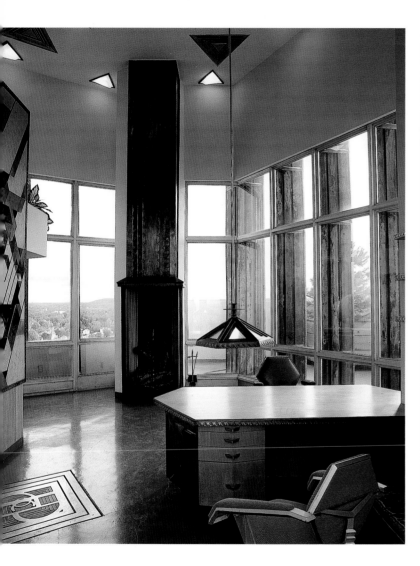

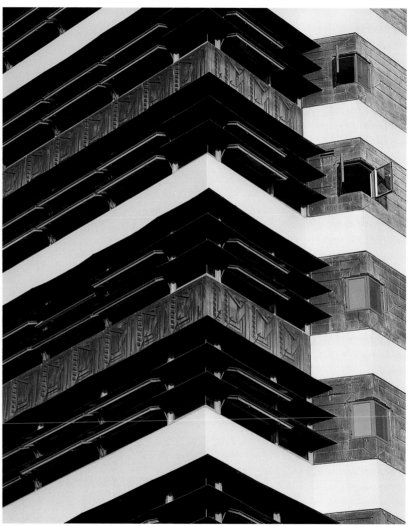

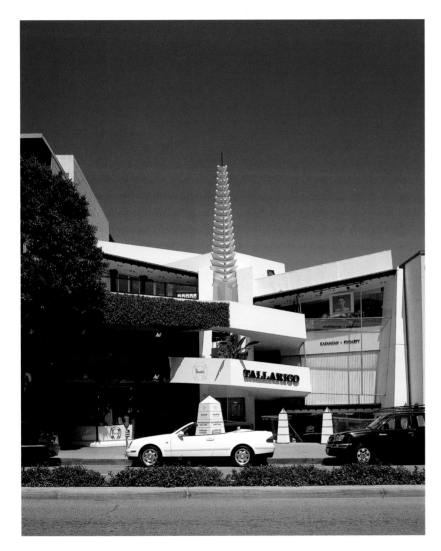

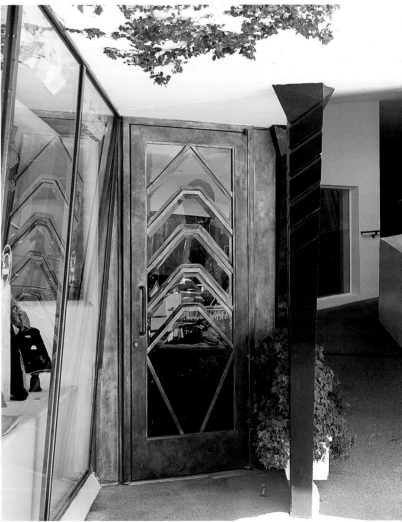

Above and opposite: Anderton Court Shops, Beverly Hills, California, 1952

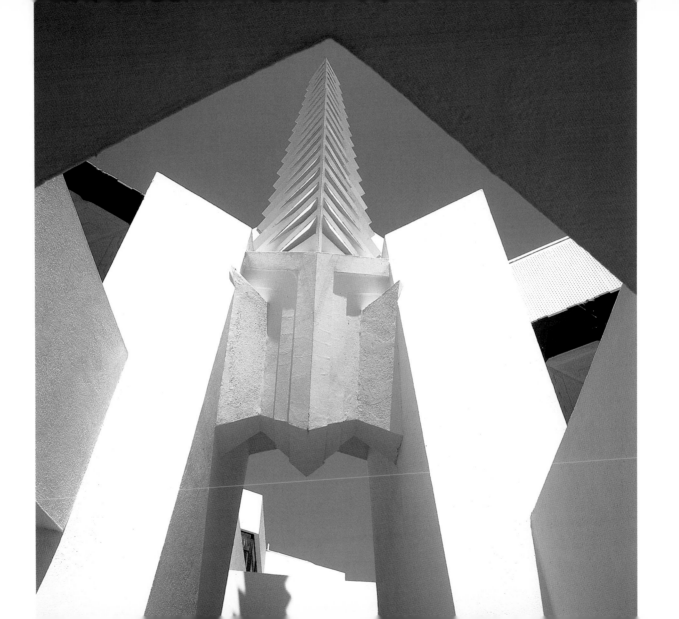

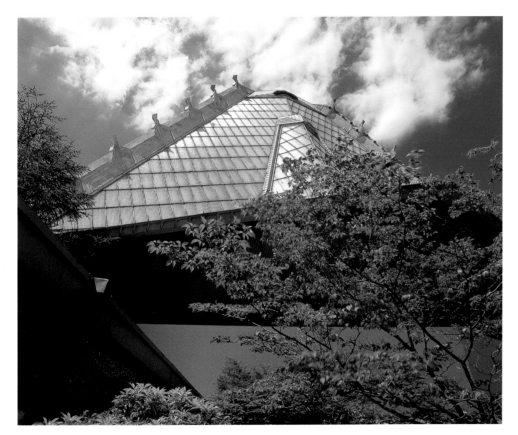

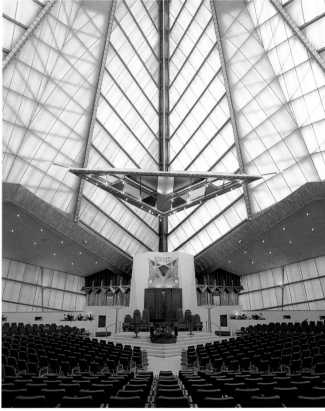

Above and opposite: Beth Sholom Synagogue, Elkins Park, Pennsylvania, 1954

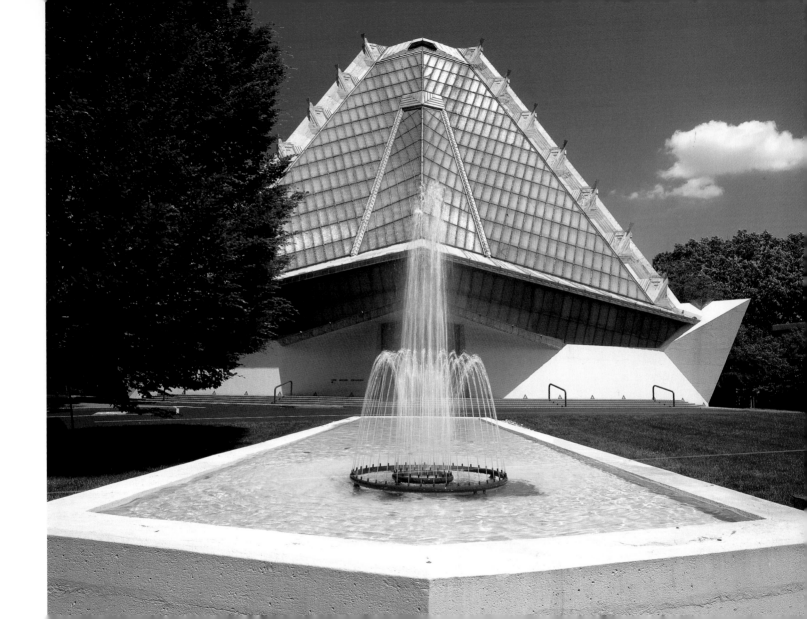

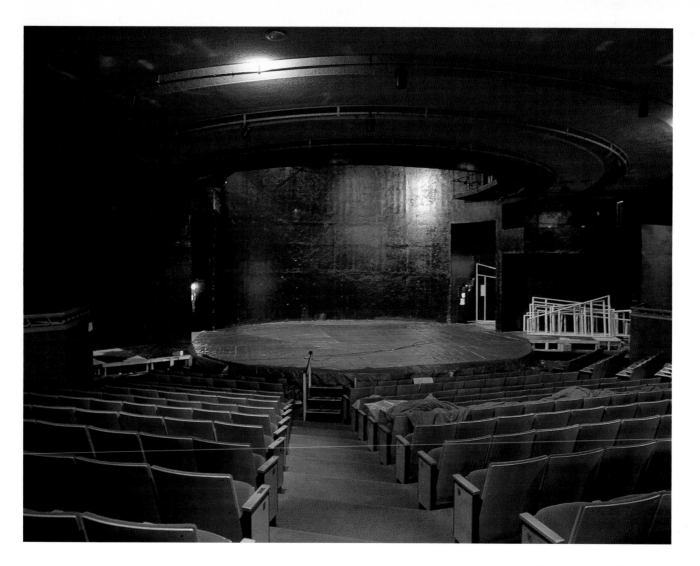

Opposite and above: Humphreys Theater, Dallas, Texas, 1955

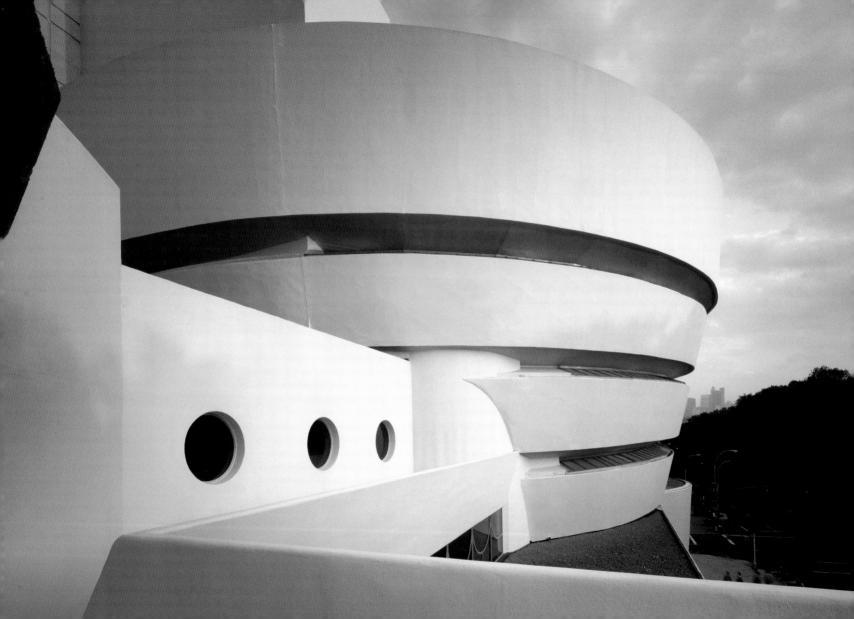

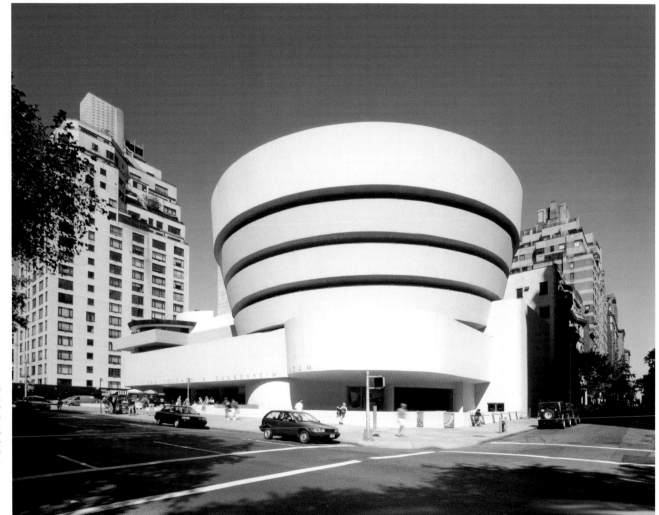

Opposite, above, following pages, and pages 378–379: Guggenheim Museum, New York, New York, 1956

Pages 376–379: Interior of the Solomon R. Guggenheim Museum during the exhibition "Cai Guo-Qiang: I Want to Believe, 2008."

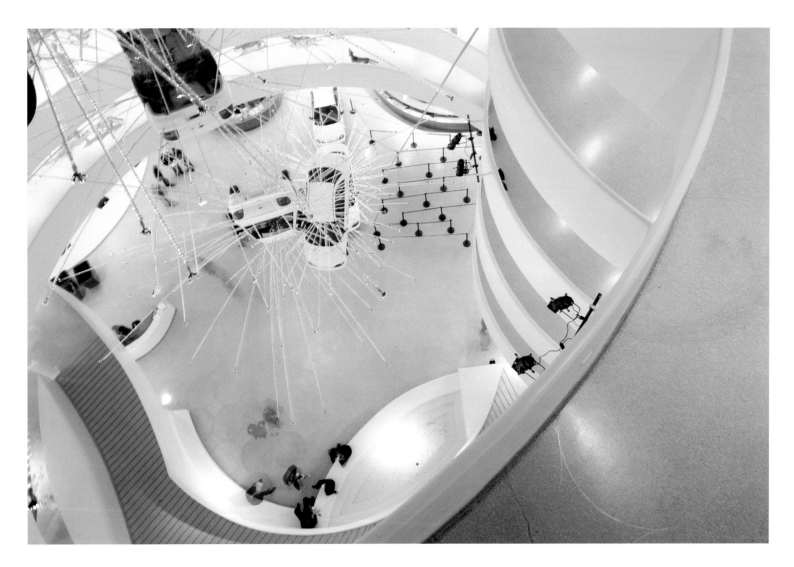

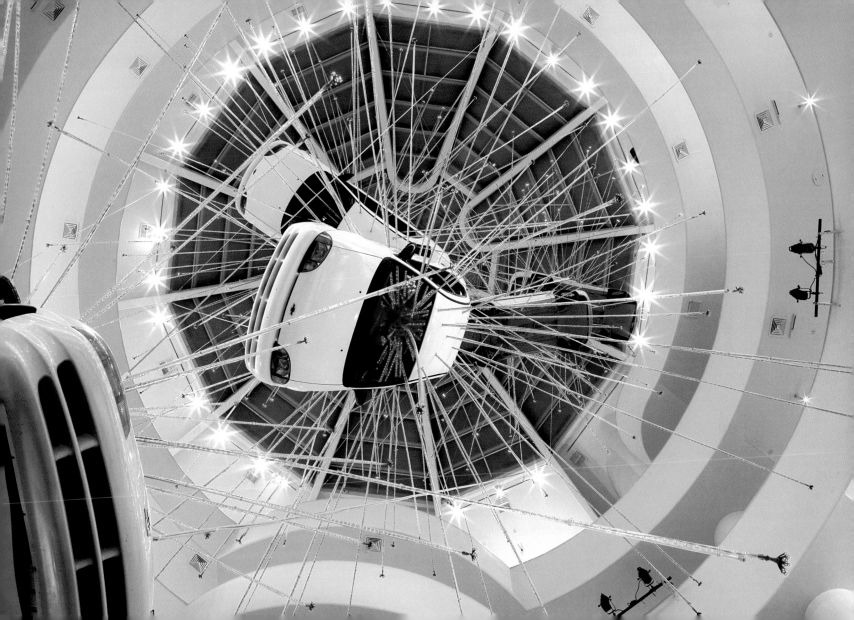

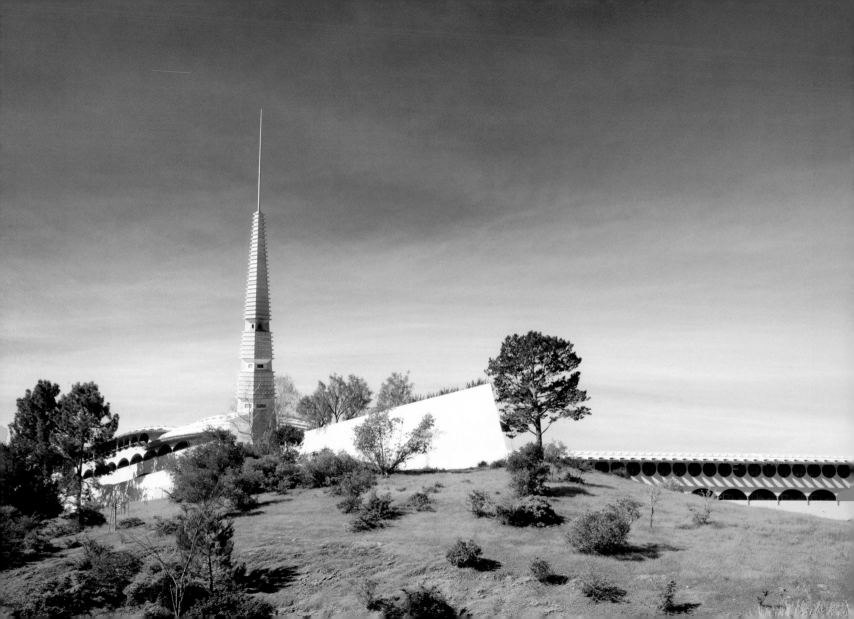

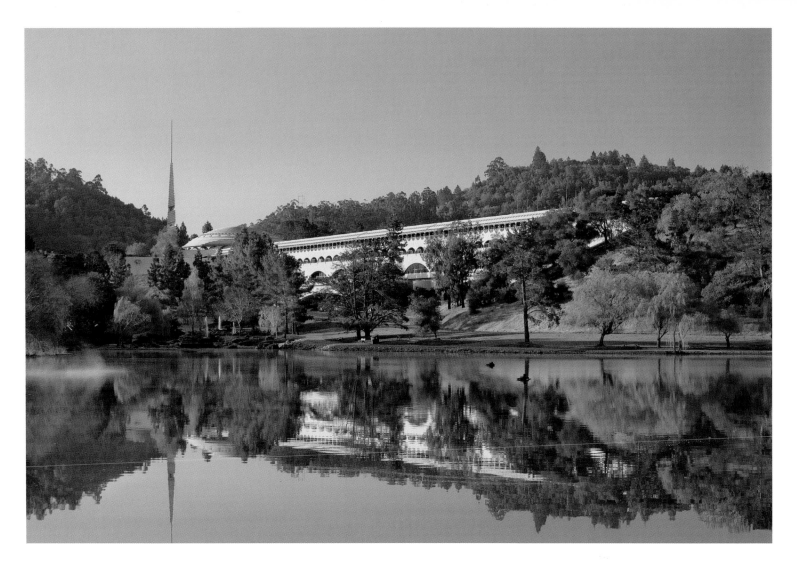

Opposite, above, following pages, and pages 384–385: Marin County Civic Center, San Rafael, California, 1957

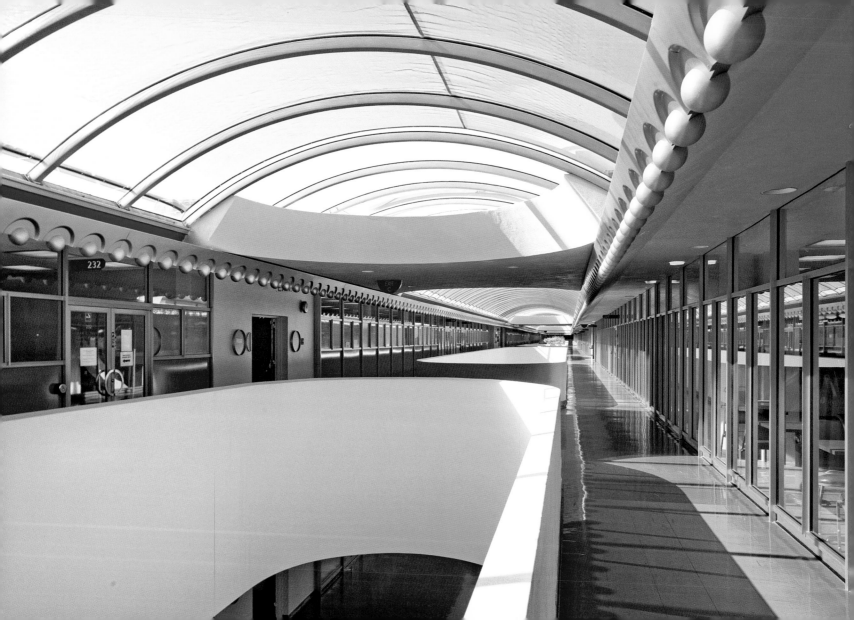

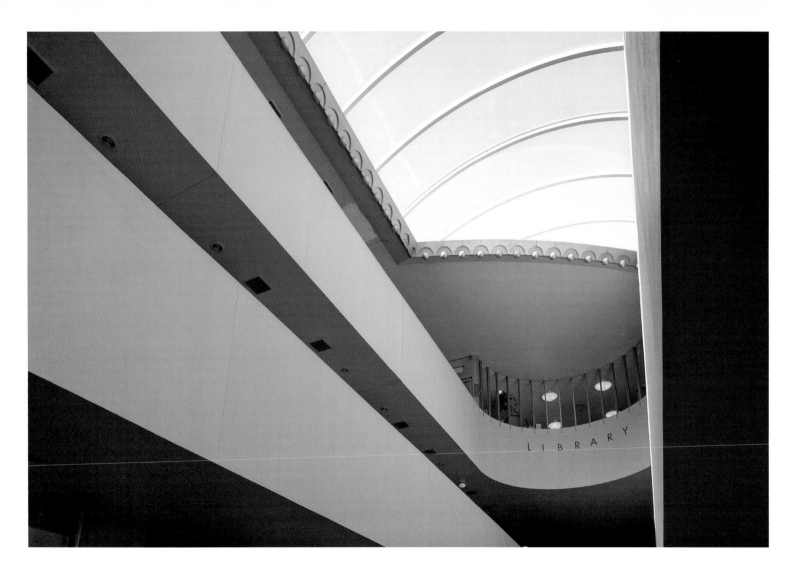

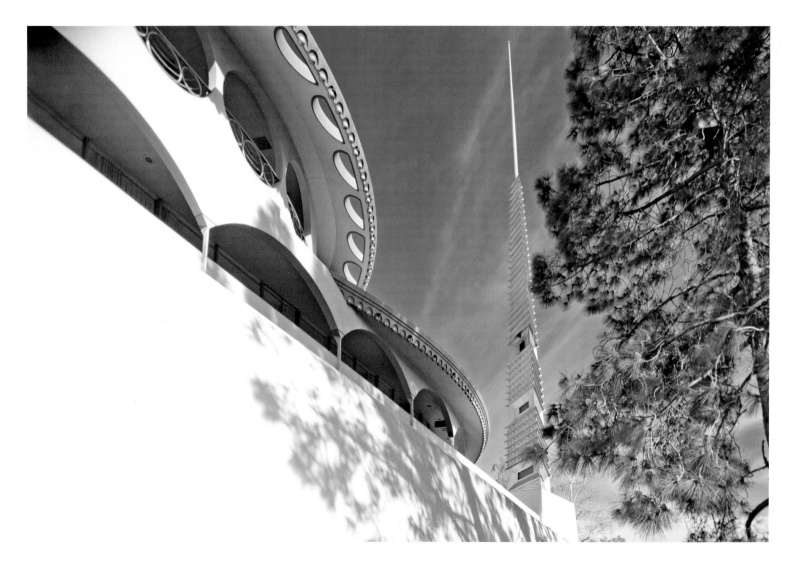

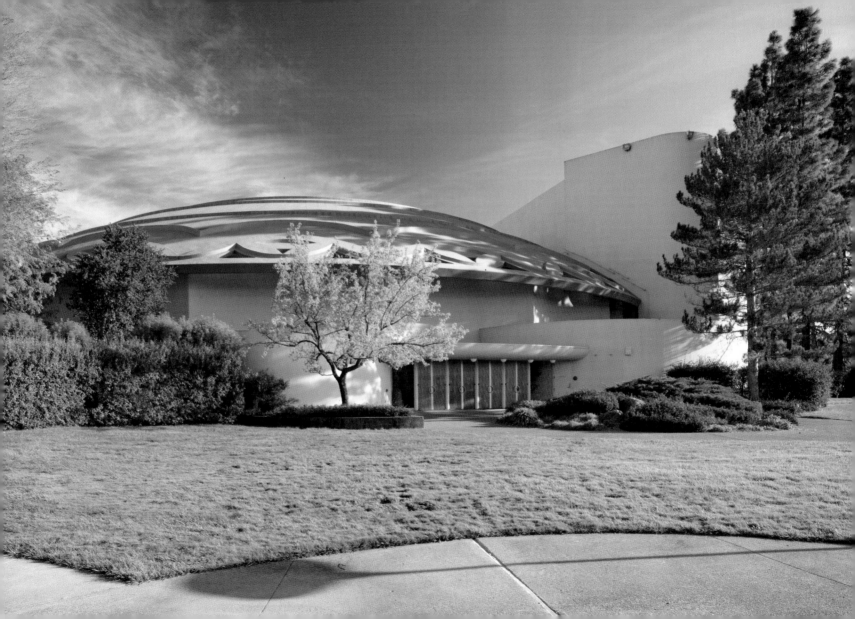

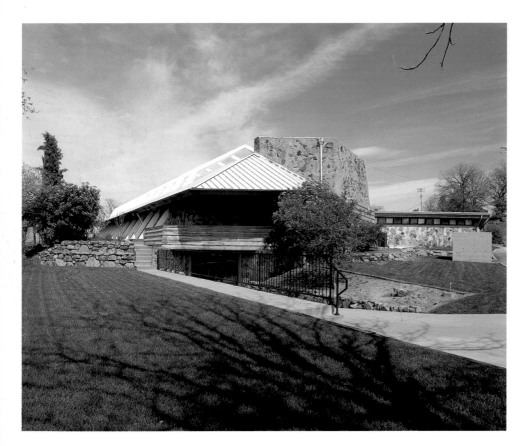

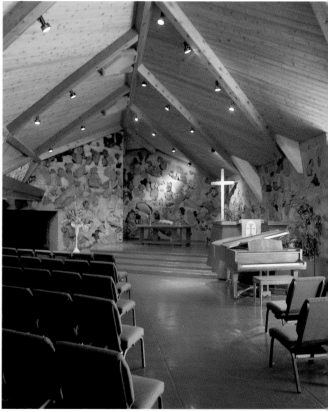

Above and opposite: Pilgrim Congregational Church, Redding, California, 1958

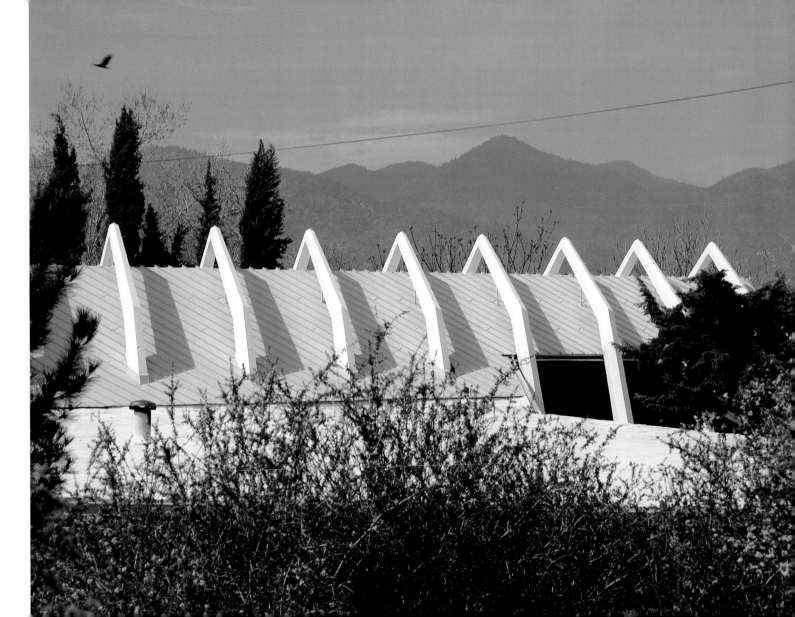

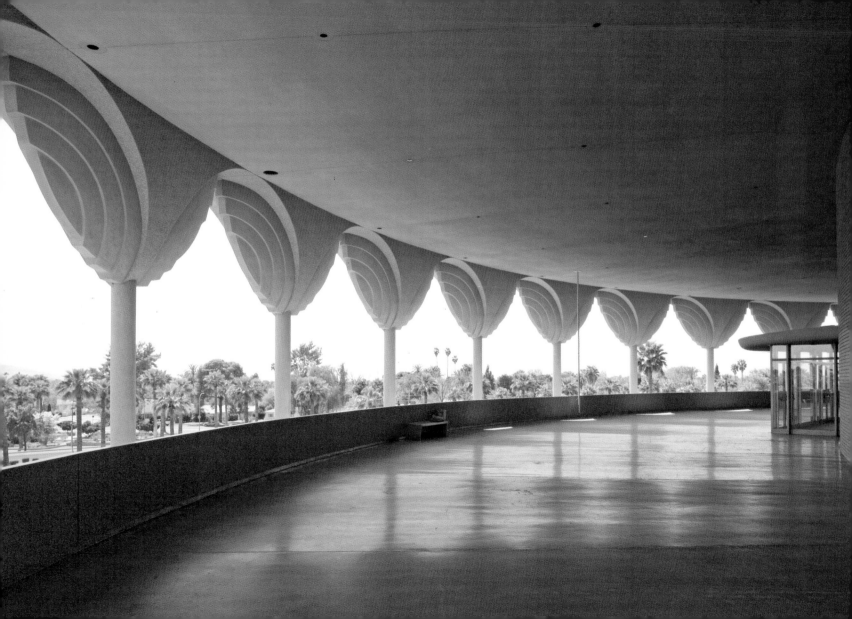

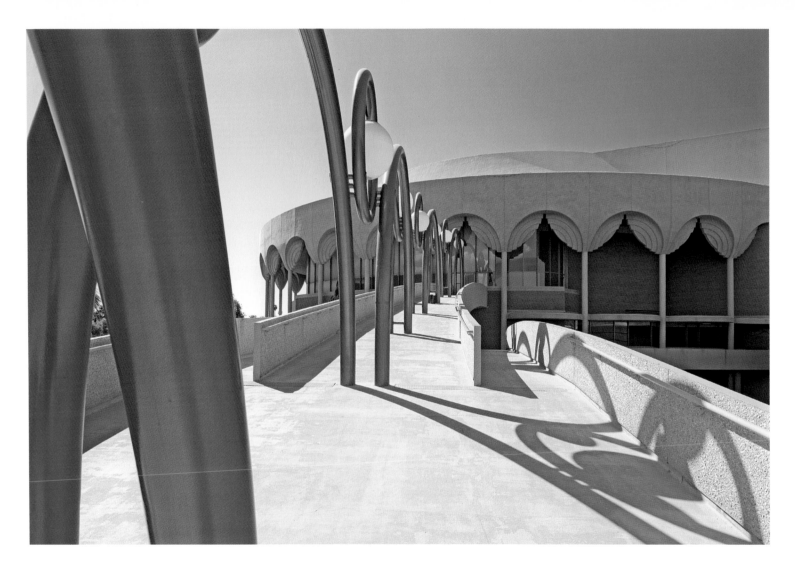

Opposite, above, and following pages: Grady Gammage Memorial Auditorium, 1959

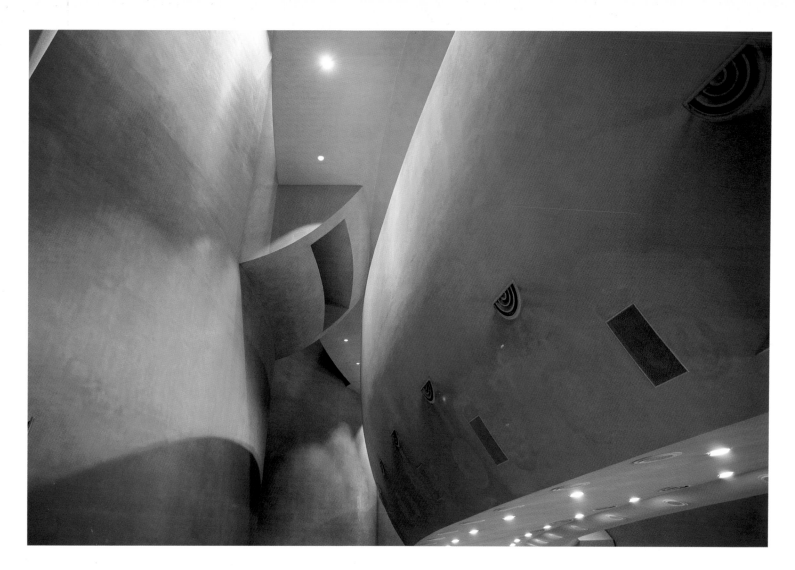

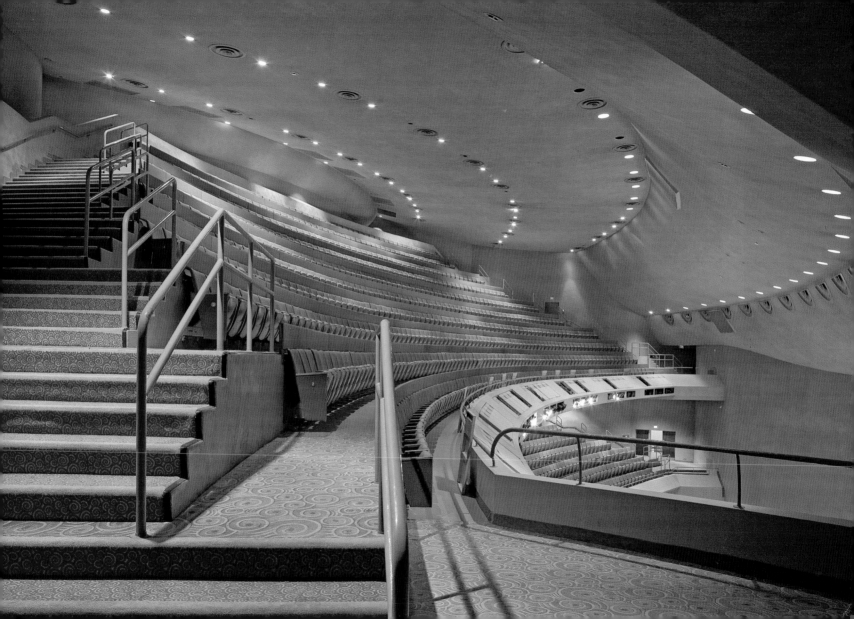

SELECTED WORKS

1886–1909

1886

Unity Chapel
Spring Green, Wisconsin

1889

Frank Lloyd Wright Home and Studio
Oak Park, Illinois
1895 – playroom addition
1897 – studio

1890

Louis Sullivan House
Ocean Springs, Mississippi
for Adler and Sullivan

1891

Charnley House
Ocean Springs, Mississippi
for Adler and Sullivan

1892

George Blossom House
Chicago, Illinois

W. Irving Clark House
LaGrange, Illinois

Warren McArthur House
Chicago, Illinois

Robert P. Parker
Oak Park, Illinois

1893

Walter M. Gale
Oak Park, Illinois

William H. Winslow House
River Forest, Illinois

1894

Francis Woolley House
Oak Park, Illinois

1895

Chauncey L. Williams House
River Forest, Illinois

Harrison P. Young Remodeling
Oak Park, Illinois

1897

George Furbeck House
Oak Park, Illinois

Rollin Furbeck House
Oak Park, Illinois

1900

B. Harley Bradley House
Kankakee, Illinaois

Warren Hickox House
Kankakee, Illinois

Edward R. Hills Remodeling
Oak Park, Illinois

Fred B. Jones House (Penwern)
Delavan, Wisconsin

1901

E. Arthur Davenport House
River Forest, Illinois

Fricke–Martin House
Oak Park, Illinois

F. B. Henderson House
Elmhurst, Illinois

Frank W. Thomas House (The Harem)
Oak Park, Illinois

1902

Susan Lawrence Dana House
Springfield, Illinois

George Gerts Cottage
Whitehall, Michigan

Arthur Heurtley House
Oak Park, Illinois

Ward Willits House
Highland Park, Illinois

1903

George Barton House
Buffalo, New York

Edwin Cheney House
Oak Park, Illinois

Francis W. Little House I
Peoria, Illinois

1904

Darwin D. Martin House
Buffalo, New York

1905

Mary M. W. Adams House
Highland Park, Illinois

Charles E. Brown House
Evanston, Illinois

William A. Glasner House
Glencoe, Illinois

Thomas P. Hardy House
Racine, Wisconsin

A. P. Johnson House
Delavan, Wisconsin

Harvey P. Sutton House
McCook, Nebraska

Unity Temple
Oak Park, Illinois

1906

Peter A. Beachy House
Oak Park, Illinois

A. W. Gridley House
Batavia, Illinois

George M. Millard House
Highland Park, Illinois

William H. Pettit Memorial Chapel
Belvidere, Illinois

Burton J. Westcott House
Springfield, Ohio

1907

Avery Coonley House
Riverside, Illinois

George Fabyan Remodeling
Geneva, Illinois

Andrew Porter House (Tanyderi)
Spring Green, Wisconsin

Ferdinand Tomek House
Riverside, Illinois

Stephen M. B. Hunt House I
LaGrange, Illinois

1908

Edward Boynton House
Rochester, New York

Walter V. Davidson House
Buffalo, New York

Raymond W. Evans House
Chicago, Illinois

Meyer May House
Grand Rapids, Michigan

Frederick C. Robie House
Chicago, Illinois

Isabel Roberts House
River Forest, Illinois

G. C. Stockman House
Mason City, Iowa
"A Fireproof House for $5,000"

1909

Hiram Baldwin House
Kenilworth, Illinois

Laura R. Gale House
Oak Park, Illinois

J. Kibben Ingalls House
River Forest, Illinois

Edward Irving House
Decatur, Illinois

Darwin D. Martin Gardener's Cottage
Buffalo, New York

George Stewart House
Montecito, California

SELECTED WORKS

1910—1948

1910

Jessie R. Ziegler House
Frankfort, Kentucky
"A Fireproof House for $5,000"

1911

O. B. Balch House
Oak Park, Illinois

Sherman M. Booth Cottage
Glencoe, Illinois
Ravine Bluffs Development

Taliesin
Spring Green, Wisconsin
1914 – remodeling
1925 – remodeling

1912

Coonley Playhouse
Riverside, Illinois

William B. Greene House
Aurora, Illinois

1915

Emil Bach House
Chicago, Illinois

Sherman M. Booth House
Glencoe, Illinois
Ravine Bluffs Development

William F. Kier House
Glencoe, Illinois
Ravine Bluffs Development

Daniel Kissam House
Glencoe, Illinois
Ravine Bluffs Development

Charles R. Perry House
Glencoe, Illinois
Ravine Bluffs Development

William F. Ross House
Glencoe, Illinois
Ravine Bluffs Development

Ravine Bluffs Development Sculpture
Glencoe, Illinois

1916

Frederick C. Bogk House
Milwaukee, Wisconsin

1919

Aline Barnsdall House
(Hollyhock House)
Los Angeles, California

1923

Alice Millard House (La Miniatura)
Pasadena, California

John Storer House
Los Angeles, California

1924

Charles Ennis House
Los Angeles, California

Samuel Freeman House
Los Angeles, California

1926

Isabelle Martin House (Graycliff)
Derby, New York

1927

Arizona Biltmore Hotel
Phoenix, Arizona
(consultant to Albert McArthur, architect)

1929

Richard Lloyd Jones House (Westhope)
Tulsa, Oklahoma

1933

Malcolm Willey House
Minneapolis, Minnesota

1934

Edgar J. Kaufmann House
(Fallingwater)
Mill Run, Pennsylvania

1936

Paul Hanna House
(Honeycomb House)
Palo Alto, California

Herbert Jacobs House I
Madison, Wisconsin

1937

Herbert Johnson House
(Wingspread)
Wind Point, Wisconsin

Taliesin West
Scottsdale, Arizona

1938

Pfeiffer Chapel
Florida Southern College
Lakeland, Florida

John C. Pew House
Shorewood Hills, Wisconsin

1939

Goetsch-Winckler House
Okemos, Michigan

Lloyd Lewis House
Libertyville, Illinois

Loren B. Pope House
(Pope-Leighey House)
Falls Church, Virginia

Stanley Rosenbaum House
Florence, Alabama

C. Leigh Stevens House
(Auldbrass)
Yemassee, South Carolina

George Sturges House
Brentwood Heights, California

1940

Gregor Affleck House
Bloomfield Hills, Michigan

Theodore Baird House
Amherst, Massachusetts

James B. Christie House
Bernardsville, New Jersey

Arch Oboler House
Malibu, California

1944

Herbert Jacobs House II
Middleton, Wisconsin

1945

Lowell Walter House and River Pavilion
Quasqueton, Iowa

1946

Douglas Grant House
Cedar Rapids, Iowa

Chauncey Griggs House
Tacoma, Washington

Herman T. Mossberg House
South Bend, Indiana

Melvyn Smith House
Bloomfield Hills, Michigan

1947

Jack Lamberson House
Oskaloosa, Iowa

1948

Albert Adelman House
Fox Point, Wisconsin

Maynard Buehler House
Orinda, California

Sol Friedman House
Pleasantville, New York
Usonia Homes

V. C. Morris Gift Shop
San Francisco, California

Della Walker House
Carmel, California

SELECTED WORKS

1949–1959

1949

J. Willis Hughes House (Fountainhead)
Jackson, Mississippi

Henry Neils House
Minneapolis, Minnesota

Edward Serlin House
Pleasantville, New York
Usonia Homes

1950

Robert Berger House
San Anselmo, California

Raymond Carlson House
Phoenix, Arizona

Richard Davis House
Marion, Indiana

R. Bradford Harper House
Saint Joseph, Michigan

William Palmer House
Ann Arbor, Michigan

Wilbur Pearce House
Bradbury, California

Don Schaberg House
Okemos, Michigan

Seamour Shavin House
Chattanooga, Tennessee

Karl Staley House
North Madison, Ohio

Isadore Zimmerman House
Manchester, New Hampshire

1951

Benjamin Adelman House
Phoenix, Arizona
Usonian Automatic

Charlcey Austin House
Greenville, South Carolina

Aaron Green–Frank Lloyd Wright Field Office
San Francisco, California

Thomas Keys House
Rochester, Minnesota

Patrick Kinney House
Lancaster, Wisconsin

Roland Reisley House
Pleasantville, New York
Usonia Homes

1952

Anderton Court Shops
Beverly Hills, California

Quintin Blair House
Cody, Wyoming

Jorgine Boomer House
Phoenix, Arizona

Ray Brandes House
Issaquah, Washington

George Lewis House
(Spring House)
Tallahassee, Florida

R. W. Lindholm House (Mäntylä)
Cloquet, Minnesota

Louis Penfield House
Willoughby Hills, Ohio

Price Tower
Bartlesville, Oklahoma

Nathan Rubin House
Canton, Ohio

Frank Sander House (Springbough)
Stamford, Connecticut

1953

William Thaxton House
Bunker Hill, Texas

1954

E. Clarke Arnold House
Columbus, Wisconsin

Bachman–Wilson House
Millstone, New Jersey

Cedric Boulter House
Cincinnati, Ohio

John Christian House
West Lafayette, Indiana

Maurice Greenberg House
Dousman, Wisconsin

Beth Sholom Synagogue
Elkins Park, Pennsylvania

I. N. Hagan House
Chalkhill, Pennsylvania

Harold Price Sr. House
Paradise Valley, Arizona

Gerald Tonkens House
Amberley Village, Ohio
Usonian Automatic

William Tracy House
Normandy Park, Washington
Usonian Automatic

1955

Toufic Kalil House
Manchester, New Hampshire
Usonian Automatic

Kalita Humphreys Theater
Dallas, Texas

Maximilian Hoffman House
Rye, New York

Donald Lovness House
Stillwater, Minnesota

Theodore Pappas House
St. Louis, Missouri
Usonian Automatic

John Rayward House (Tirranna)
New Canaan, Connecticut

Dorothy Turkel House
Detroit, Michigan
Usonian Automatic

1956

Allen Friedman House
Bannockburn, Illinois

Conrad Edward Gordon House
Wilsonville, Oregon

Solomon R. Guggenheim Museum
New York, New York

Llewellyn Wright House
Bethesda, Maryland

1957

Marin County Civic Center
San Rafael, California

Carl Schultz House
Saint Joseph, Michigan

Robert Walton House
Modesto, California

1958

George Ablin House
Bakersfield, California

Seth Condon Peterson Cottage
Lake Delton, Wisconsin

Pilgrim Congregational Church
Redding, California

Don Stromquist House
Bountiful, Utah

1959

Grady Gammage Memorial Auditorium
Arizona State University
Tempe, Arizona

Norman Lykes House
Phoenix, Arizona

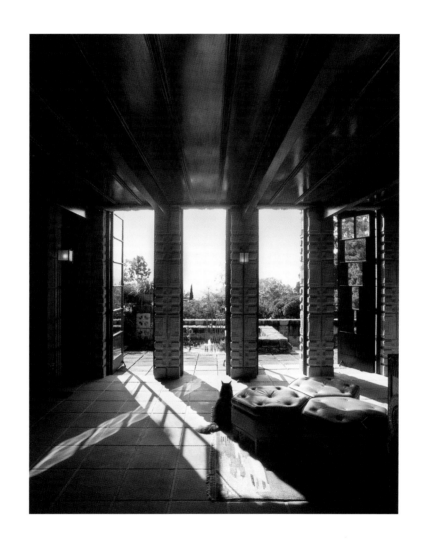

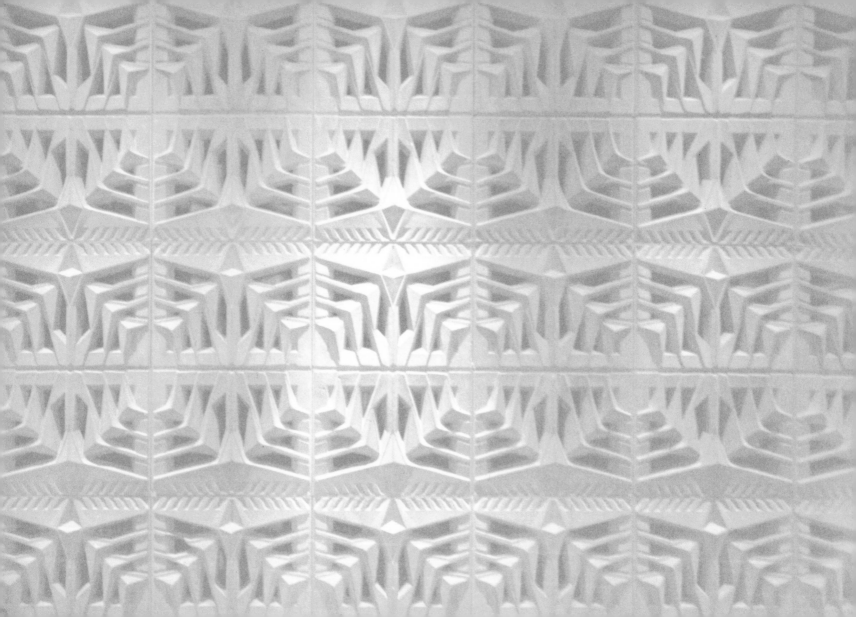